Image Government

Image Government

Monarchical Metamorphoses
in English Literature and Art, 1649-1702

T.R. Langley

James Clarke & Co
Cambridge

First Published in 2001 by:
James Clarke & Co
P.O. Box 60
Cambridge
CB1 2NT
England

e-mail: **publishing@jamesclarke.co.uk**
website: **http://www.jamesclarke.co.uk**

ISBN 0 227 67963 6

British Library Cataloguing in Publication Data:
A catalogue record is available from the British Library.

This book is published with the help of a grant from the Chambers Fund,
University College London

Printed in the United Kingdom by
Creative Print and Design, Ebbw Vale, Wales

CONTENTS

PREFACE

This book catches at a drift, rather than enforces a thesis. In the beginning (at any rate, according to Earl R. Wasserman, whose seminal article on 'Nature Moralized: Divine Analogy in the Eighteenth Century' was published long enough ago now, in 1953) – in the beginning,

> Shakespeare's King Richard appears 'As doth the blushing discontented sun' because the proportional relation of king and sun preexists in the poet's scheme of things.

'In the Elizabethan mind the assumption of the analogy lay', that is, basically 'beneath the level of consciousness'. On the other hand, in the end,

> the work of the eighteenth-century theorists [to say nothing of Bacon and Hobbes before them] was to make the age conscious of analogy. No longer thinking analogically, but consciously thinking about thinking analogically, it had split a unified concept into its two component parts and into two separate but related events. Analogy is no longer a frame of mind for meaningful perception, but a pattern for chronological procedure.[1]

These observations will serve to sketch in the outer limits of the present enterprise.

But, of course, Wasserman was generalising. Even 'in the Elizabethan mind' assumptions of analogy might rise disquietingly towards consciousness. For instance, when 'Shakespeare's King Richard' arrives (from Ireland, in the West) upon the coast of Wales, to invoke 'the searching Eye of Heaven' which 'fires the prowd tops of the Easterne Pines, / And darts his [Light] through ev'ry guiltie hole', making

> Murthers, Treasons, and detested sinnes
> (The Cloake of Night being pluckt from off their backs)
> Stand bare and naked, trembling at themselves,

he does, indeed (his royal plurals welcoming with open arms the sun as cognate), analogically assume that,

> Soe when this Theefe, this Traytor *Bullingbrooke*,
> Who all this while hath revell'd in the Night,
> Shall see us rising in our Throne, the East,
> His Treasons will sit blushing in his face,
> Not able to endure the sight of Day;
> But selfe-affrighted, tremble at his sinne.[2]

Not only, however, is he rising in the West (which might have gone unremarked without his own repeated insistence on 'Easterne' and 'East') but also 'One day too late':[3] the Welsh army he was expecting has just dispersed. 'Nor time nor place', in the words of Lady Macbeth, 'Did then adhere, and yet. . .' – And yet Richard (who has, after all, more in common with Duncan than with her husband) singularly fails to make anything of either, except purple passages. Celestial and political suns are disconcertingly (disastrously, perhaps, in a root sense) out of synchrony.

In fact, as the next scene and Wasserman's quotation reveal, it is not 'this Theefe, this Traytor Bullingbrooke' who is to do the blushing, but Richard himself. 'Yet lookes he like a King', interjects York; and still he is the sun. The 'divine analogy' holds so far, so good; so that Bolingbroke's description (for the previous lines, ironically, have been his) 'returne[s] to plague th'Inventer', casting him, by irresistible implication, into the unpropitious role of one of his own 'envious Clouds. . . bent / To dimme' that sun's 'glory, and to staine the tract / Of his bright passage to the Occident'.[4] Bolingbroke may not be 'self-affrighted' (Richard, characteristically, thinks that the king should have no more to do than put in an appearance); but he is, in a manner of speaking, his manner of speaking, and by an analogy which lies 'beneath the level of consciousness', 'self-indicted'.

His 'I-know-you-all' son-and-heir, intent on demonstrating at the beginning of *Henry IV*, Part I that he is no Hotspur Harry given to the mislaying of maps, manipulates the same imagery with much more self-conscious aplomb. He 'will a-while uphold / The unyoak'd humour' – 'damp exhalation', that is, at one level[5] – of fat, Falstaffian 'idleness':

Yet heerein will I imitate the Sunne,
Who doth permit the base contagious cloudes
To smother up his Beauty from the world,
That when he please againe to be himselfe,
Being wanted, he may be more wondred at,
By breaking through the foule and ugly mists
Of vapours, that did seeme to strangle him.[6]

Having, even thus early on, manifestly little to discover from any 'Globe of sinfull Continents' (or yet his own, proper father) about the 'by-pathes, and indirect crook'd-wayes' of turning 'diseases to commodity', he will, he undertakes, 'so offend, to make offence a skill, / Redeeming time, when men thinke least I will':[7] a pay-off which has more to do with 'creative accounting' than 'the redemption of the world by Our Lord, Jesus Christ'.

And he will 'imitate the Sunne', also, at a rather different rate from Richard, whose sheer 'presence', like that of the '*Fauns* and *Faryes*' in Marvell's 'Mower against Gardens' (who 'do the Meadows till, / More by their presence then their skill'),[8] should, theoretically, render superflous a need for lower cunning. Richard, in his own sphere or realm, as 'The Deputie elected by the Lord' 'which by *his* wisedome made . . . the Sunne to rule the day'[9], reigns not so much as the sun's imitator, as its veritable and unique twin, match or marrow.

One of Wasserman's 'eighteenth-century theorists' will help to highlight the disparity. 'Analogy', claims Peter Browne, Bishop of Cork and Ross, in *The Procedure, Extent, and Limits of Human Understanding*,[10]

conveys the Conception of a *Correspondent Reality* or *Resemblance*. Metaphor is rather an *Allusion*, than a real Substitution of Ideas; Analogy a proper *Substitution* of Notions or Conceptions. . . In short, Metaphor has *No* real Foundation in the *Nature* of the Things compared; Analogy is founded in the *Very Nature* of the Things on both Sides of the Comparison.

So Richard's rhetoric 'conveys the Conception of a Correspondent Reality', takes for granted (is this what makes 'Our Throne, the East' seem so awkward when he is literally in the West?) 'a proper Substitution'; in short, presumes upon an 'Analogy' between king and sun, 'founded in the *Very Nature* of the Things on both Sides of the Comparison'. Hal, in contrast (heir to a usurper, nothing if not skilful), moves into a more 'metaphorical' register and, instead of standing almost hysterically upon fundamental points of order, coolly cuts out a figure designed to dress up[11] his predicament and intentions to advantage. A world of immanent 'Analogy' gives ground, and simultaneously lends grist, to more machinating mills.

Richard fails, miserably. Hal succeeds, to triumph spectacularly, as Henry V, at Agincourt. Yet, in the longer term, Shakespeare cannot discount the validity of Ricardian pretensions. The chaos and civil war which he had already chronicled in the three parts of *Henry VI* and the diablerie of *Richard III* were to follow, in retribution for their having been taken in vain.

In the longer term still, after the abortive new-modellings of the Interregnum and glossolalia of a latter-day 'false tongu'd Bullingbrooke' (whom Lucy Hutchinson substitutes, as more fittingly Cromwellian, for Waller's '*France* conqu'ring *Henry*' in her riposte to his *Panegyrick*)[12] – in the longer term still, come May 29, 1660, Great Britain is to be discovered gratefully basking, once again, in the warm, procreative 'presence' of a restored and wholly legitimate monarch, widely welcomed as the summer sun, whose 'Happy Return', moreover, seemed 'wholly surprising and miraculous'[13] and thus to owe nothing whatsoever to the 'skill' or plottery of any 'vile Politician'. There was an upsurge of 'emotional togetherness': that 'physically, physiologically natural element which', Peter Laslett has assured us, underlies 'all political relationships', but which, he claims, 'political thinking since Locke' – who 'assumed that the stuff of society was conscious ratiocinaction' – has largely ignored.[14] To deploy another, overlapping distinction, drawn by Michael Walzer:[15] a 'Cromwellian' (Calvinist, Hobbist) regime of 'command and obedience gave way to older habits of 'authority and reverence', depending 'upon a mutual recognition of personal, place' (most crucially, of course, the king's) and hypostatized in the old analogies. All this, too, despite the interventions of Bacon – who, half a century ago, had made it axiomatic that, although

> There are many things in nature as it were *monodica, sui juris* [singular, and like nothing but themselves]; yet the cogitations of man do feign unto them relatives, parallels, and conjugates, whereas no such thing is[16] –

and, more lately, of Hobbes – who, in *Leviathan* , denies that there is any 'Analogy . . . founded in the *Very Nature* of the Things' between, say, 'Bees, and Ants' (numbered though they may have been by Aristotle 'amongst Politicall creatures') and human society, since, for one thing, 'the agreement of these creatures is Naturall; that of men, is by Covenant, which is Artificiall'.[17] Old habits die hard.

The euphoria, nevertheless, would not last; could not survive Plague, Fire, Dutch Wars and Popish Plots, not to mention connivance with the French

and dissipation in high places. By 1679, with Exclusion in the wind, *The Bishop of Carlisle's Speech in Parliament, concerning Deposing Princes* was 'Thought seasonable to be published', once again, 'in this Murmuring Age': 'murmuring', in biblical language, being symptomatic of 'the sin of witchcraft', rebellion, and the Bishop of Carlisle, in history as in Shakespeare's play, Richard's staunchest apologist.

Not ten years later (as will be seen), James II himself was testily to declare 'that he had read the story of Richard II', insinuating that William of Orange (whom he had earlier characterised as 'a worse man than Cromwell')[18] was another Bolingbroke – who, of course, had had no intention, either, of laying claim to the crown when he had landed at his more northerly Torbay!

For any King of England to bear the stigma of 'the Second' was, suggests the anonymous pamphlet, *Numerus Infaustus*, published in 1689,[19] fatal. Of the six unfortunates then in question, Henry II may have had his notable successes, but 'died with *Trouble of Mind*'. Charles, not so long since, after his providentially 'Happy Return', had 'reigned more than twenty-four Years, and I wish I could say happily', then ('Treacherie, seeke it out'!) 'died *suddenly*, to say no more of it'. For the remainder: William Rufus, Edward, Richard had all three come to premature and violent ends; and 'King *James* must remain single upon Record, as the only Person that wilfully and industriously dethroned himself'.

From the start his number was, as it were, up. 'Witchcraft' would win – strenuously pretending, with cries of

Away this Goblin Witchcraft, Priest-craft Prince,

Give us a King, Divine, by Law and Sense,[20]

that it wasn't. This time, too, the spell was to hold good, for good; made all the more binding (witness Howard Nenner's book, so entitled) *By Colour of Law*[21] – and, for the first few, difficult years, tincture of Mary.

Anne's advent saw affairs revert to a righter, if still not quite right, line. Pope was to proclaim that 'Peace and Plenty tell, a STUART reigns', hoping, no doubt, for better things to come.[22] But it was to be all Hanover, save for more or less posthumous spasms in 1715 and '45.

The dynasty was to prove as pertinacious as the brown, grey or (in Charles Waterton's preferred nomenclature) 'Hanoverian' rat which, as this still quixotically Jacobitish nineteenth-century naturalist pointedly records, his father ('who was of the first order of field naturalists' himself) 'maintained firmly, . . . did accompany the House of Hanover in its emigration from Germany to England': 'actually came over in the same ship which conveyed the new dynasty to these shores', just as local, Yorkshire tradition intimated. 'Some few years after the fatal period of 1688', writes Waterton (who naturally had no love for 'Dutch William', either, 'that sordid foreigner', as he calls him in his introductory 'Autobiography'),

there arrived on the coast of England a ship from Germany, freighted with a cargo of no ordinary importance. In it was a sovereign remedy for all manner of national grievances –

and a rat! – A rat of a new and particularly pernicious variety.[23]

Julian the Apostate, it is to be inferred, had most aptly, as the eighteenth

century opened, been installed in supervisory seat on the King's Staircase at Hampton Court! And the artist who painted him there, Antonio Verrio, considering his Roman Catholicism and previous loyal services to the cause of Stuart iconography and 'idol lordship', must have smiled bitterly as he wielded his brush, although those who set him to work obviously thought (with the Third Earl of Shaftesbury, who may have been one of them) atypically well of 'that virtuous and gallant Emperor':[24] that free-thinking man's monarch and disciple of Marcus Aurelius Antoninus – of whom in sharp contrast, almost nobody had anything bad to say. (Whereas 'Vicisti, Galilaee', his supposed dying words, will sum up Julian's abiding reputation, despite intermittent attempts at rehabilitation.)

'The whisker'd vermin race' (not, Samuel Johnson was to agree, a suitable subject for serious poetry)[25] had irremediably invaded the sugar-cane, whatever limited extirpatory success Waterton was to congratulate himself upon at Walton Hall. The ecological balance of the country at large had irrevocably been altered. Henceforward, something other than 'Divinity doth hedge a King'. Treason had not just peeped at what it would but (purely in the interests, naturally, of

Regal Government, and the free use of Parliaments, the profession of God's pure Religion, and the Enjoyment of our Antient Laws and Liberties)[26]

outstared, outfaced the opposition and caught 'With his surcease, Successe' (or the other way round, as Johnson conjectures, trying to make sense of Macbeth's rodomontade).[27] Old superstitions, old 'pieties' (such as the wild surmise that 'acts of love, friendship, respect, or the like' might have something fundamentally to do with civilization, 'loyalty and subjection'[12]) begin to look pale, or paler, in the light of the Hobbist or Lockean premiss that (as Laslett sees it, drawing a contrast with the older, Filmerite position) 'society . . . was created by conscious thinking and that it is . . . kept in being, kept working, by conscious thought'.[28] And we have it on Wasserman's word that, in the eighteenth century, 'Analogy is no longer a frame of mind for meaningful perception'. 'No longer thinking analogically, but consciously thinking about thinking analogically', the age 'had split a unified concept into separate but related events' – and learned to deal more or less neatly between the bark and the tree. Too much 'consciousness' of this kind was scarcely conducive to a second Stuart Restoration, although there were clansmen still prepared to sacrifice themselves, and the odd, unreconstructed aristocrat, gentleman and even bishop of the Church of England.

This, then, may serve as a rough groundplot for what is to come, which begins with the Protectorate poetry of Edmund Waller and ends with an investigation of the purport of Verrio's aforementioned programme for the decoration of the King's Staircase at Hampton Court. Others, needless to say, have undertaken exercises of similar or overlapping scope, most recently David Norbrook in his *Writing the English Republic: Poetry, Rhetoric and Politics, 1627-1660* where, in formidably researched fulfilment of its foreword's promise,

Key texts by Marvell [including *The First Anniversary*] and Milton,

including *Paradise Lost*, are set in the context of previously neglected writings by Edmund Waller, George Wither, Thomas May and many others, showing how writers re-imagined English political and literary culture without Kingship.

But perhaps, my own accent being rather on an imperial theme (the almost physical impossibility, as it were, of writing off monarchy), what is to be said in the following pages has not quite lost, any more than Milton's Satan, 'All her original brightness'. And at least Norbrook's brief does not extend far beyond the Restoration!

Looking further back, Howard Erskine-Hill's The *Augustan Idea in English Literature* does embrace all my chosen ground and more, opening in classical Rome itself and reaching forward well on into the Eighteenth Century. It proves an ideal introduction to the contours of the landscape as a whole. 'At one extreme of the tradition of the Augustan idea', he observes, concerned in his introduction to establish what would these days be called the parameters of the exercise, lies 'formal panegyric . . . and Tacitean analysis at the other'[29] – which does not, needless to say, preclude the possibility of the occasional marriage of heaven and hell, as witness the late-mentioned decorations for the King's Staircase, though the colouring there is judiciously more Aurelian than Augustan, if my reading of them is right. Gilbert Burnet, that glorious revolutionary, who had once compared (in the preface to his 1684 translation of More's *Utopia*) Charles II to Augustus, is taken to task, as Erskine-Hill drily notes,[30] by Bevil Higgons in the early years of the Eighteenth Century for shifting his ground and adducing in the *History of His Own Time* a parallel with Nero (seen ostentatiously strumming an anachronistic guitar in the Hampton Court paintings). William III, for preference (and Burnet was, indeed, preferred to the see of Salisbury) is associated with Marcus Aurelius. 1688 necessitated some nice adjustments!

The Augustan Idea was conceived as a complement to Erskine-Hill's earlier study *of The Social Milieu of Alexander Pope: Lives, Example and the Poetic Response*, also supplemented afterwards by articles on 'Literature and the Jacobite cause' and 'Alexander Pope: the political poet in his time'. This work, too, impinges instructively upon the last stage, especially, of what is to ensue, demonstrating the persistence of what another critic (Douglas Brooks-Davis) has felicitously termed 'emotional Jacobitism'.

'The tangled relations between politics and aesthetics' which, Steven N. Zwicker observes, 'must have remained close to the center' of men's experience through the ferment of the period in question, has increasingly become one of the crucial preoccupations of modern criticism. Zwicker himself can claim considerable credit for this. The quotation is culled from the opening page of his *Lines of Authority: Politics and English Literary Culture, 1649-1689*, but he had set a shoulder to the wheel long before, in *Dryden's Political Poetry: the Typology of King and Nation* – the subtitle advertises its contiguity with my own concerns – and added impetus with *Politics and Language in Dryden's Poetry: the Arts of Disguise*, which paints the picture of a poet who amply bears out the motto on the title page of *The*

Art of Complaisance or the Means to Oblige in Conversation, published in 1673 and basically a version of Eustache Du Refuge's *Traité de la Cour*: 'Qui nescit dissimulare, nescit vivere'. (I take what may be called a more radically 'pious' view.) If I have not repeatedly acknowledged his achievements, it is not because his presence is not felt.

Closely involved with Zwicker's 'tangled relations', the vexed interface between politics and literature or aesthetics, are shifting perceptions of how far human agency can affect, effect, history. To what extent, to borrow the phraseology of *Macbeth*, can time and place be made; or does all eventuality necessarily only realize, precipitate a pattern always implicit from the beginning? – With the result that, as Marvell with post-Restoration resignation affirms in the first part of *The Rehearsal Transpros'd*,[31]

> Men may spare their pains where Nature is at work, and the world
> will not go the faster for our driving,

because all things 'happen in their best and proper time, without any need of our officiousness' . Does history move inexorably in cycles, as Polybius, with his '*anakuklōsis politeiōn*' proposes? Or might not a once-and-for-all millennium be wrought, by forgery either of arms or intellect or both? A book such as David Loewenstein's *Milton and the Drama of History: Historical Vision, Iconoclasm and the Literary Imagination* may begin to suggest a range of possibilities which permeate the matter, too, of this present work.

But 'of making many books', saith the Preacher (along with much else, most notoriously 'vanitas vantitatem et omnia vanitas), 'there is no end'. And of the making of this particular book (begun, it may as well be confessed, in a dark, postgraduate past, augmented by fitful increment since, and from time to time promulgated piecemeal in the form of lectures or other teaching material) – of the making of this particular book there would have been no end, either, were strict justice to have been done to the claims of coeval scholarship and constant adjustments made to accommodate them. They should, of course, be consulted as extensively as possible with a view to complementing, controlling and, where necessary contradicting what is said here. 'I am', for my part, 'in blood / Stept is so farre, that should I wade no more, / Rewriting were as tedious as go ore'. So I have gone o'er, and be damned: 'Behold where stands / The 'Usurpers cursed head'!

Part I

1: PROLOGUE

> But they cried out, Away with him, away with him, crucifie him.
> Pilate saith unto them, Shall I crucifie your King? The chiefe Priests
> answered, Wee have no king but Caesar.[1]

'Non habemus Regem, nisi Caesarem': a pregnant text for a Royalist divine,
preaching before the exiled heir at The Hague in 1649, shortly after the
execution of that *'deuterot Christos'*, as he calls him, that 'second Christ',
his father, Charles I.

> A false colour they have readie at hand to cover their shame, *Habemus*
> *Caesarem, they* good men *have Caesar for their King*[2] –

the 'they' by this time having come to embrace not only Caiaphas and his
'chiefe Priests' but also Cromwell and his: son-in-law Ireton, Bradshaw with
his bullet-proof hat, and the rest. The sermon's published title invites such
parallels:

> *Regicidium Judaicum, or a Discourse about the Jewes Crucifying*
> *Christ, with an Appendix or Supplement upon the late Murder of our*
> *Blessed Soveraigne, Charles the First.*

'Blessed Soveraigne' and 'blessed Saviour' sound very much the same sort
of thing.

Richard Watson, author of the piece in question, sometime (see DNB.)
Fellow of Gonville and Caius College and headmaster of the Perse Grammer
School in Cambridge (he was ejected from both posts because of his
uncompromising anti-Presbyterianism and thereupon withdrew in high
dudgeon to France) – Richard Watson will figure in what is to follow primarily
as chief contributor to a pamphlet published a decade after his *Regicidium* in
1659:

> *The Panegyrike and the Storme, Two Poëtike Libells by Ed. Waller,*
> *Vassa'll to the Usurper, Answered by more Faythfull Subjects of his*
> *Sacred Majesty Charles ye Second.*[3]

For if, in 1649, there had been 'chief Priests' aplenty, but no obvious
counterpart to Caesar, the continuing rise of Cromwell was soon to supply
one, and Edmund Waller (the opportunity offering) had not been slow to lift
up his voice in the *'Habemus Caesarem'* chorus, leaving any more 'sacred'
or (to cull a term from E.H. Kantorowicz's classic *The King's Two Bodies*)[4]
'christomimetic' majesty, in the mendicant shape of Charles II, to shift for
itself.

True, 1643 had caught him plotting on behalf of 'CHARLES the First, and
CHRIST the second' (as Owen Felltham, in Watsonian vein, calls him in 'An

Epitaph' to his 'Eternal Memory')'[5] but, on being discovered, he had availed himself to the full of his 'RIGHT OF NATURE': namely, according to his acquaintance Thomas Hobbes, that

> Liberty each man hath, to use his own power, as he will himselfe, for the preservation of his own Nature; that is to say, of his own Life; and consequently, of doing any thing, which in his Judgement and Reason, hee shall conceave to be the aptest means thereunto.[6]

Two of his accomplices, Tomkins (his brother-in-law) and Chaloner, went quickly to the gallows; but he, after initial evasions, turned Pym's evidence and, when brought 'with intent to dismember him' to the Bar of the Commons,[7] delivered a most contrite speech, pleading that, on top of the trouble he had already caused, he would not wish as well to be turned into a precedent for Members of that House being tried by 'Counsell of Warre',[8] and praying that they might, for their own future sakes, go a more parliamentary (and thus, of course, long-winded) way to work with him.

> Where upon being bid to withdraw [,] the house had some debate of the matter, but did not then conclude of anything touching his tryall but gave order hee should bee returned back to Prison and appointed to take the same into further consideration the next day.[9]

'Next day' was July the fifth. Tomkins and Chaloner were hanged; Waller's case subjected to 'further consideration'.

Time was of the essence. Waller was winning it. Membership of the Commons (he had been an M.P., more on than off, reputedly since the tender age of 16) was his trump card. He played it astutely. Moreover, earlier reports of his 'distracted condition' which had caused a concerned House to dispatch 'two Godly Devines' to minister to his vexed conscience and offer 'wholesome Councell',[10] tended to bear out his eloquent professions of penitence. Furthermore, having decided on second thoughts to make a clean breast of it, he had implicated two or three of the Lords (Portland, Conway and, less seriously, Northumberland), and their cases remained to be looked into, which necessitated keeping him alive to testify. But the speech was his *pièce de résistance*. He was to be 'dismembered', inevitably (on July the fourteenth), but never, finally, in so painfully physical a fashion as he had had, at the outset, too much reason to fear; and, thought Lord Clarendon,

> He does as much owe the Keeping of his Head to that Oration, as *Catiline* did the Loss of His to those of *Tully*.[11]

Disabled from ever again sitting in the Commons (he was, of course, to be re-elected after the Restoration), Waller remained for a year, and over a year, in prison. *A Perfect Diurnall*, in its entry for the fifth of September, 1644 (a fast day, kept 'to implore directions and a blessing from Heaven on the good proceedings of the Court-Martiall') is still encouraging its readers with the promise that

> No convenient time will be protracted for the tryall of Mr *Waller*, Sir *John Hotham* and his Sonne, with such others, which for want of Judgement executed against them, we may have cause to feare, is one great cause why the Land mournes.[12]

Of late, affairs had not been running Parliament's way. There was a casting about for explanations. Ominous as this sounds – and was for the Hothams, who went, both of them, to the block – for Waller 'proceedings' were to prove as propitious as he had any right to expect. The commissioners seemed disposed to believe his claim that he had never intended an armed uprising in the City and knew little or nothing about the damning Commission of Array which had been discovered in Chaloner's house.[13] The air was growing milder. Nicely on cue, he petitioned the Commons to accept £10,000 out of his estate by way of fine. He had been setting his affairs in order and could ensure prompt payment. The offer was accepted. Parliament was in dire need of ready money, the sum not one to be sneezed at. By the eleventh of October '9000 pound of Mr. *Wallers* 10000, which was full pay for a moneths advance',[14] had been disbursed upon Sir James Harrington's new City Brigade, which was ordered to march 'forthwith'. As Edmund Calamy (second segment of the infamous and insectile Smectymnuus) had commented, sermonizing on the discovery of the 1643 plot,

> *Riches* without righteousness is . . . like an *Unicorns horne*, which
> while it is upon the head of the Unicorne is hurtfull and deadly, but
> when it is taken off, it is very useful and medecinall.[15]

Meantime the unicorn whose docility under duress had helped make such expedition possible found himself sentenced to banishment.

Waller, as befitted a disciple of Hobbes, had saved his own life, rather than losing it for Christ's or King Charles's sake. For, as 'the chiefest of natural evils', according to Hobbes, is death, so it follows, in the earlier *De Cive* (which an admiring Waller had once offered to English) as in the *Leviathan*, that

> It is therefore neither absurd, nor reprehensible; neither against the
> dictates of true reason for a man to use all his endeavours to preserve
> and defend his Body, and the Members thereof from death and
> sorrowes; but that which is not contrary to right reason, that all men
> account to be done justly, and with right.[16]

And if Waller had 'done justly, and with right' in 1643 and 1644 – done, at least, all that could be expected of a man given Hobbes's somewhat reductive interpretation of human nature – why, then he was to continue the good work in 1651/2 when he negotiated a pardon and returned to England.

A letter to him from Hobbes, dated August the eighth, 1645, which refers to his 'inclination to put a booke Called de Cive into English', also indicates that he was thinking, from early on in his exile, of repatriation. P.R. Wikelund rightly notes that 'ample justification for a decision to accept the new régime' at home was to be found in the work in which he was displaying so much interest[17]. Late in 1651 Hobbes, anticipating Waller, returned home himself. In 1662 he published *Considerations upon the Reputation, Loyalty, Manners & Religion of Thomas Hobbes of Malmsbury* to vindicate his having done so and also defend his printing (in 1651) of the *Leviathan*, which had been attacked as pro-Cromwellian. Hobbes denied that it was. 'What Title then of *Oliver's* could he pretend to justifie?' he protests.[18] Undeniably, however, his

ideas had been pressed into service in the middle fifties by writers like John
Hall of Richmond and Thomas White, to encourage Cromwell to consolidate
his position and the country to acquiesce. '*Habemus Caesarem, they* good
men [had] *Caesar for their King.*'

It was at this juncture, too, that Waller chimed in with his *Panegyrick,* a
poem which, as will be seen, makes telling play with Caesarean themes.
Cromwell and Caesar (Julius or Augustus) could, in many respects, be
regarded most profitably as type and antitype, as Hall of Richmond was
likewise well enough aware. But this is to anticipate. Suffice it to say here
that works like Hall's *Of Government and Obedience* (1654) and his *True
Cavalier Examined by his Principles* (1656), and White's *The Grounds of
Obedience and Government* (1655) can usefully assist in the construction of
a context for Waller's contemporaneous poeticizing, although this, needless
to say, is not to suggest that he wrote out of any specific study of them. He
knew and admired Hobbes (whom he seems too have employed as tutor to
his son, Robert). They adapted Hobbist ideas to suit the situation in which
they (and Waller) found themselves. It would be surprising if the drift of their
thoughts had not been, now and then, concurrent. Waller, indeed, might have
supplied Hall with a subspecies of his 'True Cavalier', though Richard Watson
for one would have sneered bitterly at the talk of 'Principles' in such an
instance.

His own *Anti-Panegyrike*, which constitutes the first part of *The Panegyrike
and the Storme,* is straightforward Royalist polemic: an attempt to wrest the
poetic instrument from Waller's renegade hands and beat him about the head
and body with it. The results of this exercise are rough and ready. As Dryden
was afterwards to observe in his *Discourse concerning the Original and
Progress of Satire,*

> There is still a vast difference betwixt the slovenly butchering of a
> man, and the fineness of a stroke that separates the head from the
> body, and leaves it standing in its place.[19]

Even a slovenly butchering, however, can be anatomically revealing, and
Watson's hacking and mangling (for he lays about him with a will, if not
finesse) does help to expose nerves and ligaments which might otherwise
have gone unnoticed. He allows himself six lines of refutation to every four
of panegyric, printing the original quatrains and his own answering sestets
alternately. This verse 'descant' is reinforced by sixteen '*prosaïke glosses*',
forming the body of a subsequent 'Solemn & Serious Advertisement to the
Reader' which, William Haller suggests,[20] is 'by a different writer'. Whoever
is responsible, however, claims the 'descant', that is the *Anti-Panegyrike*
itself, for his own, and Watson himself may reasonably be supposed to have
felt the urge to make assurance double sure.

The other half of *The Panegyrike and the Storme* comprises a somewhat
similar operation directed this time against Waller's *Upon the late Storme and
of the Death of his Highness Ensuing the Same* (1659); a poem which
provoked reaction from a very different political quarter in the shape of the
puritanical George Wither's *Salt upon Salt.*

'We look for such a Government as shall / Make way for *Christ*', Wither had announced in a slightly earlier (and, despite its title, very long-winded) piece, *A Suddain Flash* (1657), though he poured scorn on any ideas of a 'fantastical / *Fifth Monarchie*' and condemned attempts to raise 'an *Earthly Throne*' for Christ by means of 'Carnal Weapons'[21] (which, incidentally, had not stopped him from raising, in 1642, a troop of horse to fight for Parliament). His work, too, like that of Watson,[22] will serve as a revealing foil to Waller's, whose own leanings were all towards New Romes rather than New Jerusalems – appropriately enough given his reputation as a founding-father of English 'Augustanism'.

Against the background supplied by writers such as these, Waller's political poetry begins to live and move and have a being more vivid than might otherwise have been suspected. Even so, he may seem a writer too inherently second-rate to warrant more than passing acknowledgement, though whole books (one or two of them) have, it goes without saying, already been devoted to him: Warren L. Chernaik's *The Poetry of Limitation*, for instance, and A.W. Allison's *Toward an Augustan Poetic*. Never 'great' Waller is, nevertheless, often accomplished and indubitably 'significant'. His work affords a vantage-point which can be all the more revealing because not so thickly overgrown by the sort of scholarship and speculation which ramps so richly over a Milton, Marvell, or Dryden. Moreover, surveying these writers from such a vantage-point can discover things which might never have become so apparent working, as it were, from the inside out. Coming to Marvell's *First Anniversary*, for example, from Waller's coeval *Panegyrick* sharpens perceptions of the purport and purpose of each, and Dryden's manoeuvrings in *Absalom and Achitophel* (where faith in God's creative and sustaining Logos is weighed in the balance against the Hobbist axioim that 'Words are wise mens counters, they do but reckon by them; but they are the mony of fooles'[23] and found anything but wanting) – Dryden's manoeuvrings, here and elsewhere, compare illuminatingly with Waller's tactics in his poems addressed to Cromwell on the one hand and those addressed to the restored Charles on the other.

Waller, it is to be surmised, would have sided in the end with Hobbes. At least, the *Panegyrick* contains some brilliantly prestidigitatory verbal reckoning: language and wit most knowingly manipulated. It is as if the poet were appealing to a circle of fellow *adepti*, sophisticates who recognized the force of Hobbes's dictum and were consequently in a position to appreciate a book neatly cooked on their and their country's behalf at the expense of more conscientiously clodhopping wits or, come to that, non-English speaking nations in general.

2: In Medias Res – Panegyrical Economics

> To digg for Wealth we weary not our Limbs,
> Gold, though the heavy'st Metall, hither swims;
> Ours is the Harvest where the *Indians* mowe,
> We plough the Deep, and reap what others Sowe.[1]

In these lines from *A Panegyrick to my Lord Protector*, Warren L. Chernaik has earnestly assured us,

> Waller manages to endow the familiar locution 'plough the deep' with
> real force by taking its ordinarily dead metaphor literally.[2]

But the metaphor is not taken literally. Rather the wit inheres in the way in which the directly simple digging of the first line gives place to the metaphorically sophisticated and altogether less *physically* exacting activity of the last; where the English, by ploughing only on a facilely figurative level, avoid wearying their limbs in anything approaching literal labour and, liberated from the grunt and sweat of earthbound, agricultural logic, proceed patly to reap what others sow, waiving Pauline precept ('Be not deceived, God is not mocked, for whatsoever a man soweth, that shall he also reape')[3] with as much easy and insouciant urbanity as the necessity for non-metaphorical cultivation.

It is all quite consciously unconscionable. 'Without the Worm', Waller has just been proclaiming, 'in Persian Silks we shine, / And without Planting Drink of every Vine' (59-60). 'Without the Worm': silk-worm, of course (James I had promoted an extensive but unsuccessful project to introduce them); but the 'worme' which 'dieth not' three times in the ninth of Mark (verses 44, 46, 48) and in the sixty-sixth of Isaiah (v. 24) before that – where it is glossed in the Geneva Bible as 'a continuall torment of conscience' – is likewise conspicuous by its absence. Englishmen are exempt from the Curse of Adam and its consequences, the 'ayenbyte of inwyt' included. In the sweat of their own brows they do not eat their bread. Neither the necessities of life nor its little luxuries have to be worked for or laboriously produced; they offer themselves up free, *gratis* and for nothing, as once upon a time in Paradise, or the classical Golden Age when, according to tradition, 'the fertyle earth gave out / Her blessed frute, though she untilled lay'.[4] Now, again, one can 'without Planting Drink of every Vine'. Even 'Gold, though the heavy'st Metall, hither swims' in defiance of specific gravity. Yet the suave disingenuity of the rhetoric parades a *savoir vivre* flagrantly at odds with primitive innocence. Times, patently, have changed since the days depicted in Lovelace's 'Love Made in the first Age',

> When Complement was constru'd Rage,
> And fine words in the Center hid:

when, living at ease off Nature's freely proffered abundance, 'unconfined each did Tipple / Wine from the Bunch, Milk from the Nipple', and 'All damning Gold', instead of surf-riding, 'was damm'd to the'Pit' along with

fine-spun phraseology.[5]

Patently, without 'Complement' and 'fine words', panegyric itself would be nothing. Moreover, in the Golden Age proper, 'The yet free Earth' not only 'did of her own accord / (Untorne with ploughs) all sorts of fruit afford', but also,

To visit other Worlds, no wounded Pine
Did yet from Hills to faithless Seas decline.
Then, un-ambitious Mortals knew no more,
But their own Country's Nature-bounded shore.[6]

Now Waller, in a conceit which Chernaik traces back to these lines from the *Metamorphoses*,[7] loudly vaunts that 'wee / Whole Forrests send to Reigne upon the Sea'.[8] So much for the State of Innocence! 'Ships which long on loftie Mountaines stood', according to Ovid, first 'plow'd th'unpractis'd bosome of the Flood', not in the Golden, nor yet in the Silver or Brazen, but only in the Iron Age of 'Force, Treason and the wicked love of gain'.[9] So many worlds there are between not having to plough at all and arranging to do so on the *Panegyrick's* deceptiously figurative terms! 'Time will run back, and fetch the age of gold', promises Milton, 'On the Morning of Christ's Nativity'.[10] Waller's scheme is to go forwards, not backwards. His advanced views did not elicit universal approval.

Richard Watson for one, in exile and (as he was afterwards to admit) 'Morosely jealous of all that had more lately breathed in English air',[11] was quick to carp and waxes, in his *Anti-Panegyrike* (accepting that it is his), righteously indignant about Waller's economic thimblerig.

The tast of hot *Arabias* spice was knowne
Before your *scorcht-nose Master* climbd the *Throne*;
And *Persian* silkes were fetcht, for which you storme
All sailing Forts, & shine, but with the Worme,

he protests, glossing 'the Worme' marginally 'Of Conscience' in his anxiety to transfix Waller's flourish:

We, where we planted not, nor *press'd* had Wine
Unrob'd, unrakt, for merchandise or coine.[12]

Under Charles, King and Martyr, Englismen had been in the habit of paying for things. Under 'that *devoted Wretch* . . . who has practiz'd *rapine* on every Canton he could come at', 'E.W.'s Parricidall Lord Protectour', Oliver Cromwell,[13] they are not; and if they accordingly, like the inhabitants of the Golden Age, get something for nothing, it is not through an artless dependence upon Nature's spontaneous and unstinting bounty, but by privateering. They, in Waller's words, suppress 'All that Piracy and Rapine use'[14] – Royalist's included, for Robert Blake had long since taken steps to prevent Rupert's small fleet from pestering Protectorate shipping – only to reign, in Watson's words, '*Chiefe Pirates of the Ocean*' themselves.

Whose harvest *mowes* the *Indian*? Yours? Wou'd you
Not have the *spaniard carre* it for you too?[15]

But naturally! The sally about self-propelled gold unmistakably and shamelessly implies as much, though Watson pretends to be virtuously slow on the uptake.

Moreover, the fitting-out of two sizeable fleets during the year preceding the publication of the *Panegyrick* argued an offensive in some direction or another, and a hint that an Elizabethan-style raid might be in order, against the plate fleets and American possessions of the traditional, papist enemy, Spain, would not have come untimely. 'Wee cannot have peace with Spain', the Protector was deciding at a debate in Council during July, 1654, and objections were brushed aside with:

> It is hoped the design will quitt cost. Six frigots nimble [?] shall range
> up and down the bay of Mexico to gett prey.[16]

In the event, a large expedition under Penn and Venables left that winter for the West Indies, its admiral being under orders to

> Seize upon, surprise, and take, all ships and vessels whatsoever
> belonging to the King of Spain, or any of his subjects in America, or
> of any others that shall assist or aid him, or shall be enemies or rebels
> to us and this commonwealth, together with the tackle, apparel,
> ordnance, and ammunition, and all and singular the goods, monies,
> wares, and merchandise therein.[17]

Waller's verses are deftly accommodated to this trend in government thinking. Nor was he simply currying favour. As a landed gentleman, he had a vested interest in promoting any policy which promised to turn sea-power to financial account and ensure that the navy at least paid for itself, thus obviating any need for an increase in land tax, an expedient he regarded with inveterate distaste. 1675 found him, an old man (and Member of Parliament again), still reminding the Grand Committee on Supply that 'Ship-money maintained the sea by the dry land', and voicing his dismay that a solecism of Charles I's days should be repeated in those of his son.

> It troubles him that a land tax must supply the sea. We have trade,
> but an ill balanced trade, and if we come to land to maintain the sea,
> the nation is undone.[18]

On this occasion he was public-spirited enough to allow that an augmented land tax was an alternative preferable to a navy so weak as to be useless, but such concessions were to be exacted only by pressure of strictest necessity. The 'necessity', for instance, once invoked to justify the levying of Ship-money in the sixteen-thirties had cut no ice at all. 'This visour of necessity', he contemptuously calls it, twitching it unceremoniously aside during his 'Speech in Parliament, at a Conference of both Houses in the painted Chamber. 6. *July* 1641',[19] when, at the Commons' behest, he presented to the Lords the Articles against one of the Judges who had pronounced the tax legal. Mr Justice Crawley now, for his pains, finds himself slightingly compared to 'the Goat browsing on the Vine'[20] in Ovid's *Fasti*,[21] all unaware that it is itself fated to fall as a sacrifice to Bacchus. So, while merchants with shipping exposed to reprisals may have had qualms about advocating piratical tactics, Waller, with an estate vulnerable to land tax, was not above intimating that they might prove profitable; and had not his friend and philosophical mentor, Hobbes, demonstrated that, where there is no power to enforce the contrary, 'every man has a Right to every thing'?[22]

Perturbed, as befits a Bishop of St David's to-be, by such unchristian logic, William Lucy expressed concern about how application of this principle might

> spoil all commerce betwixt Merchants, betwixt men of divers nations; for if *occupancy* give no title, it may be lawful for men to *defraud*, to get by *force* what they could from an *Indian*, because I know no title they have but of *occupancy*.[23]

But his clerical querulousness failed to impress Waller who, in a letter to Hobbes, vents his wit by twitting him for some feeble word-play.

> (Sir) one shewed mee this morning Dr Lucys censure upon your Leviathan; he subscribes himself in his Epistle to the reader William Pike which (as his frend tels me) is because his name in Latine is Lucius, wherein he confirms what he is offended with you for observing, that a man must have something of a scoller to bee a verier coxcomb then ordinary, for what English man that had not dabled in latine would have changed so good a name as Lucy for that of a fish, besides it is ominous that he will prove but a pike to a leviathan , a narrowe river fish to one which deserves the whole ocean for his theater; all that I observed in the preface of this pickrill, was, that he says your doctrine takes us country-gentlemen etc: sure, if wisdome comes by leasure, we may possibly be as good judges of philosophy as country-parsons are.[24]

And a fig for the future prelate, his scruples, and the unfortunate Indians along with them; although it is only fair to mention that, towards the end of his life (and despite his unfailing hostility towards a land tax), Waller does seem to have suffered a change of heart, deciding that 'This Iron Age, so fraudulent and bold', might be metamorphosed into a Golden one by the operation of 'Divine Love' which

> Would make all things easy, safe, and cheap;
> None for himself, would either sow, or reap:
> Our ready Help, and mutual Love, would yield
> A nobler Harvest, than the richest Field.[25]

The *Panegyrick* is nothing so altruistic. Not that the Protectorate authorities appear to have held this against its author. In the December following the poem's publication Waller was appointed a Commissioner for Trade.[26]

3: 'A Deluding Streame' Gets Head

How much the *Panegyrick* had to do with Waller's appointment as Commissioner it is impossible to say, but it elicited, in the June of that year, appreciative mention from no less a person than Cromwell, who writes to his 'very lovinge friend Edward [sic] Waller, Esq., Northampton. Hast, hast' to clear up some unspecified misunderstanding:

> S[r], lett it not trouble you that by soe unhappy a mistake you are (as I heare) at Northampton, indaed I am passionately affected with itt. I have noe guilt upon me unlesse it bee to bee revenged, for your soe willinglye mistakinge me in your verses. This action will putt you to redeeme mee from your selfe as you have already from the world. Ashamed I am, Y[r] freind and Servant, Oliver P.[1]

What, and how serious, was the 'action' referred to is not clear. 'Hast, hast' suggests something not entirely trivial, although Thomas Carlyle speculates that

> To an audacious guesser it might almost seem, these Verses had reached Oliver, by messenger, a day or two before; and the 'unhappy mistake' were Oliver's, in sending, on the morrow to have an interview with Waller, and finding him to be at Northampton instead![2]

But there may have been more to it.

June, 1655, with the uprisings of earlier in the year burned out but not forgotten, was a trying time for suspected Royalists. A sympathiser (whose letter, significantly, did not fail to find its way into Secretary Thurloe's hands) wrote on the eleventh that a number of them had been committed to the Tower 'on Saturday last',

> Besides multitudes more taken in London . . . and God knowes who else in other parts; hundreds more (they say) are in his highnesse pockett. And none that I meet with can so much as guesse the businesse.[3]

At such a time, someone may well have thought Waller worth looking to, given his dubious record of plot, exile and recent return from amongst malignant ranks abroad. From the *Calendar of State Papers*, it is evident that his erstwhile affiliations were still being held against him as late as March, 1656, when President Lawrence informed William Packer, Deputy Major General for Buckinghamshire, that

> His Highness and Council having received satisfaction in the case of Edm. Waller of Beaconsfield, co. Bucks, desire you and the Commissioners to stay all proceedings against his person or estate.[4]

Delinquents were liable to a decimation tax, designed to make them pay for the expensive security measures their late fractiousness had necessitated. Waller, it seems, was to be exonerated. He had been accepted, at last, as a loyal servant of the Protectorate, though 'loyal' is the last adjective more uncompromising Royalists thought of applying to him.

'Pitifull' he is, to the author of a short poem, 'To the Pitifull Authour of the

Panegyrike', prefixed to *The Anti-Panegyrike*, but Watson himself is not so sure. In one thing, if no more, he would have agreed with Charles Herle, the minister who had preached to the Lords on the day of thanksgiving for the discovery of 'Waller's Plot': that where Waller is concerned,

> Saint *Augustines* destinction, *inter Errones & Turbones*, between seduced *Sheepe* and *Wolves in Sheeps skins*, will never be out of season.[5]

He underpins his own versifying with 'A Solemne & Serious Advertisement to the Reader' to guard against mistakes, warning that,

> Tender Hearts are addouced rather by y^e smoothnesse of his straine, then honourably incensed at the severity of his matter, which, like a deluding streame, more dangerously undermines the bankes of his *Prince*'s interest, then a bolder torrent that attempts to invade his territories by a deluge.[6]

The *Panegyrick* is the work, not of a 'seduced *Sheepe*', but a wolf in sheep's clothing. Waller's true place, it is claimed in the letter which concludes *The Panegyrike and the Storme* as a whole, is 'with the *Desperados* such as *Milton* and Britannicus' – *Mercurius Britannicus*, that is, who, in the shape of Marchamont Nedham, had published a *Hue and Cry* after the King in 1645. Only Waller 'ha's had more *wit*, though not more *honesty*' than they, not having openly traduced either Charles or monarchy in general; which makes him all the more pernicious.[7] Riposte in rhyme must be ballasted with more reasoned, prosaic commentary in order to expose the full extent of 'the slie artifice of y^e *Pöetike Rebell*'[8] and preclude possible misapprehension by detecting the most insidiously corrupting passages: for example,

> His endeavour to disparage Christian fortitude and honorable indignation against y^e *Tyrants* proceedings, miscalling it Envie, & magnifying y^e issues of his *cruelty & cosenage*s for Vertue, St. 37;

or

> His terrifying Heroike spirits, whose conscience and courage might instigate them to execute seasonable justice by the *poniard*, upon Him that hath wrought all injustice by the *sword*, with an apprehension of renewing a civile warre to be prosecuted in bloud and rage; whereas no sure peace can ever otherwise be expected,

in 'stanzas' 38 and 39.[9]

These twelve verses are well distinguished. Here the 'deluding streame' undercuts most subtly and unobtrusively 'the bankes of his *Prince*'s interest'. The appeal for objectivity with which they begin, the insistence that, with hindsight, in a dispassionate, historical perspective, affairs might look very different, is persuasive and strongly supported by the example of Julius Caesar, one of the Nine Worthies, no less, whose efforts to re-institute government by a Single Person, though bitterly resented at the time, yet paved the way for Rome's future imperial greatness. Better still, however, is the way in which the Protector manages to emerge from the passage as the natural and obvious successor to the murdered king, while the rightful, though anything but apparent, heir is passed over unnoticed.

> Had you some Ages past, this Race of glory
> Run, with amazement, we should read your story;
> But living Virtue, all atchievements past,
> Meets Envy still to grapple with at last.
> This *Cesar* found, and that ungrateful Age
> [With] losing him, fell back to blood and rage:
> Mistaken *Brutus* thought to break their yoke,
> But cut the Bond of Union with that stroke.
> That Sun once set, a thousand meaner Stars,
> Gave a dim light to Violence and Wars,
> To such a Tempest, as now threatens all,
> Did not your mighty Arm prevent the fall.[10]

On the one hand (to the wrath of Watson, who insists that

> Caesar was no such *Monster*, tis not sed,
> He did his Master *binde, lose*, then *behead*)[11]

a parallel is drawn between Caesar's predicament and Cromwell's. On the
other, the manner of Caesar's assassination immediately calls to mind the
fate of Charles I. Caesar-Charles is killed by Brutus, who represents? – Not
Cromwell, clearly, for the Protector-as-Caesar comparison cannot so readily
be discounted. So Brutus, politicly, stands for no one in particular: represents
the type of 'mistaken' (for tact still demands every extenuation – it is the age
which is 'ungrateful', Brutus himself merely 'mistaken') opponent of Caesars
in general; while Cromwell, for his part, is, no less than Charles was, a
Caesar. Far from meeting in head-on collision, these two have become con-
geners. 'Caesar' fits either, equally, King or Protector, disguising their dis-
parities; and, since some sort of Caesar (witness what happened in Rome) is
necessary to ensure political stability, Waller is prepared to lend his support
to whoever has the power to fulfil the rôle *de facto*.

This, according to John Hall of Richmond, whose *Of Government and
Obedience* had appeared in the year before the publication of the *Panegyrick*,
1654, is only right and proper; for

> If divine providence or permission, have given such success to any
> subject, as to deprive the present Prince, and to seat himself in the
> Regal Throne, from that time . . . they . . . that were by the Laws of
> God and man to be accounted loyal to the former Prince, in respect
> of that obedience they then gave him as their present higher power,
> shall become now rebels to this, if, while they live under his
> Government and Jurisdiction, they pay not that respect and obedience
> which is to Soveraignty due: and they do (therein) stand accountable
> as Criminals, aswel before the divine Throne, as that of their present
> Soveraign.[12]

Having accepted the opportunity of returning to England from exile, Waller
places himself under a compelling moral obligation to offer 'respect and
obedience' to Cromwell:

> It faring in this case, with subjects in general, towards their Prince,

as with the Tenants of any particular Landlord. For as these are to pay their Rents and Acknowledgements to him that by the present Judiciary power is put into possession, without being bound to examine whether he be a deseisor or not; or did by bribery, or other fraud thrust out the former owner; even so, subjects, being to pay their Obedience and Acknowledgements to their Prince, as God's Minister, must likewise acknowledge him for such, whom they finde by the usual way of Providence put into possession.[13]

That the *Panegyrick* should gloze so smoothly over the question of whether Cromwell 'be a deseisor or not' (a 'disseisor' is one 'who dispossesses another of his lands'), is thus very much to its credit. Fretting about questions of this kind is no responsibility of a subject, who can legitimately withold 'Obedience and Acknowledgements' to a prince in power only after 'leaving his Land and quitting his Tenancy'.[14] But Waller has done exactly the opposite: negotiated a return and renewed his tenancy.

Nor, argues Hall, can the dispossessed Charles reasonably repine at this; for who, he urges, would

have been content, if themselves had been in the condition of subjection to any Prince, and had therein been constantly loyal; that his former Prince, having now neither occasion to imploy or means to maintain them elsewhere, should ingratefully stomack and reckon as a fault, that necessary livelihood he were now forced to seek in his native Country, under the protection and obeisance of another?[15]

Waller, back in England to seek a 'necessary livelihood', composes the *Panegyrick*, not solely because self-interest dictates the move (though it did), but also because he recognizes the crucial importance of a 'due regard of the necessary rendring this obedience to the present Prince, in order to duty and the maintainance of publike peace'.[16] The *Anti-Panegyrike*'s *'prosaïke glosses'* may make light of fears that Cromwell's assassination would kill more than it cured, but is this reason for supposing Waller's 'apprehension of renewing a civile warre to be prosecuted in bloud and rage' altogether feigned, his 'artifice' so consummately 'slie' as that? Or was he honestly, as the title-page of Newcomb's 1655 edition of the poem advertises, 'A Gentleman that Loves the Peace, Union, and Prosperity of the English Nation'; a man convinced with Thomas White (who managed to be both Hobbist and a Roman Catholic) that 'the Subjects aime ought to be the publicke peace, and quiet enjoyment of their lives and interests'. *'Fiat Justitia & ruat coelum'*, as White is about, drily, to observe, 'is seldome practised amongst the wise'.[17]

Since, then, 'divine providence and permission', as has been seen, dispense success or failure, it is not for Waller, as subject, to cavil at how Cromwell came to power. 'The Question', as Hall succinctly has it, 'is not who should be, but who is in the seat of Authority'.[18] Cromwell has the power to command obedience 'as a duty'. He is the 'present subjector'. Opinion as to whether or not he should be is, for all practical purposes, irrelevant. 'Belief or opinion of the right of him that is dispossessed', says Hall,

can, during that his private condition, claim from his former Subjects

a willingness & propension only to perform actual subjection when
he shall be again possessed and restored to a capacity of actual
command.[19]

Waller was to discover a most commendable readiness to 'perform actual
subjection' as soon as Charles II found himself at last 'restored to a capacity
of actual command'. Meanwhile, no blame attaches itself to those who cast
their lots for Cromwell and stability. 'The Obligation of Subjects to the
Soveraign', states Hobbes, 'is understood to last as long, and no longer, than
the power lasteth, by which he is able to protect them';[20] and, while Hall may
have jibbed at aspects of his argument (he tends to think even Hobbes apt to
allow mere smere subjects too much contractual rope, always preferring
himself to stress that they are creatures not of rights but duties),[21] nevertheless
in practice it made little difference. His own view was (unlike Hobbes's) that
monarchy was the only valid form of government, everything else being an
aspect of anarchy.

> Whereupon it will follow, that in case the revolted party have
> overthrown the other, they are now to count all their actions unlawful
> farther then they can derive them from an officer authorized by God
> Almighty; who is onely superior to them both.[22]

But as soon as their actions *can* be derived from such an officer, 'onely
superior' to both parties (the 'prevailing factions' having been 'again prevailed
over by their own chief head' who so becomes ' one indifferent Judge' over
all): as soon as this occurs (and Cromwell's career exemplified the process
perfectly), then 'nature and policy come to be satisfied in all their claims',
and one may not only choose to consign oneself to this officer's protection;
one has no right whatsoever to do otherwise.

In short, Cromwell is to be obeyed, and it is even the responsibility of the
dispossessed sovereign to do his best to ensure that he will be. Thomas
White, in *The Grounds of Obedience and Government*, setting himself to
investigate the case of an 'innocent and wrongfully depos'd ruler', asks his
readers to consider,

> If he [the dispossessed ruler, that is] be generous, if he hath setled in
> his heart that every single man ought to preferre the common Interest
> before his particular safety, profit, or honour; if hee bee fit for a
> Governour, that is, one that is to espouse the common good as his
> owne individuall; what he will, in honour and conscience, resolve;
> whether hee bee not obliged absolutely to renounce all right and claime
> to Government; and if he does not, hee bee not worse then an Infidell.[23]

Charles's fitness to rule is to be measured by his willingness to abandon the
right ever to do so! It is he who, by not relinquishing all claim to the throne,
exposes himself to a charge of dereliction of duty, not the likes of Waller.
Waller, indeed, has the pedigree (more or less) of one of Hall's 'True Cavaliers':
men 'of the Nobility and Gentry' who, Cromwell is told, by siding with their
then present sovereign, Charles I, had 'fought for You too, and that when
You fought against Yourself'; who had been 'all along constant to the sure
way of preservation of publick peace, by their adherence to the party

possessed', and who are not going 'to be now so inconsiderately inconstant, as to cease to be loyal at such a time as is apparently advantagious also'.[24] As Hobbes himself was to contend, parrying in 1662 blows directed not only at his mathematics but also his past loyalty by John Wallis,

> They that had done their utmost endeavour to perform their obligation to the King, had done all that they could be obliged unto; and were consequently at liberty to seek the safety of their Lives and Livelihood wheresoever, and without Treachery.[25]

Nor can the *Leviathan* be held against him, being, as it was, written expressly

> in the behalf of those many and faithful Servants and Subjects of His Majesty, that had taken His part in the War, or otherwise done their utmost endeavour to defend His Majesties Right and Person against the Rebels; whereby, having no other means of Protection, nor (for the most part) of subsistence, were forced to compound with your Masters [in 1651 the Parliament, but afterwards Cromwell], and to promise Obedience for the saving of their Lives and Fortunes, which in his Book he hath affirmed they might lawfully do, and consequently not lawfully bear Arms against the Victors.[26]

The Halls and Whites of this world had not been slow to take the point without its being spelt out quite so explicitly. 'Who is no prop to a declining throne', opines John Collop in verses printed in 1656 (licensed in August, 1655),

> Sins 'gainst his Kings in Earth, in Heav'n his own,
> He's traitor helps a traitor to a Throne –

but adds, 'yet who resists him on it may be one'.[27] Just so. Richard Watson, the young Charles Cotton (who vilified Waller as 'A Flatterer of thine own Slavery' and agrees, 'Hee's stout that dares flatter a Tyrane thus',[28] and anything but 'pitifull'): these and all their ruinously obstinate allies are answered;

> And if we seriously look into the true ground of these aspersions, we shall find both the Imputation of *Usurper* fastned on him that commands, and *Flatterer* on him that defends, to proceed from heat and prejudice alone.[29]

'*Martlets* and *Capets* treasons thrones acquir'd', continues Collop,

> Yet both so well rul'd, France thought both inspir'd.
> A petty notary rul'd so well in Rome
> The time['] of th'golden Age['], did th'name assume.

Who knows? Cromwell may prove another Diocletian, 'Parens Aurei Saeculi'.[30] But whatever is to happen, and whatever one's private feelings about the individuals involved (Collop, for one, was clearly Royalist at heart),

> tribute of subjection must be held as legally due to that person in whose name the Laws are enforced and executed, as the payment of other tribute doth belong to that *Image and Circumscription* which is stampt upon the Coyn; which was enjoyned to Caesar.[31]

4: Rendering unto Caesar

No one has ever thought of criticizing Waller for reluctance to 'Render to Cesar the things that are Cesars' (Mark 12.17). The drift of the *Panegyrick* is, at bottom, unmistakably monarchical and, accordingly, must have seemed much more congenial even to the restored Charles II than that, on the face of it, of Abraham Cowley's pindaric ode (first printed in 1656) in praise of 'Excellent *Brutus*', 'God-like *Brutus*', where Caesar is arraigned as a '*Tyrant*' and the '*Ravisher*' of Rome who, in striving for his 'usurpt place', undertook

> An act more barbarous and unnatural
> (In the'exact balance of true Virtue try'de)
> Then his *Successor Nero's Parricide!*[1]

Strong stuff! – since Nero had not only arranged the murder of his mother (for whom, it was rumoured, he had once harboured incestuous inclinations) but also reputedly delivered a connoisseur's commentary upon the conformation of the corpse before having, to quote Chaucer's Monk, 'hire wombe slitte to biholde / Where he conceyved was'.[2] Caesars, clearly, are a bad lot. 'Long live the brave *Oliver-Brutus*' with a vengeance![3]

This is commending Cromwell, if it is commending Cromwell, and A.H. Nethercot, in his biography, *Abraham Cowley, the Muse's Hannibal*[4] entertains no doubts, for entirely the wrong reasons. In fact, Cowley almost certainly intended not praise, but coded condemnation.[5] His later *Discourse by way of Vision, concerning the Government of Oliver Cromwell*[6] unambiguously links the by now safely defunct Protector with, not Brutus, but 'The false *Octavius*, and wild *Antonie*': the 'Ill men' of the ode who succeeded through 'wretched *Accidents*' in perpetrating the rape in which Julius had been prevented. Brutus, for his part, had resolutely defended Rome's maternal chastity and her established form of government – republican, it goes without saying; but in England, *mutatis mutandis*, the equivalent would have been the Stuart monarchy. The poem might therefore be read as a sort of smouldering anticipation of the flagrantly anti-Cromwellian pamphlet, *Killing No Murder* (1657). '*Brutus* did somewhat, but his stroke not, misse', as Watson remarks, retorting Waller; 'No more may discontented *Lambert* his':[7] a prayer to unite both stubborn Royalist and intransigent Republican.

Cowley's poem might be so read; equally (for he was nothing if not circumspect) it might not – and frequently, it would appear, wasn't. The work, reports Nethercot[8] was 'often called in question by the King's party after the Restoration' – not very surprisingly since, jumping to what look to be the obvious conclusions, it seems to show a far more radical and, to monarchists, disquieting shift of principle than anything Waller ever wrote; which may help to explain why, while the latter had little difficulty in attaching himself to the 'Noble Company' which 'All marcht up to possess the promis'd Land' in 1660, Cowley was left, in the words of his taunting Pindaric Muse in 'The Complaint', to 'gaping stand, / Upon the naked Beach, upon the

Barren Sand'.[9]

To extol Waller's 'mistaken *Brutus*' (in Cowley, the *'Mistaken Honest Men'* are those who think he went too far) at the expense of Caesar was to invite a diagnosis of what Hobbes, on analogy with 'hydrophobia', had designated *'Tyrannophobia,* or feare of being strongly governed'; a condition apt to be provoked by too much 'reading of the books of Policy, and Histories of the antient Greeks and Romans . . . unprovided of the Antidote of solid Reason'.[10] Waller (who in the letter to Hobbes about Lucy's *Observations* goes on to note that Cromwell

> had layd sometyme since a perfect foundation of government, I mean
> by the Major-Generals reducing us to provences and ruling us by
> those provincials with the newe Levied Army etc).[11]

was as little prone to political rabies as Hall of Richmond, whose *Of Government and Obedience* contends 'that *Caesar* had a greater right to the Soveraignty of *Rome* then any of his posterity' because his power enabled him

> to keep those his warlike Country-men at peace and Agreement
> amongst themselves, and restore them to their general liberty from
> the Tyranny of all those factious heads, who, like true Usurpers indeed,
> had engrossed all liberty and power to themselves, by pretence of
> being Keepers of the Liberties of the people, and were so continually
> ready to engage their Nation in Civil war through their own sidings.[12]

A distinction between 'general liberty' and the right of the individual to pursue *ad libitum* the gratification of his personal appetites lies behind Waller's

> Let partial Spirits still aloud complain,
> Think themselves injur'd that they cannot Raign,
> And own no Liberty, but where they may
> Without controule upon their Fellows prey.[13]

Manifestly, he would have agreed with Hall:

> if things be rightly understood and considered, sociable Freedome,
> or the true liberty of Subjects cannot be separated from subjection
> and obedience. In which condition he is more or less Free, as his
> Prince or Commander is more or less powerful.[14]

This remembers Hobbes:

> It is an easy thing for men to be deceived, by the specious name of
> Libertie; and for want of Judgement to distinguish, mistake that for
> their Private Inheritance, and Birth right, which is the right of the
> Publique only.

'Public' or 'general' liberty, 'sociable Freedome', which promotes 'the Peace of the Subjects within themselves, and their Defence against a common Enemy',[15] is precisely the benefit Caesar's ascendancy conferred upon Rome, and Cromwell's can now confer upon Britain. 'Prevailing factions', as has been seen, in their turn 'prevailed over by their own chief head', make way for the 'one indifferent Judge' whose emergence not only liberates 'the subdued faction or party . . . from the partiallity of dominion under so many professed adversaries', but also the winning faction or party from the intestine

contention of adherents now grown 'singly weary of each others precessure'.[16]

> Above the Waves as *Neptune* shew'd his Face
> To chide the Winds, and save the *Trojan* Race;
> So has your Highness rais'd above the rest
> Storms of Ambition tossing us represt.[17]

The undulations of the voice, as it records the articulation of the phrasing, subside into 'represt'. Waller, we are told in the preface to *The Second Part of Mr. Waller's Poems* (sometimes attributed to Pope's friend Francis Atterbury), 'commonly closes with Verbs, in which we know the Life of the Language consists'.[18] Linguistic life, it may be inferred, should have as little as political life to do with unruly turbulence, excited outburst, or outlandish innovation; as much to do with limitation, urbane continence, and a safe keeping within established banks. The whole of the second couplet, suspended between 'has' at the beginning and 'represt' at the end, is enfolded in its perfect verb, which serves as the agent of civilised containment, not rough impulsion. It is transitive, perhaps, but not incontinently so. The aim is to close sluices rather than open them. The waters, restrained, sink with the syllables back into their accustomed bed, and English politics into the natural state of government by a Single Person.

Nevertheless, A.W. Allison, in his book on Waller, *Toward an Augustan Poetic*[19] pronounces this simile, on the whole, 'rather idly ornamental'. Not so. With some economy it refers the reader to the first book of the *Aeneid* (Elijah Fenton's suggestion that Waller 'had *Fairfax's* translation of *Tasso* more immediately in his thoughts' is somewhat distracting despite the close verbal echoes),[20] where Neptune 'o're the flood his sacred head erects', as George Sandys translates, and quells the tempest raised, on Juno's instigation, by Aeolus to harrass Aeneas. His appearance gives rise to the first epic simile of the poem (the rendering here is again by Sandys, whose run-over line endings and habit of starting new leases of sense from correspondingly emphatic caesuras, whilst coming closer to the Jonsonian ideal of couplets 'broken, like Hexameters',[21] contrast most markedly with Waller's more continent and poised, more voluble and less impetuous methods of working within his verses rather than over or through them):

> As when Sedition often flames among
> A mighty People, the ignoble throng
> To out-rage fall: then stones and fire-brands fly;
> Rage armes provides: when they by chance espy
> One reverenc'd for his worth, all silent stay
> With listning eares; whose grave perswasions sway,
> And pacifie their mindes: so when the rude
> Tumultuous Seas their King and Father viewd,
> Their fury fell.[22]

In his *Six Bookes of a Commonwealthe*, Jean Bodin, long since, had invoked the obvious application:

> If any man there bee in vertue and valour exceeding the rest, who
> will with good speech take upon him to persuade the people unto

peace and concord, hee onely, or else none, is the man that may appease the peoples frantike furie and rage. Which thing *Virgil* most excellently expressed in these few verses.[23]

Granted this perspective, Waller's set piece is seen to be trite, perhaps, but nothing so gratuitous as may at first sight appear. It calls immediately to mind another set piece, at the beginning of another poem written 'when the old form of government was subverted', by another author who now 'held his paternal estate from the bounty of the conqueror' and who likewise thought 'that all men might be happy if they would be quiet'. As Warren L. Chernak has noted, this account by Dryden of 'the genesis and moral of the *Aeneid* fits Waller at least as well as it does Virgil'.[24] Moreover, by opening with so commonplace an allusion to that epic, Waller actively courts a parallel which not only confers a measure of respectability upon apologists for usurped power (Virgil's reputation was not that of an egregious toad-eater),[25] but also implies affinities between the recipients of the respective panegyrics.

Contemporaries could take a hint. 'What obliging favours', enthuses Henry Dawbeny (or Daubeny) in his *Historie & Policie Re-viewed*, remembering the days of 'our late Great Protector', '*Oliverus Magnus*', in those of his rather less than successful son (wishfully hailed, nevertheless, as 'our second *Joshua*, in the place of our second *Moses*') –

What obliging favours has he cast upon our *English Virgil* here (I mean *Mr. Edm. Waller*) and meerly for that, and his other vertues, having in some other relations, little capacity enough to deserve them.[26]

'But Augustus', as Dryden was to observe,[27] 'was not discontented, at least that we can find, that Cato was placed, by his own poet, in Elysium', unyielding republican though he may have been. So Cromwell's 'own most excellent judgement in Poetry' could lead to an overlooking of 1643 and all that. And Dawbeny certainly makes a meal out of Waller's poetical merits:

In all his own things, his conceptions are unimitable, his language so sweet and polite, that no Ice can be smoother; his sentences are always full of weight, his arguments of force, and his words glide along like a river, and bear perpetually in them, some flashes of lightning, at the end of each period. He perfectly knows how to vary his eloquence upon all occasions, to be facetious in pleasing arguments, grave in severe, polite in laborious, and when the subject requires fervor and invective, his mouth can speak tempests; In short, he is the wonder of Wits, the pattern of Poets, the mirrour of Orators in our Age.[28]

But then the asset-stripping starts:

All this I say of him, not so much out of design to applaud him, as to adore the judgement of our great *Augustus*, who alwayes chose him out and crowned him for the *Virgil* of this Nation.[29]

Dawbeny's Waller-as-English-Virgil is, blatantly, only a means to an end: Oliver-as-English-Augustus (son Richard, for his part, having in the 'Epistle Dedicatory'[30] been greeted as the 'Chara Dei soboles, magnum Jovis Incrementum' of the Fourth Eclogue: the famous 'puer' whose birth marks

the inception of a new Golden Age, growing out of the peace established by his father). Obviously, however, both panegyrist and Protector stood to gain from the comparison, as Waller no doubt saw from the start: hence the passage above-quoted, where Cromwell, Neptune, Virgil's 'one reverenc'd for his worth', the queller of civil dissention, emerges as the Augustus of another 'Trojan Race' (the British legendarily had their roots, along with the Romans, in Troy), whose reign is to initiate a long and increasingly prosperous period of stable government, imperial expansion – and patronage of poets (even, if they are good enough, those whose 'other vertues' might have 'in some other relations, little capacity enough to deserve [it]'). W.C. Abbott, in The Writings and Speeches of Oliver Cromwell,[31] recounts how, from Cologne in 1654, there came a report that Parliament had addressed Cromwell as 'Oliver, the firste emperor of Greate Britaine and the isles thereunto belonging, allways Caesar'. The Panegyrick is not framed to scotch such rumours. George Wither, although not provoked into adding Salt upon Salt until after Waller's effusions Upon the late Storme, can nevertheless scarcely have been much amused.

In A Rapture occasioned by the late Miraculous Deliverance of his Highnesse the Lord Protector (otherwise Vaticinium Casuale), published like the Panegyrick in 1655, he argues strenuously

That Emperour to stile him, should not better
His happy Lot, or make him ought the greater,
But rather seeme a foolish overlay
Of purest Ophir Gold, with Common Clay.[32]

Printed in the same year, his The Protector, a Poem briefly illustrating the Supereminency of that Dignity' belabours a similar point:

Some, mis-advis'd, or, some deluded friends,
(And, some, concealing misdirected ends
With fair Pretendings) would have laid aside
This Title; and his Highness dignifide,
With what the Jews, Imprudently once, chose;
Or, what the Germanes, on their CHIEF impose:
Not heeding, pe[r]adventure, what Offence
It had occasion'd, against Providence.[33]

'Old Names', the argument runs,

 may obstruct
Th'effects, which changing of a Name product,
As in this present case; which, some, that have
More Wit then Grace, do well enough perceive[34] –

Edmund Waller, for one.

It is not surprising that Upon the late Storme was to elicit Salt upon Salt, or that, in this latter, Britain's tireless 'Remembrancer' as he had christened himself – the 'Chronomastix', pilloried long since in Ben Jonson's masque, Time Vindicated – should have felt moved to protest that Waller's panegyrical style

 mounts as high

As any *English Pegasus* can flie,
And, is as *well-paced*: but he feels the Reins
Lie loose upon his Crest, and overstrains [.]
To know, what best the *season* doth befit
With his *own Ends*, this *Author* wants not wit,
And, I believe, takes much more care then I,
What will best please, and wherewith to complie;
Though I, have more then forty years and five
Found, that my *Course*, is not the *Course* to thrive.[35]

This, naturally, did not deter him from persisting in it. 'A Recal to the Reader', appended to his *Protector* (p. 46), proudly (if somewhat superfluously) advises,

If, thou suppose, I, gain, by what I write;
Consider it, and thou such thoughts wilt slight.

Quite. But 'Tis a smart neat Peece, ΘPIKION sayes'[36] – θριγκίον being a diminutive of the Greek word for 'coping' or the 'wall' it caps; so Wither seems to be playing, with somewhat awkward pedantry, on Waller's name. If his own '*Course*' is not one to thrive, however, Waller is altogether a more 'finished' performer, slight him who may. But true poets, admonishes Wither,

should not strive for Words to please the ear,
In which no *solid Matter* doth appear;
But, write so plainly, that, the *meanest* Wit
Might from their *Musings*, reap some benefit.[37]

From the Muses to '*Musings*': a heavy decension! – from pure Castalian to small beer, or, if Skeat's *Etymological Dictionary* can be credited, singing goddesses to snuffing dogs. Waller gives his poetic Pegasus its head; Wither would reduce Calliope, Clio and the whole Apollonian boiling into 'to muse, dream, study, pause, linger about a matter'.[38] And 'muse' in this sense ('The image', says Skeat, 'is that of a dog idly snuffing about, and *musing* which direction to take') describes his own earnestly exhaustive and determined-to-be-understood methods of running-couplet composition to perfection. Never was the Elizabethan poetaster, George Puttenham's disdainful pronouncement that 'a *distick* or couple of verses is not to be accompted a staffe, but serves for a continuance' better borne out.[39] 'Honest *George Withers*', as Richard Baxter calls him – 'a Rustick Poet' but 'very acceptable to some for his Prophecies, so to others for his plain Country-honesty'[40] – stands in most respects the opposite of Waller, urbane purveyor (in smoothly closed couplets) of the 'guileful Charms, / Of *Humane Eloquence*', who, complains *Salt upon Salt*,

in a *Strain* doth write,
As if none could express a *Glow-Worm's* light
Unless he did Hyperbolize, so far,
At least to equalize it to a *Star*.[41]

'I wave those *Strains*', declares *The Protector* contemptuously (p. 31), and *Salt upon Salt* goes on to argue that

Such *Partialities*, at first, brought in

All *Tyrannies*: By such, Free-men have bin
Enslaved by degrees, and thereunto
Our *Fawnings* add more, then all else can do;
And 'tis impossible a means to finde
To keep those *Free*, who have a *slavish* minde.[42]

From *The British Appeals*, written to memorialize the anniversary of the execution of Charles I,[43] it is apparent that Wither held 'His Flattering *Priests* and *Poets*' partly to blame for the late king's excesses:

And by the *last* [the poets], He, and his Queen became
So often represented by the name
Of *Heath'nish Deities*; that they at last,
Became (ev'n when their *Mummeries* were past)
Like those they represented; and did move,
Within their Sphears like *Venus, Mars*, and *Jove*.[44]

Waller had been as culpable as any. Worse, he now proceeds to aggravate the offence by adopting similar, if admittedly more restrained, tactics in the Protectorate.

'*Neptune*', Cromwell appears as, at the opening of the *Panegyrick*, and 'our *Mars* in fight' towards its close (1. 176); while in *Upon the present War with Spain, and the first Victory obtained at Sea* a blandly deliberate borrowing from 'To the King on his Navy' (one of the more impressive pieces in Waller's 1645 collection of *Poems*) proclaims – a referential 'Once' substituting for the original 'So' in an otherwise identical first couplet –

Once *Jove* from *Hyda* did both Hoasts survey,
And when he pleas'd to Thunder, part of the Fray:
Here Heaven in vain that kinde Retreat should sound,
The louder Canon had the thunder drown'd.[45]

'Not fair', expostulates Francis Atterbury, friend (as said) of Pope, once Dean of Westminster, afterwards Bishop of Rochester and, finally, exiled Jacobite – 'Not fair to steal y^e verses he had made on y^e King, and apply them to Oliver'.[46] Wither, too, would have found it disquieting, although for quite opposite reasons. Philip Neve, however (whose 'Cursory Remarks' on Waller seem often to echo Atterbury's unpublished comments), detects nothing more sinister, here, than laziness:

Of his [Waller's] indolence other proof is afforded by his frequent
copies of himself: nor did he always copy with the best judgement;
for he has taken two complete verses from the poem, *To the King on
his Navy* (and those of no trifling import, the third couplet in his
book), and applied them to *Oliver*, in the poem, *On the War with
Spain*.[47]

But the lines are not included in *A Lamentable Narration*, the first printed version of the poem on the engagement with the Spaniards, and Philip R. Wikelund has assembled enough evidence to suggest that they were introduced into the Carrington text as a considered ploy, not because they were running in the poet's head and would out.[48] Waller knew very well what he was doing and, were the turn of thought not so obviously stock-in-trade, the work itself

relatively obscure, it might be tempting to recall that, in James VI and I's
Lepanto,

> The cracks of Gallies broken and bruzd
> Of Gunns the rumbling beir
> Resounded so, that though the Lord
> Had thundered none could heare,[49]

and postulate more stealing from Kings to piece out Protectors. But who,
even then, was likely to remember the *Lepanto*?

Waller's own verses, in contrast –

> Where ere thy Navy spreads her canvas wings
> Homage to thee, and peace to all she brings:
> The French and Spaniard when thy flags appear
> Forget their hatred and consent to fear.
> So *Jove* from *Ida* did both hosts survey,
> And when he pleas'd to thunder part the fray,[50]

with their neat dovetailing of Homer with contemporary Fleet Orders to the
effect that foreign vessels were now to be required to 'perform their duty
and homage in passing by' and, moreover, not 'fight with each other', if
belligerents, 'in the presence of his Majesty's Ships in the Narrow Seas'[51] –
these were a different matter: consummate and most fashionable marquetry
and, as such, still memorable even though not, in 1645, the first couplets in
the book. Yea, in the shadow of Charles's 'canvas wings' will all the seafaring
world rejoice, *in pace Domini Regis'*. He aspired to be 'the Soveraign of the
Sea':[52] was to have, indeed, a man-of-war of that name (only with 'Sea'
made plural) launched in 1637. Now the Protector's new model navy proves
equally sovereign and, suggests Waller by way of conclusion, has furnished
the wherewithal to make England once again 'This royal throne of kings, this
scept'red isle':

> With Ermins clad, and Purple; let him hold
> A Royal Scepter, made of Spanish Gold.[53]

The Stuart mantle is boldly shifted onto Cromwellian shoulders. The earlier
Panegyrick had proceeded more tentatively, though its gist is identical; and if
it is politicly less lavish with classical gods and goddesses than previous,
Caroline eulogies, why: 'Caesar' supplies the sovereign remedy. Certainly,
the prospect of a poet assiduously cultivating an imperial Roman background
against which the Lord Protector can stand out as a latter-day Augustus
cannot have delighted the uncompromising Wither, or anyone else who hoped
he had seen the last of 'all the burthensome *Aray* / Of *Kingship*, which was
lately took away'.[54] The very title of the poem proclaims it a part of this
'*Aray*'. At least, one of John Florio's definitions of *Panegyrico* in *Queen
Anna's New World of Words* (London, 1611) had been, 'an Oration in praise
of Kings, wherein they are flattered with many lyes'.

5: Building upon an Old Frame

Though explicit identification of Cromwell with Caesar Augustus is deferred until a suitably climactic point of the *Panegyrick,* the idea of Protector as Roman Emperor is continually nourished by the imagery. We hear, for instance, that

> Less pleasure take brave minds in battails won,
> Then in restoring such as are undone,
> Tygers have courage, and the rugged Bear,
> But man alone can, whom he conquers, spare,[1]

and are perhaps expected to recall that Ovid, in *Tristia* 3. 5, had complimented Augustus in somewhat similar terms: in Zachary Catlin's translation,

> The greatest spirits the [soonest] are appeased
> And wrath in generous minds is [soone] released,
> A Lyon, when his prey doth prostrate lye,
> Doth streight forbeare his suppliant enemy.
> But wolves and beares and each ignoble brest,
> With cruelty pursues the Dying beast.[2]

Again, there is a complex of commonplaces drawn, as the poet of 'To the Pitifull Authour of the Panegyrike' may have noticed, since he complains that '*Nero* is by you, as *Trajan*, show'n' (line 3), from Pliny's celebrated *Panegyric* addressed to the latter. This includes the observation that

> *Aegypt* so gloried in cherishing and multiplying seed, as if it were not at all indebted to the rayne or heaven, being alwaies watered with her owne river nor fatned with any other kind of water, but what was powred forth by the earth it selfe,[3]

which is echoed by Waller's

> As *Egypt* does not on the Clouds rely,
> But to her *Nyle* owes more, then to the Sky;
> So what our Earth, and what our Heav'n denies,
> Our ever constant Friend, the Sea, supplies.[4]

A second passage –

> How happy is it now for all Provinces, that they are come into our subjection and allegiance, since the world hath got a Prince . . . that could feede and maintaine a nation severed from us by the Ocean, as if it had beene part of the people of *Rome*[5] –

perhaps stands behind,

> Like favour find the *Irish*, with like Fate
> Advanc'd to be a portion of our State;
> While by your Valour, and your Courteous mind
> Nations divided by the Sea are joyn'd.[6]

Yet a third –

> You have curbed a hardy people in a season most favourable to them, most insufferable to us . . . when that fierce Nation was not more armed with their darts, then with their *aire* and *climate*[7] –

is more obviously the inspiration of

> A Race unconquer'd, by their Clyme made bold,
> The *Calidonians* arm'd with want and cold,
> Have, by a fate indulgent to your Fame,
> Bin, from all Ages, kept, for you to tame.[8]

'May you', Sir Robert Stapylton had wished, dedicating the translation of
Pliny's *Panegyricke* from which these quotations have come to the Prince of
Wales in 1644:

> May you be *happier then Augustus, better then Trajan*: to whom you
> are now so just a Parallel, that I present his Character as a marke of
> your owne height in honour.[9]

In 1655 Waller was presenting, implicitly, the same character to Cromwell;
fate, in the interim, having been much more indulgent to his fame than Charles's.

> 'Have . . . Bin . . . kept': after the phrasal escarpment of
> A Race unconquer'd, by their Clyme made bold,
> The *Calidonians* arm'd with want and cold,

which almost makes a pun out of 'Clyme' and threatens an avalanche, the
sense is dropped in the second couplet –

> Have, by a fate indulgent to your Fame,
> Bin, from all Ages, kept, for you to tame –

through a series of locks gated by the judiciously distributed verb (a force,
once again, for containment, not rough impulsion), so that a potential inundation
'like which the populous north / Poured never from her frozen loins' ends up
feeding a canal basin, and the wolvish Scots become muttons in the Protector's
pen. If this is not the syntax of Providence (and Cromwell himself always
considered God's hand to have been most signally influential in the battle of
Dunbar), it is, at the very least, syntax as highly accomplished civil engineering.
What barbarian turbulence (climactic exacerbations notwithstanding) could
survive such triumphant canalization; such, in prosodical terms, 'What the
Romans called "rotunditas versuum" (for I know no English word for it)'?

The *ignoramus*, here, is Pope's who adds that this *rotunditas versuum* 'is
to be met with remarkably in Waller'.[10] It seems a quality closely allied to the
'sweetness' for which he is also commended. As distinct from 'softness',
produced by a 'proper intermixture of the vowels and consonants' (which
'may be very effeminate', whereas 'sweetness' is not at all so), 'sweetness',
to the poet Blacklock, whose opinion Spence invokes by way of gloss, 'seemed
to depend upon a proper management of the pauses';[11] upon, that is, a proper
management of inlet and outlet and the flow and intonational rise and fall of
the verse as the voice registers the grammatical articulation of phrasing artfully
contoured about caesura and line-ending. Virgil is the Latin exemplar; which,
perhaps, helps to explain William Benson's acerbity when (although with
manifest onomatopoeic intent) Dryden renders a line from the *Georgics* ('Begin,
when the slow Waggoner descends'), ignoring both the 'pause' and the
'suspense' which should be incident to it. This too, when, argues Benson,

> The Suspense which is occasion'd by some Transposition or other
> of the Phrase, is very properly call'd, by the best *French* Critick in

Poetry I ever met with, the Soul of the Verse.[12]

That Waller was among the first, in practice, to identify Benson's 'Soul of the Verse' and systematically exploit it, constitutes his most distinctive contribution to English prosody. And it is appropriate that he should have been writing in a vein which Pope can only find Latin to describe, and which seems to have turned contemporary minds inevitably towards Virgil, while extolling a hero *'happier then Augustus, better then Trajan'* and, all in all, more than a match for any Caesar, Julius not excepted, if Samuel Carrington's extrapolations upon Waller's verses in his *History of the Life and Death of His most Serene Highness* are to be credited:

> The private Soldiers lost no Courage, but did gladly and joyfully
> withstand and out-brave those difficulties which stopped *Julius Caesar*
> in his enterprize in those parts, and who chose rather to be at the
> charge of a prodigious Wall which fenced him from the Scotch
> Incursions, then to engage his Army in that mountainous Country,
> hoary with Snow and Ice, and the Conquest whereof was by the
> English undertaken in the very heart of Winter.[13]

This, plainly, takes its cue from the *Panegyrick*, where Waller goes on to characterize the *'Calidonians'* as those 'Whom the old *Roman* wall so ill confin'd', though he does not go so far as to attribute the fortification to Julius Caesar. Carrington's *History* incorporates two of Waller's poems *(Upon the present War*, newly revised for the occasion, and *Upon the late Storme)* wholesale, praising their author, Dawbeny-fashion, as 'the English *Virgil* of our times, Mr. *Edmund Waller'*.[14] The *Panegyrick* is sold by retail. Twenty-odd pages earlier, for example, play has been made with Waller's comparison of Alexander, who

> safely might old Troops to Battail leade
Against th'unwarlike *Persian*, and the *Mede*,[15]

and Cromwell campaigning in Scotland, and

> we consider, how the said Conqueror of *Asia* had to do with an
> effeminate kind of People, bred in a delicious Country, accustomed
> to their ease and pleasures; but here on the contrary, That the English
> brought up in a fertile abundant Soil, and under a middle Climate,
> should come to confront a War-like Nation in a harsh, barren, and
> cold Climat.[16]

Concluding with a 'Character of his late Serene Highness', too, Carrington repeats Waller's

> Lifting up all that prostrate lie, you grieve
> You cannot make the dead again to live,[17]

remarking that his hero

> did even wish when he came to have a more absolute power towards
> the latter end of his dayes, that those which he had put to death were
> yet alive.[18]

At the other extreme, the preface discovers the Lord Protector 'dormant, like unto *David* midst his Flocks, untill the troubles of his Countrey awake him',[19] in which posture he is likewise to be found in the *Panegyrick:*

> Born to command, your Princely vertues slept
> Like humble *David's*, while the Flock he kept;
> But when your troubled Countrey call'd you forth,
> Your flaming Courage, and your Matchless worth
> Dazeling the eyes of all that did pretend
> To fierce Contention, gave a prosp'rous end.[20]

For, with the world as it was, a compounding of Caesarean themes with something biblical was advisable to make a remedy more panacean, although this

> prophane comparing *Cromwells* necessitous & melancholike retirements, with H. Davids contemplative pastorall privacie, as if yᵉ integritie of both had been the same in their recesses & yᵉ method of their lives alike order'd to the like end by yᵉ disposition of *heaven*,[21]

of course only enrages Watson, whose verse 'descant' bluntly declares,

> Your *Oliver* had no *King Davids* call,
> Nor was *King Charles* the first, *a second Saul.*[23]

Again, however, Waller knows well what he is about. David is a valuable precedent, as the renegade Hall of Richmond was also quick to realize:

> Nay, if possession give not to Princes right to command their Subjects also, I see not how *David*, in that *seven years war between the house of* Saul *and his*, 2. Sam. 3. 1. could be excused of that oath he made to him of *not cutting off his seed after him*, 1. Sam. 24. 21, 22.[23]

Cromwell, he has been arguing in the previous chapter, possesses

> all that can be expected in *him that beginneth a Royal race*; that is both Election and Conquest, like as in *David*. He is not, like *Nimrod*, a stranger by birth and relation, found to force himself in by his own greatness and power, but, being of the same Nation and Religion, is at first freely chosen and followed, and that by a more numerous and eminent party then that which *David* first headed. During which time he was also undeniably signal in those victories he obtained over such as were their enemies; by which he might come to claim right and dominion over them, even as by election he might claim it over the other of his own party, and so have must dominion over all.[24]

The history of David, best of biblical kings, can neatly be adapted to justify Cromwell. Hall, by remarking that the Protector was not 'like *Nimrod*, a stranger by birth and relation' can even insinuate that he may fulfil more nearly than the Stuarts the conditions laid down in Deuteronomy 17. 15:

> *One* from among thy brethren shalt thou set King over thee: thou mayest not set a stranger over thee, which is not thy brother.

Of course, James I (who was, besides, a Scotsman) and Charles I both owed their crowns ultimately to the intrusion of William the Conqueror, Frenchman and imposer of the 'Norman Yoke', lately the cause of so much controversy. He most certainly had 'force[d] himself in by his own greatness and power'; but David had displayed no such aggressive and self-seeking ambition.

> *David* is made King, but this is the work of Heaven, not any

atchievement of his own. He neither did, nor ought to lift a finger for
the Crown,

observes Thomas Rymer, regretting Cowley's choice of epic hero in the
Davideis.[25] What was Cowley's loss is Waller's gain. He has his hero 'called
forth' by God and his 'troubled Countrey', roused, like Virgil's Neptune,
only when universal uproar is otherwise threatened; and 'Our little World, the
Image of the Great' comes eventually to rest its weary head upon his breast,

As the vex'd World to finde repose at last

It self into *Augustus* arms did cast.[26]

The *Panegyrick*'s Protector, in short, has done no forcing whatsoever on
his own account. David is not 'The forward Youth that would appear', nor
Waller's the 'restless *Cromwel*' of Marvell's *Horatian Ode* who

could not cease

In the inglorious Arts of Peace,

But through adventrous War

Urged his active Star.

And, like the three-fork'd Lightning, first

Breaking the Clouds where it was nurst,

Did thorough his own Side

His fiery way divide.[27]

Long ago, the roots of this simile were traced back to the description of
Julius Caesar at the beginning of Lucan's *Pharsalia*. Marvell, however, does
not use the allusion, Waller-like, to – and the phraseology is Walter Charleton's
Hobbistically distinguishing between 'imagination' and 'judgement' in *A Brief
Discourse Concerning the Different Wits of Men*[28] – to 'conceive some certain
similitude in objects really unlike', pleasantly confounding King and Cromwell
in discourse of Caesar, 'which by its unexpected *Fineness* and allusion,
surprising the Hearer, renders him less curious of the truth of what is said'
(namely, that for all practical purposes they are the same thing: Caesars both).
On the contrary: Marvell's object is not to submerge disparity, but expose it.

Cromwell, like lightning 'Breaking the Clouds where it was nurst' and
born, thus – like 'The unfortunate Lover'[29] – by '*Cesarian Section*', bursts
upon the world an authentic Caesar, to strike at his ersatz namesake:

Then burning through the Air he went

And Pallaces and Temples rent

And *Caesars* head at last

Did through his Laurels blast.[30]

'*Caesars* head': Charles I has the name, but bears it like one of the 'exuvias
veteres', the 'ancient spoils' which adorn Caesar's rival, Pompey's aged and
ill-rooted oak in the *Pharsalia*.[31] Like the 'heavy Monarchs' of Marvell's
own future *First Anniversary*,[32] he goes through the motions: is, in the words
of the *Horatian Ode* itself,[33] 'the *Royal Actor* born' (Lucan's equally impotent
Pompey, incidentally, had also had a penchant for theatricals);[34] but it is
Cromwell who, as it were, actually acts – urges, indeed, 'his active Star'
instead of being impelled by its influence: makes 'by industrious Valour' his
sun not so much run as race, so ruining 'the great Work of Time'.[35] (Whereas,

in the 'Gardens' he has left behind, time is thyme and thyme is honey in the computation of 'th'industrious Bee', whose activity is entirely harmless and generically quite distinct from either Cromwell's action or Charles's acting.)[36]

The King, then, is 'Caesar' by conventional nomenclature, hereditary title, the slow gestation of time. Cromwell is the thing *per se*, reborn by sudden, caesarean section. And 'The name and all th'addition to a king' without (as *Lear* has it)[37] 'the execution of the rest', proves when experimented as sovereign as are laurel wreaths (more *pseudodoxia epidemica* ripe, by mid-century, for empirical displosion) against the shock of actual lightning. Into such a 'short and narrow verged shade'[38] has the divinity which once hedged a king now shrivelled!

Far from collision being avoided, Marvell compels his reader to appreciate the magnitude of the impact. But Waller, writing his *Panegyrick* some years afterwards in reined-in, neatly stepping and stepped couplets which are, in themselves, an urbane rebuke to the boundingly excited, energetic rhythms of *An Horation Ode*, has his Cromwell appear, not busily urging an active star, or like disruptive lightning, but as eminently ruly, '*well-pac'd*' sun:

Still as you rise, the State exalted too,
Finds no distemper, while 'tis chang'd by you.
Chang'd like the Worlds great Scene, when without noise,
The rising Sun Nights vulgar Lights destroyes.[39]

The world is a masque-set, and as painlessly transformed. The 'invention' turns smoothly upon its 'hinge'. The antimasque of 'vulgar Lights' ('the *Democratick* Stars' of Marvell's 'Upon the Death of Lord Hastings')[40] disappears, whereupon 'the whole face of the *Scene* alter[s]; scarse suffring the memory of any such thing'.[41] The whole affair is carried through with a noiselessness and well-oiled ease worthy a Sir Inigo and the Banquetting House. Cromwell is discovered as Sol, playing just the kind of role which would earlier have been assigned to a '*Royal Actor* born', James or Charles I, in those 'Mummeries' which had so vexed 'honest *George Withers*'. There is no dramatic confrontation. As is proper in a masque, 'opposition is shown by contrast rather than conflict';[42] is, in any case, between not King and Cromwell but 'Democratick Stars', 'vulgar Lights' and regal sun – it being implicitly 'questionlesse', as Percy Enderbie was to tell a recently restored Charles II, that

MONARCHY as far exceeds *Oligarchy, Democratie, Aristocratie*, or
that so much lately gaped after *Anarchy*, as the Sun in its purest and
most perfect lustre the smallest Star.[43]

Eight lines later, the sun image recurs:

That Sun once set, a thousand meaner Stars,
Gave a dim light to Violence and Wars.[44]

'That Sun', as seen, incorporates the executed King as well as assassinated Caesar – so irresistably so, in fact, that Thomas Creech was later to import the couplet almost unaltered into his translation of *De Rerum Natura*, at a point where his original could not have helped but recall memories of 1649:

Thus Monarchy was lost. –

> That *Sun* once set, a thousand litle *Stars*
> Gave a *dim* light to *Jealousies* and Wars.[45]

In the *Panegyrick*, as rising sun himself, all Cromwell has to do is to take up where his predecessor was regrettably (for he grieves he 'cannot make the dead again to live') forced to leave off.

Writing 'Upon His Majesties repairing of Pauls' (more controversial work involving 'Inigo Marquess Would be'), Waller, making the renovation of the cathedral emblematic of Charles's religious policy as a whole, commends it as 'an earnest of his grand designe / To frame no new Church, but the old refine';[46] there being to a Laudian way of thinking,

> no greater absurdity stirring this day in Christendom than that the reformation of an old corrupted Church, will we nill we, must be taken for the building of a new.[47]

Unless, of course, contariwise, 'will we nill we' it must be taken for flagrant disregard of the 'Law of leprosie Lev. 14. 44, 45' and greeted with a cacophony of cries to

> Take heed of building upon an old frame, that must be all plucked down to the ground; take heed of playstering when you should bee pulling down.[48]

The puritanical Lord Brooke, for one, was ambitious that *he 'should live to see no one stone left upon another of that building'*;[49] but Waller was always alive to the advantages of building upon old frames, whether religious, political or, indeed, poetic.

So the Cromwell of his *Panegyrick* does not 'by industrious Valour climbe', like Marvell's protagonist,

> To ruine the great Work of Time,
> And cast the Kingdome old
> Into another Mold,

or, 'ere we Dine, rase and rebuild [the] State';[50] rather he restores, personally makes good the breach made by Charles's downfall, returns the 'Kingdome old' to something at least approximate to its old shape. 'Many of God's people', laments John Owen, April 19, 1649, with the King not yet three months dead, preaching to the commons on *The Shaking and Translating of Heaven and Earth*, 'are not yet weaned from the things that are seen' (which, says St Paul, 2 Corinthians 4. 18, 'are temporall, but the things which are not seene, are eternall'):

> – no sooner is one carnal form shaken out, but they are ready to cleave to another, yea, to warm themselves in the feathered nests of unclean birds.[51]

It was upon this very unregenerate propensity that Waller was relying in *A Panegyrick*: the nest of an unclean bird, if ever there was one, feathered invitingly with pagan pluckings from Virgil and Ovid on Augustus, Pliny on Trajan and so on and so forth, and interwoven with allusions to exploded gods, Alexander the Great, Julius Caesar, 'the third *Edward*, and the black Prince too, / *France* conqu'ring *Henry* . . . and now You'.[52] For Cromwell, by imperious invitation of rhyme (a 'carnal form' not at all consonant, Milton decided with 'ancient', let alone Christian, 'liberty),[53] finds himself hatching new empires as

heir to a succession, not only of exotic gods, rulers and heroes, but also of native kings and princes.

This

> Paralleling the *purchased successes* of a *daring Rebell* to y^e cleare victories and generous conquests of three Martial Princes, and y^e *tainted bloud* of a partisan to y^e Royall current in their veines[54]

naturally enrages Watson, whose verse had been equally vehement:

> Who was that *Edward*? conqu'ring *Henry*? fam'd
> Black Prince? how? *Crom[w]ell* or *Williams* Sirnam'd?
> If from that *Royall* stemme your *Idol* spring,
> Why does he boggle at the title *King*?[55]

Why indeed! Even

> being descended from the Ancient and Illustrious Family of *Williams's*, of the County of Glamorgan, which Name in the Reign of *Henry* the eighth, was changed into that of *Cromwell*[56]

is not to be sneezed at. And their compatriot, Thomas Pugh, in *Brittish and Out-landish Prophesies* can happily trace

> *The Lineal descent of His Highness* OLIVER . . . *out of the body of* Blethin ap Cynvin *Prince of Powis in former times, as also from* Cadwallader Fendiged *the last King of the* Brittains[57] –

and ancestor reputedly, too, of Elizabeth I. A '*Royall* stemme', indeed, as Watson sarcastically remarks; though Waller, in 1655, wisely eschews irritating detail. His 'One, whose Extraction from an ancient Line', of course, 'Gives hope again that well-born Men may shine',[58] but lays no specific claim to royal blood. Watson, however, catches the gist; and, sure enough, before three years were out, his 'Vass'll to the Usurper' was openly expressing a desire to see 'the State fixt, by making him' ('*Crom[w]ell* or *Williams* Sirnam'd') 'a Crown'.[59] The *Panegyrick* had done its best more discreetly to assimilate its hero to a monarchical continuum.

Ben Jonson's friend, Drummond of Hawthornden, almost half a century ago in *Forth Feasting*, had sung

> Of Henrys, Edwards, famous for their fights,
> Their neighbour conquests, orders new of knights,

promising that these royal luminaries

> Shall by this prince's name be past as far
> As meteors are by the Idalian star.[60]

Then 'this prince' had been James VI and I; now Cromwell. And where Waller leads, Carrington proses assiduously after. '`That Grand Personage, whose conduct and fortune all the world doth admire', proclaims the preface to his *History* (with a dash of Marvellian spirit, too, though not enough to be headily eschatological[33]),

> in the space of ten years time, did accomplish the work of a whole Age: nay more, he perfected the work of future Ages, having settled *England* on such good Foundations, that if she continues to build thereon, she may expect to produce second *Edwards* and second *Henries*[61] –

'second *Edwards* and second *Henries*', be it noted, not the Second Coming.

6: Troubling the Waters – Marvell's *First Anniversary*[1]

'He seems a King by long Succession born . . .'. 'Whoever was formerly acquainted with Mr. WALLER, will easily recollect him at Sight', announces the writer of the preface *to Poems on Several Occasions* (1717), introducing *The First Anniversary*;[2] which would make this 'King by long Succession' simply a bold pre-emption of the slightly later *Panegyrick's* more tentative

> One, whose Extraction from an ancient Line,
>
> Gives hope again that well-born Men may shine,[3]

who turns out to be 'like humble *David*', germen of the Tree of Jesse. But he is not. Our positive prefator's confidence in his abilities to detect in *The First Anniversary* 'the peculiar Air, and Features of the Great Man it challenges for its Parent' is sadly misplaced and, the real author being not Waller but Andrew Marvell, things are far from running smoothly and successively just so, but abruptly quite otherwise.

The speaker at this juncture is a bemused foreign prince, who immediately adds,

> And yet the same to be a King does scorn.
>
> Abroad a King he seems, and something more,
>
> At Home a Subject on the equal Floor.
>
> O could I once him with our Title see,
>
> So I should hope yet he might Dye as wee.[4]

That's logic! Were Cromwell to accept the title of 'King', subscribe to the conditions of temporal sway, he might yet die like one – and, of course, everyone else. For, as Dryden was portentously to observe, opening his *MacFlecknoe*,[5]

> All human things are subject to decay,
>
> And when Fate summons, Monarchs must obey,

subjects themselves, in this respect, 'on the equal Floor', death being, proverbially, the universal leveller. So Cromwell, becoming King, would live and die only to confirm the generalization with which Marvell's poem, too, has opened:

> Like the vain Curlings of the Watry maze,
>
> Which in smooth streams a sinking Weight does raise;
>
> So Man, declining alwayes, disappears
>
> In the weak Circles of increasing Years;
>
> And his short Tumults of themselves Compose,
>
> While flowing Time above his Head does close.[6]

Marvell's 'O.C.', however (unlike Waller's Protector, who is always amenable to cliché), refuses to be so obligingly commonplace. His 'tumults' are not 'short', the fading ripples raised by a single dropped weight, but repeated and repeated: the result of perennial agitation. The poem ends by proclaiming him 'the *Angel* of our Commonweal' who, 'Troubling the Waters, yearly mak'st them Heal'.[7] His mother (lately dead, aged ninety-four) had, Marvell imagines, only 'smelt the Blossome, and not eat the Fruit' of the Forbidden Tree,[8]

thereby retaining something of the prelapsarian immunity to the effects of time. Her son is yet more remarkable.

> Cromwell alone with greater Vigour runs,
> (Sun-like) the Stages of succeeding Suns ,[9]

and so (taking for granted the usual sun/son equivoque) abrogates any need at all for heirs and successors.

His revolutions, then are recurrent, perpetual; do not disappear like the stone-stirred circlets on the surface of a stream, almost at once caught up and effaced in the onward flow of time. Where other monarchs are subjects, the slaves of time, content merely to signalize its passage –

> Thus (Image-like) an useless time they tell,
> And with vain Scepter, strike the hourly Bell[10] –

far from beating time in slavish attendance or supplying futile grist to the useless mills of memorial chronology, Cromwell 'the force of scatter'd Time contracts, / And in one Year the work of Ages acts':[11] not, though, with the Carringtonian intention of producing 'second *Edwards* and second *Henries*', or even (as was, in fact, to happen by default) fourth Richards. Time dances attendance upon him, not he upon it. He is sun, not Jack o'clock, although this is exactly what Cowley makes of him in *A Discourse by way of Vision*, where he is described as

> a Man, like that which we call Jack of the Clock-house, striking, as
> it were, the Hour of that fulness of time

which 'produces the great confusions and changes in the World': cataclysms of 'Divine Justice and Predestination' not attributable to 'the effects of humane force or policy'.[12] Yet even Lord Clarendon was to concede that 'he could never have done half that mischief without great parts of Courage, Industry and Judgement';[13] 'And if we would speak true', affirms the *Horatian Ode*, 'Much to the Man is due'.[14] So, in *The First Anniversary*, Cromwell as sun does not merely mark time, he makes it, with a daring to match Macbeth's ('Nor time, nor place', remember, 'Did then adhere, and yet you would make both');[15] a daring which in Shakespeare had been 'vaulting ambition' (and also, needless to say, regicidal), but of which Marvell, in 1655, is disposed to think more highly and holily.

For Cromwell – whose achievements the bewildered prince considers ought by rights (the 'antient Rights' of the *Horatian Ode*, 38) to be the fruit of a 'long Succession' – Cromwell will not tamely submit to the order subscribed to by conventional, apathetic kings who are more than happy to let the 'latter Dayes' keep 'the great Designes' and content to leave their 'earthy Projects' to their sons in accordance with a chronic law of inheritance whose principle is protraction. 'Well may they Strive to leave them to their Son', exclaims Marvell scornfully, 'For one Thing never was by one King don'.[16] Cromwell is above compounding thus abjectly with time: runs himself, '(Sun-like) the Stages of succeeding Suns', his modus operandi fierce contraction not slow dilation; the aim being not simply to get the measure of the times but abruptly foreshorten them. It is, after all, the logic of a D'Amville in an *Atheist's Tragedy* to argue:

Here are my sons . . .
There's my eternity. My life in them
And their succession shall for ever live,
And in my reason dwells the providence
To add to life as much of happiness.[17]

Better far, won over by Cromwell's example, to 'Kiss the approaching, nor
yet angry Son': God's Son, that is – Christ, rather than any offspring of
one's own loins. 'Blessed *are* all they that put their trust in him', proclaims
the psalm[18] to which Marvell is here alluding; in him, not 'Reason, so miscall'd,
of State'.[19] 'Blessed', but not numerous:

Hence that blest Day still counterpoysed wastes,
The Ill delaying, what th'Elected hastes –

the Second Coming.[20]

Marvell's jibe at the D'Amvillian rationale behind hereditary monarchy
appeared only a few weeks before a speech by the Protector himself in which
he assured Parliament that, had it been proposed 'That this government should
have been placed in my family hereditary, I would have rejected it'. 'This',
he was to insist,

> hath been my principle, and I liked it when this government came
> first to be proposed to me, that it put us off that hereditary way, well
> looking, that as God had declared what government he had delivered
> over to the Jews, and placed it upon such persons as had been
> instrumental for the conduct and deliverance to his people, and
> considering that promise in *Isaiah* that God *would give rulers as at
> the first and judges as at the beginning*, I did not know but that God
> might begin, and though at present with a most unworthy person,
> yet as to the future, it might be after this manner and I thought this
> might usher it in.[21]

Isaiah prophesies (1. 26) that a return to government by 'Judges' would
mark the beginning of the Millennium, and Cromwell –

And well he therefore does, and well has guest,
Who in his Age has always forward prest:
And knowing not where Heavens choice may light,
Girds yet his Sword, and ready stands to fight[22] –

Cromwell says he 'did not know but that God might begin' and 'thought this
might usher it in'. As a Judge he creates conditions conducive to the 'latter
Dayes'; but to accept a crown would be a retrograde step, a sinking, settling
back into time, reversion into the ranks of those who

neither build the Temple in their dayes,
Nor Matter for succeeding Founders raise;
Nor sacred Prophecies consult within,
Much less themselves to perfect them begin.[23]

If the Millennium is to be ushered in at all, it will be by a Judge, not by a King.
In Cromwell's estimation, to be Lord Protector is to be a Judge. Waller has
no eyes for such nice distinctions. Marvell has, but is not so sure.

Cromwell is compared to a Judge in *The First Anniversary*: to Gideon,

who, in his summary treatment of the citizens of Penuel and the Elders of Succoth (both of whom had declined to second his pursuit of the retreating Midianites), 'on the Peace extends a Warlike power' and so furnishes a precedent for Cromwell's own walking 'still middle betwixt War and Peace' after he, in his turn, was 'by the Conquest of two Kings grown great', Charles I and II corresponding to the two defeated Midianitish rulers, Zebah and Zalmunna.[24] So far, so good; but here the parallel falters.

No King might ever such a Force have done;
Yet would not he be Lord, nor yet his Son.[25]

'A Force' must be legal terminology: 'a particular act or instance of unlawful violence'.[26] 'No King' – for had not Bracton long ago laid down, *'lex facit regem'*,[27] not the other way about? Charles I conspicuously failed to arrest a mere Five Members? Cromwell given the whole Rump the bum's rush? – 'No King might ever such a Force have done'; but Gideon, as Judge, is in a different league, and Cromwell after him. *'They were executers of God's judgements'*, explains the 'Argument' prefixed to The Booke of Judges in the Geneva Bible,[28]

not chosen of the people nor by succession, but raised up, as it seemed best to God for the governance of his people:

were not kings, therefore, but in many respects more powerful than they. 'Yet would not he be Lord, nor yet his Son': Gideon would not, but Cromwell, though he may not have wished it, is already 'Lord': 'Lord Protector', if not yet 'My Sovereign Lord, the King' (and his son, too, was destined briefly to succeed him). 'Yet would not he be King' would, under the circumstances, have fitted either equally well, Gideon or Cromwell; but 'Lord' presents difficulties. Waller's approach is to skate smoothly round such snags ('no Ice can be smoother'!). Marvell is less inclined to let well alone.

Thou with the same strength, and a Heart as plain,
Didst (like thine Olive) still refuse to Reign;
Though why should others all thy Labor spoil,
And Brambles be anointed with thine Oyl,
Whose climbing Flame, without a timely stop,
Had quickly Levell'd every Cedar's top.[29]

The Olive, used in Judges 9 to allegorize Gideon, had, in putting by the crown proffered by the other trees demanded:

Should I leave my fatnesse, wherewith by me they honor God and man, and go to advance me above the trees?[30]

The result of this refusal (laudable in itself) was that the 'fatnesse' was in the end used to honour the utterly unworthy but eminently ambitious bramble which was anointed king with predictably disastrous consequences. Had Oliver, likewise, been so absolute, history must have repeated itself: his 'Oyle' been used in the anointing, not of its rightful recipient, but some spurious Abimelech. The *'Chammish* issue' would have exploited his achievements, not to 'Kiss the approaching, nor yet angry Son', but to set up a 'new King' (Nimrod was Ham's grandson), an Antichrist of their own devising.[31] Cromwell's acceptance of the Lord Protectorship is an attempt to forestall

this eventuality, a move forced upon him by the intransigence of a nation, no 'seasonable People',[32] but a stumbling block in the way of real progress and millennial hopes.

> Hence landing Nature to new Seas is tost,
> And good Designes still with their Authors lost.[33]

Hence, too, Marvell's subsequent contention that

> Thee proof against all other Force or Skill,
> Our Sins endanger, and shall one day kill.[34]

For, if Cromwell is, indeed, the one in whom 'High Grace' meets with 'Highest Pow'r' – and Marvell is convinced, 'If these the Times, then this must be the Man'[35] – it will follow that, should he fail to curtail time's 'useless Course'[36] and so fall victim, himself, to mortality, it will be because others have frustrated his best endeavours. Their sins will kill him, no fault of his own.

> How near they fail'd, and in thy sudden Fall
> At once assay'd to overturn us all.
> Our brutish fury, strugling to be Free,
> Hurry'd thy Horses while they hurry'd thee.[37]

His coaching-accident (Cromwell had had an upset in Hyde Park, 29 September, 1654) illustrates the danger. Even the man 'for whose happy birth / A Mold was chosen out of better Earth'[38] could not hope single-handedly to counter the effects of the Fall, the World, Flesh, Devil. So, far from forcing the pace, foreshortening time to 'precipitate the latest Day',[39] he now finds himself hurried: more like Phaethon than Phoebus as Malignancy (probably in the shape, here, of Sir John Berkenhead)[40] rejoiced to observe:

> They slander my *Lord*
> With a bug-bear Word,
>> That he did like *Phaeton* drive;
> But his Highness try'd
> Six Horses to guide,
>> And *Phaeton* had now five –

or four, according to Ovid, interpreted by the assiduous Sandys as either 'the four seasons of the yeere' or 'the common people; unruly, fierce, and prone to innovation'.[41] 'Though he us'd to lead', Berkenhead quips five stanzas before, glancing back at his Ironsides, 'This *new-modelled* Horse would lead him'[42] – away from 'The great Designes kept for the latter Dayes'. 'Landing Nature', caught in an undertow, risks being swept back out to sea, shipwracked into time again, balked of its chance of returning to 'an Eternal Spring, a standing Serenity, and perpetual Sun-shine'.

This is how, in the second part of *The Rehearsal Transpros'd*, Marvell describes 'that state of perfection' which (though 'scarce of one days continuance' apparently!) prevailed before the original Fall. By 1673, however, he has come to the conclusion that 'we must nevertheless be content . . . to inhabit such an Earth as it has pleased God to allot us'.[43] Attempts at, in the sarcastic phrase of a contemporary sermon, '(as it were) new-modelling the whole World'[44] had proved not the redemption, but a waste of time. 'Men',

Marvell had decided in the first part,

> may spare their pains where Nature is at work, and the world will not
> go the faster for our driving. Even as his present Majesties happy
> Restauration did it self, so all things else happen in their best and
> proper time, without any need of our officiousness.[45]

Charles II had regained his throne by a passively unimportunate attendance
upon events. 'Men may spare their pains where Nature is at work.' But the
protagonists of the Puritan Revolution had not spared their pains: had brought
an axe down upon the neck of 'his present Majesties' unhappy father, so
opening what Wordsworth, a century-and-a-half on, after a similar event in
France, was to call 'an interregnum's open space'.[46] 'So', to echo the famous
protest of Marvell's refractory Body concluding its 'Dialogue' with the Soul[47]
– ('But we must nevertheless be content with such bodies', claims the
Rehearsal, as 'such an Earth') –

> So Architects do square and hew,
>
> Green Trees that in the Forest grew:

make a clearing and offer to build in it, 'the Temple in their dayes'. They take
too much upon themselves. 'Men ought to have trusted God', reflects Marvell;
'they ought and might have trusted the King'[48] and, instead of trying to
transcend Nature, have given its workings more scope. For, fallen as it is,
still it is the Nature which 'it has pleased God to allot us' and which He
orders as it is not only '(as men endeavour to express it) by meer permission,
but sometimes out of Complacency':[49] because it pleases Him. It is dangerous
to give too much 'ear to proud and curious Spirits'.[50] The world has not gone
the faster for Cromwell's driving.

With the wisdom of hindsight, failure must have appeared inevitable, and
even though in *The First Anniversary* Marvell sets out to justify Cromwell's
conduct and commend what he was later to condemn as 'officiousness', yet
the poem is not, like Waller's *Panegyrick*, designed to convey the impression
that all is more or less right with the world. Far from it. 'Good Designes' are
'still with their Authors lost'. The coaching-accident is ominous. Cromwell's
having had formally to install himself as 'the headstrong Peoples Charioteer'[51]
in the first place argues the impracticability of insisting, like Gideon, that

> I will not rule over you, neither shall my sonne rule over you: the
> LORD shall rule over you.[52]

'The LORD' has become dangerously annexed to 'Protector', though the
paganizing Waller cannot yet quite cry out in triumph 'Rejoice, the Lord is
King'.

But the tide, seemingly, is pulling that way. 'It may probably be', runs a
Royalist conjecture of July, 1655,

> that Cr. will assume a legislative power before he proceede to his
> title, for that is an easy stepp. He that hath the legislative power may
> assume what title he will.[53]

And this when, 'In the time of *Moses*, *Joshua*, and the *Judges*', as William
Lucy explains in the course of his *Observations* on Hobbes's Leviathan,

> God was the sole King of the *Israelites*; he gave them Lawes; and

they by Covenant bound themselves to obey those Lawes; he to
protect them; and *Moses* was so far from being their *King*, that he
gave them no Lawes; so that he was but, as it were, a *Judge* and a
Generall to lead them in their battails, as God directed, and to judge
their causes according to God's Lawes which he had given them.[54]

To some, in the summer of 1655, it seemed that Cromwell was on the verge
of making good all that a Protector might still lack of a King; of 'growing to
[him] self a Law'[55] not through sudden inspiration but formal institution.

In the event, he held back, much to Wither's relief. 'God', he claims of the
Protectorship in *A Suddain Flash*, 'gave this Title for a difference / Betwixt
the *Kings of Babel*, and his *Prince*'.[56] Milton concurs.

You suffered and allowed yourself, not indeed, to be borne aloft, but
to come down so many degrees from the heights and be forced into
a definite rank, so to speak, for the public good,

he tells Cromwell in his *Second Defence* (1654).

The name of King you spurned from your far greater eminence, and
rightly so. For if, when you became so great a figure, you were
captivated by the title which as a private citizen you were able to
send under the yoke and reduce to nothing, you would be doing
almost the same as if, when you had subjugated some tribe of idolaters
with the help of the true God, you were to worship the gods that you
had conquered.[57]

'Protector' is, at least, 'a difference' if not, in Milton's view, exactly heaven-
sent heraldry. Having had to accept a title at all is a come-down. Marvell,
who knew the *Second Defence* well,[58] thinks somewhat similarly in *The First
Anniversary*:

For all delight of Life thou then didst lose,
When to Command, thou didst thy self Depose;
Resigning up thy Privacy so dear,
To turn the headstrong Peoples Charioteer;
For to be *Cromwell* was a greater thing,
Then ought below, or yet above a King:
Therefore thou rather didst thy Self depress,
Yielding to Rule, because it made thee Less.[59]

The Olive must leave its 'fatnesse, wherewith by mee they honour God
and man' if it is to 'goe and be promoted over the trees', or '*goe up and
downe for* other *trees*', in the Authorized Version's marginal alternative (Judges
9. 9). Oliver sacrifices 'Cromwell' and cramps himself, his self, in 'Oliver
P.' (though notably it is 'O.C.' which Marvell retains in the full title of *The
First Anniversary*). In 'first growing to [him or his] self a Law', he
simultaneously takes the law into his own hands and subjects Self to its
styptic regulation. Ambition is ruled out of court. Just as the *Second Defence*
says, he has 'suffered and allowed' himself 'to come down . . . and be
forced into a definite rank [*in ordinem cogi*][60] for the public good'. Milton
can only have applauded the assertion that 'to be *Cromwell* was a greater
thing, / Then ought below, or yet above a King', which is as much as to say

'Lord Protector'. Cromwell's honour, argues Wither,

> Is of higher nature and degree,
> Than that which *men confer* . . .
> And *Gideon*, peradventure, did therefore
> Refuse a *Kingship*, being honour'd more
> By what he was, then by what he thereby
> Might have convey'd to his *Posterity.*[61]

Marvell's Cromwell, too, is 'honour'd more / By what he was' than by what he is: not as yet a dynast or king hereditary, to be sure, but nevertheless a Lord Protector. Wither may think 'King' and 'Protector' sufficiently differenced. Waller makes them out to be approximately identical. Marvell, like Milton, sees a slippery slope. For, by as much as a Protector differs from a biblical *'Judge* and a *Generall'*, by so much hopes of a millennial transformation must recede; by so much must tedious time begin to reassert its baleful sway, foreclosing upon 'an interregnum's open space'; and by so much will the door be closed upon 'the approaching, not yet angry Son'.

Cromwell has found it impractical to stand, Gideon-like, point-device upon principle; has accepted (whatever Wither may make of the matter) an honour 'which men confer' – yielded to rule and his self deposed. 'Since', Milton explains,

> it is not indeed worthy, but expedient for even the greatest human
> capacities to be bounded and confined by some sort of human dignity,
> which is considered an honor, you assumed a certain title very like
> that of father of your country.[62]

'Non dignum est, sed tamen expedit': it helps out; is not ideal, merely expedient. Milton and Marvell both regard the Protectorship as something of a compromise, a come-down, a concession to 'carnal form'. *Cogere in ordinem* is Latin for 'to reduce to order, humble, degrade'.[63] Originally *extra ordinem*, functioning 'out of course, in an unusual or extraordinary', even 'an illegal manner'[64] – 'No King', remember, 'might ever such a Force have done' – Cromwell allows himself, 'for the public good', to be reduced 'in ordinem': declines from divinely sanctioned Judge into humanly instituted Lord Protector; and, far from feeling with Macbeth, 'his Title / Hang loose about him, like a Giants Robe / Upon a dwarfish Theefe,[65] he seems rather 'cabin'd, crib'd, confin'd, bound in' by it. 'Cromwell', indeed (the name, eight times repeated, dominates *The First Anniversary*), fits into 'Protector' about as comfortably as a quart into a pint pot.

7: More Directed to the Monarchy than the Person

Notably Waller has no use, in any of his protectorate poetry, for the 'private' name 'Cromwell'. The preface to *Of Government and Obedience* speaks of

> that different sense of loyalty which *Alexander* once wittily observed
> in his two followers, *Ephestion* and *Craterus* (namely that one loved
> *Alexander*, the other the *King*).[1]

Like John Hall of Richmond, Waller is of Craterus's disposition. Although, as will be seen, the tune changes somewhat with the Restoration, during the Protectorate '*Ephestion-like* expression' is avoided. For Waller, Cromwell is a 'Caesar' (itself a proper name become public): a type-figure designed to be fitted easily into the niche vacated by Charles I and equipped, accordingly, with all the customary appurtenances even (amusingly enough in view of what Marvell makes of the subject) down to a regulation 'long Succession'. He is, as has been said,

> One, whose Extraction from an ancient Line,
> Gives hope again that well-born Men may shine.[2]

Watson, of course, is bound to object. His eighth '*prosaïke gloss*' inveighs lengthily against Waller's

> subtile insinuation to withdraw them [he means the nobility and gentry]
> from their allegeance, & invite their submission to this *degenerated
> Creature*, by the antiquitie of his extraction together with an irrationall
> opinion of his maintaining & illustrating their privileges and honours:
> when as ye Nobilitie of no Nation ever had such a reproach & indignitie
> offer'd them, by vesting mechanike & meane-borne persons with
> aequivalent titles & much more then aequivalent authoritie,
> countenancing them in precedence and (little becoming the extraction
> he pretends to permitting these *mushrome* mere excrements or
> excrescences of his soile so frequently to offront 'em, & insult upon
> their persons.[3]

The 'deluding streame' runs true to form. Cromwell has 'restor'd the state,[4] set it up again in its original condition with himself acting as successor to the dead King. Since, it goes without saying, no 'true Cavalier' ever swears fealty to 'the Heir only as Heir, if he be not also Successor',[5] Charles the would-be Second can, with a clear conscience, be ignored; ought, in any case, to have already resigned himself to his fate.

So the drift of the *Panegyrick* is that Cromwell would do well to accept a crown, confirm himself king, 'fix', in the parlance of *Upon the present War*, the state, though Wither doubts whether the laws would be more 'fixt' under such circumstances and wonders,

> will it make the Royalists more true
> To him, because, he takes what they think due
> Unto another?[6]

As astute a judge as Lord Clarendon considered it depressingly likely. Those Royalists who, where Wither feared, hoped that

> there is nought more likely, in, to bring
> *Him* that's expelled, then, to make a *King*,
> At this time; and, to make on that accompt
> (Which is design'd) that *Title* paramount[7] –

these Royalists were deceiving themselves. Clarendon himself and

> the more sober Persons of the King's Party, who had made less noise,
> trembled at this Overture; and believ'd that it was the only way,
> utterly to destroy the King, and to pull up all future hopes of the
> Royal Family by the Roots . . . there was too much reason to fear,
> that much of that Affection that appear'd under the notion of
> Allegiance to the King, was more directed to the Monarchy than to
> the Person; and that if *Cromwell* were once made King, and so the
> Government run again in the old Channel, though those who were in
> love with a Republick would possibly fall from him, he would receive
> abundant reparation of strength by the Access of those who preferr'd
> the Monarchy, and which probably would reconcile most Men of
> Estates to an absolute Acquiescence, if not to an entire submission.[8]

Waller, who dismisses the republicans, in the person of Brutus, as
'mistaken', intimates as loudly as he dares without being provocative, that
the government is, to all intents and purposes, running again 'in the old
Channel', while Richard Watson, alive as Clarendon to the fatal allure of the
argument, hastens to disabuse the 'Men of Estates' at whom the propaganda
is primarily directed.

As for the absence of 'Cromwell' from the *Panegyrick*: Waller's aim is to
promote loyalty, not to Cromwell personally, but to the institution of a Single
Person, best designated a 'King'. The 'true Cavalier', says Hall, does not
'respect the power or place for the persons sake, but the person for the place
and power sake',[9] and it is just this attitude, which directs allegiance, Craterus-
fashion, 'more . . . to the Monarchy than to the Person', which Clarendon
finds so inimical to his prince's interest.

In contrast, Marvell commiserates Cromwell's sacrifice of self, refuses to
transform him into a typical 'Caesar', fix him up with a conventional pedigree,
suggest he fits comfortably into any pattern whether kingly or Judge-like. If
'Abroad a King he seems, and something more', yet he remains 'At Home a
Subject on the equal Floor':[10] is not 'rais'd above the rest' in any manner
calculated to satisfy Waller or the 'Men of Estates'. Patently, government is
not running 'in the old Channel'. *The First Anniversary*, in other words (Richard
Watson's in his 'Solemne & Serious Advertisement') is not so much the
'deluding streame' as 'a bolder torrent that attempts to invade his [prince's]
territories by a deluge'.

Cromwell, appropriately, is compared to 'a small Cloud, like a Mans hand',
which, growing rapidly into a storm, 'o'r-took and wet' the back-sliding
Ahab/Charles, and shortly afterwards there is reference to Noah and 'the
Wars Flood'.[11] After such a phenomenon it is necessary, not to restore, but
to begin building again from the very foundations.

So Wither, contending that the Protectorship 'must be the *Stone* / First

laid, to build their new fram'd work upon',[12] rejects out-of-hand the kind of
continuity Waller labours to establish. *'To new Creations'*, he insists in his
piece, *The Protector*,

> There do belong *peculiar Appellations*,
> To keep things from *Confusion*;

and he is careful to stress the unprecedented nature of the title:

> For, our PROTECTOR is not such a one,
> As that, whereby we did support the *Throne,*
> In Non-age of a *King*, (as some conceive).[13]

Leastwise, if a King is in the offing, it ought to be Christ, not some latter day
'third *Edward*' or '*France* conqu'ring *Henry*'. But the abject Waller 'would
be *King-rid*',[14] would 'on Foundations, by GOD's own hand laid, / Rebuild
again old *Babylon*',[15] and *Salt upon Salt* regrets that, seduced by the
blandishments of such as he,

> To *govern* us, we long'd for such a *Thing*
> As other Nations have; forsooth a *King*[16],

thereby risking God's wrath.

For the tempest, suggests Wither, which preceded the Protector's death,
is liable to other interpretations besides that accorded to it by Waller in *Upon
the late Storme*. God sent 'thunder and raine' (1 Samuel 12. 17) at harvest
time to signalize his displeasure at Israel's 'wickednesse' in requesting a
king. The weather now may be a like manifestation of divine irritation at the
people's persistence in illicit demands and Cromwell's increasing inclination
to humour them. Wither had found, himself, only cause for rejoicing when
the crown had earlier been rejected:

> For, in his condiscending to be *King*,
> He could have been at best, no *greater thing*
> Than other *Earthly Princes*: but, hereby
> He may ascend unto a *Soveraignty*,
> Which raiseth him, nine *Orbes* above their *Spheare*,
> To be inthroned, where *Immortals* are.[17]

Well, therefore, may Marvell's representative 'earthly prince' at the end of
the *First Anniversary* protest,

> 'O could I once him with our Title see,
> So should I hope yet he might Dye as wee'.

No 'gloating allusion', this, as J.M. Wallace supposes, 'to the probable collapse
of Cromwell's work at his death':[18] more a weary wish that he would
condescend to be no greater than the rest of them, '*Earthly Princes*' all,
'heavy Monarchs', saturnine and leadenly time-bound to a man. If only time
could carry off Cromwell!

It did, of course, finding Waller ready, as ever, with a timeserving couplet
in *Upon the late Storme*:

> *Princes* that fear'd him, *grieve*, concern'd to see
> No pitch of glory from the Grave is free.[19]

Concern, however, if Marvell's exemplar is anything to go by, must have
been tempered by a sense of relief at finding the old adage come good. For

The First Anniversary had postulated just such a 'pitch of Glory', and nothing less than an abruption of 'the length, the duration of time the Greek[20] calls χρονός through seizure of 'opportunity','called καιρός, which is *tempus commodum*, the tempestivity of time, the ripeness of time'.

'Let mee speake freely to you', confides Stephen Marshall (first segment of the infamous Smectymnuus), addressing the Commons, December 30, 1646, on *The Right Understanding of the Times*, and having shortly before drawn this distinction between χρονός and καιρός:

God hath cast the lot of all of us in such times as have been filled with such administrations, as the like could not have been in the space of these 1000 years; and confident I am, that he that loses these times wherein we have lived, would never have redeemed any time.[21]

Parliament might subsequently palter, its sometime commander-in-chief, Fairfax, retreat to Nunappleton, there to make, in the dynastic marriage of his only child, Maria, his '*Destiny* his *Choice*;[22] but Cromwell, bolder, would make of his choice, destiny: grasp this once-in-a-thousand-years chance to precipitate the Thousand Years, deliver the Millennium by '*Cesarian Section*' from time's 'useless Course'. He simply will not 'Dye as wee'; and when his carriage is upset in Hyde Park, it foreshadows no common-or-garden death, but a 'translation', as the vehicle itself is 'translated' from literal conveyance to 'chariot-of-state' to, finally, 'the firy Carr, / And firy Steeds'[23] not of falling Phaethon but Elijah, by the means of which that prophet was 'translated' from earth to heaven before his death. Similarly (for the term came to be applied figuratively to the decease of the righteous) Cromwell will, failing the Millennium, be 'translated'. 'Though the righteous be prevented with death', says the *Wisdome of Soloman*,[24]

Yet shal he be in rest. . . . He pleased God, and was beloved of him:

so that living among sinners, he was translated –

borne

From the low World, and thankless Men above,

Unto the Kingdom blest of Peace and Love;[25]

a Kingdom which, if all had been as dedicated as he to redeeming the times, might have been established upon earth.

Of course, in Cromwell's own 'condiscending' to be Lord Protector, there had been some inevitable falling-off; yet a Protector, albeit a 'Lord', is still a long way from King full-blown. Even if 'to be *Cromwell* was a greater thing', nevertheless he remains, as Protector, a '*greater thing* / Than other *Earthly Princes*', amongst whom Waller's hero most decidedly takes his stand, whether demonstrating by his death that 'No pitch of glory from the Grave is free' or riding, a British Augustus, in Roman triumph 'O're vanquish'd Nations, and the Sea beside', as at the end of the *Panegyrick*.

Admittedly, the very last couplet of the poem does then add:

While all your Neighbour-Princes unto you

Like *Joseph's* Sheaves pay rev'rence and bow,[26]

but this is more by way of neat finial than crucial underpinning. When, in 1651 on the day of thanksgiving for the battle of Worcester, won that autumn,

John Owen had preached that

> this is the issue of all these dispensations, that the kingdoms and
> nations are at length to be possessed by the Lord Christ, his sheaf
> standing up, and all others bowing thereunto,[27]

it was Christ's sheaf left standing, not Cromwell's. But Waller wants nothing
to do with 'the approaching, nor yet angry Son' or 'the issue of all these
dispensations' so long as there is another branch to be set ('but the branch of
the Lord only prospers', proclaims Owen!) to stop the gap of 'an interregnum's
open space'. Instead of dissociating, therefore, the Protector from his
'Neighbour-Princes', his Joseph-simile insinuates that, on the contrary, they
are all brothers, of a kind. Cromwell may be the youngest, but again, as in the
case of David, biblical precedent most usefully sanctions the elevation of a
junior over senior but less potent siblings, repine though these may at such
hiccups in customary procedure.

'Then let the Muses with such Notes as these', Waller has just announced,
beginning his penultimate paragraph, 'Instruct us what belongs unto our
peace'.[28]

> He'll teach you more sublime notes to reherse,
> If you heare him from whom you toke that verse,

rejoins the *Anti-Panegyrike*.[29] 'He' is the Third Evangelist. Watson detects
an echo of Luke 14.42, a passage which had been pressed into very different
service by more rigid Royalists.

> Wee cannot but look upon this kingdom, or rather this *Aceldama*,
> with the saddest eie of compassionate affection and sorrow, as once
> our Blessed Lord and Master did upon his sometime darling
> Hierusalem,

wrote one of them from 'New Munster, in the year of confusion' (London,
1649), and was shortly afterwards again

> forced to break off with our *Blessed Saviour* (beholding and weeping
> over *Hierusalem*) in his most pathetical expostulation and expressions,
> *O, if thou hadst known, even thou, at least in this thy daie, the things
> which belong unto thy peace.*[30]

But 'pathetical expostulation' is not panegyric, and if England, in Waller's
poem, is Jerusalem, it is the New one rather than the Old, and thus quite
capable of apprehending what pertains unto its peace. It is more a matter of
reading *Leviathan* than Luke. Besides, the poet's eyes seem set rather upon
New Rome than New Jerusalem. The *'prosaïke gloss'* at this juncture (no.
15) pertinently taxes him for 'his paganizing with H. Scripture, in an invocation
to his *apostate Muses*, the proper Deities of his devotion' and, sure enough,
the very next couplet has them drawing 'the Image of our *Mars* in fight', not
a picture of him 'that sate upon' the white horse in Revelation, Chapter 19:

> And out of his mouth goeth a sharpe sword, that with it hee should
> smite the nations: and he shal rule them with a rod of yron: and he
> treadeth the winepresse of the fierceness and wrath of Almighty God.
> And he hath on his vesture, and on his thigh a name written, KING
> OF KINGS, AND LORD OF LORDS[31] –

the approaching and by this time eminently angry Son.

8: Non Angeli sed Angli

Obviously Waller did not share Marvell's enthusiasm for, or at least sympathy with, apocalyptic politics. Indians, it will be recalled, are there, according to panegyrical economics, to be exploited, not, as Marvell appears to think, to be converted along with the Jews in some vain hope that this will hasten the Millennium.[1] Again, as might be expected of a man who was, after the Restoration, to rise in the House of Commons (April 8, 1668) 'to prevent the heat that always attends debates concerning Religion' and cause, on a subsequent occasion (March 2, 1669), an exasperated fellow-member to expostulate that 'the gentleman would have the same penalty upon the Conventiclers as upon the Papists, which is just none at all',[2] he makes no mention in the *Panegyrick* of a crusade against the Roman Beast, nor any direct allusion to the cherished Puritan plan of establishing Britain

> as Head of the Protestant Interest, which might have rendred us more
> considerable, and put us in a more likely posture to have reduced the
> Church of *Rome* to Reason.[3]

The English are at one point likened to angels because, thanks to their island-situation, 'none can at our happy Seat arrive' (that is, in the root sense still current, *ad-ripare*, 'come ashore') –

> While we descend at pleasure to invade
> The Bad with vengeance, or the good to aide[4];

but these verses are not exactly fraught with the feeling that, as God's especial executors, they labour under an awesome responsibility. They have their prerogatives ('Angels and we have this Prerogative'); descend 'at pleasure' to 'invade', literally 'walk into' the territories of those who cannot so much as set foot on theirs, and generally behave more like Olympians themselves than the dedicated emissaries of a jealous God. The 'good' and the 'Bad' is, besides, sheer Robin-Hoodery, so that it would be tempting to propose an inversion of the famous comment of St Gregory which perhaps lies at the root of the parallel: *'Non Angli, sed Angeli'*.

Disposed to take seriously this story of a providential encounter with Anglo-Saxon captives in a Roman slave-market, Richard Verstegen (*Anglicè* Rowlands), in his *Restitution of Decayed Intelligence in Antiquities concerning the most Noble and Renowned English Nation*, goes on lengthily to explain that

> The name of 𝕰𝖓𝖌𝖊𝖑 is yet at this present in all the *Teutonick* Tongue, to
> wit, the high and low *Dutch,* &c. as much as to say, as *Angel*, and if
> a Dutch-man be asked how he would in his Language call an *Angel-*
> *like-man*, he would answer, *ein 𝕰𝖓𝖌𝖑𝖎𝖘𝖍-𝖒𝖆𝖓*; and being asked how in his
> own Language he would or doth call an *English-man*, he can give no
> other name for him, but even the very same that he gave before for
> an *Angel-like-man*, that is, as before is said, *ein 𝕰𝖓𝖌𝖑𝖎𝖘𝖍-𝖒𝖆𝖓*, which they
> write 𝕰𝖓𝖌𝖊𝖑𝖘𝖈𝖍𝖊, *Angel-like*. And such reason and consideration may
> have moved our former Kings, upon their best Coin of pure and fine

Gold, to set the Image of an *Angel*, which may be supposed, hath as well been used before the *Norman* Conquest, as since.[5]

'Before the *Norman* Conquest': Verstegen's emphasis upon the Anglo-Saxon origins of the English was to be espoused (for obvious political motives) later in the century by men like John Hare, whose *St. Edward's Ghost*, deploring 'tincture of Normanism' in language and constitution alike, argues for a 'Teutonick' pedigree drawn 'from the top of Nimrod's tower' as opposed to a Latin (and so British) one derived 'from the conquered relicks of ruined Troy, whence also Virgil took so much pains to deduce his Romans'.[6]

Waller we have seen , with Virgil much in mind, taking pains to deduce his people from the very same source. 'The hated reliques of confounded *Troy*' had served him well in the days of the Stuarts who, like the Tudors before them, had had dynastic reasons for stressing the British connection. Thus the storm procured by Juno to vex Aeneas had been roused to incommode Charles in 'Of the danger His *Majesty* (being Prince) escaped in the rode at Saint *Andere*',[7] as it was to be raised again to illuminate protectorial virtue in the *Panegyrick*. For Cromwell could, as conquering Caesar (thanks again to Virgil), also assume a Trojan garb without undue awkwardness or incongruity; and in everything continuity was to be worked for. Verstegen's rival, Anglo-Saxon scheme, therefore, could be worth no more than casual reference, if, indeed, that.

Richard Hawkins, who quotes these very 'Verses of the ingenuous Panegyrist to his Highness' which '(methinks) very well express the advantage of our Situation' in his *Discourse of the Nationall Excellencies of England* shows no awareness of wordplay, though he was familiar with Verstegen's etymological lucubrations and is to comment later that

> We might also here derive our Name from Heaven it self. For Englishmen in the Teutonick tongue (our Original Language) signifies without straining for it, an Angel-like-men, and such have the countenances of Englishmen appeared to indifferent eyes. Withall we have the Authority of a Pope to warrant this Etymology, who fetcht *Angli* from *Angeli*.[8]

If Waller, by implication, does the same, he makes wittily light of the carriage. There is, to borrow an expression of Francis Atterbury's, 'a little sort of jingling' between 'angel' and 'Angle' and a catching-up of the conceit about English immunity from anything except 'winged troops, and Pegasean horse' used to good effect previously in 'To the King on his Navy'[9] – and that is that: 'yᵉ trick's done';[10] all Verstegen's plodding pedantry expertly volatilized. The handling is, in the best sense of the word, facetious; certainly not fervent. Waller is a gentleman, no professed scholar, let alone a 'saint'. If

> in the destroying of the Antichristian faction, *Christ* useth the *ministery of Angels*, of instruments coming out of the Temple and fitted for that work,

it is not in his poem but, on this occasion at least, in a sermon, *The Song of Moses the Servant of God, and the Song of the Lambe*, delivered to his detriment by Stephen Marshall to the Commons, June 15, 1643: the day, that

is, of thanksgiving for the discovery and foiling of 'Waller's Plot'.[11]

Even in *Upon the present War with Spain* – begun as his own contribution to later thanksgivings ordered by a Protector and Parliament relieved to find that at last 'The Lord has again appeared for us, and triumphed gloriously over the King of Spain, the enemy of religion'[12] – even here, rather than picking a quarrel with the enemy's Papism to justify hostilities, Waller elects to focus upon her unjust efforts to monopolize trade in the New World, her balking of rival attempts at colonization, and her misuse of South American bullion for subversive political ends, with the result that *'Europe* was shaken with her Indian Mines',[13] as he puts it with a characteristic quibble (modulating gold- and silver-workings into siege-works with the kind of metaphoric chromaticism which Atterbury's mature, 'Augustan' ear was to deprecate).

He avoids, in short, exciting religious animosities, here as elsewhere – between Christians, anyway. He shows generally no objection to a crusade against the Turk, though again, at the very end of his life, in 'Of Divine Love', he comes to recognize valedictorially that, were all as it should be,

No Martiall Trumpet should disturb our rest,

Nor Princes Arm, thô to subdue the East;

Where for the Tomb, so many Hero's, taught

By those that guided their Devotion, faught.[14]

Previously he had not been above hinting himself that the energies of the more militantly devoted might be discharged in worse directions.

Writing, for instance, 'To the Queen-Mother of France' – Italian, of course, and a Papist – 'upon her Landing' in 1638, he had suggested that, led by *'England's* Prince, and *Gallia's* Dolphin' (as latter-day equivalents to the Rinaldo and Tancredi of Tasso's *Gerusalemme Liberata*),

The Christian Knights that sacred Tomb should wrest,

From Pagan hands, and triumph o'r the East.[15]

1658 sees him repeating the proposal (less, perhaps, some of the chivalric gloss which might not have looked so well in these more plain and russet-coated days) 'To his Worthy Friend Sir *Thomas Higgons*, upon his Translation of the *Venetian Triumph'*:

Our *British* Arms the sacred Tomb might wrest

From *Pagan* hands, and Triumph o're the East.[16]

Kindred thoughts were to recur in 'Of the Invasion and Defeat of the *Turks*. In the Year 1683', and later still, in 'A Presage of the Ruine of the *Turkish* Empire' – a birthday-present, this, for the new King, James II: yet another Papist, needless to say, and one whose stubborn Romanism threatened problems enough to excuse such diversionary tactics in despite of 'Divine Love'. Puritan suspicion could be forgiven for detecting plots to divert Protestant attention from more immediate and pressing concerns by 'schismatically and seditiously' suggesting that 'the Turke is Antichrist *rather then* the Pope'.[17]

Quite obviously, it had occurred to Waller how much simpler life would be in Europe in general land Great Britain in particular if once (fond thought!) people could be persuaded to think of 'the Common Foe'[18] as Moslem rather

than Roman Catholic. Certainly, he had never been anxious, even in Protectorate days, to promote the Papal claim to be identified as 'the great Antichrist, of whom St. Paul speaketh, and St. John also in the Revelation'.[19] According to his panegyrical view of things, Cromwell's Englishmen go to war not because, as 'Head of the Protestant Interest', they burn, as Milton's *Eikonoclastes* has it, to destroy

> especially that spiritual *Babel*: and first to overcome those European
> Kings, which receive their power, not from God, but from the beast;
> and are counted no better then his ten hornes;[20]

but because, under a leader cast in the mould of Edward III, the Black Prince, '*France* conqu'ring *Henry*', they have rediscovered 'Their ancient way of conquering a*broad*'.[21]

> Much to Wither's disgust, 'What', he demands in *Salt upon Salt*,
> What got we by it, but a *Cursed Game*,
> Atchiev'd with *Blood*, and lost with *Blood* again?[22]

It cannot agree with 'Moral Honesty' or 'Sacred Laws' that, without unambiguous instigation from the Almighty,

> we, into our Neighbours *Lot*, should fall
> With *Fire* and *Sword*; and Honourable call
> Those Deeds for which, LAW, to their Actors gives
> The stiles of *Pyrats*, *Murtherers* and *Thieves*;
> Or, that, a few, should, without free assent
> Of all the *People* in a *Parliament*,
> Ingage them in a *Quarrel*, which may cost
> Their *Lives*, and all that may with *Life* be lost.[23]

So much for making 'it thy course to busie giddy Mindes / With Forraigne Quarrels': the expedient of a 'vile Politician'! And Williams, in *Henry V*, is right: 'if the Cause be not good, the King himselfe hath a heavie Reckoning to make'; not to mention the Archbishop of Canterbury who has earlier announced, 'The sinne upon my head, dread Soveraigne'.[24] Some excuse might be found, perhaps, for a Holy War of the sort Marvell advocates in *The First Anniversary*. There were Puritans, Michael Walzer points out in *The Revolution of the Saints*,[25] who looked back on the Crusades of the Middle Ages as a 'fine example of religious activism', the Church properly Militant; but to think to recommend Cromwell's overseas exploits by equating them with the activities of feudal monarchs bent on strengthening and extending their personal Norman Yokes was insufferable.

Wither's opinion of Waller, however, and of his endeavour 'To stir up *Carnal Lust*, or puff up *Pride*',[26] has already been heard. Suffice it to say here that he must have suspected a Divine Finger in the fount had he happened across the printer's error in Carrington's *History* as a result of which 'the ensuing Poem penned by one of the most exquisite Wits of *England*' (Waller's *Upon the present War*) is introduced as being written in a 'shaming Stile'. 'For *shaming*', warns a hastily preventive advertisement prefixed to the book, 'read *sublime*: for other lesser Mistakes, the expedition of the Press may obtain thy excuse'.[27] But for 'sublime' to shift shapes with 'shaming' is

more than a compositor's error, and Wither would have exulted in the transformation. A prisoner in Restoration Newgate, he was to disdain descent to anything so base as panegyric in an attempt to curry favour. His *Verses Intended to the King's Majesty* roundly inform the reinstated Charles,

> Yet, to extol your *Worth* I shall not dare,
> Till I know truly what your *Vertues* are.
> For, though to *Flatrers* all *Kings* seem to be
> Of like desert, they seem not so to me.[28]

To Waller, on the other hand, not only do 'all *Kings* seem to be / Of like desert'; distinctions between them and Protectors are not all that nicely observed either, and Cromwell's head is crowned at the end of the *Panegyrick*, even though it is, for the time being, only with 'Bayes and Olive'.[29]

He looks forward to seeing 'the State fixt'. Wither, believing 'that this PROTECTOR, is not he / Whom long we look'd for; this was sent to be / His *Ways Preparer*[30], a St John the Baptist at best, must greatly have preferred Marvell's conclusion to *The First Anniversary*, depicting Cromwell as 'the *Angel* of our Commonweal / Troubling the Waters, yearly' to make them heal. 'Very Agitation laves', Marvell elsewhere observes, 'And purges out the corruptible waves'.[31] The process of purgation, the 'shaking and translating' which John Owen had told Parliament in 1649 is a necessary preliminary to a nation's 'becoming a quiet habitation for the people of the Most High',[32] continues. Cromwell his 'venerable Head does raise'[33] not, like a Virgilian Neptune, 'To chide the Winds, and save the *Trojan* Race', still the waters, but trouble them, like the angel of the Pool of Bethesda. 'The worke that God hath now in hand', William Sedgwick had explained in the year of *The Shaking and Translating*,

> is not an earthly, fixt thing, but he is upon motion, marching us out of Egyptian darknesse and bondage, into a Canaan of rest and happinesse.[34]

Six years on, Cromwell is still engaged upon what Samuel Butler unsympathetically describes as

> A *godly-thorough-Reformation*,
> Which always must be carry'd on,
> And still be doing, never done.[35]

He is still 'upon motion', his task to keep 'an interregnum's open space' receptively open, preventing relapse into 'Egyptian darknesse and bondage', and a 'fall again into a grosse conforming stupidity', 'a stark and dead congealment', as Milton puts it in *Areopagitica*, of *wood and hay and stubble* forc't and frozen together':[36] the sort of settlement, in short, which Waller wants, promotes in 'language so sweet and polite that no Ice can be smoother' and a closed couplet which was, for years to come and in the face of *Paradise Lost*, to seduce the heroic poem away from its 'ancient liberty' into 'the troublesome and modern bondage of rhyming'.

Give Truth but room, urges Milton in *Areopagitica*:

> give her but room, & do not bind her when she sleeps, for then she speaks not true, as the old *Proteus* did, who spake oracles only when

he was caught & bound, but then rather she turns herself into all
shapes, except her own, and perhaps tunes her voice according to
the time, as *Micaiah* did before *Ahab*, untill she be adjur'd into her
own likeness. Yet it is not impossible that she may have more shapes
then one.[37]

A pool of Bethesda, this: prose on a rolling boil; the similarities between 'the
old Proteus' and New Testament Truth 'not an earthly, fixt thing, but . . .
upon motion', unlike and like in dynamic relationship; Milton himself
nevertheless supremely confident in his grasp of it, the Truth (even when
'she speaks not true'); syntax not like civil-engineering, but the seething of
conviction. But 'Such fustian bumbast as this', remarks Samuel Parker, coolly
supercilious on the subject of *Areopagitica* in *A Reproof to the Rehearsal
Transpros'd*, the year now 1673 and 'the ghost of a linnen decency' resurrected
and abroad in the midday sun (Parker was subsequently to be preferred Bishop
of Oxford in the days of the papistical James II): 'Such fustian bumbast as
this past for stately wit and sence in that Age of politeness and reformation'.[38]
Waller's sarsenet stuff, in contrast ('sublime' or 'shaming' depending on
point of view or printer's error), passed for wit and sense on both sides of
the Restoration, the business of his couplets being, not to give truth room,
but ('so sweet and polite no Ice can be smoother') fix it: cool and congeal
troubled waters into a seemingly pacific polish. One way or another he wished
to see 'the State fixt'.

But, argues Wither's *A Suddain Flash*, the Protectorate originally

Was only modellized, but to save

From likely ruine, till we *strength* should get

To raise up *that*, which might be more compleat.[39]

Cromwell, *faute de mieux*, assumes provisional control until such time as the
disposition of the people conduces to the raising-up of something 'more
compleat'; by which is not meant a monarchy, unless maybe Christ's. Wither,
however, had found, in *The Protector*, cause to wonder

what *he can do*, whilst our sins and passions

Foment our Strife; or, whilst Mis-applications,

Mis-representings, or such-like, obstruct

The *Blessing*, which GOD's mercy would product.[40]

Published in the same year, *The First Anniversary* expresses comparable
doubts and fears. Already, the coaching-spill was 'soyl'd in Dust' Oliver's
'Crown of silver Hairs'.[41] ('The hoary head, is a crowne of glory', says
Proverbs, 16.19, and the only one to which Marvell's Cromwell aspires, on
earth.) 'Good Designes' are 'still with their Authors lost'. But warnings, as is
anticipated, proved all in vain. Oliver died. Richard piddled. Monk acted.
England was happy, more than happy, to subside back into a Stuart monarchy.
Marvell himself was to decide that 'the world will not go the faster for our
driving' and concede the necessity of coming to some sort of terms with the
times.

9: Restoration

Waller, naturally, had little difficulty in making the necessary adjustments – tuning his 'voice according to the time, as *Micaiah* did before *Ahab*'. For a poet, there were advantages in the redintegration of rightful heir and 'actual subjector'.

Since, for instance, arms and legs could not feasibly be expected to chop off the head and survive (whereas in a ship-of-state an inefficient pilot can be disposed of not only with impunity but advantage), this kind of organic imagery of the body-politic had tended, as Walzer notes in *The Revolution of the Saints*,[1] to become the preserve of Royalist polemicists. Waller himself had suffered at Watson's hands, having, for example,

> Our little World, the Image of the Great,
> Like that amidst the boundless Ocean set, [2]

retorted in,

> That litle *Isle* improperly is sed,
> The *Great Worlds image*, since *without an head*,
> Except that *brasen* one, who rules, and speakes,
> By ginnes, & screwes, now *thunders*, & then *squeakes*.[3]

A new-model head *à la,* Friar Bacon looks diabolical compared to the real thing, artifice ridiculous in the face of Nature.

Notably Watson has had to go out of his way somewhat to drag all this in. Waller does not unthinkingly expose himself. Once again in a position to capitalize upon the body politic, he hastens to avail himself of a potent resource. The opening stages of *To the King, upon His Majesties Happy Return* rework a well-tried comparison (ultimately, again, from Pliny) which he could have found in his copy of Domenicus Nannus Mirabellius's *Novissima Polyanthea*,[4] catalogued under '*Principes*' amongst the similitudes:

> Ut Cyclops apud Homerum amisso unico oculo, huc illuc impingitur,
> & denique ruit: sic moles populi, sine lumine principatus –

in English,

> As the Cyclops in Homer, his only eye lost, dashed himself about
> hither and thither and finally collapsed altogether: so fares the clumsy
> mass of the people without the light of sovereignty.

The image appears also in the *Mystagogus Poeticus* of Alexander Ross (sometime chaplain to Charles I and butt-to-be –

> There was an ancient sage *Philosopher*,
> That had read *Alexander Ross* over –

of Charles II's favourite *Hudibras*)[5] who explains,

> A Commonwealth without a King is like great *Polyphemus* without
> an eye; and then there is nothing but Cyclopian cruelty and oppression,
> great men feeding on the flesh of the poor; then is nothing but intestine
> Wars and broyls, the servants of *Vulcan* making thunderbolts and
> chariots for *Mars: Aetna* resounding with the noise of their hammers
> on the anvil.[6]

Waller's version of all this (combined, possible, with an echo of Horace's 'Vis consili expers mole ruit sua', 'force, void of conduct, falls by its own weight')[7] runs:

Great *Britain*, like blind *Polipheme*, of late
In a wild rage became the scorne and hate
Of her proud Neighbours, who began to think,
She, with the weight of her own force, would sink:
But You are come, and all their hopes are vain,
This Gyant-Isle has got her Eye again;
Now she might spare the Ocean, and oppose
Your conduct to the fiercest of her Foes.[8]

Waller, remarks Henry Felton in *A Dissertation on Reading the Classics and Forming a Just Style*, is distinguished by his address 'in raising modern Compliments upon ancient Story'.[9] This is an accomplished example. *Great Britain* and Polyphemus happily hybridize in 'Gyant-Isle', making what might have been a stale analogy seem piquantly apt, while the turn of the last couplet is likewise managed adroitly. For, of course, in the *Odyssey* the blinded Cyclops could not afford to 'spare the Ocean' but, having failed to soft-talk the escaping Ulysses back ashore and into his clutches, was constrained to call upon his father, Poseidon or Neptune, to avenge the loss of his eyesight.

Moreover, just as (according to the famous French critic, Father Bouhours)

Tully spoke very nobly . . . when he said there was no necessity of opposing the *Alpes* to the *Gaules,* or the *Rhine* to the *Germans*: and that tho' the loftiest Mountains should sink, tho' the deepest Rivers should be dried up, without the help of Nature, by *Caesar's* Victories alone, and by his great Actions *Italy* would be sufficiently fortify'd[10] –

so Waller, if more succinctly, in these last two lines. The *Panegyrick* had harped, to the Protector's advantage, upon Britain's island position and her sea-power. The English were 'Lords of the Worlds great Waste, the Ocean';[11] to which Watson, punningly body-politicizing again (but 'With a kinde of Smile, / That ne'er came from the Lungs'), had countered:

Let with us *Head* or *[M]ember* of the vast
World once *unite*, where's your *Lord of the wast*?[12]

Now that it is Charles's turn to play Caesar triumphant, the strings are strained an octave higher: he will protect his realm 'without the help of Nature', by his 'Victories alone, and by his great Actions'; or, in the absence of 'great Actions', by – in a telling phrase from Carew Reynell's *The Fortunate Change*[13] – 'his presence and his lovely charms'.

Because, in another respect, too, Charles is privileged over Oliver. Just before the Polyphemus simile in Waller's *Upon His Majesties Happy Return* there is a biblical parallel which also resonates differently from anything of its kind in the *Panegyrick*:

All are obnoxious, and this faulty Land
Like fainting *Hester* doth before you stand
Watching Your Scepter.[14]

Elijah Fenton's 'Observations on some of Mr. Waller's Poems'[15] refer the

reader to 'the Book of *Esther*, Chap. V.'; but the real reference is to the apocryphal chapter fifteen in which Esther, perceiving the King's 'countenance that shone with majestie . . . looked very fiercely upon her', actually faints and then subsequently recovers to explain why:

> Then said shee unto him, I saw thee, my lord, as an Angel of God,
> and my heart was troubled for feare of thy majestie. For wonderful
> art thou, lord, and thy countenance is full of grace.[16]

'The excellency of *Princely dignity* shines in the very face and countenance of a King', John Rawlinson had reminded his congregation at Paul's Cross in the days of James I and 'The RIGHT DIVINE of Kings to govern wrong'.[17] There is

> an impression or character of dreadfull Majestie stampt in the very
> visage of a King. The Lyon's look is terrible to all the beasts of the
> Forrest. And *Nature* herself . . . hath made the *Physiognomy* of Princes
> to bee such, as strike's an awfull feare and reverence into as many as
> behold them.[18]

A king's nature is to be somehow supernatural.

The idea is implicit from the start of Waller's poem, in his comparison of Charles to the sun. Esther faints before the awful brightness of Artaxerxes's countenance as flowers flag under intense sunlight and as the British people quail on their sudden exposure to the brilliancy of Stuart majesty at high noon:

> The rising Sun complies with our weak sight,
> First guilds the Clouds, then shews his globe of light
> At such a distance from our eyes, as though
> He knew what harm his hasty Beams would do.
> But Your full MAJESTY at once breaks forth
> In the Meridian of Your Reign, Your worth,
> Your youth, and all the splendor of your State,
> Wrapt up, till now, in clouds of adverse fate,
> With such a floud of light invade our eyes,
> And our spread Hearts with so great joy surprise,
> That, if your Grace incline that we should live,
> You must not (SIR) too hastily forgive.
> Our guilt preserves us from th'excess of joy,
> Which scatters spirits, and would life destroy.[19]

'King's like the Sun, in their full Majesties', wrote Richard Flecknoe on the same occasion, 'Are too resplendent bright for Subjects eyes'.[20] A triumphantly obvious opening, however, does not, in Waller's case, herald an equally obvious conclusion. He is not so dazzled as to forget himself and plead for forgiveness with inurbane directness. The refractive index of his style is shamelessly high, despite the talk of 'spread Hearts'.

'Spread Hearts': subject has come to stand in relation to sovereign as plant to the sun; the sun being, as Henry Valentine had described it while pursuing the same analogies in 1639, on the threshold of civil war,

> *Sponsus naturae*, the beauty and Bridegroom of Nature, appointed by

God to rule the Day, and it runs from one end of the Heavens to the
other, so that nothing is hid from the heat and light of it, but every
creature from the Cedar to the shrub receives benigne and propitious
influences from it.[21]

The King, as 'the Sun of the Common-wealth', also radiates 'benigne and
propitious influences'. 'Your Reign', Waller assures Charles late on in his
poem (having early on arranged that Jove should discharge his excess brilliance
upon a Semele representative of foreign princes rather than his own subjects) –

> Your Reign no less assures the Ploughmans peace,
> Than the warm Sun advances his increase.[22]

His 'Conversation' is more than a 'delight'; it is genial, life-giving, and when
Waller uses this noun in the context of his Semele-Jove comparison[23] he is
perhaps doing so with a quite conscious play on the meaning 'sexual intimacy'.
Semele, whose fate, says George Sandys, illustrates

> how those who search too curiously into the divine Majesty shall be
> oppressed with the glory and brightnesse of the same,

incited by a customarily jealous Juno, had presumed too far and, not resting
content 'with the rape / Of Jove, disguised in a mortal shape',[24] was destroyed
by the flash of divine potency fully revealed. Modest Esther, however,
preserver of her race, has already preempted the part of fearful island-wife.
Charles's impact upon his own people, if not upon his neighbour princes, is
to be less drastic and, as might be expected of 'the beauty and Bridegroom'
of the commonweal, more simply fructifying. As the warm sun's just being
there assures plant-growth and a plentiful harvest, so the King's just being
there assures peace. 'And Peace and Plenty tell, a STUART reigns', to quote
Pope again (happy to have the government running approximately in its old
channel once more after William III and hydraulics) in *Windsor Forest*;[25] a
poem which begins –

> The Groves of *Eden*, vanish'd now so long,
> Live in Description, and look green in Song –

with a deliberate improvement of Waller's opening to *On St. James's Park*:

> Of the first Paradice there's nothing found,
> Plants set by Heav'n are vanisht, & the ground;
> Yet the description lasts.[26]

One is reminded, too, of the '*Fauns* and *Faryes*' of Marvell's 'The Mower
against Gardens', which 'do the Meadows till, / More by their presence then
their skill'.[27] 'The Tulip, white', notoriously, had first 'learn'd to interline its
cheek',[28] not in such meadows, but polders kept cultivable only 'by great
store of Wind-mills, and other Artificial Engines'.[29] Watson's 'brasen',
Cromwellian head-of-state in the *Anti-Panegyrike* is another of these 'Artificiall
Engines', the products of skill operating in defiance of Nature, kept functioning
only through perverse ingenuity and incessant business. Waller's
'Congratulation', remarks Samuel Johnson, meaning *Upon His Majesties
Happy Return*,

> is indeed not inferior to the *Panegyric*, either by decay of genius or
> want of diligence; but, because Cromwell had done much, and Charles

had done little.[30]

But Charles's virtue is not to be computed in deeds alone, and sheer 'skill' is to him supererogatory in a way it could never be to a Protector obliged to 'square and hew / Green Trees that in the Forest grew' rather than privileged to preside more numinously over their 'increase'.

> In such green Palaces the first Kings reign'd,
> Slept in their shades, and Angels entertain'd:
> With such old Counsellors they did advise,
> And by frequenting sacred Groves grew wise.

So Waller compliments Charles's improving hand in *On St. James's Park*,[31] and it had been to the shelter of such a place, 'the Hill and Grove at Billborow', that Marvell's Fairfax had withdrawn when confronted with the challenge of lopping the Royal Oak:

> No hostile hand durst ere invade
> With impious Steel the sacred Shade.[32]

But the Cromwell of *An Horatian Ode*, bursting 'thorough his own Side' like Lucan's Julius, allies himself with the man who, laying *'cruell Siedge to true Messilia'*, had dared to do just that; who, when

> the Soldiers valiant hands
> Trembled to strike, moov'd with the majestie,
> And thinke the axe from off the sacred tree
> Rebounding backe would their own bodies wound . . .
> In his bold hand himselfe an hatchet tooke,
> And first of all assaults a lofty oake,
> And having wounded the religious tree,
> Let no man feare to fell this wood (quoth he)
> The guilt of this offence let *Caesar* beare.[33]

And so 'sacred Shade' is turned into timber for siege-works.

Waller's conciliatory ambitions in the *Panegyrick* naturally preclude emphasis upon such egregiously 'industrious Valour', let alone attention to the 'wiser Art' by means of which Cromwell supposedly inveigled Charles I from Hampton Court into *'Caresbrooks* narrow case'.[34] His Caesar is delivered, not by *'Cesarian Section'*, but a softer obstetric and Virgilian hand, and certainly does not proceed to tear his pleasures with rough strife and Machiavellian machination 'Through the Iron gates of Life', mount 'Times winged Charriot', urge his sun into a precipitant gallop and expect wheels to catch apocalyptic fire from the very rapidity of their motion. 'The world will not go the faster for our driving.' Hence Charles's happy Restoration; and so, too, Cromwell, in the *Panegyrick* rises as regular, sovereign sun, to elicit from Edmund Burke, who quotes the 'Still as *you* rise, the *state* exalted too' passage in his *Reflections on the Revolution in France* (the emphases are his), the comment that, unlike their modern French counterparts,

> These disturbers were not so much like men usurping power, as
> asserting their natural place in society. Their rising was to illuminate
> and beautify the world. Their conquest over their competitors was
> by outshining them. The hand that, like a destroying angel, smote the

country, communicated to it the force and energy under which it suffered.[35]

Even 'when without noise, / The rising Sun Nights vulgar [Burke italicises 'vulgar'] Lights destroyes',[36] Waller's lines, he thinks, convey a sense of the transforming 'force and energy' involved. Shortly afterwards, indeed, the Protector has to have recourse to the leverage of his 'mighty Arm' to 'prevent the fall' back into anarchy.[37] Sun-like he may be, but his beams are never felt as fondly 'warm' as are Charles's: do not mellow into a pervasive fecundity and 'increase'. And the 'Dazeling' he does is the effect of 'flaming Courage'[38] – Seneca, by the by, commends in *De Providentia* Phaethon's resolve 'to stand there, where the Sunne it selfe shall tremble', no matter what his father says[39] – not because his 'countenance is full of grace', *ex officio*.

'Not to found *dominium in gratia*' had been, in 1655, one of Cromwell's professed resolutions.[40] 'The first coins issued : . . . after his investiture', records J.A. Dabbs in his book on *'Dei Gratia' in Royal Titles*,[41] had carried the familiar letters; but 'the D.G. was soon dropped' (though it appeared on his great seal).[42] Waller tempers his panegyric accordingly.

Caesar inthroned thus we leave him then

If not a God, at least the Man of Men,

runs the epitaph in John Raymond's *An Abridgement of the Life of Julius Caesar*, published, significantly, in 1649 (see p. 43). In Fairfax's copy 'If' has been altered to a more unequivocal 'Though'.[43] 'Though not a God, at least the Man of Men' would fit, too, the protagonist of Waller's *Panegyrick*. 'Cromwell, our chief of men' he had been for Milton, writing his sonnet 'To the Lord General' in 1652,[44] and 'our chief of men' he remains for Waller in 1655, rather than a King fully-fledged and *Dei gratia*: a monarch after the fashion of Esther's 'Angel of God', Charles I or Charles II.

10: No Force but Love, nor Bond but Bounty

In *The First Anniversary*, however, 'Angelique *Cromwell's* not only 'outwings the wind',[1] but ends 'the *Angel* of our Commonweal', therapeutically 'Troubling the Waters'. He is, nevertheless, a creature of a breed quite distinct from Esther's.

> To the Puritan way of thinking, points out Michael Walzer, angels
> were a species of heavenly civil servants, divine instruments. They
> were no longer in any sense intermediate powers; they had no
> independent sphere of action.[2]

So Cromwell, a heavenly civil servant, one of those executive 'instruments coming out of the Temple' mentioned by Stephen Marshall, 'and fitted for [the] work' in hand – a Judge, in short, in William Lucy's definition of that word – Cromwell is reluctant to exceed instrumentality by assuming a crown and becoming a legislative power in his own right. The olive loses its 'fatnesse' by growing to itself a law. Oliver, by accepting the Lord Protectorship, has already moved a degree further in this direction than Gideon had thought proper and so, to this extent, compromised himself, his self:

> For to be *Cromwell* was a greater thing
> Then ought below, or yet above a King,

though Waller notably fails to register this fact.

Charles II, on the other hand, is not barely an instrument of God's will but, like his father before him, His vicegerent on earth, to whom an 'independent sphere of action' has been delegated. Nor has he been called to his office by Walzer's 'arbitrary and willful' Calvinist God, 'without reference to any preexisting hierarchy'.[3] He is by birth and nature inalienably a King and, although Jove may be 'disguised in a mortal shape',[4] there can never be any question of his being transformed, out of office, into simply 'a Subject on the equal Floor', a mere private person, 'the said Charles Stuart' and no more,[5] as Waller (seeing in the process a golden opportunity to extenuate his own human frailties) does not omit to insinuate:

> For, though your Courage were so firm a rock,
> What private vertue could endure the shock?
> Like your great Master you the storm withstood,
> And pitied those which Love with Frailty shew'd.[6]

Support is discreetly withdrawn from Hall of Richmond's contention that 'during his private condition' a dispossessed sovereign has no right to claim allegiance from his former subjects.[7] It is tacitly conceded that a King can never be in a 'private condition' and, as a consequence, Hall's further asseveration,

> that the way to be a constant Royalist, is to be a constant Loyalist;
> not to respect the power or place for the persons sake, but the person
> for the place and power sake,[8]

cannot be true, either. Kingly virtue, inhering in the person rather than being a perquisite of the place, is not lost with the throne. 'There is no difference

between the King and his Kingly power and office', asserts Sir Robert Poyntz, whose *A Vindication of Monarchy* was printed in the heady days following the Restoration, when heaven itself seemed to have declared in its favour:

> by an indissoluable bond are conjoyned his natural person, and his politick capacity: his person and his power, his person and Majesty, his person and Crown: these are all naturally conjoyned by Gods and ordinance, and by the Institution of Monarchy; and a curse is laid on them who separate those whom God hath joyned.[9]

'What', demands Richard Baxter rhetorically in *The Saints Everlasting Rest*, 'is the King more then another man, when he is once depos'd from his Throne and Authority?'[10] But a curse is laid on such questions, and Waller, determined as ever not to catch cold, smiles as the wind sits. The '*Physiognomy*' of Princes' is innately important, the King's person *per se* worthy of respect, adorable. It will be in order, therefore, to draw attention to not only a 'countenance that shone with majestie', but also other, more personal details like 'His manly posture and his graceful meen', or 'His shape so lovely, and his limbs so strong' such as are mentioned in *On St. James's Park*.[11] Charles II, Abraham Cowley agrees, is

> The comliest Youth of all th'Angelique Race;
> Lovely his shape, ineffable his Face.

And the earthily gigantic, hideously tatooed spirit of Cromwell-past flies howling at his advent.[12]

When, in the *Panegyrick*, the Lord Protector is said to 'invite affection'[13] the invitation is prudently pitched on a distinctly more impersonal, less visceral and more cerebral plane. It is not a case (to adapt an expression from *The Song of Solomon*, 5. 4) of the 'bowels' being moved for him', Valentine's 'beauty and Bridegroom'; more a question of the head having put two and two together and recognized a good thing when it saw one. 'Cromwell', as Johnson has been heard to observe, 'had done much', and judgement is based not so much on 'his presence and his lovely charms' as on assessment of what he has skilfully achieved and what, without him, might happen.

That he was 'lovely' would, indeed, have been the last claim that Hall would have thought of pressing on the Protector's behalf. 'From that very root of Love, and desire of beneficence and thirst of Honor, ingraffed for mutual comfort and assistance', he writes in *Of Government and Obedience*,

> do we daily finde contrary effects to be produced; when by too strict and irregular fixation and use thereof, according to the particular interest and guidance of our private appetite and discretions, we are led into Faction and Civil war.

Obedience to a prince may, it is true, be 'perfected in love'.[14] It is begun another way. Hobbes, his preceptor, had, according to Richard Coke's *Justice Vindicated*, made 'Fear to be the prime cause of all Humane Government and Civil Society', and religion, too.[15] Only in a state of 'angelical perfection of comprehension and understanding', Hall argues[16] would love, of itself, be a sufficient guarantee of order. In this imperfect world it is something a ruler 'ought always to seek, but never to trust to'.[17] The foundations of empire lie

elsewhere. Bare 'loyalty and sujection', resulting in obedience to a 'present subjector' able to 'command it as a duty', have earlier, in his chapter 'Of Dominion', been seen operating at the expense of 'acts of love, friendship, respect, or the like'.[18] 'Place and power', the *True Cavalier* reiterates, take precedence over 'person'.[20] Under such circumstances, the '*Physiognomy of Princes*' will be apt to recede in significance; and luckily so, too, if W.B. Yeats is right and, by the middle of the century,

> typical men have grown more ugly and argumentative. The face that Van Dyck called a fatal face has faded before Cromwell's warty opinionated head.[20]

Rawlinson's *Vivat Rex*, in 1614, had compared the sovereign to Moses, of whom it is reported, in Exodus 34,

> that after *his conference with God, the skin of his face shone so bright, that the people were afraid to come near him.*[21]

Historie & Policie Re-viewed, in 1659, unblushingly follows suit, praising

> the true virile, Princely beauty, which our second Moses had, in its perfection, equal to the former Moses, or either of those great Romans [meaning Marius and Octavius], by which he has frequently, confounded Traitours, dasht all assassinates, dissolv'd conspiracies, and rendered himself the wonder of the Age.[22]

'*Cromwel*', assents Samuel Butler, 'wants neither Wardrobe nor Armour', but accounts for the prodigy rather differently:

> His Face wears natural Buff, and his Skin may furnish him with a rusty Coat of Mail. You would think he had been christened in a Lime-pit, and tanned alive, but that his Countenance still continues Mangy. We cry out against Superstition, and yet worship a piece of Wainscot, and idolize an unblanched Almond.[23]

His malice, crows Clement Walker, 'is known to be as unquenchable as his Nose', and John Cleveland, too, adds his more subtly vituperative voice to the Royalist execration:

> He is so perfect a hater of Images, that he hath defaced Gods in his own countenance.[24]

If Cromwell was 'carrying Gods stamp and mark among men', as Cleveland elsewhere[25] claims the true sovereign, '*Christus Domini*, the Lords anointed' does, it was not obvious to every eye.

A way around immediate physical difficulties is indicated by Carrington's argument that

> God would have the Legitimateness of Children and Nephews to be manifested, rather by the better part of man, which is the Soul, then by his Complexion, his Behaviour, his Speech, and the Shape of his Body.[26]

There follows some general talk of 'glorious souls' penetrating 'like unto a transparent sun . . . through those thick clouds' to attract 'esteem and veneration', and an edging towards Dawbeny, whose book is several times mentioned, always with approbation. As for Cromwell specifically:

> In his person he somewhat exceeded the usual middle stature, but

was well proportioned accordingly, being of a becoming fatness, well
shaped, having a masculine face, a sparkling eye, both courteous and
harsh at once, according as there was occasion[27] –

and so on, with comparative modesty. ''Tis true', confirms Dryden in the
Heroique Stanza's published on the Protector's death:

'Tis true, his Count'nance did imprint an awe,
And naturally all souls to his did bow;
As *Wands of Divination* downward draw
And point to Beds where Sov'raign Gold doth grow.[28]

Waller's '*Wand of Divination*', though vibrating suggestively in the *Panegyrick*,
does not dip conclusively towards 'Sov'raign Gold' until the end of *A
Lamentable Narration*, an early version of *Upon the present War* published as
a broadside apparently in April, 1658. Moreover, the '*Physiognomy* of
Princes', where Cromwell was concerned, was a topic all too vulnerable to
the derision of Watson and his ilk. There were more convincing, or at least
less controversial, ways of recommending the Protector to 'most Men of
Estates', 'us country-gentlemen' with whom Waller aligns himself in that
letter to Hobbes on the subject of Lucy's *Observations*.

Come the Restoration, the climate changes. Waller can profitably revert to
singing the praises of a ruler who, extending to secular realms the principle
enunciated in the ecclesiastical context of 'Upon His Majesties repairing of
Pauls', 'Spouse-like may with comly grace command / More then by force
of argument or hand.'[29] 'The Spouse', reiterates 'Of Divine Love' – Waller,
in his dotage, could hardly be expected to give up a lifetime's habit of repeating
himself – 'No force but Love, nor Bond, but Bounty, knows'.[30] And as the
sun is '*Sponsus naturae*, the beauty and Bridegroom of Nature', so is Charles
'the beauty and Bridegroom' of the commonweal. Love, once again, becomes
fundamental to politics, and a plea can be put forward on behalf of 'those
which Love with Frailty shew'd': the men 'of litle faith' (Waller himself
prominent among them) who, like the Disciples in Matthew, 8. 24-28, panicked
in the storm on the Sea of Galilee, but who now begin 'To strive for Grace,
and expiate their sin'.[31]

Sin and pity, grace and expiation, the King a forgiving Christ (when is
Cromwell compared to Christ?), the subject a wayward yet loving disciple,
wife, child: plainly the relationship involved will be one heavily entailed upon
'*love, friendship, respect, or the like*', upon those emotions which Hall, in his
anxiety to present the protectorial claim as exclusive, seeks to discount in his
chapter 'Of Dominion'. Ruler and subject have returned to a situation in
which they are, as Walzer's *Revolution of the Saints* describes it, 'related to
one another in terms not of command and obedience, but rather of authority
and reverence'.[32] The old order – and, appropriately, the King-compared-to-
Christ-in-the-storm compliment revives a theme first sounded, if to rather
less purpose, in 'Of the Danger His Majesty . . . escaped [in] the rode at Saint
Andere', where it is observed that

Next to the power of making tempests cease
Was in that storme, to have so calm a peace[33] –

the old order is restored, and the monarch discovered hedged with divinity enough to make it extremely difficult for him to do anything except forgive (if not 'too hastily'). In all conscience he is obliged to follow the example of that 'great Master' who is so egregiously *his* – 'Like your great Master you the storm withstood'[34] – rather than ours, and excuse the understandable fallibility of those by nature less immediate to the Godhead.

11: Indulgent to the Occupant

'When is Cromwell compared to Christ?' Perhaps – although 'there is no question to be made, but tha[t] *Caesar*, if possible, would raise up many a *Pompeian* from his grave, seing he saves every one he can of the remaining Army' – perhaps, despite so obvious a precedent from *The Oration of Cicero for Marcus Marcellus*[1] – perhaps in these lines from the *Panegyrick*:

> To pardon willing, and to punish loath,
> You strike with one hand, but you heal with both,
> Lifting up all that prostrate lie, you grieve
> You cannot make the dead again to live.[2]

'Indeed', Speaker Widdrington was to inform Oliver at his second solemn investiture as Protector in 1657, 'a Magistrate must have two hands, *Plectentem & amplectentem*, to cherish and to punish'.[3] But, grumbles A.W. Allison, in *Toward and Augustan Poetic*, Waller's 'reach for antithesis has closed barely on its semblance'.[4] Exactly: there is an overbalance in favour of mercy. Swords, by that time, were usually one-handed; but the laying on of hands still took two. 'And hee laid his handes on every one of them, and healed them':[5] that is, Christ did, who performed, also, what is beyond either Cromwell or Caesar and made 'the dead again to live'.

Would Cromwell really have wanted Charles I alive again? Julius Caesar, famously, lamented the murder of Pompey. Neither, however, unlike Christ, was in a position to do anything about the situation, and the upshot is that Cromwell is seen to have rather more in common with Cicero's Caesar than the Lord's Anointed, despite his obviously Christian inclinations. Carrington's prose variation on the theme shows the Protector, 'towards the latter end of his dayes', wishing

> that those which he had put to death were yet alive; protesting solemnly
> that if he could not change their hearts, he would have changed their
> Dooms, and convert their deaths into a banishment.

The conclusion to be drawn is that 'he learned not his Politicks in *Machiavils School*',[6] as even Lord Clarendon was constrained to admit: '*Cromwell* was not so far a Man of blood, as to follow *Machiavel's* method'.[7] The effusions of *Upon His Majesties Happy Return* are something quite different. Walzer's dichotomy between, on the one hand, 'authority and reverence' and, on the other, 'command and obedience', serves usefully to characterise the change in *timbre* between Waller's Protectorate and his Restoration poetry.

At the opening of the *Panegyrick*, the Protector appears as a horseman, bridling faction and commanding, as a result, hearts. A similar image is evoked towards the end, where Cromwell is praised for his control over 'victorious Armies' disinclined to take orders from civilian, parliamentary masters:

> You that had taught them to subdue their Foes,
> Could order teach, and their high Spirits compose,
> To every Duty could their Minds engage,
> Provoke their Courage, and command their Rage.[8]

The last line is reminiscent of the strenuous Jonson , in an epigram addressed
'To William Earle of Newcastle' (ironically the general whom Cromwell's
own grasp of horsemanship and cavalry tactics was to defeat at Marston
Moor):

> When first, my Lord, I saw you back your horse,
> Provoke his mettall, and command his force
> To all the uses of the field, and race. . . . [9]

Here, the energy released and harnessed in the antithetical second, is modulated
into usefulness in the admirably run-on third verse. The manoeuvre is
characteristic of Jonson. The second line offers to complete a syntactic
movement and then, unexpectedly, another member is added, so that it escapes
from its own symmetry. If the ear self-indulgently anticipates a pause at
'force', then it is disappointed. Never, where Jonson is concerned, presume.
Waller is more complaisant. Even so, on this occasion, at least, he avoids
closing with the verb, and 'command' rings more forcefully for not being
terminal. The spur stabs with 'provoke', but immediately the head is brought
up and the reactive bound curbed by a masterful use of the bit.

Except that, as it emerges, it isn't a horse that Waller has in mind at all:

> So when a Lyon shakes his dreadfull Mayn,
> And angry growes, if he that first took pain
> To tame his youth, approach the haughty Beast,
> He bends to him, but frights away the rest. [10]

This animal, as Elijah Fenton notes, [11] comes straight out of Edward Fairfax's
translation of *Gerusalemme Liberata*, Book 8, Stanza 83, where the self-
same simile, first line ditto and 'who first took pain / To tame his youth'
inclusive, is used to depict Godfrey of Bulloigne's control over the disaffected
Italian contingent in his crusading army. [12] Equipped with his 'golden mace' –
Tasso's words are 'l'aurato scettro' [13] – he appears 'In shape an angel, and a
god in speech', the very image of Esther's golden-sceptered Artaxerxes, and
promptly quells the rebellion. Even the fierce ring-leader, Argillan, 'shook /
For fear and terror, conquer'd with his look'. [14] Meekly, he allows himself to
be bound and led off to execution.

'No Ice can be smoother', says Dawbeny of Waller, and may be his
Protector might, in time, slide into a King, '*Christus Domini*, the Lords
anointed': grasp a 'Royal Scepter, made', in this instance, not of Spanish but
Italian gold. At the moment, what current there is flows beneath the surface.
The *Panegyrick* focuses on the lion-taming end of the business, and new-
model lions, like new-model armies are more the products of training and
discipline than innate instinct or inclination.

The returning Charles, in contrast has everything running for him spon-
taneously:

> When straight the People by no force compell'd,
> Nor longer from their inclination held,
> Break for that once, like Powder set on fire,
> And with a noble rage their KING require.
> So th'injur'd Sea, which from her wonted course,

To gain some rich ground, avarice did force,
If the new Banks, neglected once, decay,
No longer will from her old Channel stay,
Raging the late-got Land, she overflowes,
And all that's built upon 't to ruine goes.[15]

'Men', as Marvell has repeatedly been heard to observe, 'may spare their pains where Nature is at work'. 'The Crown' does not here, as in *On St. James's Park*,[15] 'triumph over popular rage'. 'Popular rage' becoming 'a noble rage' promotes monarchy instead of acting as its antithesis; and fire and water, contrary elements, are wittily combined in illustration. Waller remembers, perhaps, the flood which threatens devastation at the end of Denham's *Coopers Hill* – also the result of 'Bays and Dams' and a greedy striving to force old channels into 'a new, or narrow course'.[17] But he turns, with customary skill, diseases to commodity.

And Cromwell, it appears, despite all that the *Panegyrick* has made of him, had been affecting 'the fame / Of some new structure':[18] building, not modestly upon an old frame and established foundations, but presumptuously upon what Marvell, in *The Character of Holland*, sarcastically calls 'new-catched Miles'.[19] For

Holland at the creation of the world was no Land at all, and therefore not at the first intended by God or Nature for a dwelling place of men.[20]

The Dutch Republic, its population 'usurpers that deprive fish[e]s of their due dwelling places',[21] is a contrivance of perverse human industry operating in defiance of God and Nature: a place where, sneers Marvell,

To make a *Bank* was a great *Plot* of State;
Invent a *Shov'l* and be a *Magistrate*.
Hence some small *Dyke-grave* unperceiv'd invades
The *Pow'r* and grows as 'twere a *King of Spades*.[22]

On the one hand, then, a shovel; on the other, a golden sceptre: self-made magistrate, as opposed to Lord's anointed who knows his work is to set 'bounds, as Heav'n does to the *Main*',[23] not seek to delve beyond them. With the Restoration, all the Dutch engineering of the Interregnum is swept into oblivion: government floods triumphantly back into the 'old Channel', and the constitutional coastline reverts to its natural, British and divinely ordained monarchical configuration. 'By Art', claims Hobbes, 'is created that great LEVIATHAN called a COMMON-WEALTH, or STATE';[24] but art has its limits.

Who shut up the sea with doores, when it brake foorth . . . And said,
Hitherto shalt thou come, but no further: and heere shall thy proud
waves be stayed . . . Canst thou draw out Leviathan with an hooke?[25]

The People's appetite, with a not-to-be-denied urgency, craves a king, and Charles, his initial threatenings sapped by Waller's conciliatory circuitousness (some civil engineering is always advisable), settles down into his natural, God-given seat to satisfy them.

Even as 'the lost Sun, while least by us enjoy'd' (a pregnant verb), he has

been ripening 'spices, fruit, and precious Gums, / Which from remotest Regions hither comes'[26] – without the conspicuously witty transports of Cromwell's days.[27] Now his light is felt warm , as it were, upon the skin. The Protector's, more a matter of sheer brilliance, dazzles the eyes of all that do pretend without issuing in any quite comparable 'increase'. Admirable he may be, but the Lord Protector's 'conversation' is never our 'delight', like Charles's, once his favours, withdrawn from Semele-like foreign princes, are comfortably bestowed upon their rightful subjects.

> Where Love gives Law, Beauty the Scepter sways;
> And uncompell'd, the happy World obeys,

Waller enthuses in 'The Triple Combat', celebrating 'the splendour of the Golden Age', now restored for a decade and a half,[28] and recalling the

> But beauty with a bloodlesse conquest findes
> A welcome sovereignty in rudest mindes

of 'Upon His Majesties repairing of Pauls'.[29] But there is a difference – a mark of bastardy, a bend sinister; for the beauty now in question has nothing to do with any Laudian 'beauty of holiness', and there is certainly no thought of 'Spouse-like' commanding more by 'comly grace' than is possible 'by force of argument or hand', as in the earlier poem.[30]

Previously in the piece, even the normally unscurrilous (and now sixty-nine years old) Waller allows himself the liberty of two lines which both Tonson and Fenton, in more prudish times to come, see fit to suppress in their editions. They concern the rival claims of the duchesses Mazarin and Portsmouth for the King's affection and comment, in favour of the latter,

> Nor does her Grace the better title want;
> Our Law's indulgent to the Occupant.[31]

'Possession', as the pre-decimalized proverb put it, 'is eleven points of the law and they say there are but twelve'; but there is more to it than this: a joke 'as odious as the word "occupy", which', on Doll Tearsheet's authority, 'was an excellent word before it was ill-sorted',[32] but, being ill-sorted, tainted its noun, too, with the stink of whoredom and fornication.

Her Grace cannot have been best pleased with her 'better title', however much it may have amused the salacious Charles; and not even he can have been greatly gratified by the Earl of Rochester's contribution to the occasion or its aftermath – a 'Dialogue', begun by Nell Gwynne (who perhaps appears decorously disguised as 'the lovely *Chloris*' of Waller's lines, though Thorn Drury thinks the Duchess of Cleveland is probably meant):[33]

> When to the King I bid good morrow
>> With tongue in mouth, and hand on tarse,
> Portsmouth may rend her cunt for sorrow,
>> And Mazarin may kiss mine arse.[34]

There follow three more stanzas of no less delicacy from Portsmouth, King, and People, respectively, the last giving the impression that it would be no bad thing for Charles to devote himself to bona fide bona-robas and lay off whores of Babylon, Mazarin in particular. When sceptre and prick are of a length, 'And she may sway the one who plays with th'other',[35] goodbye to

love as the cement of a commonwealth. Exit, also, all Walzer's 'authority and reverence'. Enter, 'in the Zenith of his Lust' (his 'full MAJESTY', too, 'at once breaks forth / In the Meridian of his Reign'), King Bolloximian in a *Farce of Sodom*:

> Lett other Monarch's who their Scepters bear
> To keep their Subjects less in love than feare
> Bee slaves to Crownes my nation shall be free
> My Pintle only shall my Scepter be
> My Laws shall act more pleasure then Command
> And with my Prick I'le governe all the Land.[36]

> And so he held up his golden scepter, and laide it upon her necke, And embraced her, & said, Speake unto me. Then said shee unto him, I saw thee, my Lord, as an Angel of God, and my heart was troubled for feare of thy majestie. For wonderfull art thou, lord, and thy countenance is full of grace. And as she was speaking, she fell downe, for faintnesse.[37]

How are these things reconcileable?

It took the genius of John Dryden to turn this situation to his sovereign's credit.

12: Pious Times – Dryden's *Absalom and Achitophel*

In the First Part of *Absalom and Achitophel*, Charles, flattered by a backdrop of 'pious times, e'r Priest-craft did begin, / Before *Polygamy* was made a sin',[1] still manages to appear 'the beauty and Bridegroom' of the commonweal, and that not so much in despite, as because of his nature-prompted promiscuity and 'diviner Lust'.[2] We are back with Lovelace's 'Love made in the first Age', when a 'diviner Lust' was the driving force, as distinct from the 'wiser Art' which prevails in Marvell's *An Horation Ode*. The King transmits God's creative impulse with expansive power and relaxed, good-humoured generosity, scattering 'his Maker's Image through the Land'[3] with the largesse of a Patriarch under divine licence to 'bee fruitfull, and multiply, and replenish the earth',[4] unconstrained by the carping legalism of subsequent 'Priest-craft'. For Polygamy has to be *made* a sin.

> Art thou not asham'd *Vulcan*, to offer in defence of thy fire and Art,
> against the excellence of the Sunne and Nature, creatures more
> imperfect, then the very flies and insects, that are her trespasses and
> scapes?

In Ben Jonson's *Mercurie Vindicated from the Alchemists at Court*, 'the *Genius* of the place', 'the *Sol* and *Jupiter* of this spheare'[5] had been the presiding James I, whose grandson is now seen to be comparably instinct with 'the excellence of the Sunne and Nature': so divinely instinct, indeed, that his very 'trespasses and scapes' prove no mere 'flies and insects' but culminate in the beautiful and brave, if not notably intelligent, Absalon, alias the Duke of Monmouth; physically 'his Maker's Image' but 'much Divinity without a Noûς' to apply a phrase from Pope's *Dunciad*.[6]

On the other, the anti-masque side, when the 'formidable cripple', as he is called in *The Medall*,[7] Achitophel/Shaftesbury (like Vulcan lame and an adept in 'fire and Art') endeavours – intellect erect, other parts etcetera – 'to outwork the sun in virtue, and contend to the great act of generation, nay almost creation',[8] all that he can manage is the embodiment of what Earl Miner, in *Dryden's Poetry*,[9] has termed 'the absurd definition of man attributed to Plato, *implumis bipes*': videlicet

> that unfeather'd, two Leg'd thing a Son:
> Got while his Soul did hudled Notions try;
> And born a shapeless Lump like Anarchy[10] –

like anarchy, or like a bear-cub, afterwards to be licked by laborious art, new-modelled by its parent into some sort of shape but devoid, in itself, of any intrinsically informative germ.

And as with offspring, so with body-politics: as there is 'Priest-craft', so there is state-craft, and commonwealth-smiths as well as 'God-smiths',[11] amongst whom Achitophel/Shaftesbury is a veritable Benvenuto Cellini at the melting-down of an 'Idoll Monarch' and the re-founding of him into 'that Golden Calf, a State';[12] a state being, as Hobbes tells, 'an artificiall animal' – in his own terms, 'that great LEVIATHAN called a COMMONWEALTH'.

In the alchemical furnace, then, of Whig plotting in general, and Shaftesbury's in particular –

Plots, true or false, are necessary things,

To raise up Common-wealths, and ruin Kings[13] –

the constitution runs the risk of being rendered down and recast into as shapeless a lump as the Earl's own son. Why plots should be such 'necessary things' to commonwealths as opposed to kings is a matter of easy inference: because commonwealths are artificial, the contrivances of craft which arise, not naturally of themselves and containing within themselves the germ of their own organic development, but as a result of the material to hand having been cut down, squared and hewed and assembled according to the design of some 'Forrain *Architect*' or local political geometer who 'Did for a Model vault his Brain', in Marvell's words, instead of relying on more '*holy Mathematicks*' in order 't'immure / The *Circle* in the *Quadrature*'.[14] Hobbes is a case in point – who did, incidentally, have a passion for geometry and became involved in acrimonious controversy over the squaring of the circle – or Plato, whose name figures prominently in the title of Henry Neville's *Plato Redivivus*, a work published, like *Absalom and Achitophel*, in 1681 and associated by Dryden himself with the machinations of the Shaftesbury faction in his 'Postscript' to *The History of the League*.[15]

Ironically, *Absalom and Achitophel* presents Shaftesury's son as having been conceived in literal fulfilment of a pseudo-platonic formula: he is no more and no less than '*implumis bipes*'. So Swift, in *Gulliver's Travels* was to arrange for *animal rationale* to produce the Houyhnhnms, the '*Perfection of Nature*' according to their own etymology, though of course Nature herself never dreamt of such creatures. '*Perfection of Nature*' the Earl's son is not, by any stretch of the imagination, but a manifest abortion. And, inspired by their manic leader, the Whigs would have the body-politic toe equally ludicrous, formulaic lines.

Such impious Axiomes foolishly they show;

For, in some Sohyles Republiques will no grow,

comments *The Medall*.[16] In fact the soil in which republicanism most flourished contemporaneously was, as has been seen, 'at the creation of the world . . . no Land at all'. Again, Bacon may have insisted that axioms be educed from experience, but Whigs go a different way to work: open with axioms, sub-platonic 'ideas', 'hudled Notions', formulations as crass on a political plane as is *implumis bipes* on a human, and, conceiving a state or commonwealth in these terms, go big with 'a shapeless Lump, like Anarchy', which owes nothing to natural courses or experience of what a given soil will or will not bear. They have no regard to 'the *Genius* of the place'; but Charles, whose 'vigorous warmth'[17] variously imparted causes grateful soil to germinate after its own native disposition, not only has regard to this 'Genius': he is himself its very unthinking embodiment. Plainly, too, this 'vigorous warmth' – for the sun, proverbially, shines on all alike – is not parsimoniously doled out according to mathematical prescription or 'Such frugal Vertue' as is typical of Whigs[18] – though, by the by, it is perhaps noteworthy that

When the Matron *Houhyhnhnms* have produced one of each Sex
they no longer accompany with their Consorts, except they lose one
of their Issue by some Casualty, which very seldom happens.[19]
On the contrary, it is spontaneously and genereously diffused to all-and-
sundry according to the impulses of nature as we know it. Priest-craft may
have made it axiomatic that polygamy is a sin, but Charles's promiscuity
springs from a bedrock which lies beneath all craft and crafted law. If
Monmouth is illegitimate, he is no less of a 'natural son' for that, rather the
reverse. Shaftesbury's progeny, on the other hand, strictly legitimate,
axiomatically conceived, got according to the letter, is an anomaly: 'for the
letter', we know from St Paul, 'killeth, but the spirit giveth life'.[20]

Shaftesbury's political calculations, too, depend upon the letter of the law;
'For he presum'd he ventur'd nothing', Dryden remarks in his 'Postscript'
to *The History of the League*, 'if he cou'd have executed his design by form
of Law'.[21] Abstracting law from its natural matrix, Shaftesbury converts it to
'form' and would have the 'True Succession'[22] so cherished by Dryden give
place to a 'legal' succession. 'Such is the inseparable relation between the
King and his Subjects', Sir Robert Poyntz had proclaimed in the flush of
Restoration,

> that, as they cannot renounce or withdraw their allegeance from their
> Soveraigne, *Principis aeterna autoritas in subitos*; . . . so cannot a
> King and Parliament and all the Powers in earth bar the lawfull
> Successor from the rights of Soveraignty, the individual and sacred
> rights of the Crown; neither bind, nor limit the succession.[23]

Shaftesbury argues the opposite: that (in Gilbert Burnet's summary of the
Whig position in *The History of my own Time*),

> The king and parliament were entirely possessed of the whole authority
> of the nation, and so had power to limit the succession, and every
> thing else relating to the nation, as they pleased; and by consequence
> there was no such thing as a fundamental law, by which the power
> of parliament was bound up.[24]

There is 'no such thing as a fundamental law', no 'inseparable relation between
the King and his Subjects', no inviolable 'Native Right',[25] no odds between
Monmouth, the trespass or scape of nature, and James, Duke of York, the
work or duty thereof. The law can make whomsoever it will heir, without
reference to consanguinity, or the Biblical admonition that 'the son of the
bondwoman shall not be heire with the son of a freewoman'.[26] Men, in other
words, can 'Make Heirs for Monarks, and for God decree'.[27]

Not that Shaftesbury's god could care less about this invasion of divine
prerogative. His, if he has one at all, says *The Medall*, 'must be one / That
lets the World and Humane-kind alone',[28] leaving the emmets on their ant-
heap to look after themselves, fabricate their own laws, impose their own,
self-invented political structures. Dryden's, however, is of a quite different
disposition.

Discussing *Absalom and Achitophel*, Martin Price, in *To the Palace of
Wisdom*, perceptively quotes a remark of the historian, Peter Laslett, on the

import of Sir Robert Filmer's *Patriarcha*, written long before but first published
in 1680 as a contribution to the Exclusion debate:

> Society was not an intellectual construct at all, its members had not
> created it by taking thought, it was a given, natural phenomenon.[29]

It was by 'taking thought', as was seen, that Achitophel/Shaftesbury sought
to 'contend to the great act of generation' and, as the offspring of this
impertinence was abortion, so Dryden leaves his reader in no doubt that a
body politic, similarly conceived, would be born into the world similarly
malformed and malfunctioning. He would, it appears, not have been
unreceptive to the notion that society, to quote Laslett on Filmer again, 'was
physically natural to man', that it 'was not created by conscious thinking and
that it is not kept in being by conscious thought'.[30]

At the opening of *Absalom and Achitophel*, while 'conscious thinking' on
the part of the King is not, things 'physically natural to man' are very much
in evidence; yet the energies discharged, although perhaps 'tending to wild'
like Nature's wanton growth in Milton's paradise,[31] are not felt to be inherently
inimical to society. In fact, at bottom, they seem implanted to promote rather
than disrupt it: to be radically 'pious' to suit the 'pious times'.

Piety. 'The word in Latin', Dryden explains to Mulgrave in the 'Dedication'
of his *Aeneis*,

> is more full than it can possibly be expressed in any modern language;
> for there it comprehends not only devotion to the gods, but filial love,
> and tender affection to relations of all sorts.[32]

The definition of *Pietas* in *Rider's Dictionarie* (as 'Corrected and Augmented
... by Francis Holyoke', London, 1606) also begins with *'the dutie, honestie
and good conscience that is first due to God'*, and expands into duty *'to our
parents, and friends'*, commencing in *'godlinesse'* to end in *'natural love
and affection'*. 'Pious', at the opening of *Absalom and Achitophel* is thus
used provocatively not in its normal, modern, narrowed and priest-crafted,
but in its generous, latinate and radical sense to comprehend everything from
'godlinesse', through such 'acts of love, friendship, respect, or the like' as
John Hall of Richmond had been, of late, quick to discountenance when they
proved politically inconvenient, to the exuberance of Charles's *'naturall love
and affection'*: his 'tender affections to relations of all sorts' – more sorts, it
is true, than respectable lexicography may sanction, but then, as noted,
Absalom and Achitophel is all for the life-giving spirit as distinct from deadly
legalistic letter. There is a good leavening of humour, naturally, but it is very
much to Dryden's purpose to suggest that there is no original discontinuity
from one edge of this broad spectrum to the other. The garment is throughout
seamless until – enter 'Priest-craft', politicians, and the cutting and tearing
Whigs of whatever age it happens to be.

> Urge now your Piety, your Filial Name,
> A Father's Right, and fear of future Fame;
> The publick Good, that Universal Call,
> To which even Heav'n Submitted, answers all.[33]

One or two other, typically Whiggish 'impious Axiomes' – Caiaphas's

crucifixion-justifying 'Better one suffer, than a Nation grieve', for example, and 'All Empire is no more than Pow'r in Trust' – have been bandied about earlier in this speech of Achitophel's.[34] Now the slogan is 'publick Good' deftly excised, exalted, employed 'to cancel private Crimes'[35] and set in opposition to 'Piety' to which it is not basically opposed at all. Shaftesbury is once more dealing between the bark and the tree, as he did in pilling law from nature to make division between the 'legal' heir and legitimate next-in-blood.

'Piety', in fact, has radically to do with 'publick Good', embraces
 the emotional togetherness implied by all political relationships, the
 physically, physiologically natural element which . . . political thinking
 since Locke has misunderstood to the danger of us all.

This is Laslett again, introducing this time Locke's *Two Treatises of Government*,[36] the second of which was, he thinks,[37] begun in 1679, probably with the connivance of Shafesbury, whose secretary Locke was, and with the immediate object of refuting Filmer (although the *Patriarcha* itself had yet to be printed). All of which would suit the present argument admirably. Certainly, as Dryden describes him, 'the physically, physiologically natural' is not Shaftesbury's characteristic element, and he is divorced from any securing complex of 'pieties'. 'Polititians', *Absalom and Achitophel* observes in parenthesis, 'neither love nor hate'.[38] The traditional web of emotional ties has no hold over Achitophel, whose whole endeavour is concentrated upon dissolving the natural bonding between father and son, and (which in Filmer's book amounts to the same thing) king and subject.

For, as Filmer had objected against Hobbes in *Some Observations concerning the Original of Government,* published in 1652, men do and did not initially 'as mushrooms (*fungorum more*)' spring 'all on a sudden . . . out of the earth without any obligation one to *another*',[39] only afterwards by contract contriving to bind themselves into communities on the discovery that life in a prevailing free-for-all is 'solitary, poore, nasty, brutish, and short'.[40] Lucy's *Observations* makes the same point:

 Methinks he discourses of Men as if they were *Terrigenae, born out*
 of the earth, come up like *Seeds,* without any relation one to another.[41]

'Yet', he goes on to note some pages later,

 their natures are framed in such necessities of their *Parents,* and their
 Parents looke downe upon them with hearts so filled with kindness
 and sweetnesse, and this so setled by nature, that although that
 disposition may be hindred in its operation sometimes from working
 its proper effects; yet it is seldome, or never destroyed from its being[42] –

which would imply an original state 'most peaceable and free from warre', not Hobbes's hypothetical shambles. His State of Nature is, in fact, the premiss of art, of craft, not natural at all.

'Since', begins *The Second Part of Absalom and Achitophel,* with a retrospective glance at Part One and the Golden Age, the 'pious times' in the background –

 Since Men like Beasts, each others Prey were made,
 Since Trade began, and Priesthood grew a Trade. . . .'[43]

and the unmistakable message is that, although men may have, through the course of time, been made 'like Beasts' (as polygamy has been 'made a sin'), they were not so originally, as witness Genesis. Far from sprouting independently and each with aggressive intent, like Cadmean *Spartoi*, the 'sown men', each from his individual dragon's tooth, everyone from the days of Adam and Eve onwards has, or ought in the way of nature to have, been born into a patriarchal family and a tissue of concomitant obligation, 'kindness and sweetnesse', 'authority and reverence', which has nothing whatsoever to do with trade or contract or 'conscious thinking' or Hobbist State of Nature denatured. And kingdoms are a natural development of this patriarchal, familial rootstock, the prototypal king being, quite literally, 'the Father of his People', and this title descending on his demise to the 'true heir' and on along the line, ideally for ever. Filmer goes so far as to assert that,

> If Adam himself were still living, and now ready to die, it is certain
> that there is one man, and but one in the world, who is next heir,
> although that knowledge who should be that one man be quite lost.[44]

As, of course, it is: ignorance and negligence have intervened and men have had, perforce, to come to other arrangements. An Achitophel-like contempt for 'a Successive Title, Long, and Dark, / Drawn from the Mouldy Rolls of Noah's Ark'[45] is, however, quite obviously out of order. It is one thing to make merry over

> The Heraulds office all imploy'd to bring
>
> *Crumwells Descent* down from some *Brittish King;*[46]

quite another to make a mockery of efforts like George Owen Harry's attempt to trace the Stuart's lineal descent back to the Flood in *The Genealogy of the High and Mighty Monarch, James, by the Grace of God, King of Great Brittayne*, &c.,[47] a work published to mark the inception of a new dynasty. Filmer, at least, would have sympathised with the attitude of mind which lead to such researches. Dryden likewise.

His 'Postscript' to *The History of the League* is at pains to show 'God Almighty taking care of his own Anointed, and the True Succession'[48] at the expense of intruders like King Stephen and 'Henry the Fourth, and his Descendants of the House of Lancaster' – including, rather embarrassingly 'Henry the fifth, the glory of England, and of Monarchy' who, vaunts Richard Hawkins, writing in Cromwellian times and with a distinct note of triumph in his voice, 'had but a crackt Title to the Crown'.[49] 'Both these Kings', insists Dryden, wisely not making an issue of 'France conqu'ring Henry',

> were but Usurpers in effect, and the Providence of God restor'd the
> Posterities of those who were dispossess'd. By the same Argument
> they [the Whigs who say that the 'Right Line' is a rope of sand]
> might as well justifie the Rebellion and Murder of the Late King: For
> there was not only a Prince inhumanly put to death, but a Government
> overturn'd; and first an Arbitrary Common-wealth, then two Usurpers
> set up against the Lawful Soveraign; but to our happiness the same
> Providence has miraculously restor'd the Right Heir, and to their
> confusion, as miraculously preserv'd him.[50]

God does not 'let the World and Humane-kind alone'. On the contrary, after spasmodic bouts of humanly-induced deviation, He typically intervenes to ensure that the 'Right Line' is once again re-established. 'So then', agrees 'F., E.' writing *A Letter from a Gentleman of Quality in the Country to his Friend . . . Being an Argument Relating to the Succession to the Crown*,

> it doth most evidently appear by these Instances that the Succession of the Crown to the next of Bloud is a Law eternal, and wrote with the immediate hand of God and Nature. And that although Nature may for some time be repell'd and kept off with the Forks and Instruments of humane violence, that yet it will sooner or later ever more recur, and return with the greater swing and vigour. And therefore a Dominion obtain'd by Usurpation is like a vast and ponderous Globe of Iron, supported in the Air by main strength of Arms, which upon removal or withdrawing of the same force by fatigue or imbecillity of the Bearers, will at length certainly attain its Centre of Gravity, and with the fall crush and confound the Supporters.[51]

Cromwell had had need of his 'mighty Arm' to 'prevent the fall' in the *Panegyrick*! – A poem throughout, for all Waller's smoothness, indicative of a 'main strength' which the Restoration rendered redundant. An Atlas or Hercules supporting the iron globe of a commonwealth or state, Cromwell had done, continued to do, much – of necessity; Charles, at the time of his Restoration, little: 'sure Attraction' and 'strong impulsive gravity' were as much on his side, then, as ever they were to be on that of Pope's Goddess of Dulness in *The Dunciad*.[52] 'Men may spare their pains where Nature is at work', to say nothing of 'the immediate hand of God': have no need of 'Forks and Instruments' or 'great store of Wind-mills, and other Artificial Engines' if they build sensibly above sea-level on land 'at the first intended by God or Nature for a dwelling place of men'.

But, protests Milton, trying a last, desperate throw on behalf of republicanism in *The Readie and Easie Way to Establish a Free Commonwealth*, 'the death of a king, causeth ofttimes many dangerous alterations'[53]. It ought not to. To this day, an heir could be found for Adam had only a proper attention been paid, from the beginning, to genealogy. The question of who should succeed being genetically, and therefore divinely determined, ought to be beyond argument;

> and therefore God did very justly and wisely settle this Succession, that both King and People might know, That it is by him that Kings Reign, and Kingdoms are secured in Peace against Faction.

So claims Sir George MacKenzie in *Jus Regium . . . Maintain'd against Buchannan, Naphtali, Dolman , Milton &c*.[54] Milton would not have been impressed.

The *Second Defence* compliments Cromwell, or rather excuses him, for having assumed 'quodam titulo patris patriae simillimo', 'something like a title, resembling most that of *pater patriae*, the father of your country'.[55] The precedent which springs most immediately to mind is that of Cicero

who, for his part in preserving the Roman Republic at the time of Catiline's conspiracy, was awarded the cognomen of 'pater patriae' by vote of the Senate. Filmer, with his

many a child, by succeeding a King, hath the right of a Father over
many a grey-headed multitude, [and hath the title of Pater Patriae]

inhabits a different world entirely – one from which the Miltonic Cromwell has liberated his countrymen, and so himself become worthy of the appellation 'By merit more than birthright', like the Son of God in *Paradise Lost*.[56] The 'spontaneous voice' of 'all good men' hails him as such, claims the *Second Defence*: 'pater patriae'.[57]

Pater patriae is, however, what Cromwell officially is not, but something very similar – 'Protector', needless to say, although Milton never permits the word to pass his pen. George Burnett's translation, revised by Moses Hadas, speaks at one point of Cromwell as 'Your country's deliverer, the founder of our liberty, and at the same time its protector', but the Latin refutes this licence and not liberty: 'tu patriae liberator, libertatis auctor custosque idem et conservator'.[58] Whereas Waller, in his *Panegyrick*, and in his Protectorate poetry more generally, tries to sink 'Cromwell' in 'Protector', in *A Second Defence*, as in Marvell's *First Anniversary*, the emphasis is all the other way round.

Protector, admittedly is post-classical, *conservator* Ciceronian: but there is more at stake than this. 'For what is a title, but a certain definite mode of dignity?' demands Milton: 'Quid enim est titulus, nisi definitus quidam dignitatis modus'.[59] But to give truth room and not bind her when she sleeps is to be wary of 'definitus modus', as Marvell suavely acknowledges (having his cake and eating it nonetheless) when his couplets 'On Mr. Milton's *Paradise Lost*' confess, in the face of 'ancient liberty recovered to the heroic poem from the troublesome and modern bondage of rhyming' that,

I too transported by the *Mode* offend,
And while I meant to *Praise* thee, must Commend.[60]

Marvell, may be, had noticed that the verb 'transport' in *Paradise Lost* is consistently used pejoratively. 'Rage / Transports' Satan in Book 3 (81); in Book 10, God the Father, the Unmoved Mover, rebuts any idea that he might be 'transported with some fit / Of passion' (626-627); in betweentimes, in Book 8, Adam confesses himself 'transported' by Eve's exterior (529-530), eliciting from Raphael a contemptuous 'What transports thee so, / An outside?' (567-568). An outside, in this instance, transports Marvell,

Against his better knowledge, not deceived,
But fondly overcome with female charm:[61]

the 'female charm' of rhyme.

When the spontaneous voice of all good men 'sent forth from the heart' hails Cromwell, in *A Second Defence*, as 'pater patriae',[62] it is like the unrhymed, 'unpremeditated verse' of *Paradise Lost*, where angelic voices, in the Third Book,[63] fuse extemporally with Milton's to transcend time and space in praise of God's boundless mercy; or like the 'prompt eloquence' ascribed to the unfallen Adam and Eve,[64] who need no set form of prayer. But

as 'definitus modus', definitive measure, a title may become not so much 'prompt' as 'prompted' eloquence, and a kind of prescription. Milton is no Waller to oblige with an anticipated formula (though his translators, whether consciously or not, do so) – an

And then your Highness, not for ours alone,

But for the Worlds Protector shall be known.[65]

He is too apprehensive of 'the gripe of custom', that 'fall again into a grosse conforming stupidity, a stark and dead congealment of *wood and hay and stubble* forc't land frozen together'. In *A Second Defence* as in *Areopagitica*, his aim is, troubling the waters, to keep them upon motion and away from 'an earthly fixt thing': seethe, not freeze. 'Very Agitation laves', to reiterate Marvell, 'And purges out the corruptible Waves', shaking and translating; but freezing simply fixes corruption. It is Dawbeny's icy-smooth Waller, poet of civilly-engineered syntax and fixing couplet (a 'definitus modus' if ever there was one) who would see 'the State fixt', too: fix the Protector up with a crown and sceptre made, to add insult to injury, out of 'Spanish Gold'.

Worse was to follow. In *Upon the late Storme*, complains Wither (who cannot, however, convince himself that Waller is quite serious),

Allusions, too, are made, as if surmiz'd

That, He, henceforth should be idolatriz'd

As more then *Man*.[66]

'Gods they had tri'd', remarks Dryden of the Jews in *Absalom and Achitophel*, 'of every shape and size / That God-smiths could produce, or Priests devise'.[67] Recognising the importunate demand. Waller, as ever, was ready for peace and quietness's sake to turn his hand to supply, 'Let us first look to our saifty, and then to our honour' had been his watchword since the beginning of the troubles.[68]

13: The Exquisite Truth

So *Romulus* was lost:
New *Rome* in such a Tempest mis't her King,
And from *Obeying* fell to *Worshipping*.[1]

'The final belief', runs one of Wallace Stevens's 'Adagia',

is to believe in a fiction, which you know to be a fiction, there being
nothing else. The exquisite truth is to know that it is a fiction and that
you believe in it willingly.[2]

The transition from '*Obeying*' to '*Worshipping*' is coolly euhemeristic.
Leviathan comes to mind, and Hobbes's contention that

The *Canonizing of Saints*, is another Relique of Gentilisme: It is neither
a misunderstanding of Scripture, nor a new invention of the Roman
Church, but a custome as ancient as the Common-wealth of *Rome* it
self. The first that ever was canonized at Rome, was *Romulus*, and
that upon the narration of *Julius Proculus*, that swore before the
Senate, he spake with him after his death, and was assured by him,
he dwelt in Heaven, and was there called *Quirinus*, and would be
propitious to the State of their new City: And thereupon the Senate
gave *publique testimony* of his Sanctity,[3]

According to some expositors – 'the best historians' thinks Elijah Fenton,
elucidating Waller's poem in his edition of the *Works*,[4] and Richard Watson,
too, sharpens his riposte with their version – the Senators would have been
all the more anxious to give credence to Proculus's story because, in fact,
outraged by Romulus's overbearing behaviour, they had murdered him
themselves. Out of all patience with this, as Watson puts it, '*Wolfe-suckled
Thing*, / Who of a *Cottager* would be a *King*',[5] they had killed him in closed
session and, hacking the body to pieces, borne away the bits beneath their
conveniently voluminous robes.[6] So Proculus's account, devised in the hour
of direst need to explain Romulus's disappearance and prevent the people's
wrath, gained immediate official blessing. The 'canonization', that is, was an
act of deliberate policy, state-craft if not priest-craft. 'There is scarce a
Common-wealth in the world', notes Hobbes drily in the 'Review and
Conclusion' of his *Leviathan*, 'whose beginnings can in conscience be
justified'.[7] The establishment in Rome of a Jonsonian '*Genius* of the place'
owed more to human ingenuity and what Philemon Holland, translating Livy's
account of the episode, calls 'the politike practise of one person',[8] than to
anything supernatural, although, as Fenton relates, the coincidence of a fierce
storm and eclipse of the sun 'contributed to gain a general belief of his
deification'.[9]

Growing out of this ground, Waller's lines, too, savour of 'politike practise'.
Wallace Stevens's 'exquisite truth' may not be quite apposite but, nevertheless,
the (in Stevens's sense of the word) most unexquisite Wither's assumption
that 'in sport he writ'[10] is likewise ill-founded. The turn of the balance between
'*Obeying*' and '*Worshipping*' is nicely gauged and suggests someone familiar

with the mechanics of Romulean apotheosis who has set himself about promoting a myth-of-state to which he is prepared to commit himself in the hope of collusion from the cognoscenti and admiration, or at least acquiescence, from the rest. Great Britain needed a unifying figurehead, New Rome a New Romulus, a presiding '*Genius* of the place'. 'Conscious thinking' might help to advance one, where the more visceral 'pieties' to be invoked by Dryden in *Absalom and Achitophel*, and Waller himself and countless others writing 'Upon His Majesties Happy Return', would be impotent or counter-productive. Lovelace's 'First Age', it will be recalled, was remote from that depicted in the *Panegyrick*, where Englishmen 'plough the Deep, and reap what others Sowe', internal rhyme pours oil on potentially troublesome waters (substitute 'Sea' for 'Deep' and see what happens!), and St Paul is successfully circumvented. Dryden's 'pious times' are equally far removed from this world of 'New *Rome*', 'Priest-craft', 'God-smiths' and – 'For words are wise mens counters, they do but reckon by them: but they are the mony of fooles'[11] – a purely token currency.

True, Waller does appeal to that most 'pious' of all sentiments, gratitude –
> Ungrateful then, if we no Tears allow
> To *Him* that gave us *Peace,* and *Empire* too[12] –

but, as Dr Johnson reflects and Waller is careful to stress, 'Cromwell had done much'. 'Trade' and 'Interest' are on his side, and things have been weighed to a fraction.

> On *Oeta*'s top thus *Hercules* lay dead
> With ruin'd Okes, and Pines about him spread;
> The Poplar too, whose bough he woont to wear
> On his Victorious head, lay prostrate there.
> Those his last fury from the *Mountain* rent,
> Our dying-Hero, from the *Continent*,
> Ravish't whole *Towns*; and *Forts*, from *Spaniards* reft,
> As his last Legacy, to *Brittain* left.
> The *Ocean* which so long our hopes confin'd
> Could give no limits to His *vaster mind*;
> Our Bounds *inlargment* was his latest toyle;
> Nor hath he left us *Prisoners* to our *Isle*;
> Under the *Tropick* is our language spoke,
> And part of *Flanders* hath receiv'd our yoke.[13]

Pope claims the last couplet for *Peri Bathous*, that is, 'the Art of Sinking in Poetry', quoting it to illustrate

> The ANTICLIMAX, where the second line drops quite short of the
> first, than which nothing creates greater surprise.[14]

After the progressively expansive gestures of the preceding verses, the abrupt refocussing upon Flanders (and only a part of it, at that) does come as something of a shock, and seems, on the face of it, ridiculous enough. Recent events, to an immediate contemporary, might have made it less so.

The occupation of Dunkirk by British troops after the Battle of the Dunes in June, 1658, was an event which promised much. Allingston and Allsopp,

colonels commanding the garrison, were to write, next summer, to the Council
of State referring to the town as a

> place which our ambition and desire is to perpetuate to our nation, as
> a goade in the sides of their enemyes, and to secure our footing in the
> continent of Europe, lost ever since queene Marye's days, and now
> regained.[15]

With ports on both sides, British control over the Channel and its vital
trade routes seemed, given a powerful fleet, assured, and a sallyport had
been gained, besides, into Europe. Dunkirk would be, to Cromwellian Great
Britain, what Calais had been to 'the England of 'the third *Edward*', Black
Prince and '*France* conqu'ring *Henry*', and the ignominy of 'queene Marye's
days' had been expunged. Dunkirk, in 1658, would have seemed an acquisition
well worth harping upon. But the end was bathos. In 1662 it was sold, not
back to faltering Spain, but worse still, to up-and-coming France, for some
£400,000; sold, it goes without saying, not by Cromwell, nor yet by his son,
Richard, but by the restored Charles II, 'The Faiths Defender, and Mankinds
delight', may be, but never the less impecunious for all that.[16]

Not that any such mercenary detail is allowed to impair the lustre of
Absalom's review of the inestimable benefits of his father's reign. And what,
in Dryden's eyes, could true loyalty have to do with computations of 'Towns
stormed' and 'Armies over-run' and the like manifestations of unholy Whiggish
book-keeping, trade, craft and interest? 'Natures Holy Bands' lie deeper than
these considerations, in 'Loyal Blood',[17] the stirrings of which prompt
Absalom's speech, not the calculating intellect. Absalom is a son (albeit a
bastard one) as well as a subject, and the pull of 'piety' is the stronger
therefore.

Filmer's *Patriarcha* explains that, 'after a few descents', the 'true
fatherhood' of the founding patriarch necessarily becomes extinct. The true
heirs, ascending to his throne in due sequence, will cease to be literally the
'fathers of their people', and, as has been seen,

> by this means it comes to pass, that many a child, by succeeding a
> King, hath the right of a Father over many a grey-headed multitude,
> [and hath the title of Pater Patriae.][18]

If 'the right of a Father', under these circumstances, is in danger of becoming
etiolated and more theoretical than felt directly upon the pulses, then Dryden,
in *Absalom and Achitophel*, will infuse new sap into it by emphasising the
confluence of filial and subjective obligation in Absalom. Barzillai's firstborn,
too, 'All parts fulfill'd of Subject and of Son',[19] enforcing the correlation of
the roles. Moreover 'Kinsmen to the Throne' is the phrase used earlier to
describe those 'Pardon'd Rebels' (Shaftesbury chief among them) who had
been 'rais'd in Power and publick Office high' as a result of Charles's 'fatal
mercy'[20] after the Restoration, so that their defection now is presented as a
violation of kinship; and the Strong Bands, if Bands ungratefull men could
tye' which ought to have restrained them, are seen to be as much 'Natures
Holy Bands', the bands of 'loyal Blood', of 'piety', 'filial love, and tender
affection to relations of all sorts', as those which should have restrained

Absalom. 'Your servants', Thomas Dekker had long ago announced in *The Seven Deadly Sins of London*,[21]

> are your adopted children; they are naturalized into your blood, and if
> you hurt theirs, you are guilty of letting your own –

and the other way round, of course; the trouble being that, although Dryden's Charles, ever lavish (over lavish) of 'tender affections to relations of all sorts', has fostered his state-servants as though they had been 'naturalized into [his] own blood' and 'Kinsmen to the Throne', some of them (and one in particular) will not reciprocate.

In his biography, *The First Earl of Shaftesbury*, K.H.D. Haley observes of Charles's chiefest ministers that, although by no means always completely and uncritically obedient, yet,

> in the last resort, these men had all been Royalists whose careers had
> been based on personal loyalty to the King as their principal political
> guide.[22]

The one outstanding exception was Shaftesbury who, as sometime Lord Chancellor, had alone of the 'Pardon'd Rebels' ever penetrated the inner circle of Charles's advisers, from the rest of whom he was in the long run separated 'because', says Haley,

> for him loyalty to the King was not an end in itself. He had supported
> the Restoration not from any conviction of Charles's inherent right,
> but because, after he had tried other expedients, a monarchical régime
> seemed most likely to provide the government and the society he
> wanted. Times might change, and ultimately he might find it necessary
> to oppose the policy of Charles II.[23]

He was, in Dryden's words, 'Restless, unfixt in Principles and Place':[24] a creature of no 'piety'. Society was not, for him, 'a given, natural phenomenon' endowed by physiological programming with a patriarchal and kingly form which had been, as it were, in the blood from Genesis onwards. Rather it was the creation, not so much of God and Nature, as the human intellect – an 'Artificial Animal' as Hobbes said, and as such quite susceptible of being melted down and modified as times changed and new needs arose. 'Achitophel', Sanford Budick remarks in *Poetry of Civilization*, 'is a *maker*',[25] and one of the things he would make, or rather re-make, is society, thus usurping God's function as surely as he does when he engages in 'conscious thinking' at the expense of 'the great act of generation'. The end of Dryden's poem demonstrates how insanely presumptuous his endeavours are.

> When expectation is at the height, the King makes a speech, and
> henceforth a series of new times began. Who can forbear to think of
> an enchanted castle, with wide moat and lofty battlements, walls of
> marble and gates of brass, which vanishes at once into air when the
> destined knight blows his horn before it?[26]

Johnson, however, is on the wrong tack. The world is not one of *The Castle of Otranto*, gothick magic and romance, but of the Bible and miracle. When Dryden talks in the 'Postscript' to *The History of the League* of the King having been 'miraculously restored . . . and . . . as miraculously

preserved', he means exactly what he says.

Longinus, whose influence upon Dryden's criticism had lately begun to make itself felt,[27] had picked out from Genesis one, soon to become most celebrated, example of the Sublime: 'And God said, Let there be light: and there was light'.[28] Boileau, whose French translation of *Peri Hupsous* had appeared in 1674, comments in his Preface:

> Ce tour extraordinaire d'expression qui marque si bien l'obéissance
> de la Créature aux ordres du Créateur est véritablement Sublime & a
> quelque chose de divin.[29]

The 'tour extraordinaire' of the conclusion to *Absalom and Achitophel* is likewise intended to have about it 'quelque chose de divin' and to illustrate the obedience of the creation to its Creator. King Charles speaks, and God in him, and his words have the effect of a divine fiat: 'He said. Th'Almighty, nodding, gave Consent',[30] and the poem ends. The Word alone is enough. To introduce cause-and-effect machinery to account for its operation would be beside the point, as impertinent and distracting as Shaftesbury's 'conscious thinking' during copulation. Machinery and machination, 'Guns invented since full many a day'[31] and the like, are the province of Satan in *Paradise Lost* (where the invention of cannon is the diabolic *pièce de résistance* of the War in Heaven and utterly futile) and the Jebusites and other plot-smiths and craftsmen of church and state, headed by Shaftesbury, in *Absalom and Achitophel*.

Now a 'craftsman-like' mentality, where it could not approve, might yet very well appreciate Cromwell's proposed Romulean apotheosis in *Upon the late Storme*, for at least this myth, with its history of down-to-earth explanation, bears about it the hallmarks of human manufacture, god-smithery. Waller, in his way, is as much a 'maker' as Budick's (or Dryden's) Shaftesbury. Moreover, the classical mythology which is his preferred medium gives scope to his talent. Dryden's biblical analogising calls, in the end, for assent at an altogether higher rate. Besides, Dryden, as poet, as 'maker', pointedly gives up 'making' at the crisis, 'when expectation is at its height', refusing to gratify his readers with a satisfying 'shew of a total', artfully contrived.

As a result, *Absalom and Achitophel* seems truncated, abruptly curtailed in a way which makes Johnson think of magic but which is intended to intimate miracle. 'God' as John Tillotson was to remark – ironically after a Glorious Revolution which Dryden saw in another light –

> hath reserv'd to himself a power and liberty to interpose, and to
> cross as he pleases, the usual course of things; to awaken men to
> the consideration of him, and a continual dependence upon him.[32]

So God, argues Dryden in his 'Postscript' to Maimbourg, has crossed the course of English history, miraculously preserving as before, against all odds, He had miraculously restored the Monarchy. So he has Him cross the course of his poem, speaking through the Davidic Charles to put an end to human invention, Dryden's no less than Shaftesbury's, just when rival forces have been marshalled into battle-lines and it seems that conflict is inevitable.

But it will not do to trammel an omnipotent God with talk of inevitability. He intervenes to disappoint artistic and historical expectation. The sense of anticlimax which results is entirely deliberate. In his handling of the 'fiat motif' Dryden notably avoids the consummatory polish cultivated by a Pope who had learned everything there was to be learned from Waller and his 'fixing' couplet.

> At length great ANNA said – Let Discord cease!
>
> She said, the World obey'd, and all was Peace![33] –

all within the compass of two deftly turned lines! Belinda achieves something similar in *The Rape of the Lock*:

> The skilful Nymph reviews her Force with Care;
>
> *Let Spades be Trumps*! She said, and Trumps they were.[34]

It is all neatly in accord with the rules of the game, in this case ombre. But Dryden is, in the last analysis, not playing games in *Absalom and Achitophel* and so, instead of arranging to take the final trick with artistic flourish and economy, he throws in his hand before the real business is well begun and leaves the rest to a God Who does not let 'the World and Humane-kind alone' to play their cards according to rules of their own devising.

> Reason by sense no more can understand,
>
> The game is play'd into another hand,

runs a couplet in the First Part of *The Hind and the Panther*, where Dryden is treating of the 'mysterious things of faith'.[35] So, in this instance, the design is to evoke a sense of the 'mysterious' and leave 'sense' and 'reason' without the wherewithal to fabricate an 'unusefull scaffolding'[36] which would only supply redundant, second-cause support to an event which is essentially an Act of God.

'The game is play'd into another hand': and so the atmosphere could scarcely be more different from that prevailing in those lines with which we began our account of Waller's *Panegyrick*:

> To digg for Wealth we weary not our Limbs,
>
> Gold, though the heavy'st Metall, hither swims;
>
> Ours is the Harvest where the *Indians* mowe,
>
> We plough the Deep, and reap what others Sowe.

The poet, tipping the wink, as it were, to his cronies, featly stacks the cards in his own side's favour, deals – in confident contempt of all Pauline convention – now from the literal top, now the metaphorical bottom of the pack, and proceeds to take the trick and pocket the pot before innocent Indian or iron-handed Don know what it is they are about. 'Mysterious things of faith' are not much in evidence. Indeed, the audience is in on the act and a beneficiary of the deception, though this 'exquisite truth' escapes the unduly honest reader who will insist on endowing 'the familiar locution 'plough the deep' with real force by taking its ordinarily dead metaphor literally'. 'Words', however, 'are wise mens counters', no more, no less.

A wide, wide gulf separates this Hobbist conception of words as 'counters', aids to computation, to addition, subtraction, division, multiplication and cooking, when convenient, the books, from the Word as creating Logos to

which Dryden appeals at the end of *Absalom and Achitophel*, attempting as
he does to call peace into being by what amounts to an act of faith; a resigning
of himself and his country up into the hands of Providence. Waller, in *Upon
the late Storme*, remains characteristically a 'maker' to the end: deity, instead
of impinging upon artifice, tends to take its place neatly within it, and
Romulus's apotheosis – 'he was', comments Dryden in the 'Dedication' of
his *Aeneis*, 'but a god of their own making'[37] – seems scarcely calculated to
provoke any Tertullian-like

> *Prorsus credibile est ... quia ineptum est; certum est quia impossibile*:
> 'it is therefore very credible, because it is foolish; and certain, because
> it is impossible'.

It may be 'necessary', as Tertullian claims, that 'the Christian Faith should
be thus disgrac'd, by the Belief of Impossibilities and Contractions', though
Tillotson ('whom all *English Free-Thinkers* own as their Head', as Anthony
Collins was rather impudently to assert in his *A Discourse on Free-Thinking*)[38]
begs to differ; finds Tertullian's argument 'a strange Commendation of any
Religion to the sober and reasonable Part of Mankind'.[39] Waller, with this
'sober and reasonable Part' in mind, does not so disgrace his myth of state.
On the contrary, Romulus's ascent to the empyrean (unlike, say, Elijah's) is
all too obvious to 'sense' and 'reason', granted a little research. It remains
'mysterious' only to the gullible and hoodwinked plebs.

There is about Proculus's story and Waller's poem alike the air of 'a Scheme
of Policy in the Brain', as opposed to the ring of an 'Oracle of Truth and
Righteousness in the Breast', to deploy a distinction drawn by Thomas
Manningham, preaching *A Solemn Humiliation for the Murder of K. Charles
I.*[40] In *Absalom and Achitophel* Dryden seeks to reverse the emphasis:
recommend the motions of breast and conscience above the machinations of
the dangerously detached intellect. He would wholeheartedly have agreed
with Manningham,

> that the English Monarchy is not a model of the Brain, or a few
> conseqences drawn from an affected speculation of Humane Nature;
> but a form of Government suited to the genius of a wise and Loyal
> People, founded on a Power deriv'd from God, politically guarded
> by a publick Successive Prudence, and pronounc'd good by the
> experience of many Ages.[41]

Waller, of course, would cheerfully have acquiesced in all this so long as it
was convenient and practicable to do so. He was happy to admit, for instance
– in a debate on the Bill against Conventicles, 10th November, 1669 – that 'an
argument from the genius of the nation is not always ill';[42] and he had, in
1660, been happy to allow himself to be carried along by the tide of 'emotional
togetherness' which had then, for a short time, flowed through the land.

During the Interregnum, however, conditions were different. After the
Restoration he could roundly condemn what he pilloried as 'Government by
Bashaws' and Lord Clarendon's supposed project for a Standing Army
designed, in his view, to impose it.

> Mr. Waller] Looks upon the first article [of the charge against the
> embattled Chancellor] as a new form of government, like Sir *Thomas
> Mores Utopia, Plato*, and *Oceana*,

reports Grey's entry for Saturday, November 9, 1667.[43] Mr Waller was,
apparently, as against a political 'model of the Brain' as another man. But
'Government by Bashaws' was not such a 'new form of Government' in
England as all that. The late sixteen-fifties, we have seen, had found him
writing to Hobbes crying up Cromwell's Major Generals as a 'perfect
foundation of government' and lauding *Leviathan*, a work notably absent
from his list of dangerously notional writings. Hobbes's 'model of the Brain'
had offered a practical recipe for the maintenance of basic order in times
otherwise confused and confusing, when old formulas seemed unworkable
and there could certainly be no relying on 'emotional togetherness' to produce
constructive political results.

According to Hobbes, there never could be. In his view, explains Thomas
Spragens in his book, *The Politics of Motion*,

> Nature, in the guise of passion, is not, as Aristotle conceived it, the
> inspiration to end motivating force behind the creation of political
> society. It is the problem rather than the solution.[44]

Dryden, in contrast, is plainly of the old, Aristotelian party. It is felt strongly,
in *Absalom and Achitophel*, that 'nature in the guise of passion' does urge
men towards political society; that man's natural energies are predisposed to
find fulfilment in a political resolution; and that, no matter what 'trespasses
and scapes' a superabundance of this energy may spawn on the way, yet its
fundamental thrust is always towards cohesion.

So despite his excesses – indeed, in a sense because of them – Charles II,
as David, is treated with indulgence: his urge to generate is generous and
handled with generosity. Shaftesbury, on the other hand, the man whose all-
consuming intellect will allow physiological 'piety', 'filial love, and tender
affection to relations of all sorts' no scope, let alone room to play (''Tis
Natures trick', he says, 'to Propagate her Kind')[45] – Shaftesbury is
condemned, under the figure of Achitophel, 'to set his House in order' and
hang himself like Judas.[46] But in a world where the passions seemingly can
conduce to no such positive end, where 'all society is for gain or glory'[47] and
Laslett's emotional togetherness' holds no effective sway or can only confuse
the issue, then the remedy will lie in 'conscious thinking' and the invention of
rules to regulate the inevitable competition, backed by force sufficient to
command obedience, since there can be no future in requiring it out of
reverence.

Waller had been prepared to come to terms with such a world. Dryden
beheld and, growing more and more in the conviction that it was not good,
turned for relief to God, Roman Catholicism, and King James II.

What Britain in fact got, needless to say, was another Protestant revolution
and William III: more Dutch engineering, in short, of the kind which has been
encountered above, and which Dryden denounces, through his mouthpiece,

the Hind, in *The Hind and the Panther*:

> Your care about your Banks, infers a fear
> Of threatning Floods, and Inundations near;
> If so, a just Reprise would only be
> Of what the Land usurp'd upon the Sea;
> And all your Jealousies but serve to show
> Your Ground is, like your Neighbour-Nation, low.[48]

It is as just such a 'just Reprise' that Waller presents the Restoration in *Upon His Majesties Happy Return*. Had he been alive in 1688-9, however, there can be little doubt as to whose cause he would have espoused: not James's. His famous 'sweetness' (witness Watson's remark about 'a deluding streame') is the perfume of pantherine breathing. 'The Panther's breath', Dryden has her opponent comment, 'was ever fam'd for sweet',[49] and, manifestly, there can be no mistaking Waller's work for that of 'A milk-white Hind, immortal and unchang'd'.[50]

PART 2

14: Wonder en is gheen Wonder

Some people, seeing the extraordinary power of the sea and large
rivers, take this on the whole to be God's work, about which men
trouble themselves in vain.[1]

'Men may spare their pains where Nature is at work': 'the immediate hand of
God and Nature', in the phraseology of 'F., E.',

may be for some time repell'd and kept off with the Forks and
Instruments of humane violence . . . yet it will sooner or later ever
more recur, and return with the greater swing and vigour.[2]

The Restoration was inevitable: 'a just Reprise . . . Of what the Land usurp'd
upon the Sea'.

But the author of the opening quotation – 'a very great man', according to
Tristram Shandy's Uncle Toby,[3] sometime a tutor to William the Silent's son,
Prince Maurice and, says Charles Wilson in his book on *The Dutch Republic*,[4]
'a key figure in the unique partnership between science and technology'
which was forged as that republic began, literally and metaphorically, to gain
ground – Simon Stevin, or 'Stevinus', was no advocate of a 'wise passiveness',
Wordsworthian or otherwise, in the face of Nature. 'Wonder en is gheen
Wonder' was his motto; his basic premise, 'Tis wel waer datter inde Natuer
niet wonderlick': 'Miracle is no Miracle', it being 'true indeed that in Nature
there is nothing mysterious', nothing 'miraculous' – 'wonderlick' signifying
properly no more than an ignorance of natural causes.[5] 'Seeing', therefore,
'the extraordinary power of the sea and large rivers', Stevin proposed not
awed acquiescence, but measures of control: scientific investigation, for
instance, into the effects of erosion, 'waterscouring', and improvements in
the design and siting of that 'great store of Wind-mills, and other Artificial
Engines' by the means of which great tracts of Holland and Zeeland, especially,
were kept dry – in the summertime, at least:

yet the greatest part thereof lies under water in the Winter Season: so
as you would think the land were then swallowed up by the sea.[6]

The Zuyder Zee was not reclaimed in a day!

Nor, strictly speaking, was it 'reclaimed' at all, if the writer of the pro-
Spanish *Observations* of 1622[7] is to be believed and 'Holland at the creation
of the world was no Land at all'.

And God said, Let the waters under the heaven be gathered together
unto one place, and let the dry land appear; and it was so.[8]

But not so in the Netherlands. What, then, of Hatfield Chase and the Fens in
England? (Vermuyden's contract to drain the former was drawn up in 1626.
He was knighted in 1629, and the next decade saw the beginning of work in

East Anglia.) The Dutch, remarks Owen Felltham, composing his *A Brief Character of the Low Countries* while these operations were going forward,

> shame us with their industry, which makes them seem as if they had
> a faculty from the worlds Creation, out of water to make dry land
> appear. They win our drowned grounds which we cannot recover,
> and chase back Neptune to his own old Banks.[9]

'Recover . . . chase back . . . old Banks': not 'new Banks' such as, 'neglected once, decay' in Waller's *Happy Return*, and collapse to allow the sea (here of Mother Nature's sex) to rush back into her 'old Channel', overwhelming the artificial 'Bays and Dams' of Interregnum and Protectorate in a flood-tide of warm, royalist reaction. 'These naturall demonstrations do teach us', to quote again from the 1622 *Observations*, 'that Principality or Kingly government is the best'.[10]

So Vermuyden's sovereignly sponsored engineering, it would appear, like Inigo Jones's 'repairing of Pauls' , is 'earnest' of Charles's 'grand designe', not to innovate, but 'reduce', lead back, 'things half swallow'd from the jaws of time', or ocean its analogue, to a pristine condition. Hatfield Chase, seemingly, was not 'at the creation of the world . . . no Land at all' but, on the contrary, 'at the first intended by God or Nature for a dwelling place of men', albeit now sadly sunken from its first estate.

> That the grounds now sought, by those new Sewers to be won and
> drained, are such as naturally and antiently were dry grounds, and
> not continually overflown; so as they were truly land and not water,
> and still are to this day dry half the year, and sometimes in good years
> longer,

had been point number one in '*The opinion of Sir* Henry Hobart *Knight, Attorney General to King* James', given in favour of a project to make new drains in the Isle of Ely, '12° Jacobi'; and Sir William Dugdale, who records this judgement in his *History of Imbanking*,[11] notes, furthermore, in an introductory 'To the Reader', that, if only 'our industry were but comparable to that of our Neighbours in the *Belgique* Provinces' with respect to land drainage, the English would have the advantage:

> forasmuch as theirs, lying below the Levell of the Sea at high Tydes,
> is drayned by Engines, which cast out the water; and ours have not
> only a descent to the Sea, but divers large Rivers and streams for
> leading the waters to their natural out-falls.[12]

In England, therefore, it is merely a question of co-operating with, not contradicting Nature. Yet still,

> As touching the drying up of this Fenny country, what discourse and
> arguing oftentimes there hath beene either way of sound and
> wholesome counsell, or of good pretence and shew of a common
> good, even in the High Court of Parliament –

still, in the words of Philemon Holland's version of Camden's *Britannia*,

> It is to be feared least (that which often hath happened to the *Pontine
> Marshes* of Italy) it would come againe to the former state. So that
> many thinke it the wisest and best course according to the sage

admonition in the like case of *Apollo* his Oracle, *Not to intermeddle
at all with that which God hath ordained*.[13]

Still there were those who put more trust in oracles than in engineering.

As for the Dutch, they were definitely building upon shaky ground: 'an
Aequilibrium of mud and water', jokes Felltham, adding,

A strong Earthquake would shake them to a Chaos, from which the
successive force of the Sun, rather than Creation, hath a little emended
them.[14]

They are not, that is, the creation of primary fiat, but of later, more equivocal
generation. The operation of the sun on mud was thought to engender flies
and insects, the 'trespasses and scapes' of Nature: toads and, of course,
frogs, with which the Dutch (not French) were once popularly identified.
Their republic, also, was (to purloin a jocular expression from Shakespeare's
Much Ado) an 'illegitimate construction':[15] born out of revolt, so that, as the
generous, cavalier (and thus archetypically English) Captain Towerson tells
his captors in Dryden's *Amboyna* (cobbled together as propaganda for the
Third Dutch War), 'your Fathers are all damn'd for their Rebellion.[16] 'A just
Reprise' would obliterate all they had worked for.

Even when Felltham, whose main purpose in *A Brief Character* is witty
display, whether *pro* or *contra*, turns to praise rather than ridicule,
precariousness is still the order of the day:

Even their dwelling is a miracle. They live lower than the fishes. In
the very lap of the floods, and incircled in their watry Arms. They
are the Israelites passing through the Red Sea. The waters wall in
them, and if they set ope their sluces shall drown up their enemies.[17]

'Their dwelling', manifestly, is no 'Fortresse made by Nature for her selfe'
such as John of Gaunt eulogises in *Richard II*.[18] And 'dwelling' is, perhaps,
the wrong word for what they do there, given the distinction drawn by Ben
Jonson at the end of 'To Penshurst'. Other lords, he asserts, 'have built', its
lord 'dwells' – an activity predicated upon a place where 'walls be of the
countrey stone', not pretentiously imported 'touch, or marble'; which is not
'built to envious show', but 'joy'st in better markes, of soyle, or ayre, / Of
wood, of water: therein thou art faire'.[19] Therein, however, Holland is not
fair, according to the *Observations*, being unable to yield

the inhabitantes bread to eate, & wood, or stone to build with all; and
the foure elements . . . have conspired togeather to be there all naught.[20]

Its inhabitants, in short, live not with the willing co-operation of an inclinable
Mother Nature, but in defiance of her basic laws, 'repell'd and kept off with
the Forks and Instruments of humane violence' and industriously perverse
ingenuity.

For if 'their dwelling is a miracle', in Dutch, 'miracle is no miracle', the
language being by its very constitution cut out, argues Stevin with enthusiasm,
'to teach the liberal arts, to fathom the hidden secrets of nature, and to prove'
– precisely that: 'dat wonder gheen wonder en is'.[21] Why then all Bishop-
and-Fellow-of-the-Royal-Society Wilkins's subsequent toil and trouble over
his *Essay towards a Real Character and a Philosophical Language*?[22] What,

demands Stevin, might not Archimedes long ago have achieved had only he been fortunate enough to speak Dutch, not Greek!

For where would one find any languages in which one can say
Evestaltwichtich, Rechthefwicht, Scheefdaellini and the like?[23]

Yet 'Nature has specifically designed Dutch for it'! A high number of basic monosyllables, for a start, means that words for more complex phenomena and operations may readily be compounded in a way which accurately registers make-up and mode-of-action ('*Rechthefwicht*', for example: 'vertical lifting weight').

Thus, whereas other languages like 'French, Italian, Spanish, Polish, etc. serve to carry on trade' and barely do the business, Dutch, its 'words, easy to understand and modest in appearance, but in reality of an infinite power',[24] provides the medium for a uniquely exact understanding of the mechanics of a natural world in which there is, strictly speaking, 'niet wonderlick', nothing 'miraculous'.[25] It may not be practicable, as King Canute demonstrated, to pronounce a magical 'and heere shall thy proud waves be stayed' (although Dryden, in all seriousness, has Charles II attempt something of the sort to conclude *Absalom and Achitophel*); it is to lay aside the sceptre, 'Invent a Shov'l, and [Marvellian sarcasm notwithstanding] be a *Magistrate*':[26] 'make a Bank', constructed and sited to best advantage thanks to a detailed analysis of the effects of 'waterscouring', and, from 'some *small Dyke-grave*' (as opposed to 'landgrave'), even grow at last 'as 'twere a *King of Spades*', if not diamonds, hearts, or divine right[27] – having discovered, moreover, in the course of industriously digging about, that peat moorland has apparently been laid down over decayed forest. Could it be, therefore, that geography is not still the map of Flood over Fiat, but the more gradual product of what Joseph Hutton, though admittedly not until the end of the eighteenth century, in his *Theory of the Earth* (1795, which supplies the OED. with its first instance of the adjective), would call 'geological operation'? And what, in this perspective, is to be made of the *Observations* primitive premise about 'Holland at the creation of the world'?

He first enclos'd within the Gardens square
 A dead and standing pool of Air:
And a more luscious Earth for them did knead,
 Which stupifi'd them while it fed.

'Them' refers to 'the Flow'rs and Plants', lured from their open fields by 'Luxurious Man, to bring his Vice in use', and artificially prostituted to his pleasure in an environment which, as Marvell's 'Mower against Gardens' describes it, irresistibly recalls that of the Netherlands of anti-Dutch propaganda. Wasn't it in the polders of the Low Countries, windmill-drained and dyked from the sea, that 'the Tulip, white' had been most conspicuously 'taught to paint'; 'learn'd to interline its cheek' with, in the case of that most egregiously prized of varieties, 'Semper Augustus', red on white:[28] the colours of a sensuous and passionate sexuality beyond the green thought of a purely 'vegetable Love' and, on top of that, adding insult to injury, the fucus of that passion's meretricious perversion? 'Their wisedome', writes Felltham of the

Dutch ('Non seria semper', his title-page proclaims, but now seemingly serious enough),

> is not indeed Heroick or Numinal; as Courting an Universall Good;
> but rather narrow and restrictive, as being a wisedome but for
> themselves. Which to speak plainly, is descending into Craft; and is
> but the sinister part of that which is really Noble and Coelestiall.[29]

A descent into corners and 'Craft', 'the sinister part', is what the Mower deplores: graft and a selfish dealing 'between the Bark and Tree, / Forbidden mixtures there to see', so that 'No Plant now knew the Stock from which it came',[30] 'true succession' is utterly subverted, and Ben Jonson's 'great act of generation' sophisticated into an attempt 'To procreate without a Sex'. ''Tis all enforc'd', cries the Mower, and the 'Numinal', meanwhile, is deadlocked into mere 'Attic shape' and 'attitude'.

> Their Statues polish'd by some ancient hand,
> May to adorn the Gardens stand,[31]

but 'The *Gods* themselves' have gone, ceased to 'dwell' in these enclaves of horticultural sharp-practice where 'Wonder en is gheen Wonder', Virgin Birth the product of a pruning-knife. 'And *Faunes* and *Faryes*' no longer, as in the unenclosed meadowlands, 'till, / More by their presence then their skill', or sport as they had once in 'To Penshurst'.

And as they continue to revel ('although their aery shape / All but the quick Poetick sight escape') in Denham's *Coopers Hill*, on the flood-plain of '*Thames*, the most lov'd of all the Oceans sons'[32] – and as such, of course, one of 'the *Gods*' himself; indeed, the shaping 'presence' of the poem in its revised form:

> Though deep, yet clear, though gentle, yet not dull,
> Strong without rage, without ore-flowing full,[33]

but, as has been seen, given, within limits, to running over, nevertheless.

> Though with those streams he no resemblance hold,
> Whose foam is Amber, and their Gravel Gold;
> His genuine, and less guilty wealth t'explore,
> Search not his bottom, but survey his shore;
> Ore which he kindly spreads his spacious wing,
> And hatches plenty for th' ensuing Spring.
> Nor then destroys it with too long a stay,
> Like Mothers which their Infants overlay.
> Nor with a sudden and impetuous wave,
> Like profuse Kings, resumes the wealth he gave.
> No unexpected inundations spoyl
> The mowers hopes, nor mock the plowmans toyl:
> But God-like his unwearied Bounty flows;
> First loves to do, then loves the Good he does.
> Nor are his Blessings to his banks confin'd,
> But free, and common as the Sea or Wind[34] –

and therefore, in Felltham's phrase, 'Numinal; as Courting an Universall Good', rather than 'narrow and restrictive'. The river flows outwards 'to boast, or

to disperse his stores . . . and in his flying towers / Brings home to us, and
makes both *Indies* ours';[35] but by way of a Just Exchange, not Waller's
panegyrical privateering, although these 'flying towers' do, perhaps, owe
something to the 'canvas wings' and 'towers of oake' of the latter's 'To the
King on his Navy'.[36]

Those towers, however, riding 'in triumph ore the drowned ball',[37] had
represented a heady cocktail of Noah's Ark and a Tower of Babel hubristically
designed by Nimrod to be, as Joshua Sylvester's popular translation of Du
Bartas's *Divine weeks and Works* explains,

A sure *Asylum*, and a safe retreat,
If th'irefull storme of yet-more floods should threat.[38]

Thus the infamous 'mightie hunter before the LORD',[39] primal tyrant and
impious builder who put no faith in God's covenant of the rainbow, finds
himself deftly budded upon the obedient, patriarchal stock of the preserver
of all animal and human life. Waller 'grafts upon the Wild the Tame', in the
words of Marvell's Mower (or, worse, *vice versa*),

That the uncertain and adult'rate fruit
Might put the Palate in dispute;[40]

and all is, too, at a time when 'necessity, / The Tyrant's plea',[41] and arbitrary,
inland exactions of ship-money (in theory to pay for the very navy being
praised) were inducing many contemporaries to see more of Nimrod than of
Noah in a monarch who seemed to have arrogantly dispensed, once and for
all, with parliamentary government. So the culminating fusion of 'such power
with so much piety', though it lacks quite the race of 'We plough the Deep,
and reap what others Sowe', relishes nevertherless of a vintage which can be
drunk, somehow, 'without Planting'. And the sheer address with which the
compliment is carried through is fixating!

Should natures selfe invade the world againe,
And ore the center spread the liquid maine:
Thy power were safe and her distructive hand,
Would but enlarge the bounds of [thy] command.
Thy dreadfull fleet would stile thee Lord of all,
And ride in triumph ore the drowned ball.
Those towers of oake ore fertile plaines might goe
And visit mountaines where they once did grow.
 The worlds restorer once could not endure
That finish'd Babell should those men secure:
Whose pride design'd that fabrick should have stood
Above the reach of any second floud.
To thee his chosen more indulgent he
Dares trust such power with so much piety.[42]

'Here', enthuses Thomas Rymer in *A Short View of Tragedy*, 'is both
Homer and *Virgil*; the *fortis Achilles*, and the *pius Aeneas*, in the person he
Compliments'. All this, and more! 'The First Booke of Moses, called Genesis',
too, with its *fortis Nimrodus* and *pius Noachus*! 'And the greatness', continues
Rymer, 'is owing to his Vertue. The Thought and Application is most Natural,

Just, and true in Poetry'[43] – though, of course, 'Dennis and Dissonance, and captious Art', combining to constitute *The Impartial Critick*, beg to differ.[44] Dennis had even himself composed a piece 'Upon the Fleet then Fitting Out. Written in 1682' to demonstrate how it ought to be done:

> Now floating Tow'rs the Royal Docks prepare,
>
> To scowre the Main, as Tempests purge the Air –

and so on and so forth.[45] But his 'floating Tow'rs' make no Arks Royal: remain a relatively inert circumlocution for 'ships', unlike Waller's 'towers of oake'.

More like, however, Denham's 'flying towers' in *Coopers Hill* which, half-anticipatory though they may be of 'Cities in deserts' to come, are yet nothing to 'put the Palate' deliciously into 'dispute'. However global the Thames's influence in conceit –

> Now shall the Ocean as thy Thames be free
>
> From both those fates of stormes and piracie,

had been Waller's extravagant promise in 'To the King on his Navy',[46] while Cowley's *Discourse by way of Vision* had fondly remembered a time 'When all the liquid World was one extended Thames'[47] – in *Coopers Hill* exploration of 'His genuine and less guilty wealth' begins at home, thence to spread out orderly to furthest shores, distribution his own increase, returning in a reflux of riches which are not 'adult'rate fruit' or 'The spoyles of Kingdoms, and the Crownes of Kings'. For second thoughts have led to the exclusion of the 'A' Text's comparison of the river to a 'wise King' who, having settled peace and plenty 'In his own realms', invests the surplusage in 'warre abroad',[48] there to reap where others have sown: a theme which, as the *Panegyrick* demonstrates, could readily have been adapted to fit the bill in the mid-sixteen-fifties.

And at home, the Thames, source of 'genuine wealth' as distinct from the fabulous gold and amber of Pactolus, Tagus, Po – the fictional effects of Midas's cupidinous touch and Paethon's overreachingly ambitious fall – overflows annually to fertilize his bordering fields. Everything is safely seasonal, rhythmically regular. 'All things . . . happen in their best and proper time, without any need of our officiousness':

> No unexpected inundations spoyl
>
> The mowers hopes, nor mock the plowmans toyl.

True,

> When a calm River, rais'd with sudden rains,
>
> Or Snows dissolv'd, oreflows th'adjoyning Plains,
>
> The Husbandmen with high-rais'd banks secure
>
> Their greedy hopes, and this he can endure;[49]

but farmers, notoriously, are muckworms, and their officiousness seems, by implication, as unnecessary as it is 'greedy'. 'For men may spare their pains where Nature is at work.'

'All things steadfastnes to hate, / And changed be', concedes Nature herself, taxed by the Titaness Mutability in the *finale* of Spenser's *Faerie Queene*;

> yet being rightly wayd

> They are not changed from their first estate,
> But by their change their being doe dilate:
> And turning to themselves at length againe,
> Do worke their owne perfection so by fate.[50]

'All things' naturally 'worke their owne perfection'. 'Genuine, and less guilty wealth' arises from an acknowledgement of this: from reaping the harvest consequent upon the Thames's winter floods, not striving to forestall or divert them; from having '*Fauns* and *Faryes*', 'the *Gods* themselves' at liberty to till the meadows 'more by their presence then their skill', not transfixed in alien marble, petrified into fashionable accessories to be disposed, artfully and 'to envious show', about 'A dead and standing pool of Air'. (And so the dryads, 'ruddy *Satyres*', 'lighter *Faunes*' and suchlike of 'To Penshurst' are, in their way, vital; and the 'Fairies, Satyrs, and the Nymphs their Dames', too, of *Coopers Hill* itself.)[51] 'Some people, seeing the extraordinary power of the sea and large rivers, take this on the whole to be God's work'; and on the whole, in Denham's view, they would be right, if not in Stevin's.

But Stevin was a Dutchman, and to what 'genuine, and less guilty wealth' could Holland pretend? – a country, if the *Observations* is to be credited, incapable of providing, of its own natural growth, its inhabitants with 'bread to eate' or 'wood or stone to build with all': 'Holland, where', reiterates *England's Path to Wealth and Power* in 1700,

> you have no minerals, and where it is in vain to dig for any thing but turf and clay; Holland, where you have no tree but what you planted, nor stone but what you brought hither; Holland, so much lower than the ebbings of the tides and rivers, that at vast expence you are obliged with mills to drain the very floods occasioned by rains; Holland, where notwithstanding your continual charge (as was said) in repairing banks and dykes, frequent inundations destroy man and beast for several miles together, and then vast sums (and whole years) are spent ere the land can be regained;[52]

Holland, a place where, according to Felltham, 'the foure elements have . . . conspired together to be . . . all naught' and 'barking Waves', in Marvell's words, 'still bait the forced Ground', the abject *'Plot of State'*.[53] Originally 'a shapeless Lump like Anarchy', neither sea nor solid ground but (to remember Ulysses's famous description of chaos in Shakespeare's *Troilus and Cressida*)[54] a mere 'soppe', Holland has had to be plotted out, embanked, pumped dry entirely by human artifice and 'at vast expence':

> Whereas the sea that encircles happy England (barrier-like) fenceth it against surprise and ravages, exempts us from the charge and terror of garrisons and fortifications and (with our floating castles) continues to us that quiet liberty and security the rest of Europe more or less have lost.[55]

There can, in Holland, be no such reliance upon Nature and things working 'their owne perfection': on what Coleridge, in times to come, would call 'form as proceeding' in contrast to 'shape as superinduced'.[56] Like Shaftesbury, or 'Count Tapski' as he was nicknamed, with his misshapen

son and silver spigot in his side to drain his abcessed liver, the Dutch were, perforce, 'makers', engineers to whom 'Plots . . . are necessary things'.

'Therefore', observes Marvell's *Character*, '*Necessity*, that first made *Kings*, / Something like *Government* among them brings';[57] and the reference to '*Kings*' here causes his Oxford editors to suspect an allusion to Hobbes, who had made them, no less than 'Commonwealths', a function of 'conscious thinking' as distinct from a physiological imperative, and whose 'state of nature' had been light-heartedly foreshadowed in Felltham's comment that,

> Had *Logicians* lived here first [in the Low Countries, that is], Father
> and Son had never passed so long for Relatives. They are here
> Individuals, for no Demonstrance of Duty or Authority can distinguish
> them, as if they were created together, and not born successively.[58]

The Dutch, seemingly, have sprung up '*fungorum more*', as Filmer contends the generality of mankind has not, 'all on a sudden . . . out of the earth' – or in their case mud – 'without any obligation one to another'. 'Relatives', thus, will be more a matter of plot than piety: of calculated self-interest rather than innate obligation. And the ideal river will be a canal, not such a Thames-like '*Genius* of the place' as is encountered in *Coopers Hill* 'the most lov'd of all the Oceans sons, / By his old Sire', first seen,

> Hasting to pay his tribute to the Sea,
> Like mortal life to meet Eternity,[59]

in pious recognition of a world-order which is fundamentally 'God's work, about which men trouble themselves in vain'.

English propaganda in the seventeenth century habitually pillories the United Provinces as the negation of 'piety' (in any sense of that word) erected into a system of government, or rather, according to Henry Stubbe,

> an *Anarchy*: they subsist not by any *wise reiglement*, but combination
> of *Interest*, and sense of *common danger*[60] –

prime stimuli both, of course, in *Leviathan*. In a subsequent pamphlet, *A Further Justification*, Stubbe goes on to stress that the treatment of the Stadholder, most notably by the de Witts and their party, has been especially despicable, not to say improvident;

> for *that office*, together with the *hereditary reverence* which the
> generality had for the Princes of Orange, was the cement of the
> *Republick*:[61]

'Strong Bands', in the words of *Absalom and Achitophel*, 'if Bands ungrateful men could tye'.[62] Bands, however, which could scarcely be expected to bind an 'insolent son of a *Tallow Chandler*' like de Witt[63] any more effectively then they had 'A Rake-Helly Brewer' like Cromwell. To such, such cordage was as flax in the fire.

Dryden himself, in *Amboyna*, printed like Stubbe's pamphlet in 1673, makes 'Ingratitude' the 'main Theam' of an indictment of the Dutch delivered by Beaumont; a character whose name is perhaps supposed to suggest a natural elevation lacking in the Low Countries, and who comforts himself with the thought that,

> The best is, we are us'd by you, as well as your own Princes of the

House of *Orange*. We and They have set you up, and you undermine
their Power, and circumvent our Trade.[64]

Almost ten years before, *The English and Dutch Affairs Display'd to the
Life*, by W[illiam] W[instanley], had touched a similar string, calling the then
twelve-year-old-William:

a most hopefull Prince, whom *Holland* is jealous of, and hath been
uncivill to, considering his Greaat Ancestours Merrit and Service,
though we make no doubt, but he will attain by his Deserts, to no
less Power and Grandeur, then any of his Renowned Predecessours.[65]

As indeed he did, becoming in due course King of Great Britain and, in that
capacity, a candidate himself for comparison with that same 'Rake-Helly
Brewer' in the guise of, not 'O. P.', but 'P. O. the Grand Thief',

Who his *Father* did *rob*,
And the *Nation* did *bob*;

And swears by his Power and Might,

That he is a *Widgeon*
That matters *Religion*,

Since *Strength* and *Success* gives a *Right*;[66]

which is not where Denham's Thames, left to itself, would have landed us,
or where Dryden, for one wanted to go – though Waller, it has been suggested,
had he lived that long, might well have mounted the bank, full of accomodating
argument.

Not a sullen and inflexible *Sincerity*, but a fair and seasonable
accomodation of one's self, to the various exigencies of the times,

is made, not altogether unfairly, his credo and 'golden virtue' by Richard
Hurd in the dialogue, 'On Sincerity in the Commerce of the World', which he
devises for him and his contemporary, the 'Cambridge Platonist' (and author
of an *Enchiridion Ethicum*), Henry More.[67]

And 'a fair and seasonable *accomodation*' of, in context, a peculiarly
interesting kind was, indeed, to be achieved by Matthew Prior in his *Carmen
Saeculare, For the Year 1700*. Here, his Muse, in pindaric rapture, 'wings
her desperate Way' over a Russia ruled by Peter the Great, 'Whose Sovereign
Terror Forty Nations dread', and whose late visit to England had left Gilbert
Burnet helplessly

to adore the depth of the providence of God, that had raised up such
a furious man to so absolute authority over so great a part of the
world.[68]

She in His Rule beholds His *Volga*'s Force,
O'er Precipices, with impetuous Sway
Breaking, and as it rowls its violent Course,
Drowning, or Bearing down what-ever meets its way.
But her own King she likens to His *Thames*,
Serene, yet Strong, exempt from all Extreams,
And with fair Speed devolving fruitful Streams.
Each ardent Nymph the rising Current craves,

> Each Shepherd's Prayer retards the parting Waves;
> Round either Bank the Vales their Sweets disclose,
> Fresh Flowers for ever rise, and fruitful Harvest grows.[69]

This, however, is only a beginning. By 1709, 'exempt from all Extreams' – suitable as the expression is to the widespread notion that 'Our Government is like our climate',[70] essentially temperate – has gone; gone with the triplet. Instead, the river, now in couplets, 'With gentle Course devolving fruitful Streams', drops into a metrical bed which is a copy out of *Coopers Hill* –

> Serene yet Strong, Majestic yet Sedate,
> Swift, without Violence; without Terror, Great –

and thence flows onwards, past such nymphs and shepherds as constitutionally cannot escape 'a quick Poetick sight', to swell softly above the brim of the pentameter and hatch plenty, perennial flowers and 'fruitful Harvest', across the concluding alexandrine.[71]

All of which, obviously, stands in marked contrast to the Volga goings-on of the previous part of the stanza; and, likewise, to the 'too impetuous Speed', much earlier in the poem, of Roman virtue and 'their *Tyber's* Flood', its image, whose characteristic epithet, 'flavus' ('reddish yellow', the effect of the surrounding soil), lends colour to Prior's pronouncement that 'there always ran / Some viler Part, some Tincture of the Man', through everything the greatest Romans did, from Romulus down to Julius and Augustus.[72]

'O could I flow like thee', had been Denham's wish, introducing his most memorable of couplets:

> O could I flow like thee, and make thy stream
> My great example, as it is my theme!
> Though deep, yet clear –

and so on.[73] And so William: wish become achievement. He flows, quite clearly, just so. Centrally so, too: 'Swift, without Violence; without Terror, Great' is the two hundred and eighty-third line out of five hundred and sixty-five, and the poem is at its watershed – about, in a stanza or so, to exchange 'Thy elder Look, Great *Janus*', the retrospection which has hitherto prevailed, for his more youthful face and 'forward Eye'.[74] (Janus, god of doorways and beginnings, had two faces, the rearward bearded and old, the other youthful, looking to the past and future respectively, making him an appropriate deity to preside over a work composed on the threshold of a new century.)

'O could I flow like thee': yet Prior's own Muse, 'With *Pindar's* Rage, without his Fire', whose 'tow'ring Flight . . . To wise persuasion Deaf, and human cries' is to provoke comparison to '*Icarus's* Downfall' and court 'uncommon Ruin' – Prior's Muse, trying 'her desp'rate Way'[75] to get the measure of her hero, is hardly making a habit of it. Amidst all this, the metrical repetend from *Coopers Hill* comes like a lucid interval. The Thames, at least, flows as it did through the very heart of things, and the King with it, thoroughly naturalized. Government seems reassuringly (and as it never did, according to Lord Clarendon, in Cromwell's day) to 'run again in the old Channel': a pathway settled by 'the immediate hand of God and Nature', not artificially engineered or otherwise presumptuously new-modelled.

By 1709, of course, it had run onwards to Anne, 'And Peace and Plenty' were shortly, in *Windsor Forest*, to 'tell a STUART reigns'.[76] So sucks to Oranges, is Pope's implication; and, as for the future . . .? Anne had no heirs of her own body, any more than the 'bright Eliza' before her, to whose reign hers was so readily comparable.[77] Another Stuart, however, waited in the wings. Yet the Act of Settlement stood, bearing out what the stubbornly Protestant Bishop of London, Henry Compton, had reportedly told James II in the House of Lords, November, 1685, during a debate on the commissioning of Papist army-officers in defiance of the Test Act:

> The laws of England were like the dykes of Holland, and universal Catholicism like the ocean – if the laws were once broken, inundation would follow.[78]

His simile must have cut to the quick; was, in fact, premonitory of 'a great *Plot of State*' such as Marvell, this time, might have approved, and in which the Bishop himself was certainly to be a committed participant.

15: Restoration, Revolution

> He did it in such a Manner, as to show, that He was the Sole Author
> of it, and that it sprang not from Human Wit, or Contrivance.

'He did it', God did it – arranged the Restoration; or so Francis Atterbury
assured the House of Commons, preaching on the Anniversary of His Majesty's
Happy Return, 29 May, 1701.

> He did it, after our Forefathers were reduc'd to Extremities, and had
> tir'd themselves, by Various Attempts to bring this Great End about,
> and had been bafled in all of them, and sat down at last in despair of
> effecting it. Then was it time for him to appear for our Redemption,
> and to give Himself the Glory of it. All was Darkness about them,
> without form, and void; when the Spirit of God mov'd upon the
> Face of this Abyss, and said, *Let there be Light*: And both God, and
> Men *saw that the Light was Good*; The One, rejoycing in his Own
> Gift, and the Other, blessing and Magnifying the Bestower of it.[1]

And as once He had 'miraculously restor'd the Right Heir' (Dryden's words,
remember, in his 'Postscript' to Maimbourg), so, more lately, He had 'as
miraculously preserv'd '– not 'the Right Heir', exactly, but the Constitution
as a whole: 'Regal Government, and the free use of Parliaments, the profession
of God's pure Religion, and the Enjoyment of our Antient Laws and Liberties'.[2]
For Atterbury's sermon, observes G.V. Bennett in *The Tory Crisis in Church
and State, 1688-1730*,[3] 'is the classic short apologia for the Revolution';
Glorious Revolution and Happy Return being much of a muchness granted

> that in every sudden Revolution of State, tho' there may be many
> visible Dispositions and Causes, that concur to favour it, yet still the
> last Finishing Turn is always from God.[4]

So 'the last Finishing Turn', 'la tour extraordinaire' of 1688, as of 1660, has
about it 'quelque chose de divin', although there were a good many Dutchmen
around on the later occasion, and in Dutch, as has been seen, 'Wonder en is
gheen wonder'.

Over the Restoration, there was little argument. Most were prepared to
'take this on the whole to be God's work, about which men trouble themselves
in vain'.

> Then were strange things to be seen, Republicans with Royalists,
> Church-men with Church-robbers, Rebels and Traytors with Loyal
> Subjects, Papists with Protestants, Episcopists with Anti-
> episcoparians, all agreed to bring in the King, or let him be brought
> in. That Ethiopians should thus change their Colour, and Leopards
> their Spots, that the Lyon should associate with the Lamb, and the
> Wolf with the Kid, that things on a sudden should change their Natures,
> or act against them, are Miracles in the Moral, as well, as the natural
> World, and ought to be ascribed to his Power and special Providence,
> who only doth wonderful things.

But the author of this, George Hickes, Dean of Worcester, here preaching on

an earlier May 29 in 1684,[5] was to bear stubborn witness to the fact that not everyone considered 1688 a repeat performance.

Kings, he had proclaimed (the Exclusion Crisis now happily resolved), 'are petty Gods, who govern Men upon Earth . . . by immediate Delegation from God':

> they are Supreme on Earth, as he is in heaven, they derive not their Authority from their Subjects (for that would be a Contradiction) as he derives not his from his Creatures, but from him alone they derive it –

and in consequence, it goes without saying, can never legitimately be deposed.[6] Steadfastly, after 1688, he stuck to his guns. 'The old *Cavaliers*' (contrast John Hall of Richmond's new, 'true' variety) had been right, he stoutly insists in *A Vindication of Some among Our Selves against the False Principles of Dr. Sherlock*;

> for they both called *Charles* II, King, and thought him to be so, tho' he was out of Possession, and out of the Land too.[7]

As with Charles II then, so with James II now; which must make 'P.O.' a mirror image of 'O.P.': not, Hickes hints, anticipating *A Parallel* ('By which we may see', stanza 9, 'His *Highness* O.P. / Was an Ass to his *Highness* P.O.'), at all an impossible inference. Indeed, 'I am sure Dr.', he tells Sherlock (who had, not long since, spectacularly abjured non-juring, and whose Restoration Day sermon of 29 May, 1692 was the occasion of Hickes's *Vindication*) –

> I am sure Dr. you have done *their Majesties* [William and Mary] much disservice by awarding the legal Right from them, and giving them instead of it, *an airy Title by Providence*, which *Athaliah, Absalom*, and *Cromwel* had, and every prosperous Usurper can pretend to[8] –

anybody and everybody, in short, and John Hall of Richmond's pragmatical pronouncement, who is found 'by the usual way of Providence put into Possession'.[9]

> So let O.P. or P.O. be King,
> Or anyone else, it is the same thing,
> For only Heaven does that blessing bring,
> Which nobody can deny,

as another ballad, *The Weasel Uncased*, written to celebrate Sherlock's sudden conversion to the Williamite cause, maliciously proclaims.[10]

Something else 'which nobody can deny' is that 'the usual way' is not what is normally understood by 'miracle' – unless, of course, 'Wonder en is gheen wonder'. 'As Nature is nothing but Divine Art; so such admirable Revolutions can be nothing but Divine Artifice and Contrivance', had been Hickes's assessment of the Restoration. Then,

> Certainly the seasonable Contrivance of so many wonderful Scenes into every Act, and of so many curious Acts into one harmonious Play, must needs have been the Study and Invention of a very skilful Author, even of the All-wise, and Almighty Dramatist; who hath the World for his Theatre, and seldom less than a Kingdom for his Stage.[11]

Then, all well and good; but now?

 Now,

 'Tis to your Pen, Great Sir, the Nation owes
 For all the Good this mighty Change has wrought;
 'Twas that the wondrous Method did dispose,
 E're the vast Work was to Perfection brought,
 Oh Strange effect of a Seraphick Quill!
 That can by unperceptable degrees
 Change every Notion, every Principle
 To any Form, its Great Dictator Please!
 The Sword a Feeble Pow'r compar'd to That,
 And to the Nobler Pen subordinate;
 And of less use in *Bravest* turns of State.

Now, according to Aphra Behn's *A Pindaric Poem to the Reverend Doctor Burnet*,[12] what has happened is not so much the result of a divine as of a divine's 'Plot of State': the realisation of a 'model' not of God's, but the future Bishop of Salisbury's 'Brain', trumpet though he may about

 that amasing Concurrence of Providences, which have conspired to
 hatch and bring forth, and perfect this extraordinary Revolution . . .
 for we have before us a Work, that seems to our selves a Dream, and
 that will appear to Posterity a Fiction.[13]

'A Fiction', implies the ironic Aphra, is just about what it will be, too

 'Tis you, Great Sir, alone, by Heaven preserv'd,
 Whose Conduct has so well the Nation serv'd,
 'Tis you that to Posterity shall give
 This Ages Wonders, and its History,
 And great NASSAU shall in your Annals live
 To all Futurity.
 Your Pen shall more Immortalize his Name,
 Than even his own Renown'd and Celebrated Fame.[14]

This 'Great Sir's' – and 'Great Sir', by the bye, is normally an honorific of the King, as in the coda to Waller's *Instructions to a Painter*[15] which begins,

 GREAT SIR, Disdain not in this piece to stand
 Supreme Commander both of Sea and Land:

so Behn is laying it on with a trowel – this 'Great Sir's' contractarian propaganda had, before 1688, mapped out the groundplot for revolution. His 'Annals' will colour future conceptions of what then happened 'glorious'. Whig history will become canonical. 'Posterity' will view developments through Burnet-tinted spectacles, Restoration providentially plumbed into Revolution, the tide of affairs neatly canalised, William III the creation, in the last analysis, of Gilbert the King-maker.

 Even Behn herself had been sucked, struggling somewhat, into his vortex; been cajoled, if report is right, by the man himself into supplying her own notes towards his 'Supreme Fiction' (to remember, again, Wallace Stevens), in the shape of *A Congratulatory Poem to Her Sacred Majesty Queen Mary upon Her Arrival in England.*

> Yet if with Sighs we View that Lovely Face,
> And all the Lines of your great Father's Trace,
> Your Vertues should forgive, while we adore
> That Face that Awes, and Charms our Hearts the more;
> But if the *Monarch* in your Looks we find,
> Behold him yet more glorious in your Mind;
> 'Tis there His God-like Attributes we see.
> A Gratious Sweetness, Affability,
> A Tender Mercy and True Piety;
> And Vertues even sufficient to Attone
> For all the ills the Ungrateful World has done,
> Where several Factions, several Int'rests sway,
> And that is still i'th Right who gains the Day;
> How e'er they differ, this they all must grant,
> Your Form and Mind, no One Perfection want,
> Without all Angel, and within all Saint.[16]

'Ecce homo'! 'Behold the Lambe of God, which taketh away the sinne of the world' (John 1. 29). The features of the father look with meek reproach through the lineaments of his daughter's 'Perfection'. 'He is despised and rejected, a man of sorrows, and acquainted with griefe' (Isaiah 53. 3). This is 'emotional Jacobitism'[17] if not quite with a vengeance, then a *mea culpa*! And resemblance, customarily cause for rejoicing, the very stamp of legitimacy –

> Your Mother was most true to Wedlock, Prince,
> For she did print your Royall Father off,
> Conceiving you,

Leontes congratulates Florizel in the final act of *The Winter's Tale*[18] – resemblance becomes now, despite the reassuringly conclusive triplet, distinctly disquieting. 'For I know *that* my Redeemer liveth' (Job, 19. 25), and the issue (a key word, by the way, in *The Winter's Tale*) was, as everyone knew, not straightforward: the father not dead, and so regularly succeeded, but supplanted; and that, too, having just been blessed (though sceptics spoke of juggling-tricks with warming-pans) with a male heir who should have taken precedence, and whose birth had been welcomed by Behn herself with a euphoria which makes even Dryden's effusion on that occasion, *Britannia Rediviva*, seem a model of restraint.

'Methinks', she had prophesied, addressing *A Congratulatory Poem to the King's Most Gracious Majesty*:

> Methinks I hear the *Belgick* LION Roar,
> And Lash his *Angry Tail* against the Shore.
> Inrag'd to hear a PRINCE OF WALES is Born:
> Whose *Angel* FACE already does express
> His *Foreign* CONQUESTS, and *Domestick* PEACE.
> While in his *Awful little* EYES we Find
> He's of the *Brave*, and the *Forgiving* KIND[19] –

a true Stuart, in short; born to be '*Forgiving*' as an uncle whose 'fatal mercy' had once made 'Pardon'd Rebels, Kinsmen to the Throne', *Brave*' as a father who had once cut –

> so prodigal is he
> Of Royal Blood as ancient as the Sea,
> Which down to Him so many Ages told,
> Has through the veins of Mighty Monarchs roll'd –

so fine a figure in Waller's *Instructions to a Painter*,[20] inspiring (except that 'Told is a paultry botch') 'four of ye best verses almost yt ever were writt'. So Atterbury thinks, at least;[21] who was, in the end, to be carried away by that blood-dimmed tide.

What, then, all this will amount to, is an heir apparent born to put a miserable heir presumptive's nose quite out of joint: a genuine 'PRINCE OF WALES' whose advent ought (though the upshot was the opposite) to banish all thought of ersatz Oranges and leave their *leo belgicus*, pictured by patriotic cartography[22] in the outline of Netherlandish territory, to ramp off into the Continent and lash the North Sea into frustrated foam with a tail rooted by the mapmaker around Gravelines and thence drawn up and over to dangle a terminal tassel (concealing that bony protuberance or 'thorn' with which lions were legendarily supposed to lash themselves into a fury) provocatively under East Anglia's nose. 'The devill', St Peter warns, 'as a roaring Lion walketh about, seeking whom he may devoure'; but Isaiah exults, 'unto us a child is borne'.[23]

This note resounds, too, through the companioning *Congratulatory Poem* to James's wife, Mary of Modena:

> bless'd QUEEN, to whom ALL HAIL belongs
> From *Angels*, rather than from Mortal Tongues;
> Whose Charms of *Beauty, Wit* and *Vertue* join'd
> To chuse you Second *Bless'd* of *Woman-kind*.[24]

'Your MAJESTY is authoris'd by the greatest example of a Mother, to rejoyce in a promis'd Son', affirms Dryden, dedicating to her his translation of *The Life of St. Francis Xavier*.[25] '*Ave Maria, gratia plena*': music to papistical ears! Yet, having knelt thus devoutly, June, 1688, before this image of a Madonna (without warming-pan) and Child, come February next, Behn is hail-marying, if somewhat less perfervidly, William's wife; and that, moreover, on the instigation, so it would seem, of Bishop-to-be (that very year, for services rendered) Burnet himself. So it is not surprising that the eulogium should sound, now and then, cracked within the ring. Nor, most conspicuously, is there on this occasion a companion-piece – or, indeed, any reference whatsoever to a husband. Behn, Hamlet-like, promises, 'I shall in all my best obey you, madam', leaving William, if he wants, to conclude, "Why, 'tis a loving and a fair reply', with the disregarded Claudius.[26]

16: 'Bright *Maria's* Charms'

Incircled round with bright *Maria's* Charms,
He Conquer'd by Consent, and not by Arms.

Or so the author of *The English Gentleman Justified*[1] would have it believed.
He is responding to Defoe's *The True-Born Englishman* which (contrast
Atterbury) cares not a stiver for 'Royal Blood as ancient as the Sea', though
it is pointed out *en passant* that, if such lineages do count for anything, then
that of Nassau is one of those

Lines which in Heraldry were Ancient grown,
Before the Name of *Englishman* was known.[2]

'But England, Modern to the last degree', habitually 'Borrows or makes her
own Nobility'; which might be no bad thing were its denizens not then so
ridiculously prone to pique themselves upon time-worn pedigree:

For Fame of Families is all a Cheat,
'Tis Personal Virtue only makes us great.[3]

So Pope's 'And Peace and Plenty tell, a STUART reigns' will be all my eye
and Betty Martin. Nor, although 'In his own age [and Dryden's version of
Juvenal's Tenth Satire], Democritus could find / Sufficient cause to laugh at
Humankind', would Defoe have found the injunction which follows a
particularly shrewd, let alone risible, hit:

Learn from so great a wit; a land of bogs
With ditches fenced, a heaven fat with fogs,
May form a spirit fit to sway the state,
And make the neighbouring monarchs fear their fate.[4]

This, with its unmistakable by-blow at William and the Dutch, is 'all a
Cheat', too. 'Learn from so great a wit': but how? Because he said so and his
authority is unimpeachable? Or because (which as Dryden has set things up
seems a less likely alternative) he, the 'great wit', having been born in 'a land
of bogs' himself, is proof of the pudding *in propria persona*? The latter, of
course, is what Juvenal meant.

Hailing from Abdera (proverbially dull and full of fools), Democritus 'shews
us', according to another contemporary translation's barely accurate rendering,

that there may be born

Men of great Sense and exemplary Worth,
In the worst Clymes and Countries upon Earth.[5]

His wondrous prudence plainly does declare
A *boggy* soil, a dark and *foggy Air*
The Countrey full of *Sheepsheads* may give birth
To *greatest* men, and *best examples* upon Earth,[6]

agrees Shadwell; 'Mature in dullness', may be, but despite this reputation
(for which no thanks to 'the Author of *Mack-Fleckno*', as his preface protests),
here a more concrete and colourful translator, though somewhat ponderous.

Offering his version as a 'Foyl' to 'Mr. *Shadwell's*', Henry Higden attempts a more brisky, octosyllabic Juvenal, 'making him *English* in a Modish and Familiar way' which drew commendatory verses from Dryden and presents a Democritus who

> everywhere amongst the rout
> F[ou]nd follyes for his Wit to flout:
> Which proves that *Goatham* and grose *Clymes*
> Produce prodigious Wits sometimes.[7]

So friend and foe concur on the gist; only Dryden, improving on the '*boggy* soil' imported by Shadwell to complement the thick air and fat heads of the original, cultivates an 'uncertain and adult'rate fruit'. Is William, with Democritus himself, one of Shadwell's '*greatest men*, and *best examples* upon Earth', or the target of Democritean derision? Isn't the fact that he has been deemed 'fit to sway the state', given his boggy origins – forget, for the moment, all about Abdera – 'Sufficient cause to laugh at humankind' and its incorrigible perversity? Isn't, when you think about it, the most likely sort of 'spirit' to 'form' in 'a land of bogs / With ditches fenced, a heaven fat with fogs', a will-o'-the-wisp? – 'fools' fire', the *ignis fatuus* which serves, not as cynosure, but to lead hopelessly astray. 'All a Cheat', indeed!

And 'prodigious', too (to pick up Higden's adjective), in that a will-, or William-o'-the-wisp, getting above itself, will readily – since the science of the day took them for cognate phenomena – grow into

> an exhall'd Meteor,
> A prodigie of Feare, and a Portent
> Of broached Mischeefe, to the unborne Times:[8]

something, as Dryden says, to 'make the neighbouring monarchs fear their fate'. Like *ignes fatui*, meteors (the Greek word means simply 'lifted up') were thought to be earthy exhalations, quite different in substance from sun, moon, stars: the heavenly bodies proper. 'Pure Stars' and 'muddy meteors'[9] was a commonplace-book antithesis. Drummond of Hawthornden's 'passed as far / As meteors are by the Idalian star', complimenting James I in *Forth Feasting*,[10] may be recalled; or the 'Meteors' which in Shakespeare's *Richard II*,[11] 'fright the fixed Starres of Heaven', foreboding Bolingbroke's usurpation, Richard's dethronement and death and the disruption of hereditary order and right succession. (James II, poignantly, was heard to declare, 27 November, 1688, 'that he had read the story of King Richard II' – not necessarily in Shakespeare's version, of course.)[12]

Now Defoe (though even he cannot resist observing that this William was 'Too great a Genius for so damp a Soil')[13] would have considered Juvenal's original point unexceptionable. Don't jump to conclusions. Being born and bred in Abdera, or the Low Countries, need predetermine nothing, any more than being the scion of blue-blooded stock. ''*Tis Personal Virtue only makes us great*.' Dryden, however, thinks there is more to it; gives, accordingly, an anamorphic twist to his translation. From one angle, perspective dictated by knowledge of the original, William may yet look something like a Mars. The other way's a Gorgon. He is the disastrous emanation of his own '*boggy*

soil': a will-o'-the 'wisp ('a Nol with a wisp' had once been one royalist's assessment of a certain East Anglian with 'an oily nose'),[14] a jumped-up jack-o'lantern, grown ominously meteoric; not at all 'the Idalian star' which the crown of Great Britain and Ireland legitimately demands, but yet another nasally-challenged intruder.

As for his queen: Behn's welcoming poem derives some comfort, at least, from the fact that this 'bright *Maria*' – her phrase, too[15] – is her father's daughter; none whatsoever from the fact that she is her husband's wife. 'Mr Rymer', in contrast – '*Tom* the Second' who, from 1693, was to reign 'like *Tom* the first'[16] in the displaced Dryden's seat of Historiographer Royal, and pronounce, in his year of accession, Waller's 'To the King on his Navy' '*beyond all modern Poetry in any Language*'[17] – Rymer, in his *A Poem on the Arrival of Queen Mary, February 12th 1689*, makes much more of her marital status:

 She turns the mighty Machine of Affairs,
 Strikes Harmony throughout the jangling Spheres:
 The Elements, set free, resume their Place,
 And Nature shines, with Triumphs in Her Face.
 Love shakes his Wings, mad Animosities
 Lye husht, beneath the healing Breeze.
 No Discords range; all from the angry heap,
 Charm'd into Form, and beauteous Order leap.
 With Godlike State, above Mechanick sway,
 She sits, and sees the second Causes Play;
 Unmov'd Her Self, with an untroubl'd Brow,
 Beholds the Thorns that vex Crown'd Heads below;
 The Active Part Her Mighty Consort takes;
 And for the Weal of Humane Kind He wakes.[18]

She sits, apparently, this Mary, not so much the Mother of God (like Behn's Mary of Modena), as God the Mother: an Unmoved Mover in her serene empyrean, looking down upon the activities of a beloved 'Consort' at once both spouse and 'Sonne, in whom I am well pleased' (Matthew, 3. 17), who plays the part of Second Person, taking up His Cross and Crown of Thorns and busying Himself down below about the redemption of mankind. 'Love shakes his Wings' in the fifth line as a classical Cupid, perhaps; but the 'healing Breeze' which results transpires into a holier spirit, more dove-like than putto-esque. And, of course, the Persons of the Trinity are all perfectly distinct, yet essentially co-equal and one and the same: evidence of a lively appreciation, on Rymer's part, of the *Reasons for Crowning the Prince & Princess of Orange Joyntly, and for placing the Executive Power in the Prince alone*, which is the title of an exactly contemporary (London, 1689) pamphlet. Certainly, William had made intervention conditional upon his at least sharing the throne, and not playing ignominious second-fiddle to a wife whose own humble opinion had, in any case, 'ever been that women should not medle in government', and who, accordingly, 'had never given my self to be inquisitive in those kinds of matters'.[19]

As Second Person to her First (her hereditary claim, such as it was, taking precedence), all good Trinitarians would have had to agree, he need suffer no feelings of inferiority; and so an air of orthodoxy is imparted to arrangements held by many to be distinctly heretical – 'heresy' being Greek for 'choice', and the Earl of Thanet, for one, fearing lest 'we had done ill in admitting the monarchy to be elective', whilst voting, nevertheless, for joint sovereignty because

> He thought there was an absolute necessity of having a Government;
> and he did not see it likely to be any other way than this.[20]

Thanet, plainly, was (recalling the title-page to Waller's *Panegyrick*) 'A Gentleman' – nay, a Noble Lord – 'that Loves the Peace, Union, and Prosperity of the English Nation'; though, equally plainly, while he might bring himself (just) to swallow a P.O., an O.P. would have turned his stomach.

Mary makes the difference. 'Our Great *Queen* has been not a little useful to produce those great Events', summarizes 'Peter Jurieu', one of the ministers at the French Church, Rotterdam, in his *Pastoral Letter on the Death of the Queen*, who had succumbed to smallpox in the December of 1694, aged a mere thirty-two:

> If she did not lead the Prince to the Throne, she facilitated the ways
> to it, which his own Wisdom and Courage had open'd. She was the
> Bond of Union between the King and the Nation.[21]

'A Reign so gentle, and a Mind so strong', lamented George Stepney,[22] 'Both made us hope we shou'd obey Her long'; and the echo of lines describing the recently-returned and almost identically-aged Charles II in Waller's *On St. James's Park* reverberates with doleful irony:

> His shape so lovely, and his limbs so strong,
> Confirm our hopes we shall obey him long.[23]

In the *Panegyrick*, 'Mistaken *Brutus*' had 'thought to break their yoke, / But cut the Bond of Union with that stroke',[24] creating 'an interregnum's open space' for 'industrious Valour, and *'Personal Virtue only'*. In 1688, this 'Bond of Union' (though there was talk of the throne having become 'vacant')[25] was never so completely severed. Rymer's *Poem on the Arrival of Queen Mary* seeks neatly to make good any fraying by twisting together the two vital threads. William actively *performs* (had already, like Cromwell, 'done much'). Mary, more passively and Charles-like, *informs*. 'Her fair Influence', 'Her Vertue' permeates 'through the Mass of Things' to work 'Miracles'.[26] Her 'Reign no less assures the ploughmans peace, / Than the warm sun advances his increase'. She is the Stuart 'Genius of the Place' – 'where I was now grown a perfect stranger'![27] Meanwhile, 'Cheer'd by Her Rays His Care salutes the Morn':[28] William addresses himself to the tasks of ploughing, sowing, reaping, mowing – the executive business of 'Mechanick sway'. Her 'presence' is the catalyst of his 'skill'.

And so 'there is no Breach made at all' in the Succession, maintains the author of *The Protestant Mask Taken off from the Jesuited Englishman* confidently;[29] none, at any rate, worse than several that have occurred in the past,

most of them greater than this, *viz. William* the Conqueror, *William Rufus, Henry* the First, King *Stephen*, King *John, Henry* the Fourth and Seventh; to which some (who deny *Henry* the 8th's Marriage with his Brother's Widow to be lawful) add Queen *Mary*; and the Papists put in Queen *Elizabeth*:[30]

'no Breach made at all, except one Contingency happen'. He means the death of Mary, leaving William to reign on his own. 'And if it do', and he does,

'tis Personal, Temporary, and highly-merited: and if greater Breaches never made this Monarchy Elective, this lesser one cannot do it.

Without Mary, nevertheless, 'P.O.' will look more nakedly a variation on the theme of 'O.P.'. Faithorne's fine, 1658 engraving of the latter, trampling the Whore of Babylon and her dragon of error and faction, had been adapted, come 1690, to suit new circumstances by the substitution of William's features, hook-nosed and be-periwigged, for Cromwell's. The other most conspicuous modification is the replacement of sun and moon in their roundel atop the pillar to the Protector's right with a portrait of William's wife, lending him the light of her countenance.[31]

17: Machines and Máchines

'With Godlike State, above Mechanick sway, / She sits' 'Machine' and
'mechanic' are interesting terms.

> The word *machine*, without the prosaic associations it has acquired
> in a later age, refers admiringly to a complicated structure composed
> of many parts,

notes Harold Jenkins, glossing Elizabethan usage in general and Hamlet's in
particular, who subscribes his letter to *'the most beautified Ophelia'*, *'Thine*
evermore, most dear lady, whilst this machine is to him' – 'whilst', that is, 'he
is in the body'.[1] So (whatever, under the circumstances, is to be made of
'rude mechanicals') admiration is in order when William Camden, in *Hibernia*,
tells –

Tunc sensim vasti laxatur machina mundi,

Conjunctaeque manus linquunt suprema sorores –

how the Geniuses of Ireland and England, twin reconciled sisters, leave the
empyrean hand in hand for their earthly stations, and how, as they descend,
the *machina*, 'fabric' or 'frame' of the 'vast world' parts and the heavens
obligingly open, step by step, to let them through.[2]

Such a 'vasti . . . machina mundi' as Camden's has, still, obvious affinities
to Rymer's 'mighty Machine' a hundred years on. In both cases, to repeat
Jenkins,

> The word *machine*, without the prosaic associations it has acquired
> in a later age, refers admiringly to a complicated structure composed
> of many parts:

a structure, moreover, which seems to operate more by an interplay of inherant
sympathies and antipathies than by the laws of what nowadays is called
mechanics.

By the end of the seventeenth century, too, the word had acquired currency
in a literary-critical sense, developed from the *deus ex machina* of classical
dramatists (and Rymer himself, of course, had made his name as a
neoclassicizing critic of the drama). Thus when Dryden, dedicating the *Aeneis*
in his 1697 *Works of Virgil*, speaks of 'machining persons',[3] he does not
mean lathe-operators or the denizens of sweat-shops, but Father, Son, and
just about everyone else in *Paradise Lost* except Adam and Eve: 'above
Mechanick sway', all of them, more or less – less, as it happens, where
Satan and his crew are concerned, who increasingly subject themselves to it,
imagining that they can with their 'devilish enginery'[4] and 'Guns invented
since full many a day' match God's almighty thunder, victims of their own
conceit.

Rymer's Mary is a 'machining person'. 'Above Mechanick sway' she yet
'turns the mighty Machine of Affairs' by extra-mechanical means: 'a singular,
extraordinary, and unaccountable dispensation', in Rymer's words; that is, 'all
is carried on by Machine',[5] by supernatural agency. Her 'presence', to borrow
Jurieux's phrase, 'facilitates the ways' of William's 'skill'. She sets the plot

in motion, sits back and 'sees the second Causes Play', manipulated by her 'consort' from the land of '*Evestaltwichtich, Rechthefwicht, Scheefdaellini* and the like', 'great store of Wind-mills and other Artificial Engines', calculation and conscioius thinking as distinct from sublime fiat and numinous influence.

Very proficient he was to prove, too, in Defoe's estimation.

> The Constitution's like a vast Machine,
> That's full of curious Workmanship within:
> Where tho' the parts unwieldly may appear,
> It may be put in Motion with a Hair.
> The Wheels are Officers and Magistrates,
> By which the whole contrivance operates:
> Laws are the Weights and Springs which make it move,
> Wound up by Kings as Managers above;
> And if they'r screw'd too high or down too low,
> The movement goes too fast or else too slow.
> The Legislators are the Engineers,
> Who when 'tis out of Order make Repairs:
> *The People are the Owners*, 'twas for them,
> The first Inventor drew the Ancient Scheme.
> *'Tis for their Benefit it works*, and they
> The Charges of maintaining it defray:
> And if their Governours unfaithful prove,
> *They, Engineers or Mannagers remove,*
> Unkind Contention sometimes there appears,
> Between the Managers and Engineers,
> Such strife is always to the Owners wrong,
> And *once* it made the work stand still too long.
> Till *William* came and loos'd the Fatal Chain,
> And set the Engineers to work again:
> And having made the wondrous thing compleat,
> To *Anne's* unerring hand he left the Helm of State.[6]

The accent has altered, quite literally: from Rymer's 'mighty Máchine' of 1689 to this 'vast Machíne' of 1702, stressed as has become prosaically normal and running, too, to a comparatively prosaic rhythm. Though coined by Dryden long since to describe someone else, 'the very Withers of the city'[7] would suit Defoe well enough, always earnest to be understood, anxious 'that, the *Meanest Wit* / Might from his Musings, reap some benefit', not given to Pegasean flights. His 'Fatal Chain' may, momentarily, seem to catch the note of

> The chaine thats fixed to the throne of Jove:
> On which the fabricke of our world depends,
> One linck dissolv'd, the whole creation ends –

young Wallers' simile, that is, for the fortuitously-cast cable which, a long lifetime ago, had saved Prince Charles's barge from being swept out to sea and disaster off Santander;[8] but such Homeric machinery (Waller, notes

Fenton, 'alludes to a passage in the 8th Iliad')[9] has given place to something much more Stevinian.

The passage may begin with 'a vast Machine', end with 'the wondrous thing compleat'; but if, as Dr Johnson claims (and Stevinus would warmly have endorsed his analysis),

> Wonder is a pause of reason, a sudden cessation of the mental progress, which lasts only while the understanding is fixed upon some single idea, and is at an end when it recovers force enough to divide the object into parts, or mark the intermediate gradations from the first agent to the last consequence[10] –

then, once again, 'Wonder en is gheen Wonder'. Because this is how Defoe has employed the interim: not in pindaric rapture, but sober demonstration of how it is all put together, naming parts, marking 'intermediate gradations', making what might otherwise seem 'a singular, extraordinary, and unaccountable dispensation' seem singularly accountable – and accountable, what is more, to *the People*', who are to understand themselves *the Owners*'.

'The Fatal Chain', linking in with all this, will sooner suggest something out of William Derham's *The Artificial Clock-Maker* than anything from Homer, or *Paradise Lost* – where Satan sees[11] 'fast hanging in a golden chain / This pendant world' – or the Boethian 'faire cheyne of love' described in Chaucer's *Knight's Tale*.[12] Quite simply, the works have jammed. Happily, William is on hand to offer a solution 'And set the Engineers to work again' modify the mechanism and fix the state by making him (and his wife) a crown.

'The Constitution's', in short, liker to a clockwork orange than one which sweetens in gratefully spontaneous response to ripening majesty; and not a phenomenon to be taken 'on the whole to be God's work, about which men trouble themselves in vain'. '*Fauns* and *Faryes*' may 'the Meadows till, / More by their presence then their skill', but kings are 'Managers', and not 'above Mechanick sway' or beyond arithmetic. Skill counts – to William, especially, once Mary was dead; whom Rymer had fashioned into 'The Firste Movere' of a 'faire cheyne of love', though Rymer (son, as he was, of an executed Roundhead) is in no way

> Agog for some odd transubstantiate thing,
> Chimera reign, and Metaphysick King,

like Behn or Dryden.

> Sublim'd [by] School Divinity t[']extreams,
> Their Brains would crow with Patriarchal Dreams,

jeers a broadside *Epistle to Mr Dryden* and those of his persuasion, published '*Exeter*, Nov. 5, 1688' – the anniversary of Gunpowder Plot and, more immediately, the very day of William's landing at Torbay.

> So high from solid honest wisdom blown,
> They'd have some *Hippo-Centaur* on the Throne.
> Not Law-ordain'd, but by some God appointed,
> Not Lay-elected, but be Priest-anointed.
> Away this Goblin Witchraft, Priestcraft-Prince;

Give us a King, Divine, by Law and Sense.

Defoe's sentiments, exactly. Magic and 'Managers' do not go together. But 'Patriarchal Dreams' still haunt Behn's *Congratulatory Poem* on Mary's arrival, and silent memories, too, may be, of '*Awful little* EYES'. Many, however, readily 'left the Son, to praise the Son in Law' – accent (sarcastically in this instance) on the last word.[13] Can men 'Make Heirs for Monarks, and for God decree'? Are kings 'onely Officers in trust'?[14] Dryden is incredulous. Defoe thinks 'yes'. John Donne would have talked of 'the sin directed against the Father, whom wee consider to be the roote and center of all power'.

Preaching on this subject 'upon Trinity-Sunday' in 1621 or earlier, he explains that,

> as some men have thought the soule of man to be nothing but a resultance of the temperament and constitution of the body of man, and no infusion of God, so they thinke that power, by which the world is governed, is but a resultance of the consent and the tacite voice of the people, who are content, for their ease to bee so governed, and no particular Ordinance of God: It is an undervaluing, a false conception, a misapprehension of those beames of power, which God from himself sheds upon those, whom himselfe cals Gods in this World –

but Defoe calls 'Managers'.[15]

When, therefore (to pursue Donne's analogy), 'the reasoning engine' lies 'huddled in dirt', as it does in Rochester's 'A Satyr against Reason and Mankind',[16] to invite the inference that the soul of man may 'be nothing but a resultance of the temperament and constitution of the body' – not even an oddity in '*this machine*' temporarily '*to him*', but an oddity, superfluous malfunction of it (one which Swift was to make provocatively all even in Houyhnmland): when this happens, what is to be expected but that 'consent and the tacite voice of the people' will become the basis for political thinking?

As it has in Hobbes, whose uncompromising materialism did much to create a climate conducive to Rochester's disillusion, and who introduces his 'great LEVIATHAN' with clockwork terms anticipatory of the engineering of Defoe's 'vast Machine'. He may '(to speake more reverently)' refer later to 'that *Mortall God*',[17] but this 'absolute Representative of the people' is, unambiguously, their representative; its body, in the famous frontispiece, being literally a representation of a concourse of their atomies crowding upwards, gigantically out of the earth, and no indication at all of any 'infusion of God' or 'beames of power' from above.

They could scarcely be called 'the Owners' though, these atomies. Their 'absolute Representative' is altogether too 'absolute' for that. He is not, as Leslie Stephen observes, 'a delegate, bound to carry out their wishes', a 'manager' appointed by them to conduct business on their behalf and removeable if he flagrantly breaks contract.

> He 'represents' them in the sense that whatever he does is taken to be done by them. They are as responsible for all his actions as though he was their volition incorporated.[18]

So, in practice, the situation will hardly differ from that postulated by Donne in *Pseudo-Martyr*:[19] 'when therefore people concurre in the desire of such a *King*, they cannot contract, nor limitte his power'. When, however, in the conviction that 'God inaninmates every State with one power, as every man with one soule', Donne adds,

> no more then parents can condition with God, or preclude or
> withdraw any facultie from that Soule, which God hath infused into
> the body, which they prepared, and presented to him,

Hobbes declines to follow. If there must be 'one power', a 'single person', it will be fore strictly logical, not analogical reasons.

Donne's characteristic appeal, here, to 'the great act of generation, nay almost creation' may recall Shaftesbury, engaged (but ambitious, almost, 'to procreate without a Sex') in this very act, trying out 'hudled Notions' inappropriately at the very instant of infusion, striving to 'condition with God', prescribe the result: a *'Son in Law'* with a vengeance, and most distinctly limited powers, as God and Nature stand back to show what the letter can do without the spirit. But if Shaftesbury can thus produce only an abortive squab (barely its maker's, let alone 'his Maker's Image', such as Charles, who ploughs his fields and scatters with a different sort of will, broadcasts so handsomely 'through the Land') – if Shaftesbury produces a squab, and Hobbes a dismayingly absolute 'Artificiall Man' to which *'Soveraignty'* is an Artificiall Soul'[20] – 'a resultance of the temperament and constitution of the body . . . and no infusion of God' – yet, in the end, Shaftesbury's secretary, John Locke, did succeed in fashioning out of Donne's 'sin directed against the Father' something acceptable in the sight of Defoes and Addisons and the eighteenth century to come, finally laying to rest the ghost of all serious theoretical treatment of 'the political community as a "mystical body"'.

This idea, as Walzer's chapter on 'The Attack upon the Traditional Political World' in *The Revolution of the Saints* demonstrates, had been under pressure throughout the sixteen-hundreds, with the mid-century, not surprisingly, marking a crisis-point. His sub-section heading sums up the process: 'From Body Politic to Ship of State'; which is what Defoe's 'wondrous thing compleat' is to turn into in the very next verse:

> And having made the wondrous thing compleat,
>
> To *Anne's* unerring hand he left the Helm of State.

'And Peace and Plenty tell, a STUART reigns.'

But Pope's line vibrates with a restorative resonance unheard in Defoe's, striking a sympathetic chord with 'Another age' to come in *The Epistle to Burlington* which

> Shall see the golden Ear
>
> Imbrown the Slope, and nod on the Parterre,
>
> Deep Harvests bury all his pride has plann'd,
>
> And laughing Ceres, re-assume the land.[21]

For 'howso'ere the Figures do excell', in the words of Marvell's 'Mower against Gardens' – or don't, in context, Timon's arrogance having signally

failed to 'consult the Genius of the Place' at all and stuck statues about to utterly incongruous effect – 'howso'ere the Figures do excell, / The *Gods* themselves with us do dwell'.[22] 'Do Dwell', or will once again, Pope prophesies, when in the natural course of events 'Deep Harvests' flood back to overwhelm artificial 'Slope' and 'Parterre' and reclaim, like Charles II in Waller's *Upon His Majesties Happy Return*, 'the land' which – because this term 'in the old books, and in fines and the like, strictly signified nothing but arable land'[23] – is properly theirs, rightly belongs to Ceres: the goddess once again with us.

As she had been earlier in *Windsor Forest*, even if Samuel Johnson does find some of the supporting cast of '*Fauns* and *Faryes*' unconvincing. Lodona's metamorphosis, for instance, he calls 'a ready and puerile expedient':[24] not quite Amphitrite sailing 'thro' myrtle bowers', may be, but misplaced figure nevertheless, however assisuously 'polish'd'; and Thames's urn, too,[25] is a pretty dusty device, although there are no signs here of the swallows which 'roost in Nilus's dusty Urn' at Timon's villa.[26] In contrast, 'laughing Ceres' (landscapes conventionally may 'smile'; it takes a present goddess to make one convincingly to 'laugh'),[27] is undeniably vital; and a comparable sense of 'presence' transcending mere 'figure' – 'real presence', the capitals seem to insist – is conveyed when, in the earlier poem,

Rich Industry sits smiling on the Plains,
And Peace and Plenty tell, a STUART reigns.

The pilot of a ship-of-state, we have seen , unlike the head of a body-politic, can be chopped and changed in emergencies without necessarily fatal implications; and the 'Manager', too, of a constitutional 'Machine' who perversely persists in screwing its clockwork up too high or down too low, and picking quarrels with his 'Engineers'. But Pope finds 'a STUART' indispensable, and Anne, like Dryden's davidic Charles before her, the embodied 'Genius of the Place' – 'above Mechanick sway', a 'machining person' as distinct from a machine operator. '*Anne's* unerring hand' in *The Mock Mourners* is, however, precisely that of a skilled operator and worthy replacement for the Dutchman who had been steering the vessel for the best part of a decade, before he died, without the assistance of a covering Mary. Dextrously he had unjammed 'the Fatal Chain', got the legislative 'Engineers', Lords and Commons, to work again, set up the machinery of Protestant Succession. Equally dextrously, Defoe implies, Anne will keep 'the wondrous thing compleat' all ship-shape and Bristol-fashion and on a right course, handing over 'the Helm of State' when the time comes – *not* (although Pope, in 1713, seems still to be living in hopes of a possible prolongation of this line of 'earthly gods')[28] to 'a STUART' at all, but to George Lewis, Elector of Hanover, who was in turn, as the arrangements grew rooted, to be succeeded in 1727 by his son, George Augustus. '*Habemus Caesarem*'.

Pope may not have died of despair. He did begin to write the *Dunciad*.

18: Peace and Plenty and Julian the Apostate

'*Habemus Caesarem*': twelve Caesars, no less (not to mention Alexander the Great); and the Emperor Julian, 'Julian the Apostate', on an adjacent wall, makes thirteen – the whole baker's dozen decorating Sir Christopher Wren's King's Staircase at Hampton Court (Pls 1, 2) and painted at the beginning of the eighteenth century[1] by Antonio Verrio, of whose work Pope was later to be so contagiously contemptuous in his *Epistle to Burlington.*[2]

Here, too, is Ceres, re-assuming the land across the stairwell (Pls 2, 3) from Julian; not, on this occasion, 'laughing', but more pensively reclined, cloud-cushioned in mid-air and mid-picture, bare-breasted – 'Her Breasts swell with Milk', notes Antoine Pomey's popular *vade-mecum* of classical mythology, *The Pantheon*, '(which gives her the epithet *Mammos*a sometimes)',[3] but probably Verrio needed no iconographical excuses, other goddesses on the ceiling being equally exposed – bare-breasted, and with a sheaf of corn in the crook of her left arm. Her right motions towards a platter or flat basket of loaves. 'She wears a *Turbant* made of the Ears of Corn'[4] and, for good measure, the uppermost of her four attendant putti makes two triumphant fists of five and three stalks of grain, right and left respectively.

Below, ranged on edge across a sort of rocky dresser, is a double row of richly chased and embossed basins, fronted by a brace of accompanying ewers and backed by great, shapely jars for wine or oil, the whole assemblage being hedged behind by flowers. In the left foreground stands Flora, or (remembering Botticelli's *Primavera*, and in view of her cool colouring and plain dress) perhaps she should be called Chloris. She looks away from the action, regarding with maidenly reserve a chaplet of roses with which she has yet to crown herself, while behind, a warming, butterfly-winged Zephyrus, all puffing cheeks and demonstrative gesture, urges upon her attention a floral cornucopia: the efflorescence of fertility about to be released what time she is inspired by 'his sweete breeth' to turn about, don her chaplet and step decisively into summer – letting fall, as she does so, her skirts to shed abroad the blossoms gathered in her lap, where (to piece out Chaucer with Thomas Carew) *'Those flowers as in their causes, sleepe'.*[5]

On the right, cascading fruit would indicate autumn, with spring's Flora and Zephyrus being counterbalanced by, presumably, Pomona and Vertumnus, doubling, perhaps, as Peace and Plenty. She, in front, carries a sprig of fruiting olive and wears in her neatly-dressed, brown hair (Flora's flaxen locks are more girlishly dishevelled) a wreath of the same. He seems to have plucked, from the cornucopia of fruit which matches that of flowers, a branch bearing two apples (are they? the leaves are somewhat elongated), and to be offering these golden, appropriately – given Britain's western situation – hesperidean cultivars for approval, looking up over his shoulder, apparently in the direction of Bacchus, high on the back wall. She addresses a river-god next to them, astride his flowing urn, who salutes in acknowledgement – both of her and, may be, the flying

cherub on the diagonal, above, who points enthusiastically at Ceres's sheaf: product, likewise, of his fructifying flood. 'The Romans', we gather from Alexander Ross's *Mystagogus Poeticus*, 'placed the image of Vertumnus near the image of *Tiberius* [meaning the river, not emperor], to shew how plants, flowers, and trees, prove [thrive] by moysture'.[6] There is a corresponding figure on Flora's side, and (though both of them are hoarily masculine and each accompanied by his own tributary naiad) George Bickham the Younger merely reiterates, in his *Deliciae Britannicae* (London, 1742, p. 22), the assertions of *Apelles Britannicus* (London, 1741?, p. 2), declaring that

> This part of the Painting is a lively Representation of the Marriage of *Thame* and *Isis*; alluding to the Palace being erected on the River, which takes its Name from the Union of their Streams.

William Camden's *Britannia*, recently, in 1695, republished by Edmund Gibson in a new English version to replace Philemon Holland's, had included substantial fragments (dispersed to fit the book's 'chorographical' arrangement) of a poem *De Connubio Tamas et Isis*, composed, as likely as not, by Camden himself, and freely translated for Gibson's edition by Basil Kennet.

> *Hic vestit Zephyrus florentes gramine ripas*
> Floraque *nectareis redimit caput* Isidis *herbis*:
> Here, with soft blasts, obliging Zephyrs pass,
> And cloath the flowry banks with long-liv'd grass.
> The fragrant Crown, that her glad hands have made,
> Officious *Flora* puts on *Isis* head[7]

Could this be what she is about in the picture? It looks, on reflection, improbable, and other half-resemblances similarly prove, in the upshot, glancing rather than convincingly homethrust. Isis's source, for example (in the Latin and Holland's lumbering fourteeners, if not Kennet's couplets), is in a cave:

> *Haud procul a Fossa longo spelunca recessu*
> *Cernitur, abrupti surgente crepidine clivi* –

> Within a nouke along not much the *Fosse* and it betweene,
> Just at the rising of a banke upright, a Cave is seene.[8]

Again (this time according to Kennet, if not Holland and the Latin), the rivers consummate their union 'In a fair vault beneath the swelling stream',[9] and there are hecatombs of 'spoils and trophies' both here and there.

A cave, too, opens amidst the rocky outcrop bearing the opulent display of plate in Verrio's painting, while the flanking cornucopias pour out mingling abundance before its mouth. Yet Proserpina, winter, and shades of underground occur to mind more readily than riverine nuptials, even though Ceres, above, is notably not equipped with either her customary lighted torch or her pain-killing poppies – signs, both, of prolonged and arduous question for a ravished daughter. Ceres herself, it may be recalled, had once, after her own rape by Neptune, likewise retreated

> into the dark recesses of a Cave; where she lay so private that none

of the Gods knew what was become of her. Till *Pan*, the *God of the Woods*, discovered her by accident.

Whereupon she was persuaded

> at last to lay aside her grief, and arise out of that Hole, to the great good and joy of the World. For all the time of her retreat, a great Infection reigned throughout all sorts of living Creatures, which had been occasioned by the Corruption of the Fruits of the Earth, and the Granaries, every where.[10]

And here, as it happens, is Pan, placed by Verrio in the clouds just over her head, holding his pipes and conning a paper. So it cannot be, here, that '*Pan* presents illiterate rusticity, *Apollo* the mind imbued with the divine endowments of art and nature', which is how George Sandys had allegorized him in *Ovid's Metamorphosis*, commenting on the story of Midas (who, adjudging Pan the better musician of the two, was rewarded with ears suitable to his asininity). Rather he has joined – the silhouette of his body defining its lower edge – the circle of the Muses; over whom, of course, Apollo himself presides, head, shoulders and harp significantly extending across the ornate coving which separates wall from ceiling and onto the aetherial plane above.

They are not, then, rivals any more, these gods, but players in the same ensemble. If Pan's paper is a musical score, and his raised finger a token that he is counting time, he must be attending his own entry – waiting to play his own proper part in the universal symphony. 'Les ancients tenoyent Pan pour gouverneur du monde sensible', records Bolzani, 'Des Flustes' in his *Les Hieroglyphiques*.[11] His office is to transmit the celestial music downwards into more physical regions below – where sits Ceres, a harmonizer herself, of sorts, and mother, not only of agriculture, but, as a corollary – because men thereupon 'began to dispute the limits of their fields' – also of the notion (dear to Locke) of property; 'from whence she received the Appellation of *Legifica,* the *Founder of Laws*, Ηεσμομόϱος'.[12] In this guise she will look not a little like Astraea, goddess of Justice who, having left in disillusion earth to its Iron Age, will nevertheless return to reinstitute a new Golden one, and who in the meantime, as the constellation, Virgo, supervises harvest and carried ears of corn accordingly.[13]

In Verrio, then, as in Virgil, 'Iam redit et virgo, redeunt Saturnia regna': 'Even now the virgin returns, and Saturn's reign' - the Golden Age anticipated in the *Fourth Eclogue* which, addressed to Pollio (but with Augustus, as ever, in the offing), prognosticates a time when, once again,

> Unlaboured harvests shall the fields adorn,
> And clustered grapes shall blush on every thorn.[14]

Eventually, 'every soil shall every product bear', rendering ships (and Wallerian conceit) redundant. No one will have to 'plough the Deep'. 'No plough shall hurt the glebe, nor pruning hook the vine', either.

'Non vinea falcem' certainly fits Verrio's picture. The *Mystagogus Poeticus* reports[15] that Vertumnus 'was painted with a pruning hook in one hand, with ripe fruit in the other'. There, sure enough, is the fruit, but the pruning hook is conspicuous by its absence. Nor does Pomona supply the deficiency, though

such an implement would have been equally appropriate to her. The plate displayed upon the rock – Plutus, incidentally, in Hesiod's *Thegony*,[16] is said to be the son of Ceres/Demeter – seems conspicuously more for enjoyment than use. There are definitely no ploughs or harrows in sight: not so much as single sickle in the hands of one of Ceres's putti, to show how her sheaf was reaped. The harvest is 'unlaboured', 'mollis' in Virgil's latin: not 'barbarous in beauty' like that of Gerard Manley Hopkins's 'Hurrahing in Harvest', but altogether 'soft' and civilized – 'easy', painless. Ceres has no need of narcotic poppy, has laid aside her lighted torch. Pan has no shepherd's crook. Though the grisailles underneath, marching up the stairs and across the landing, are all of military trophies, swords and hatchments, the only instruments visible in the picture itself are musical ones. War has been forgotten, labour itself transposed into music. All is harmony, perfect concord, the octave achieved!

'8 beyond 7', Vincent Hopper points out in *Medieval Number Symbolism*, '= eternity after mutability'. It is the number of 'regeneration', of 'the state of felicity', representing 'a return to original unity', 'the age of Final Redemption'.[17] It is the sum of the ears of corn demonstratively held out by Verrio's spreadeagling cupidon (could he be the child, Plutus?); is, in fact, roughly the shape of the entire composition.

'8': the shape itself of the arabic numeral may, J.E. Cirlot's *Dictionary of Symbols* notes, be regarded as significant; it is, for example,

> associated with the two interlacing serpents of the caduceus, signifying
> the balancing out of opposing forces or the equivalence of the spiritual
> power to the natural.[18]

It might have been designed deliberately to figure the circulation of influences from an upper to a lower sphere and back. More: if, as Alexander Ross suggests, 'By *Vertumnus* may be meant the year, *In se vertens*, returning into itself'[19] – why, the figure 8 will mirror this movement, too, simulate the timeless cycle of the season, summer, winter, seedtime, harvest. The eighth month of the year, needless to say, is August, the month of harvest: of Ceres, high summer – and Augustus, the surname assumed by Octavius (there's eight again!) after he had achieved undivided authority on Rome. '*Habemus Caesarem*'! Isn't it all just too good to be true?

Julian the Apostate seems to think so; looks askance, not at this ideal scene of Augustan peace, plenty and perfection, but over his right shoulder, roused from writing by a descending Mercury. The god, although his caduceus is depicted broadside-on, so that the '8' formed by its 'two interlacing serpents' is quite clear, nevertheless draws his attention not to the opposite, but back wall, with its tableau of Alexander and the Caesars: aptly, since Mercury is the supposed inspirer of the work on which it has been based, namely – as Edgar Wind long ago established – Julian's own '*Satire, The Caesars*, available at this time in several translations'.[20]

The one Marvell was plundering in 1673 for missiles to hurl at his opponent, Parker (who had had the temerity to respond to a previous sneer that '*Julian himself . . . could not have out-done you either in Irony or Cruelty*' with the assertion that the Apostate, in fact, '*was a very civil Person, a great* Virtuoso,

and . . . had nothing of a persecuting Spirit in him against Christians'), had been 'Printed at Paris 1583' as part of a bilingual, Greek and Latin *Opera*.[21] The most recent must have been Ezekiel Spanheim's likewise parallel Greek and Latin *Juliani Imp. Opera, et S. Cyrili contra eundem Libri Decem*, published in Leipzig in 1696. However, 'the one most commonly quoted', asserts Wind in a footnote, was that same scholar and diplomat's French version of *Les Césars* alone. This had first appeared in Heidleberg in 1660, dedicated 'A son Altesse La Duchesse de Brunsuic et de Lunebourg, née Princesse de la Maison Electorale Palatine', the head of which was Spanheim's then employer;[22] but the edition specified by Wind is that produced, revised, re-dedicated, newly prefaced and frontispieced, and more grandly now in quarto rather than octavo, in Paris some twenty-three years later.

1683: the year of Gilbert Burnet's post-Rye House Plot visit to that city! Who, although he may 'say very little of the protestants. They all came to me: so I was well known among them', nevertheless makes a point of recording:

> I knew Spanheim particularly, who was envoy from the elector of Brandenbourg, who is the greatest critic of the age in all ancient learning, and is with that a very able man in all affairs, and a frank and cheerful man.[23]

The 1683 dedication, accordingly, is 'A Sa Serenité Electorale' , in whom it discovers

> un Héros, sur lequel la Satyre n'a point de prise; en qui elle ne peut blâmer, ni ces débauches, ni ces emportements, ni ces foiblesses, ni ces autres déréglements de l'Ame ou de l'Esprit; ces vices enfin; & ces taches, quelle dévoile icy librement dans un Alexandre; dans un Jule; dans un Auguste; dans un Trajan; dans un Marc Aurele; dans un Constantin; c'est à dire les plus grands, les plus sages, ou les plus vertuëux Héros de l'Antiquité Grêque & Romaine[24] –

not to mention (though there is some routine flattery to come at the end of the preface) a certain 'Roi Soleil' currently illuminating France and beginning to look witheringly upon Huguenots and the Edict of Nantes. 'Both a Christian and a hero', Burnet was to concur, reviewing the Elector's career in his *History*:[25] a prop of Protestantism who had, for instance, taken 'great care of all the refugees' who came his way, fleeing from Louis XIV's increasingly savage persecutions. What more natural, then, that a book once issued as a compliment to one major, protestant prince should spring to mind when decorations were being devised for another?

The new frontispiece – 'Petrus le Pautre invenit et fecit', a cousin of the more famous sculptor and himself a *'Designer and engraver of the Bâtiments du Roi'*[26] – may conceivably be what suggested to Verrio, or to whomsoever it was who devised the programme for the King's Staircase, that the subject had pictorial possibilities on a grander scale yet. Though Wind makes no mention at all of the engraving (Pl. 5), Verrio's figure of Rhea, or Cybele, sitting as Julian specifies with Jupiter, Juno and her own consort, Kronos, in one of the four places of honour (in Verrio's version, at a top table transecting

the circle of the zodiac, centre-ceiling), seems too similar to le Pautre's, despite the much steeper perspective, for the resemblance to be entirely coincidental. Perhaps Verrio had been shown a copy of *Les Césars* when the scheme was being formulated? Perhaps Burnet might have had something to do with it. He knew and liked Spanheim; had been on familiar terms with him in Paris only a few months after the new edition of the work had been printed (in April); was still writing to him come 1706 – to thank him for (what else!) the presentation of a copy of a treatise.[27]

But Spanheim's enthusiasm for Julian must have been well-known in England among the cognoscenti. He had, he records in his *Relation de la Cour d'Angleterre*, been 'renvoyé en Angleterre en 1678' in the course of his diplomatic duties and had remained 'jusques au commencement de 1680'.[28] Staying at the house of the Dutch scholar, Isaac Vossius, who had been a canon of Windsor since 1673 and had a fine residence in the countryside nearby, he had seized the opportunity to consult an especially good manuscript of *The Caesars*.[29] His researches may even have been a stimulus to the 'Philaretus Anthropopolita' who, in 1681, produced a pamphlet which Wind does mention – indeed, makes much of: *Some Seasonable Remarks upon the Deplorable Fall of the Emperour Julian.* This, describing Julian as

> severely Vertuous, profoundly Speculative, admirably learned and
> Eloquent, and (which is yet more) firm and positive in the belief of a
> Deity,

attributes his otherwise 'unaccountable' apostacy to 'the debaucht Christianity of those times . . . for then first our Religion was converted into Faction, Policie, and vile Hypocrisie':[30]

> I am perswaded nothing offended him so much, as the vile Hypocrisie
> of the then Clergy, who besides their crying of contrary Creeds, in
> the Reigns of *Constantine* and *Constantiu*s, and modelling Religion
> by Court-Intrigues, seemed almost wholly to dispense with Morality,
> placing Sanctimony not so much in a good Life, as in the Strict
> Observance of the Rituals and the Symbolical Representations of our
> Religion; such as Baptism, the Eucharist, Chrism, but above all
> submitting to the Formalities of Confession and Penance, upon which
> the worst of offences were too easily remitted.[31]

'The then Clergy' of the early fourth century A.D., in other words, were already behaving just like up-to-date Papists and their high-flying fifth-columnists amongst the Anglicans. But

> this discerning Prince soon saw their Designe was to erect in all
> parts of the Empire their own *Mosaick* or Ecclesiastick Politie, by
> themselves Metamorphos'd from a Democracy into an Absolute
> Tyranny.[32]

And let the scheming priests and prelates of today, too, beware: take heed of what happened to their fourth-century forebears,

> who in process of time were themselves also swallow'd up by
> Patriarchs, and all at last by one *Demogorgon* Pope. In manner not
> unlike to this, the *Roman* Senate, too (to compare great things with

small) by trampling upon the poor Plebeans, brought the Usurper *Caesar*, with a whole train of Successors, upon their own heads.[33]

So it is not just a question of what will happen to the Church of England, but to Lords, Commons, the whole fabric of government if, to ill-conceived cries of 'apostacy', Exclusion is rejected and the vote goes in favour of a future James II, initiating the inevitable chain-reaction. A '*Loyalite*' (the word is a jesuitical miscegenation of 'loyalist' and 'Loyola') – a 'Loyalite' like Petavius may have jibbed at translating some of Julian's more corrosive, antichristian sarcasms for the benefit of 'his Catholick Friends', but 'pious Protestants . . . since they derive not their Religion from *Constantine*'s Bishops, but from Christ immediately', will, in their 'Primitive Candour and Ingenuity' and utter contempt for 'this sort of *Egyptian* Vermine',[34] find nothing to embarrass them; though Spanheim, for his part (that of a diplomat, publishing, what is more, in Paris), treads as always diplomatically despite being, as Emile Bourgeois observes, 'un protestant plus que convaincu, fervent'.[35] He thinks, for instance, that

> Il serait bien injuste à mon avis, d'apuïer la haine d'un Payen & d'un Apostat contre le premier & le plus célebre d'entre les Empereurs Chrétiens.[36]

Constantine's exalted reputation, therefore, is not necessarily to be questioned; as it is not, either, by Burnet who, preaching a Fast Sermon before Queen Mary, 16 July, 1690, notes how the 'repeated Fires of their Martyrs' served only to kindle

> another Fire in the Minds of the Christians, and setting them to Fastings and Prayers, God did at last arise, and sent them a Deliverer, from this Island, *Constantine*, who first gave them Quiet and Liberty, and then Protection and Favour, and then the Christian Religion shined with a new Lustre of Wealth and Prosperity.

Yet his very next words, just as Constantine seems to be shading felicitously into William III, are to be a 'But, alas, . . .':

> The Church did soon degenerate, and the Bishops of the chief Sees fell into Factions. The History of that Time gives us but a sad view of the governing Men of the Church. But yet even there we have a Witness in favour of that Religion that is beyond Exception, I mean *Julian*, who tells his Heathen Priests, in his Zeal for the restoring of Paganism, how both Priests and People ought to imitate the Lives, the Temperance, the Gravity, and above all the Charity that was among the Christians.[37]

Here, again, is 'this discerning Prince' of *Some Seasonable Remarks*, who reacts vehemently against 'vile Hypocrisie' in high places while remaining highly appreciative of 'Primitive Candour and Ingenuity' wherever it is to be found. Perhaps, then, after all, it should not be so surprising to discover, from Henry Fielding's *A Journey from This World to the Next*,[38] that Julian's last incarnation before achieving Elysium was as Hugh Latimer, one of the prime movers and martyrs of the English Reformation, burnt at the stake by Bloody Mary and her 'sort of Egyptian Vermine'.

But it is, and Fielding expects it to be. Julian had an indelibly bad name. To identify an opponent with the dog – '*Julian*, one would almost swear you were spit out of his Mouth', Marvell tells Parker[39] – was the ready and easy way, and the one to which, despite the subtler windlasses and assays of bias attempted in *Some Seasonable Remarks*, Whig propaganda was by-and-large to resort, thanks to the intervention of Samuel, 'Julian' as he came to be known in his notoriety, Johnson.

> The Apostacy of *Julian* the Emperor did not perhaps make a greater Noise in the Cities of the *Roman* Empire, than the Short Account of his Life, called, *Julian the Apostate*, did in the City of *London* at its first Publication,

complains George Hickes, introducing his rebuttal of Johnson's pamphlet.

> It started from the Press, as Racers usually do from the Post, with a great and mighty Shout, and was attended all along with loud Acclamations of men set on purpose to cry it up in all Places, as indeed they apparently combine to disperse and cry up any thing, that is plausibly written against the Doctrine of *Non-Resistance*, *the Succession*, or any of *the Rights of Soveraignty*, which keep the Crown firm upon the Kings Head.[40]

'As if', he snorts incredulously,[41] 'the Right and Title of *Julian* were of the same nature with that of his R.H. to the *Brittish Throne*'! Nevertheless,

> The Faction was sensible that Mr. *Johnson* had hit upon an unlucky Parallel, and therefore must be condemn'd at any rate,

it is recorded in 'Some Memorials' prefixed to the eighteenth-century edition of Johnson's *Works*.[42] Wind even reports 'in the second edition of "Julian the Apostate" . . . an explicit comparison between Julian and James'.[43] 'Mr *Johnson*', accordingly, was condemned at the rate of a fine of 500 marks. Since he had no means of paying, this meant, in effect, 'perpetual Imprisonment',[44] which failed to deter him from further exasperating 'his R.H.', once King, by fomenting disaffection in the army and bringing upon himself worse punishment.

After all, therefore, to find Julian, by stubbornly persistent reputation the most execrable of emperors, preferred to a place of honour on the walls of a royal palace, and those of so important a feature of it as the King's Staircase, no less, remains – the best efforts of *Some Seasonable Remarks* notwithstanding – still somewhat surprising: an invitation, perhaps, to 'conscious thinking' as distinct from automatic assumption. The solution, however, thinks Wind, once one knows about Julian's satire, is comparatively simple.

Here, on the rear wall, is 'the Usurper *Caesar*, with a whole train of Successors' (whom the Senate, by spurning the wishes of the people, had brought upon their own heads; but in Britain, thank goodness, Halifax and his allies were to see sense at the eleventh hour). He turns (Pl. 2), hand indignantly on breast, to meet the challenge of Alexander, entering from the left, finger arrestingly raised and with a winged Victory behind to bear him out and, to judge from the gesture of her wreath-bearing hand, up. Immediately over

Julius's head, an embarrassed Romulus, deified as Quirinus and accompanied by an equally sheepish-looking wolf, is being twitted by Silenus, astride his ass just over the way:

> prens-garde, luy dit-il, que tous tes Neveux ensemble ne méritent pas
> d'estre comparez à ce Grec.[45]

So, concludes Wind ,[46] all is clear: 'William III is the new Alexander with whom the Romans cannot compete' – the 'new' Romans, that is, to correspond to his 'new Alexander': the Roman Catholic kings and princes of Europe, led by Louis XIV and including the exiled James II.

But can this be quite right? Spanheim, we have seen, instead of identifying 'Sa Serenité Electorale' with Alexander, assures his employer that he, on the contrary, is free from 'ces vices enfin, & ces taches' which satire 'dévoile icy Librement dans un Alexandre', first and foremost of the list, and in no way to be differentiated in this respect from the Romans to follow – as he seems not to be, either, in le Pautre's frontispiece, which shows him expostulating with Silenus from the head of the queue (pointedly lined up over a scene of rape evocative of the miseries of war and Sabine women). Or could this figure conceivably be Romulus? But then the bearded, be-laurelled, cloaked and evidently cuirassed suppliant at Jupiter's elbow would have to be Alexander's advocate, Hercules, oddly over-dressed for him, yet without either lion-skin or club, pleading the cause of a client now entirely out of the picture: a most unlikely scenario! Even Johan Schweizer's frontispiece, or perhaps it should be titlepage, for the smaller, 1660 edition had picked out Alexander for depiction, pairing him, to the left of the composition, with his great rival, Julius. A very satyr-like (as opposed to Socratic-looking) Silenus, backed by a plumpy and infantine Bacchus, gesticulates rudely from the right. The middle is taken up with a bust of the author, seen in left profile in front of a column surmounted by a spread eagle with a scroll in its beak which proclaims the title of the work.

Alexander, to be sure, is a key figure; but Spanheim is equally sure that he cannot be compared to his Elector. And if he had not been good enough, in 1683, for Spanheim's 'Brandenbourgh', champion of the Protestant Interest, how can one be confident that he must be meant for William on Verrio's wall, especially when its designers appear to have been taking some leaves at least out of Spanheim's book?

19: 'Saturnian Times'

Some more scene-setting seems desirable. It is the time of the festival of the Kronia, the Saturnalia, and Kronos or Saturn, as before noted, sits with Jupiter, each with his respective spouse, at the topmost table of the gods. In fact, Julian introduces him first as the elder and, if not superior, then certainly equally impressive deity: not 'Dark with excessive bright', like Milton's God the Father in *Paradise Lost*, but 'bright with excessive dark', his couch being.[1]

> d'une Ebéne, don't la noirceur avoit si grand & si merveilleux éclat,
> qu'on ne pouvoit y arrêter le veuë, & les yeux n'en estoit pas moins
> ébloüis, que lors qu'on regarde fixement le Soleil[1] –

although all Verrio can manage to convey the effect is a scattering of stars over his dark blue mantle.

'Saturnian times', too, have patently 'Roll[ed] round again' (to borrow Dryden's turn of phrase, translating Virgil's *Fourth Eclogue*) on Ceres's wall beneath, and a new Golden Age such as Prior, in his *Carmen Seculare, For the Year 1700* (which takes its epigraph from that same *Eclogue*), prays Janus to promote, conjuring him to shut his 'Mystic Gate' – left open in times of war –

> Be kind, and with a milder Hand
> Closing the Volumn of the finish'd Age,
> > (Tho' Noble, 'twas an Iron Page)
> A more delightful Leaf expand;
> Free from Alarms, and fierce *Bellona's* Rage.
> Bid the great Months begin their joyful Round,
> By *Flora* some, and some by *Ceres* crown'd;.
> Command the laughing Hours to scatter as they fly,
> Soft Quiet, gentle Love, and endless Joy;
> Distribute Years of Peace land Plenty fam'd,
> > And Times from better Mettle nam'd –

'From *Saturn's* Rule, and better Metal nam'd', in the revised version of 1709.[2]

Verrio's composition, then – which he had begun painting by February, 1701/2,[3] and which must, therefore, have been in plan around the turn of the century – expands on its left-hand wall 'A more delightful Leaf' full, like Prior's, of hopes for a new era of peace and plenty and visions of Flora and Ceres and But 'the laughing Hours' have been promoted to the ceiling and zenith of the zodiac, where they 'scatter as they fly' flowers, in lieu of 'soft quiet, gentle Love, and endless Joy'. Or are they adding their wreaths to the already well-filled receptacle borne upon his head by the winged infant who is with them – favourite fruit, could it be, of 'great *Rhea's* pregnant Womb, / Where', *Carmen Seculare* will avouch, 'young *Ideas* brooding lie'?[4] Rhea, it seems, is saying something on the subject to Saturn-cum-Kronos, her consort, upon whom developments will necessarily depend. He, chin lifted from hand (roused from characteristic melancholy or saturnine posture),

looks thoughtfully up at the child: Father Time, as it were, considering 'the future in the infant'! – An infant, moreover, like the famous 'puer' of *Eclogue* IV, evidently supposed to be redolent of golden promise and happy times to come, although Verrio pours a little cold, recusant water over the prospect by having the imp make it, in a definite if unobtrusive stream which descends, splash! into the salver of a divine Hebe who all unwittingly looks the other way, over her shoulder towards Fame with her two trumpets.

'It is all an *Italian* Bite', as Francis Peck was to remark relative to another stair-well ceiling of Verrio's at Burghley House, where a devil defecates to such effect that the roof appears to have been leaking.[5] He was given to such tricks. He was also (as it is usual to observe) a Roman Catholic who had entered reluctantly into William's service, remembering, no doubt, his obligations to the brother-monarchs who had treated him generously during the two preceding reigns and whose right line had been so gloriously wronged in 1668; which could explain why, in the zodiac over Jupiter and Juno's heads, Gemini's place has been most fishily usurped by Pisces, February fill-dike obtruding upon the merry month of May – made all the merrier since 1660 by the anniversary (on the 29th) of the Restoration. Moreover, 'Piscino', that is *'borne under Pisces, of the fishes nature'* (an epithet not unsuited to Dutchmen who 'live lower than the fishes'), in Florio's *Queen Anna's New World of Words*,[6] stands next door to 'Piscio', the Italian for *'pisse, stale, urine'*; so perhaps the two aberrations are punningly connected. Times and seasons, hints Verrio, may not be running entirely and eirenically to order. Nor were they. Even as he painted, the War of the Spanish Succession was confirming its iron grip, and before the minute

for subsistence of himself and painters that assist him £10 per week

for 26 weeks from ye 25th December 1701 to hye 25th June 1702

(signed by Wren and William Talman)[7] was thirty seconds through, the King himself had met his mole-hill.

Pisces apart, the zodiac appears regular enough, though Infant and Hours between them combine to obscure the reigning sign which ought, since Cancer and Virgo are plain on either hand, to be Leo. The sun enters Leo (or entered, Old Style) on the twelfth of July, continuing there for the first third of August: high summer, in other words, with harvest in prospect if not process; the two months in question being, besides, those 'dedicated to the Memory of the first two Emperours', as John Ogilby, retailing Servius, records in a gloss on the 'magni . . . menses' of *Eclogue* IV – the 'great Months', obviously, to which Prior is alluding in *Carmen Seculare*. These 'magni . . . menses', it emerges, have also been

by *Turnebus* appli'd to the great year foretold by the *Sibyls*; by *La Cerda* understood of the ensuing greatness and prosperity of *Augustus*, the most probable opinion –

if, at least, 'Uncle *Ogelby's*' own is to be trusted.[8]

As for the ceiling of Wren's staircase: it is noticeable that (although getting as far as the eleventh of November, Old Style, with Scorpio overhead) the lower, more wintry half of the zodiac, which should have contained Pisces,

has been left blank. This may simply have been Verrio's way of avoiding an unpainterly clutter, but might, perhaps, have been prescribed to indicate a 'joyful Round' of the kind canvassed by Prior. The blankness, too, would square with the lack of a figure or figures ('nobot an olde cave'!) to stand for Winter on Ceres's wall. But this part of the scheme, thinks Wind, is 'a separate allegory' depicting the 'union of William and Mary', though he has regrettably no room to elucidate, making the assertion in the course of a short footnote whose main business is to explain that the zodiac above 'culminates in the sign of Leo' because the lion was William's beast, while the roses with which it is 'half covered' are 'the emblems of Mary, which are strewn by genii'.[9]

He may have a point about Leo and the Batavian lion. Roses, too, could be reminiscent of Mary (by this time six years or so dead). But the strewing 'genii' look reach-me-down: no real improvement upon the 'several *Zephyrs*, with Flowers in their Hands' specified in Bickham the Younger's *Deliciae*[10] and the *Apelles Britannicus*[11] before that, which agree with Wind in pronouncing 'This Piece is a Compliment to King *William* and Queen *Mary*', but focus on Juno's peacock ('an Emblem of their Grandeur') rather than Leo. '*The Zephyrs*', they decide, 'represent their mild and courteous Disposition', countervailing 'one of the *Parcae*, or *fatal Sisters*' who 'denotes their Power over their Subjects' and attends below Ganymede on Jupiter's right, 'with her Scissors in her Hand, ready to cut the Thread of Life' on his command.

Neat: but neither the *Deliciae* nor the *Apelles*, despite identifying Julian on the adjoining wall and expanding largely on his life and reputation, displays the least inkling of the relevance of his *Caesars* to what is going on, with the result that Alexander is labelled Aeneas and Nemesis 'The Genius of *Rome*',[12] and so on. Yet they concur, again, with Wind in detecting a marriage afoot to the left, but (as has been seen) 'of *Thame* and *Isis*', not William and Mary.

How Wind's allegorical 'union' is to be made out is not immediately obvious. 'Thy own Apollo reigns', of course, at the beginning of *Eclogue* IV,[13]

> Reflecting, as some Interpreters conceive, upon *Augustus Caesar*,
> who was reputed the Son of *Apollo*, and had his Statue erected with
> all the Ornaments and Ensigns of that God.[14]

So the Apollo who warms Ceres's world might, conceivably, represent a corresponding British Augustus – one who would, however, then cut a markedly different figure from his namesake on the rear wall; which might make this allegory, even so, not necessarily so 'separate' as Wind's adjective suggests, but rather questioningly complementary: 'Saturnian reign' set against 'saturnalia', Virgil's visionary idyll juxtaposed to the Apostate's satire, with Apollo head and shoulders above the coving to indicate ultimate interconnections.

There, anyway, on the back wall, quite unmistakably (Wind being in this instance quite right), is Julian's Octavius, prominent among the painted Caesars. Zeno – forget the *Apelles's* and *Deliciae's* 'celebrated *Spurina*, the Soothsayer'[15] who had warned Julius to 'Beware the Ides of March' – Zeno, the philosopher, is having a word in his ear, prompted by Apollo to stiffen

with stoicism his compulsive chamaeleonizing. He stares, moreover, strangely
wide-eyed, out of the picture: a reference, perhaps, to his aspiration

qu'on crust, qu'll sortoit de ses yeux des rayons aussi perçans, que
du Soleil, en sorte que personne n'en pust soûtenir ses regards.[16]

Another 'Roi Soleil' would-be, it would seem! And, according to Wind, clearly
'the figure of a "priest-ridden" monarch': 'one presumably like James II',
adds Howard Weinbrot, following up Wind's 'Romans equal papists' lead,
and remarking by the by, also, upon what he interprets as 'the vapid look on
his face'.[17] May be Verrio did not strive to make his gaze particularly
penetrating or daunting. A somewhat doll-like expression will agree very well
with Silenus's dismissive 'Ce faiseur de Poupées'; which 'plaisant nom',
Spanheim's note explains, is given him

pour avoir introduit à Rome la coûtume de l'Apothéose ou
Consécration, qui mettoit les Empereurs, aprés leur mort, au rang
des Dieux[18] –

with what justification, Julian's satire sets out to explore.

It is, it will be recalled, the festival of the Kronia, the Saturnalia. Romulus
has invited gods and emperors to a joint banquet, though the latter are to eat
below the moon, at a table placed (as Verrio pictures it) at the base of a huge,
Yardley-oak-like trunk of cloud. This rises up behind Diana and her crescent,
lodged (at an appropriately lower, more wall-bound level than the sun-god,
Apollo) on a knob or knarr of it, and towers on upwards, across the framing
architecture, illusionistically onto the ceiling. Here, truncated, it supplies a
floor for the first circle of the gods: Mars, Venus, Vulcan, Neptune, Pluto, to
mention the most identifiable amongst them. Below the emperors' table (Verrio
has made it intermediately octagonal, rather than supremely circular), still in
mid-air, the cloud-mass bifurcates into two great roots or spurs, extending
earthwards, left and right. On the right stands Romulus, introducing his
Caesars. On the left, sits Hercules, pressing the claims of his protegé,
Alexander, with Silenus and Bacchus overhead, alongside Diana and similarly
supported.

In the text, the emperors are introduced one by one to a railing descant
from Silenus, the gods' licensed fool, with his characteristically Socratic
features. Sometimes there is nothing whatsoever to laugh about. The 'Beste
farouche', Caligula, for example, presents himself only to be despatched
post haste to hell by 'La Déësse Némesis',[19] whom Verrio has depicted
swooping in from the right and whom *Apelles* and *Deliciae* mistake for 'The
Genius of *Rome*', 'the flaming Sword and Bridle' in her hand being possibly
an Allusion to the Revolution, at which Time, had it not been for the
Assistance of our great and glorious Deliverer, King *William* III. the
British Nation had felt again the eight of the *Romish* Yoke.[20]

They are certainly, however, perfectly proper to Nemesis: standard equipment.

Several imps of infamy – deformed parodies of the cherubic putti elsewhere
– also flit ominously over the Caesars' heads, bat-winged but armless, with
pendulous female breasts and serpents' tails. One spits contempt over an
emperor who may, indeed, be meant for Caligula, since 'Caligula' (a nickname

acquired during a childhood spent in military camps) is a diminutive of 'caliga', 'military boot', and the figure behind (Claudius, perhaps, whose 'hams being feeble failed him'?)[21], with supporting stick and extended index-finger, points suggestively downwards in the direction of his foot.

Nero is another given unsurprisingly short shrift. He enters 'avec une Guitarre à la main';[22] and a guitar (a favourite instrument, coincidentally, with Charles II – coincidentally another pleasure-loving monarch whose capital city burned down) is just what he is equipped with in the picture; which is all very *à la mode* and Stradivarius, to be sure, but perhaps not quite what the scrupulously academic Spanheim himself would have ordered. Conscious that his translation of κιθάρα, par le mot *Guitarre* qui en vient' is novel (other words, 'comme de *Luth*, de *Lyre*, ou de *Harpe*' being more usual), he explains that he is under no illusion 'que nôtre *Guitarre* moderne soit la même que celle des Anciens'. He is, however, concerned to register

> que quelque raport qu'il y eût autrefois entre ces deux Instruments
> *Lyra* & *Cithar*a, qu'il y avoit aussi de la différence.[23]

Such point-device antiquarianism might well have boggled at Nero's notably up-to-date model in Verrio, whose Apollo, on the other hand, is furnished with a conventionally 'classical' instrument, even if the Muses about him are less antiquely equipped with, amongst other things, a violin fully as modern-looking as the guitar. Muses had been known to play guitars, too. One of them, for instance, 'pince les cordes' of one in a painting of 'Minerva's visit to the Muses' by Frans Floris (1516-1570) discussed by A.P. Mirimonde in an article on 'Les Concerts des Muses chez les Maîtres du Nord';[24] but that was over a century ago, the instrument being, as John Playford protested while introducing *Musick's Delight on the Cithern* in the year of the Great Fire, 'but a new old one'.[25] 'Toute la guitarerie de la cour', to borrow Anthony Hamilton's contemptuous collective from his *Mémoires du Comte de Gramont*[26] – 'toute la guitarerie de la cour' was, in Restoration England, following the fashion set by a monarch who performed himself and took lessons from an Italian virtuoso, Francesco Corbetta: 'the only man who could make anything of the guitar', in Hamilton's opinion (he refers to the 'raclerie universelle' of imitators), and the author of *La Guitarre Royalle*, which appeared in 1671, 'dediée au Roy de la Grande Bretagne'. (Three years later, Corbetta published another collection of pieces under the same title but dedicated, this time, to Louis XIV, a shared enthusiasm for the instrument being one of the things the two kings had in common.)

Could, then, mischievous misprision account for Nero's guitar, as distinct from a more innocent mistaking of Spanheim's meaning or the kind of anachronistic licence frequent in many earlier depictions of 'Concerts of the Muses', 'Feasts of the Gods'[27] and the like? Striking a chord on what, in Charles's dissolute days had been 'the instrument of dilettantes',[28] he signally fails, despite fixing him with his eye, to evoke any sympathetic vibrations in the god of music who, relates Julian, egged on by Silenus ('se tournant vers Apollon, voy-tu, dit-il, comme celuy-ci tâche de t'imiter'), has the emulative emperor summarily stripped of his laurels and consigned to Cocytus: a watery

fate which, as Spanheim notes,[29] squares neatly with the Roman punishment for parricides who – though, as Juvenal remarks,[30] 'no solitary ape, adder or sack' would have been adequate to Nero's crimes – were bagged up with those animals and cast 'dans le fond de la Mer ou d'une Rivière'.

Out and out criminals having been thus disposed of out of hand, Mercury proposes the personal examination of those remaining. At this juncture Hercules intervenes to demand that Alexander be included, and Silenus needles Romulus by suggesting that he, singly, may prove worth all the rest put together – the remark which leads Wind to his Greek-protestant, Roman-papist equation. It is decided that only leading contenders need be considered: Alexander, Julius Caesar, Octavius, Trajan. Saturn speaks up for philosophy, and Marcus Aurelius is added to the list. Bacchus (since the gods can lack for nothing) facetiously argues for a hedonist, and so Constantine the Great is allowed at least a look-in. Each of these six (and there are six figures, significantly, in the Alexander-led group in le Pautre's engraving) is permitted a speech on his own behalf, the lot to begin falling to Julius Caesar. Motives, however, being deemed as important as achievements, cross-examination follows, this time beginning with Alexander whose third-degree ends, literally, in tears.

Could those familiar enough with *The Caesars* to recognize in it the inspiration for the scheme Verrio was required to execute be relied upon, nevertheless, to forget all about this episode? Or, remembering it, would anyone be quick to conclude that Alexander must, perforce, represent William III? Silenus, questioning Alexander's right to be called a conqueror when, in reality, his soldiers had won his battles for him – and in the painting a bearded veteran peers round a pillar behind, as if asking for acknowledgement – begins to recite some bitterly apposite reflections of the aged Peleus (father of Achilles) from Euripides's *Andromache*,[31] only for Bacchus to interrupt and warn him that he is courting Cleitus's fate: the insubordinate lieutenant whom Alexander had drunkenly struck down with the self-same verses on his lips. No sooner done, this bloody deed, than regretted. The tears, therefore, are not necessarily discreditable; but bibulousness and rash choler were hardly William III's habitual style, 'ordinarily so saturnine and reserved', as Macaulay observes, except when 'danger acted on him like wine'.[32]

The child of Saturn amongst Julian's final triallists is, manifestly, Marcus Aurelius; 'that most sublime pattern of Vertue and Philosophy', as Burnet had called him in *A Sermon Preached at the Coronation of William III and Mary II, April 11, 1689*, who

> in a Reign of almost twenty Years continuance, is represented by all the Writers of the succeeding as well as of his own Age, as so perfect a Pattern, that there never appeared either in his private Deportment, or in his Government, one Single Blemish. He was never once seen either transported with Anger or with Joy. He was never charged with one Light Word, or any one Rash Action. He lived in a perpetual Application to the Affairs of the Empire, and in the intervals of business, even in his Expeditions and Camps, he was imployed in those profound Meditations of Philosophy, which carry the Noble Title *Of Himself*

to Himself.[33]

'It is hard to set forth any of the Vertues that become Princes', he affirms, on a slightly later State Occasion,

> without some memorable Instance out of the Life of *Marcus Aurelius*, who all Writers represent as the compleatest Pattern of a perfect Prince.[34]

Again, six years on, 'before the KING at Whitehall' and in thanksgiving, this time, for the peace temporarily achieved by the Treaty of Ryswick, he harps once more upon the same string, observing that 'Forced Rhetorick and hired Panegyricks lye thick in the lives of some Princes who have deserved them the least', and reflecting that 'Perhaps *Commodus* had as many Flatterers, as his incomparable *Father* had silent Admirers' – a speculation which could owe something to Spanheim's note remarking upon 'les plusieurs Médailles Romaines' struck, improbably, in the former's honour, celebrating the *'Felicité des Temps'* and proclaiming (but this is the legend of a Greek example from Bithynia) *'que Commodus Regnant le Monde estoit heureux'*; which could not have been further from the truth.[35]

Commodus was Marcus Aurelius's worthless son whom, fondly hoping for improvement with age, and despite having a son-in-law who could have done the job much better, he appointed his successor: an error of judgement which Julian's Silenus is quick to pounce upon. Nor is it just a matter of 'one Single Blemish', either. Divine honours decreed after death to a less-than-deserving wife are also called in question. But if Burnet's 'compleatest Pattern of a perfect Prince' was not too good to be true, still, he represents the best that can reasonably be hoped for, and an infinite improvement over, for instance, 'Alexander, falsely styled the Great', or Julius Caesar, whose 'names' Burnet resolved, on his appointment as tutor to Princess Ann's sole surviving son-and-heir, 'to make . . . ever odious in his eyes. Their [example] even from then cradle infects nearly all princes with distorted principles.'

Silenus, for his part, is also remarkably free with their reputations, but impressed, in spite of himself, with Aurelius; and better gods besides, who mostly vote for him at the end of the day. And when, by way of conclusion, each contestant is required to go and join his celestial paragon or patron, 'Marc Aurèle se tint ferme auprés de Jupiter, & de Saturne': the *vir activus* and *contemplativus* in steadfast combination – Michelangelo's Giuliano and Lorenzo de'Medici rolled into one.[37] Meanwhile, of the others, 'Aléxandre courut vers Hercule; Auguste vers Apollon'; Julius up and down every which way until taken pity upon by Mars and Venus; Trajan to Alexander.

> Pour Constantin, comme il ne trouvoit point de Modéle de sa vie parmi les Dieux, ayant aperçeu la Molesse proche de luy, il s'alla ranger auprés d'elle.[38]

'Molesse' ('Τρυφή' in the Greek: 'Softness', 'Delicacy') then hands him on to ''Ασωτία', 'Prodigality', and a Christianity custom-made for prodigal sons, with its shameless assurance:

> *Ho! Whosoever is either Sodomite, Murderer, Rogue or Villain, let*

him dread nothing but repair hither, with this water I'll make him
*clean in a trice: And if he shall happen (*as humane Nature is frail*) to*
repeat the same Crimes, if he will but thump his breast, and box his
noddle, I'll warrant him as Innocent as a Child unborn.[39]

Julian, Spanheim comments,[40] writes as though the penitence enjoined upon
the Christians of his day was hollowly ritualistic: a matter of merely going
through the prescribed motions. He begs to differ; but 'Philaretus
Anthropopolita' has no doubt as to why a modern 'Loyalite' will blench from
a passage which he himself can render with a full-blooded, truly reformed
and Protestant relish. (Even he, however, might have been slightly taken
aback to discover that these words, in the original, do supposedly come
'from Christ immediately' and not, as in the reading then current, from
Constantine's son, Constantius.)[41]

Spanheim, for his diplomatic part, 'protestant plus que convaincu, fervent'
though he may have been, yet carefully prefaces his translation with that
proviso which has already been quoted about how unjust it would be to make
too much of 'la haine d'un Payen & d'un Apostat, contre le premier & le plus
célébre d'entre les Empereurs Chrétiens'[42] – a rider perhaps no more scholarly
than prudent, given his place of publication and in the light, say, of Louis
XIV's minister, Colbert's request to Bernini to make his projected statue of
the Sun King 'similar' to the equestrian *Constantine* he had sculpted for the
'Scala Regia' ('Royal Staircase'!) in the Vatican – 'but to vary it a little so
that nobody could say it was a copy'.[43]

'Now view at home', enjoins Dryden in *Britannia Rediviva*,[44] 'a second
Constantine; / (The former, too, was of the *Brittish* Line)'. He means James
II, of course, piously bent upon the reconversion of his people; but the emperor
had been 'view[ed] at home' on a regular enough basis before – in the shape,
once, for instance, of James's pacific grandfather in *An Holy Panegyrick*
preached on 24 March, 1613, by Joseph Hall who finds the analogy so
compelling that

> I may not omit how right he hath trod in the steps of that blessed
> *Constantine* in all his religious proceedings. Let us in one word parallel
> them.

In the event, it takes two hundred or more, 'and James's church triumphant
is already seen approvingly as an intolerant church', as Graham Parry remarks,
having quoted the passage in *The Golden Age Restor'd*.[45]

William himself, obviously, could not expect to escape the comparison:
was bound to see himself sooner or later whirligigged by the panegyrical
merry-go-round into 'Some *Moses, Joshua, Jephtha, Constantine*, / Some
pious *Hercules* of Race divine' – as here (by irresistible inference) in the dead
vast and middle of Sir Richard Blackmore's epic, *King Arthur*.[46] He is, too,
the eponymous *Constantinus Redivivus* of John Whittel's '*account of the
wonderfull providential Successes that have all along attended the Heroicall
Enterprises of his present Majesty*';[47] and Burnet has already been heard alluding
to 'a Deliverer, from this Island, *Constantine*',[48] though he chose, on that
occasion, not to develop the parallel. Shortly, however, he was to expand on

it, preaching on the 'Day of Thanksgiving for His Majesties Preservation in
Ireland', October 19, 1690, when, to illustrate

> The Methods by which God has raised up Kings and Empires for the
> advancing the Glory of his great Name, for the punishing and humbling
> of persecuting Tyrants, and for giving Salvation and Protection to his
> People,

he adduced not only Constantine's miraculous victory over Maxentius at the
Milvian Bridge, but also his preservation from the plots of 'his Father-in-law
Maximian, who had abdicated the *Empire*' only with a disingenuous intention
of reclaiming it when an opportunity arose.[49]

> His Fore-Head resembled that of *Julius Caesar*, his Eye that of *M.*

Antoninus the Philosopher, his Nose that of *Constantine* the Great,
concludes Robert Fleming with sublime moderation (no wonder William had
sought his advice on Kirk affairs!), judging, he claims, Spanheim-like, 'From
the Observations I have made upon Ancient Medals, which, I may say, I
have perus'd with some Care.'[50]

The figure in golden armour who shares the centre-foreground with Julius
in the Hampton Court tableau seems, certainly, to be significantly enough
nosed: may, therefore, be meant for Constantine, but (unless Verrio is up to
his Italian tricks again) scarcely for William. The companion-imp to the one
venting opprobrium on 'Caligula' blows contempt crosswise upon him, and
he appears, besides, to fear that he may be Nemesis's intended target. With
the author of *The Caesars in cathedra* on one wall, no one could reasonably
look for William to be Constantined in compliment alongside – or Alexandered,
for that matter. The turn of the work is against it.

But for 'M. *Antoninus* the Philosopher', for Marcus Aurelius, who had,
moreover, been extolled on more than one state occasion and in the King's
presence by Burnet as the pole star of princes: most lengthily and importantly
in his Coronation Sermon of April, 1689. Here,

> The different State of the *Romans*, when they passed from the vicious
> Reigns of such Execrable Monsters, as *Tiberius, Caligula, Nero*, and
> *Domitian*, to the happy times of *Trajan, Hadrian, Antonine*, but above
> all, of that most sublime pattern of Vertue and Philosophy, *Marcus
> Aurelius*,[51]

is vividly evoked. 'In the former, nothing was studied but Vice land pleasure'
(shades of Rochester, and Robert South's 'Diabolical Society, for the finding
out *new Experiments* in Vice').[52] 'Flattery, and an obsequious courting of
every Creature of Fortune and Favour' was the order of the day. 'The whole
business of the Court was to corrupt and debase the Senate' (hadn't James
lately done his best to pack Parliament?):

> Spies and Informers were every where imployed, to engage Men
> into Discourses and Plots, which were to be betrayed, while corrupt
> Judges [like the infamous Jeffreys?] and false Witnesses [the Titus
> Oatses and Israel Tonges of the day] were sure to carry all things
> before them.

Religion 'was vitiated by impudent mixtures of the most shameful Idolatry'. Emperors 'that were the reproach of Humane Nature, had divine Adorations payed them'. 'Their great City was laid in Ashes, only to gratify the wild Frolicks of an extravagant Tyrant.' 'Warlike Spirit'was enervated by Luxury and dissoluteness; and the Empire it self was exposed, first to the contempt, and then to the Inroads of their formerly subdued Provinces – (and so ships of the United Provinces, previously cowed by Cromwell, had sailed humiliatingly up the Medway, Dunkirk been sold to the French and all hard-won respect for British arms abroad utterly dissipated). Under evil emperors, in short, Rome had repeatedly gone from bad to worse to the very dogs,

till a fatal Revolution, or a deadly stroke awakened Men out of their Lethargy.

But this side of the Picture, is not more hideous than the other is glorious;

and most glorious of all in the spectacle of 'that most sublime pattern of Vertue and Philosophy', '*Marcus* in a Reign of almost twenty Years continuance'. (William's might plausibly have been expected to last that long.) But where is this paragon, this Marcus, in Verrio's picture?

20: More than Conqueror

Il comparut en même temps avec une mine grave, les yeux enfoncés, & les joües tirées, a force de travail & de contention d'esprit. Aprés tout, on vit paroître en luy une beauté d'autant plus admirable, qu'elle estoit negligée, & qu'il ne prenoit aucun soin de la faire paroître. Aussi avoit-il une grand'barbe, un habit simple & modeste, & l'abstinence luy avoit rendu le corps luisant & aussi transparent, qu'on pourroit dire de l'air le plus pur & le plus serein.[1]

Marcus Aurelius's first appearance in *The Caesars* had yielded no physical details. Now, summoned by Saturn to take his place amongst the six 'finalists', the omission is made elaborately good. And, though the adjacent Julian is comparably hirsute, there is only one conspicuously bearded Caesar on the back wall, just, incidentally, as there is only one among the five following Alexander in le Pautre's frontispiece. In Verrio's composition this bearded figure stands on the right, making a group with Nero and a third emperor in between who, turning his back on the onlooker, rolls up his eyes apprehensively towards Nemesis, sousing from above but evidently more interested in the other side of the picture. This third party represents, perhaps, Tiberius who, we are told, when viewed from the front, displays 'toutes les marques d'un homme prudent & brave' but, turned around, reveals a back 'plein d'éleveures, & de cicatrices honteuses': the pustules and scars of debauchery, disease and desperate remedies.[2] Naturally, one cannot see through his cuirass in the painting, but 'une facheuse demangeaison', 'a deplorable itch' might give unconventional point to the somewhat exaggerated version of the hand-on-hip pose which, more usually indicative of easy assurance, arrogant nonchalance or even downright defiance, seems ill-assorted with the upturned eyes.

Possibly, then, he is meant for Tiberius. To his right, Nero, thanks to the guitar, is quite unmistakable, gazing towards Apollo. The bearded emperor stares intently in the opposite direction, into the air between his companions' heads, frowning, abstracted – and arguably as reminiscent of Julian's description of Hadrian as of Marcus; Hadrian being another 'homme à grand'barbe, d'une démarche fiére, & [which might make his proximity to Nero a puzzle] entre autre choses fort sçavant dans la Musique': 'Il levoit ordinairement les yeux au Ciel, & sembloit fort adonné aux curiositez les plus défenduës'.[3]

Silenus wickedly suggests that he may paederastically be peering after his beloved boyfriend, Antinous, a famously shapely and much-sculpted youth who was deified by the desolated emperor after drowning himself in the Nile. Rumour had it that William, also, had his Arnold Van Kepple to console him for the loss of a wife and put his old crony, Bentinck's nose out of joint into the bargain; but, malicious gossip apart, there seems no other reason for

introducing Hadrian here. Besides, the figure is peering, if anywhere (and as Nero regards Apollo), towards Mercury and Julian himself: author, as Bickham notes (ignoring *The Caesars* along with everything else he wrote), of

> a Satirical Letter, that he call'd *Misopogon*, or Beard-hater, as a
> Testimony of his Contempt of the People of *Antioch*,

where the fashion was for clean-shaving and his own 'thicket for wild beasts' (*videlicet* lice) had attracted derisive comment.[4] The shared beards, that is, could well be diagnostic: badge of a shared penchant for philosophy.

> Go too now and tell me of Alexander and Philippus, and Demetrius
> Phalereus. Whether they understood what the common nature
> requireth, and could rule themselves or no, they know best themselves.
> But if they kept a life, and swaggered; I (god be thanked) am not
> bound to imitate them. The effect of true philosophy is, unaffected
> simplicity and modesty. Persuade me not to ostentation and vainglory.[5]

Marcus Aurelius, remarks Peter Brown in *The World of Late Antiquity*, characteristically 'looks at the world as if through the small [he means the 'large', the 'wrong' or reducing] end of the telescope', with the result that even

> the Danubian campaigns by which he saved the empire in 172-5 and
> 178-80 strike him as 'puppies fighting for a bone'.[6]

Very wise puppies, it follows, will Alexander, Julius Caesar and company appear, as depicted by Julian, disputing not who saved an empire but who conquered the biggest the quickest against the most formidable opposition.

And where will William fit in, whose campaigns had sustained Protestantism in Europe?

> I am certain in his proudest tryumph (pardon the Barbarity of that
> Epithet) he would have taken it very disdainfully to have been saluted
> with the Address of the Thief to *Alexander*, viz. To be Entitled that
> *Greatest of Robbers*, however otherwise glorious Name, a *Conqueror*.

Such, at least, was the opinion of the author of *An Account of Mr. Blunts late Book, Entitled, King William and Queen Mary Conquerors, now under the Censure of the Parliament* (London, 1693, p. 6). Under the censure of this same Parliament, served up by his enemies as dessert to Blount, Burnet's *Pastoral Letter* of 1689 was likewise (though by a mere seven votes) condemned to be burnt –

> Some wag cried out 'Burn it; burn it;' and this bad pun ran along the
> benches, and was received with shouts of laughter[7] –

for having argued that William might legally have claimed the crown 'in the right of a Conquest' over his predecessor:

> But he chose rather to leave the Matter to the Determination of the
> Peers and People of *England*, chosen and assembled together with
> all possible freedom, who did upon that declare him their King; so
> that with relation to King *James's* Rights, he was vested in them by
> the Successes of a Just War, and yet he was willing, with relation to
> the [P]eople, to receive the Crown by their Declaration, rather than
> hold it by the Right of his Sword.[8]

But 'but me no buts' was the hue and cry: ' "Ha! Ha! The fox!" and after him they ran', roughshod over delicate distinctions with relation to 'King *James's* Rights' on the one hand, and what might be equitable 'with relation to the [P]eople' on the other.

> Had now *Pythagoras* liv'd, he would have said
> *Hugh Peter's* Soul had Transmigration made
> Into thy Bulk, and not more damn'd could be,
> Than as, in Spirit, he survives in thee,

taunts *The Pastoral Letter Reburnt by a Poetical Flambeau*.[9] 'So let O.P. or P.O. be King, / Or anyone else, it is the same thing', and Burnet merely a second edition, augmented of Hugh Peter (or Peters): Cromwell's sometime chaplain and the so-called 'Canterbury' of his revolutionary day who had been hanged, drawn and quartered as one of the unpardonables in 1660.

But Burnet's 'But' is important. *Victoria in regem* and *victoria in populum*, as 'the most eminent jurist of his day',[10] Sir Matthew Hale had argued a generation ago, with his eye on 1066 and all that, are to be carefully distinguished. So the present William, having acquired all James's personal 'Right and Title . . . in the right of Conquest over him', nevertheless is prepared to accept that he is possessed, so to speak, of only half a pair of indentures without 'the Determination of the Peers and People' in Parliament. What 'with relation to King *James*' he had justly taken, 'with relation to the [P]eople' he was justly 'willing . . . to receive'; and

> as he came detesting the Imputation of Conquest that was cast on
> him, so he was received in a way suitable to his good Intentions,

as Burnet had already approvingly observed, preaching 'before the Prince of Orange' at St James's, 23 December, 1688.[11]

'He came detesting the Imputation of Conquest'; continued to hate it as, politically, a poisoned kiss. It was good sport, therefore, against most of the evidence, to turn Burnet, earnestly trying to be all things to all men, into a hybrid of Judas Iscariot and a lickspittle of Tyrannosaurus Rex. And it will follow, likewise, that comparisons between William and Alexander might prove, in ways not dreamt of by Wind, not at all 'suitable to his good Intentions'. '*Alexander . . . Greatest of Robbers*' and 'falsely styled the Great', as Burnet himself has been heard to avouch, will turn at a touch into 'P.O. the *Grand Thief*' into 'William the Conqueror' with 'Norman Yoke' new-made in Holland; though indeed,

> whether the invidious Name of Conqueror which this King [the first
> of that title] had so carefully avoided, were entailed upon him by the
> Flattery of his Friends or the Malice of his Enemies, among whom
> the Monkish Writers seem to have been the chief and most inveterate,

is, contends Sir William Temple in his *Introduction to the History of England*,[12] a moot point.

Temple sees all the time double. 'The Whigs', E.R. Wasserman has noted, apropos of *Windsor Forest* in *The Subtler Language*,[13] 'apparently felt that they could not settle the right of William III without also settling the right of William I' – not upon conquest, but '*the Election and Consent of the People*.

To whom he swore to observe the Original Contract between King and People';
or so the re-vamped title-page of the 1689 re-issue of E. Cooke's *Argumentum
Anti-Normanicum* (originally published as a contribution to the Exclusion
Crisis in 1682) would have it believed.

So 'the invidious Name of Conqueror' was, is, of neither William's seeking,
but the imposition of either flattery or malice: the latter in the case of *Windsor
Forest*, where, far from 'detesting the Imputation', 'Our haughty *Norman*
boasts that barb'rous Name',[14] and 'Our haughty *Dutchman*', by implication,
also ('who regarded even his own consort as ill-born because of her Hyde
blood').[5] 'Proud Nimrod first the bloody Chace began'.[16] They, hot with 'a
foreign master's rage', spur despotically after, wreaking havoc 'With wrongs
yet legal';[17] which is as much as to say, 'wrongs yet rights': 'forest laws'
('forest' and 'foreign' spring from the same root) as distinct from the home-
grown 'common law' of the land, which does not trample over the produce
of 'kind Seasons'[18] and is 'form as proceeding' as opposed to arbitrary 'shape
as superinduced'.

But 'The Swain with Tears' and 'Subject starv'd'[19] are a Popean, not to
say popish, 'Monkish' invention (Pope being one of those who stubbornly
persisted in deriving their 'Religion from *Constantine's* Bishops'). In fact,
claims Temple (without saying where exactly he gets his facts from), William

> took care not to provoke the Commoners, by leaving Pasturage free
> for such of the Neighbours who lived most upon their Stock, and
> thereby took no great Offence at the Restraint from their Sport which
> they had not Time from their Labour much to follow; yet the Nobles
> and Knights, who valued their Sports more than common Gains, and
> made use of their Riches but for Encrease of their Pleasures; resented
> this Restraint as a sensible Injury, as an Invasion of their Liberties,
> and even as an Affectation of Arbitrary Power in this Particular.[20]

How utterly unreasonable of them!

Hungry for hunting - after all 'the only Pleasure to which this Prince was
addicted' (both Williams being alike in this respect) – the so-called 'Conqueror'
strictly curtailed the sport of others in order to guarantee his own; or perhaps
he wanted to augment his income from the consequent fines; or may be even
acted

> from a Desire of being absolute and arbitrary in one Part of his
> Government, which he found he could not be with any Safety in the
> rest.[21]

So the Forest Laws were an exception to prove the rule: by no means typical
of the régime in general, a mere safety-valve, William having resolved prudently
and 'upon mature deliberation',

> not only to continue the Laws and Customs of the Realm, but to give
> the People new, and more evident Assurances of this resolution, in
> pursuance whereof he granted and confirmed them by a publick and
> open Charter, and thereby purchased the Hearts, as well as Satisfaction
> of his English Subjects[22] –

'common Subjects' especially, 'who ask nothing but Security in their Estates

and Properties'[23] and are characteristically 'not so apt to trouble themselves about the Rights and Possession of a Crown as about their own'.[24] Hence their indifference to the 'undisputed Right (which they say never dies)' of the Atheling, the Saxon Pretender, 'stiled England's *Darling*', but no proper Charlie for all that, since, coming to a composition with William and

> returning to *England*, he passed the rest of his Life in the Ease and
> Security of a large but private Fortune; and perhaps happier than he
> might have done in the Contests and Dangers of Ambition, however
> they might have succeeded.[25]

No '15 or '45 for him!

'Great Nobles', then, eager to recapture their own sporting lives, irritated by 'the King's too apparent Partiality to his *Normans*', ulterior motive writ large, might agitate 'in favour of a better Right and Title'; and resentful clergymen likewise, religiously opposed to

> The Provision he made for so many poor *Normans*, by disposing
> them among the rich Monasteries to share in their Plenty.[26]

But among 'the Commoners of the Realm', the great 'Mass of the People', 'most were satisfied because they either liked their new King, or hated the last Usurper'[27] – and because, as Temple constantly reiterates, they felt fundamentally secure in their own properties and rights, the Forest Laws being wholly exceptional and scarcely affecting most of them anyway. As William

> had claimed the Crown, only from the Testament of King *Edward*,
> and wholly avoided that odious Name of Conquest, so he expressed
> upon all Occasions, his Resolution to govern the Kingdom as a legal
> Prince, and leave the ancient Laws and Liberties of the *English Nation*,
> as they had before enjoyed them.[28]

And, argues Temple, he was as good as his word. In sum, William then reigned as William now, neither as conquerors, whatever 'Monkish Writers' (who had similarly dubbed Julian indelibly 'Apostate') would disingenuously insinuate.

But Alexander was, egregiously, 'the Great' through conquest: had 'cry'de', it was a commonplace (witness Waller's *Panegyrick*), for 'more Worlds' to subjugate should this one, at last, fail to afford grist to his insatiable mill. Yet

> If we compare this great Conqueror with other Troublers of the World,
> who have bought their glorie with so great destruction, and effusion
> of blood,

and if we are Sir Walter Raleigh, we will reckon him, nevertheless, 'farre inferiour to *Caesar*'; so that on this score Julian's Romulus was worrying, perhaps, unnecessarily.

> He safely might old Troops to Battail leade
> Against th'unwarlike *Persian*, and the *Mede*,

proclaims the *Panegyrick*,[29] rehearsing old arguments, the comparison now being, inevitably, between Alexander and Oliver Cromwell, who had subdued one particularly savage and intractable northern race beyond even Caesar's 'veni, vidi, vici'. 'Fortune and Destinie (if we may use those termes)', affirms

Raleigh,

> had found out and prepared for him, without any care of his owne,
> both heapes of Men, that willingly offered their necks to the yoke,
> and Kingdomes that invited and called in their owne Conquerors.

As had Great Britain William of Orange? Not a question which supporters of constitutional monarchy wanted asked, any more than they would have relished their man (imported, remember, to maintain laws which 'were like the dykes of Holland') being linked with Raleigh's last word on Macedonian ambition, which also happens to have been Seneca's:

> who speaking of *Philip* the Father, and *Alexander* the Sonne, gives this judgement of them . . . *That they were no lesse plagues to mankinde, than an over-flow of waters, drowning all the levell; or some burning droughth, whereby a great part of living creatures is scorched up.*[30]

21: A King Divine by Law and Sense

'Go too now and tell me of Alexander and Philippus': Marcus Aurelius, like Seneca a stoic, like Seneca thinks poorly of the pair of them. 'If they kept a life, and swaggered', he (God be thanked) was not bound to imitate them, Ancient Pistols of the Ancient World. 'Unaffected simplicity and modesty' were his desiderata, and (according to Herodian) 'not so much respect to ancient Nobilities or great Wealth', when it came to a choice of sons-in-law, 'as to their Excellence in all Morall & Intellectual Endowments'; which ought to have pleased the meritocratic Defoe.

> In a word, he was the only Emperour that shewed himselfe a Wise Man, not only in Words or Edicts, but in Gravitie and Continencie of life.[1]

'Persuade me not to ostentation and vainglory.'

This, suggests Burnet in his sermon of thanksgiving for the Treaty of Ryswick, is equally William's way:

> A PRINCE, who has the just and Noble Ambition of meriting Fame and Glory, without the troublesome Vanity of shewing it, who deserves all the Return of Duty and Gratitude from his People, without being fond of hearing or seeing it express'd, though in the highest Form of a just Magnificence.

Both are to be numbered among that select band of 'best Princes'

> who feel the pleasure of making their People happy most sensibly, and yet are uneasy and in pain, when in compliance with what is not only decent but almost necessary on Solemn Occasions, they submit to hear it acknowledge'd though in Strains far below the Dignity and Majesty of the Subject.[2]

Something of the sort being 'not only decent but almost necessary' to a king's staircase in a royal palace, Verrio's paintings themselves might be ascribed to 'the troublesome Vanity of shewing it', though 'the highest Form of a just Magnificence' is not a description which has sprung readily to art historians' minds since, despite the painter's elevated contemporary reputation. Horace Walpole, with only a half-century of hindsight, was to characterize him as 'a Neapolitan; an excellent painter for the sort of subjects on which he was employed; that is' – and here comes a series of blows to send him sprawling as helplessly as Pope's rabbit-punch in the *Epistle to Burlington* –

> that is, without invention, and with less taste, his exuberant pencil was ready at pouring out gods, goddesses, kings, emperors, and triumphs, over those public surfaces on which the eye never rests long enough to criticise, and where one should be sorry to place the works of a better master, – I mean ceilings and staircases. The New Testament or the Roman History cost him nothing but ultramarine; that and marble columns and marble steps he never spared.[3]

The works under discussion were not even among his better efforts. His pro-Stuart, papistical heart was not in them. Condescending at last to serve

King William, he was 'sent to Hampton Court, where among other things, he painted the great staircase, and as ill as if he had spoiled it out of principle'.[4]

Not that Walpole's eye has rested long enough to register mingent cherub or misplaced Pisces: what concerns him is the overall aesthetic effect. ('After gold and silver', incidentally, 'ultramarine was the most expensive and difficult colour the painter used', and hence the 'ultramarine gesture' identified by Michael Baxandall in Quattrocento painting which, however, 'became less important' as the 'conspicuous consumption' of 'precious pigment' gave place 'to an equally conspicuous consumption of something else – skill'.[5] So much then for Verrio's reversion to the tactic three hundred years on!) Wind, in his turn, speaks of 'forbidding scenes' and 'that pompous style of allegory' which produces them, and essentially agrees with Walpole's aesthetic judgement. He notes, nevertheless, that 'the fascination of the programme . . . stands in strange contrast to the mediocrity of the execution'.[6] Stranger contrast still if all this 'pompous style', expense of ultramarine, welter of simulated marble has been deployed in recommendation of someone whose golden rule was, 'Persuade me not to ostentation and vainglory': who left it to Alexander and his ilk to have 'kept a life, and swaggered', and viewed without enthusiasm all 'the troublesome Vanity of shewing it'.

Looking, however, for William's match and marrow in the painting, whom should Wind's eye rest upon *but* Alexander, hitherto supposed Aeneas, 'inviting the Twelve *Caesars* . . . to a celestial Banquet',[7] but now revealed in true, more combative colours thanks to Julian's satire. True, Julian's own 'Love of Glory transported him sometimes to Excess', as Eutropius, in a passage quoted in the *Apelles*, but omitted in Bickham's *Deliciae*, admits. Yet, 'To conclude he very much resembled *Marcus Antoninus*, whom he was very desirous to imitate'.[8] 'To the resemblance and imitation of whom he framed all his actions & whole deportment', affirms Ammianus Marcellinus.[9] And so they are depicted like-bearded, with Marcus gazing intently in the direction of his disciple, his back turned upon all the puppet-making going on or being mooted centre-stage.

'Ce faiseur de Poupées, it will be recalled, is Silenus's put-down of the aspiring Octavius, whom the world has to thank for 'un grand amas de belles Statuës & d'Effigies de Divinitez véritablement salutaires'; which is as much as to say, in plain English, plainly useless: the concrete results, Spanheim's note explains, of his having introduced to Rome the custom of 'l'*Apothéose* ou Consécration, qui metoit les Empereurs, aprés leur mort, au rang des Dieux.[10] However Hobbes – the passage has already been quoted in connection with Waller's *Upon the late Storme* – Hobbes would have such 'Canonizing of Saints' to be as old as the Eternal City itself: maintains that 'The first that ever was canonized at Rome, was Romulus', on Julius Proculus's say-so and the Senate's subsequent and most politic '*publique testimony*'; adds that

> *Julius Caesar*, and other Emperors after him, had the like *testimony*; that is, were Canonized for Saints; for by such testimony is CANONIZATION, now defined; and is the same with the Ἀποθέωσις of the Heathen.[12]

Here he is then, the primal Roman Saint and exemplar of all 'popetry' to
come, making intercession for all his imperial 'Neveux' on the wall at Hampton
Court. Here, too, is Alexander, anxious to assert, with the help of his own
'patron-saint', Hercules, his own Divine Right. Here is Marcus Aurelius,
looking the other way, towards Julian the Apostate, whose presence puts a
cat among canonical pigeons, calls accepted encomiastic standards in question,
causes Wind (Walpole's 'never' notwithstanding) to stay his eye on these
'public surfaces . . . long enough to criticise': calls, in brief, for intelligent
assessment as opposed to easy assumption,

For *Princes* more of *solid Glory* gain

Who are *thought fit*, than who are *born* to *Reign*,

as Shadwell had proclaimed, with William very much in mind, in *A
Congratulatory Poem to the most Illustrious Queen Mary upon her Arrival in
England.*[13]

Perhaps Wind, despite his insights into 'the fascination of the programme',
does, in the end, too easily assume – that Alexander the Great, as a Greek
with a sufficiently impressive panegyrical pedigree, must represent the
challenger of more modern Roman ambitions. But Marcus Aurelius, though a
Roman and grouped with Romans, nevertheless wrote in Greek; a habit he
shared, as well as the diagnostic beard, with the Apostate alongside, both
being philosophically inclined: committed, that is, to 'conscious thinking' as
a matter of principle. 'Il se moque agréablement', writes Spanheim, introducing
the latter,

& sans égard à son interest particulier, de cette coûtume introduit par
Auguste; de cette flatterie, ou de cette Politique de Rome Payenne, de
mettre des hommes aprés leur mort, & des hommes souvent
abominables, de les mettre, dis-je, au rang de ses Dieux; d'en faire
des objets de son cult & de son adoration.[14]

What was that cry from '*Exeter*, Nov. 5, 1688'?

Away this Goblin Witchcraft, Priestcraft Prince;

Give us a King, Divine, by Law and Sense.[15]

Could this be the import of all those, if Silenus is to be credited, largely
unedifying, sub-lunar antics depicted on the back wall, after Julian's
sardonically disinterested prescription? Away – to re-cycle a punning phrase
from Ben Jonson's *Sejanus*[15] – away with 'idol lordship': with magic and
mummery, apotheosis, canonization, Divine Right; and with the vainglorious
boasts of birth and conquest. 'Give us a King, Divine, by Law and Sense':
someone '*thought fit . . . to Reign*'; a competent 'Manager', lack though a
'Manager' may something of the charism of an autochthonous 'Genius of
the place'. If, of course, 'Wonder en is gheen wonder', this will scarcely
matter; though Protestant Winds, naturally, were always welcome and some
Williamite clergymen had been known to make heavy meals out of them: the
chameleon's dish!

How, though, will all this square with the contiguous wall, where sun not
moon presides, and the words of Mercury have given place to the songs of

Apollo? Where, instead of 'des hommes . . . & des hommes souvent abominables' jostling to 'get a Deitie' and climb the cloudy extensions of a celestial Scala Regia, the gods themselves descend with us to dwell in peace and harmony: most centrally Ceres, a type of 'Astraea redux', whose loaves and armful of ripe corn contrast with the apparent emptiness of the emperors' table which, with its harpyan buttresses of double-headed, imperial eagles, occupies the same level in the adjacent scene. It is, indeed, 'couverte', this table, as specified in *Les Césars*,[17] but barely so: there is nothing about it to indicate more nourishment than Diana's moonshine on the tablecloth. Good cheer, seemingly, stops short with Bacchus, and most of what there is of it, is being borne upwards for the gods' delectation. Silenus's gesture is one of rebuff.

To the side, it is quite otherwise. Earth, from its cavernous mouth, utters riches at no cost: flowers, fruit, fine pottery and precious plate. The gods make music, rivalries forgotten.

Iam redit et Virgo, redeunt Saturnia regna;
iam nova progenies caelo demittitur alto . . .

'When, in the fourth eclogue', remarks Bruno Snell, Virgil

announces the hope that the birth of a certain small boy will mean the beginning of a new and blessed era, he is hoping for a miracle. This means that, as a matter of principle, he pays no attention to the fact that politics is grounded in reality . . . Political thought thus breaks into two, ideology and *Realpolitik*, with the attendant danger that each of these two will pursue its own journey without paying much attention to the other.[18]

The decoration of the King's staircase might have been designed to propound the problem. Under a shared ceiling-sky, the alternatives are juxtaposed. Virgilian 'miracle' and willing suspension of disbelief rub shoulders with apostatical '*Realpolitik*'. Fondly poeticized, idyllic vision of a future 'standing Serenity, and perpetual Sun-shine' flanks a harsher, more sceptically prosaic and satirical survey of the 'lunatic' vicissitudes of historical reality, with its pageant of twelve assorted Caesars. Endless summer and 'Saturnian times' are set against the wintry mockeries of saturnalia and chronic experience. Each tells off the other, so that a king, climbing his staircase beneath, might find himself (should his eye ever rest long enough to criticize) in an interestingly questionable position.

With the new century, as *Carmen Saeculare* shows, came hopes for the beginning of a new era, fostered by the false dawn of Ryswick (a peace which Prior himself had been instrumental in negotiating). But if Virgil, in his day, had expected a miracle, it hadn't happened – unless, as Christian exegesis claimed, it was the birth of Jesus, Whose 'kingdome', however (and as Benjamin Hoadly was whiggishly to point out in 1717, preaching before George I), 'is not of this world':[19] 'Christ's No Kingdom here', in Pope's sarcastic summation.[20] Political reality for Rome meant, after Augustus, Tiberius; then Caligula, Claudius, Nero: the procession paraded through the pages of *The Caesars* and selectively represented on the wall at Hampton Court – which

includes, of course,

> (that I may give ye one instance that there was once one good
> Emperour; for with much ado I can make it out)

Marcus Aurelius.

The 'I' speaking here is Folly in Erasmus's *Praise* (or, more strictly, John Wilson's 1668 version of it), mischievously bent on demonstrating that philosophy is worse than useless to a statesman. Even Aurelius is only apparently an exception: just 'good' enough to have 'become burthensome and hated of his Subjects, upon no other score but that he was so great a Philosopher'. His degenerate son is thus a prime example of 'Nature, it seems, so providentially ordering it, lest this mischiefe of Wisdome should spread further among mankind'.[21] The world, according to Folly, is one expressly created *not* to 'go the faster for our driving', 'conscious thinking' or civil (or genetic) engineering.

Still, hope springs eternal. Time on the ceiling looks to a flowery future, although Verrio (his Roman Catholic sensibilities understandably piqued by what he had been asked to paint) seems only just to have restrained himself from having it piss in his eye. Instead, as has been seen, the stream descends a little more decently and directly (and, unless one is looking for it, unobtrusively) into as dainty a dish as was ever, in all innocence, set before a Jupiter and Juno.

Even discounting such unofficial interpolations and '*Italian* Bite', the programme as authorized seems to have been carefully devised to provoke more than starry-eyed adulation or blasé wall- (or Walpole-) eyed indifference. If Marcus Aurelius is the man, we have some ado to make him out, and need to think apostate thoughts to do so. Our Hero is not being sucked heavenwards in an irresistible vortex of steepling perspective, 'on the back of an imperial eagle and globe', guided by Justice and backed by Faith and Religion, like King James I, centre-ceiling in the Banqueting House at Whitehall. But then, if Roy Strong is right, Rubens's key text had been James's own, divinely-right *Basilikon Doron*, which is as far a cry from Julian's *Caesars* as one can get.[22]

There is, however, what appears to be one apotheosis on the stairwell ceiling (Pls 1, 5). In the back, right-hand corner, a dark-haired woman is being carried aloft by an angelically youthful Aion, or genius of eternity,[23] assisted by two putti. From her place next to Pluto, Proserpina seems to invite her to join the first circle of the gods. She extends an arm in grateful acknowledgement, but gestures upwards with the other as though indicating, with modest apologies, a prior engagement at a higher table. Does this represent the 'Bright *Maria*'s' divine *numen* on its way to confirming the conclusion of Rymer's poem on her arrival in England?

> Her no Ambition moves, nor is She Proud,
> Save in the Glorious Power of doing Good.
> So may She still above proceed a Queen,
> If She, on Earth, should ever cease to Reign.[24]

'If', thanks to what Marvell calls time's 'useless Course', having become all

too prematurely 'when', here she is proceeding 'still above . . . a Queen', and one certainly, now, 'above Mechanick sway' – though how, in her modesty, she would have reacted to finding herself as divinely *'Mammosa'* as Ceres or any of the other goddesses represented is anyone's guess. All this, however, is taking place more or less in a corner. Mary is not to be imagined coveting her great-grandfather's Solomonic centrality. Meanwhile, down below, the whole machinery of apotheosis is being looked at in a distinctly dry light, sidelong and with an apostate's protestant eye.

22: 'Cette Folle Vanité d'Alexandre'

Julian, it should be said, had been associated with Protestantism from the beginning. In 1549, Prince Philip, eldest son of the Emperor, Charles V, had undertaken a magnificent progress through his father's extensive European territories to mark his recognition as hereditary ruler of the Low Countries, where William's most famous forebear, William the Silent, was shortly to prove a thorn in his flesh. 'Each town' reports Roy Strong, describing the pageantry in his *Splendour at Court: Renaissance Spectacle and Illusion*,[1] 'vied with the other in the splendour of its reception of the Prince'. During his entry of Lille he came upon a tableau of two complementary temples, one dedicated to Virtue, the other to Honour. In the latter, records Juan Christóbal Calvete De Estrella's *El Felicissimo Viaie D'el Muy Alto y Muy Poderoso Principe Don Phelippe*,[2] stood

> David, Cyro, Julio Cesare, Augusto Cesar, Constantino Magno, Carlo Magno, Hector, el Rey Pyrrho, Publio Scipion, Ayace Thelamo[n], Hannibal, Alexa[n]dro Magno, el Emperador Maximiliano, y otros muchos.

In the former, which was surrounded by beautiful virgins representing all the virtues, were the figures of Philip himself and his father. Beneath these two temples, a tortuous road wound down 'a una ventana con una dificultosa escalera' ('to a window with a difficult ladder'), on which stood 'el Apostata Juliano', closely followed by 'Neron, Tarquino Superbo, y el Emperador Valente, Arrio y Luthero, y otros Tyranos y herejes'. Seeking to enter by way of the window – and perhaps we are meant to recall that 'He that entereth not by ye doore . . . the same is a theefe, and a robber'[3] – these all found themselves rejected, condemned 'enel profundo del infierno', consigned to the depths of hell.[4]

So Julian and Luther are two of a kind. To confirm the connection, a step or two further along Philip's way,

> the figure of the Catholic Church was to be seen, treading Heresy underfoot, attended by the Pope and Emperor as the shield of faith.[5]

Accompanying the Emperor (on the right side, naturally) were Charlemagne, Godfrey of Bulloigne, Saint Louis, King of France, Ferdinand and Isabella of Spain, and Prince Phillip. To the left, 'como presos' ('as though prisoners'), were ranged

> los Principes delos hereges, el Emperador Juliano Apostata, Symo[n] Mago, Arrio, Jua[n] de Hus, Martin Luthero, Zuinglio, y otros muchos.[6]

From captive's chains, hell-fire and bad eminence on 'una dificultosa escalera' at Lille in 1549, Julian, by the beginning of the eighteenth century, has been translated at Hampton Court to a tribunal at the head of a fine Wren staircase, 'made with Steps of the Irish Stone, such as are at Kensington but longer and easier, with Iron Rayles of good worke',[7] and thus, in deference

to the King's asthma, the very reverse of 'dificultosa'. Protestantism, plainly, is making a point, although not in a way which would have recommended itself to the earlier Stuarts, not even the most Protestant among them.

> Nor in any sort do I purpose to set *Julian* the Apostata before mine
> eyes, as a patterne for me to follow,

James I had declared in irate response to Cardinal Perron's repetition of a comparison originally suggested by Bellarmine in his attack on the Oath of Allegiance, instituted in 1606 as a test of Roman Catholic loyalties after Gunpowder Plot.[8] Yet here he is, 'set . . . as a patterne' before William's eyes, and the eyes of subsequent climbers of the King's Staircase: the pattern of, if nothing else, Philaretus Anthropopolita's 'discerning Prince'.

'He made you', James's *Basilikon Doron* advises his heir, 'a little GOD to sit on his Throne, and rule over other men'.[9] This 'RIGHT DIVINE of Kings to govern wrong'[10] could, of course, work in favour of Protestantism, which helps to explain James's preoccupation with it. If kings hold their crowns directly from God and

> The State of MONARCHIE is the supremest thing upon earth: For
> Kings are not onely GODS Lieutenants upon earth, and sit upon GODS
> throne, but even by GOD himselfe they are called Gods[11] –

then papal claims to throne and dethrone, command or countermand allegiance, will look distinctly sick, regardless of a sovereign's religious persuasion. If the Divine Right of Kings, however, put a damper on the Divine Right of Popes, it was balm to the 'baroque absolutism' which became increasingly the rule as the seventeenth century progressed.

> They saw how Soveraign Authority Reigned in France, as Independent
> of the Laws, as in Turkey: They beheld the face of the Kingdom of
> Sweden and Denmark, changed by Introducing Hereditary
> Succession, whereas they were Elective before; They viewed the
> Face of the Kingdom of Hungary, heretofore the Seat of Liberty,
> Disfigured by the same Innovation; and Poland that boasts to have
> preserved the Ancient Laws entire, has notwithstanding suffered
> Injurious Alterations; In short, which way soever we cast our Eyes,
> we shall find Attempts of the same Nature prosper.[12]

Only 'they', 'we', the English people, stood out against this trend and even reversed it, so that, 'at that very Moment, that the King began to act like his Neighbour', like Louis XIV, 'they presently put a Stop to his Designs, without the least respect to his Dignity': waved goodbye to James II, welcomed (for the most part) William and Mary;

> For *Princes* more of *solid Glory* gain
> Who are *thought* fit, than who are *born* to *Reign*.

'*Thought fit*' insinuates a right to choose (such as had, in fact, already been exercised); and 'choice', as has before been observed, lies at the root of 'heresy'. So Julian is aptly given a watching brief over the staircase; whose surname, 'Apostate', naked and unashamed and as 'The word [heresy] means, literally, no more than "choice"' (Skeat), means, literally and in its original innocence, no more than 'one who stands off, away from, apart' – as, literally,

he does; or rather sits, aloof on his own wall while his fellow-Caesars on theirs make claims (more or less spurious) to divinity alongside, accompanied by Alexander the Great who, Spanheim notes, 'avoit même voulu passer pour tel [a god] durant sa vie', with the result that

> cette ambition extravagante se communiqua à ses Successeurs, & passa, à leur exemple, aux Empereurs Romains; témoin entre autres leurs Médailles & leurs Inscriptions.[13]

Far, therefore, from his being Wind's gust of fresh, Protestant air, the champion of Herculean reform against Romulean superstition, 'cette folle vanité d'Aléxandre, à *vouloir luy-même se déïfier*',[14] would appear to have been the *fons et origo* of subsequent lunacy. Only Marcus Aurelius, of Julian's six main protagonists, remains effectively uncrazed: Burnet's 'compleatest Pattern of a perfect Prince', and the Apostate's, also.

Meanwhile, in modern Gaul,

> Usually the Court of *France* is crowded with Flatterers, who make no other Prayers then for the Glory of their Monarch, and sing no other Hymns then in his Praise; all their Opera's sound forth the Grandeur and Conquests of their new Deity, *Jupiter-Bourbon*. They perswade him that he was sent into the World to reign by himself, and to subdue all the People of the Earth under his Dominion; they have given him the Sirname of *Dieu-donné*, or *God's Gift*, and make their Oblations to the immortal Man, *Viro Immortali*. To which purpose they have erected his Statue in the Piazza of Victory at Paris, to the end that all his Subjects should pay the same Homages to his Figure as to his Person.[15]

'*Jupiter-Bourbon*' sounds virtually the spit and fetch of '*Jupiter-Ammon*', the god who was, so Alexander believed (or would have had it believed), his real father, not Philip of Macedon at all. 'Nay, which is much more, he suffer'd himself to be worshipp'd like a Deity', concludes John Whittel in his *Constantinus Redivivus*, after having similarly noted that this not Alexander but '*Lewis Le Grand*'

> permits his Statue to be erected and adored by his 'Subjects in the posture of Prosternation; he permits Holy-days to be Dedicated to them, as if they were really so many Deities, so that upon the Bases of these base Idols, you may see these Inscriptions in Capital Letters, TO THE IMMORTAL MAN.[16]

'Cette folle vanité d'Aléxandre', patently, is a perniciously recurrent disease. And those 'Opera's', too, mentioned in *A Brief Display*: were such performances not once called 'masques' in the days when George Wither was grumbling about 'Flattering *Priests* and *Poets*', '*Heath'nish Deities*' and a King and Queen who

> Became (ev'n when their *Mummeries* were past)
> Like those they represented; and did move,
> Within their Sphears like *Venus, Mars*, and *Jove*?[17]

The paintings on the King's Staircase are an antidote to this kind of 'Eikon Basilikolatry': seem carefully adjusted to the requirements of

> A Prince who by his own Merits and the Peoples Election can justly
> claim the best Title that ever any King of *England* had, let the Fools
> and Knaves who madly dote on the Divine Right of Succession, &c.
> say what they will to the contrary;

which is how the author ('D.J.') of *King Charles I. no such Saint, Martyr, or
Good Protestant as commonly reputed*[18] sees King William. Charles, however,
had been a good deal worse than

> the late Tyrant *James*, who had not committed half so many arbitrary
> and illegal Actions, nor been guilty of such notorious Violations upon
> the Laws and Liberties of *England*, as *that Holy Martyr* . . . was
> justly charged with.[19]

Bowing down, therefore, and worshipping, 'not only in a religious, but a civil
kind of Idolatry',

> the Image and Memory of him, who hath offered at more cunning
> fetches to undermine the Liberties of *England*, and put Tyranny into
> an Art, than any *British* King before him,

was nothing short of lunacy, as Milton, in as many words, had once observed
in *Eikonoklastes*.[20]

To lend weight to this thesis, the title-page of *King Charles I. no such
Saint* promises *in addendum* no less a person than 'Dr. Burnet's (now Bishop
of *Salisbury*) . . . Reasons against the keeping up any longer the observation
of a Fast on the 30th of *January*'; but these prove, in the wake of such
Miltonic fulmination, disappointingly uninflammatory, especially when restored
to the context from which they have been purloined: a sermon composed in
commemoration of Charles, King and Martyr, delivered to the Aldermen of
the City of London on January 30th, 1681, not quite a fortnight after the
ending of the second exclusion parliament (January 18, 1681).

This sermon, it is true (and scarcely surprising under the circumstances),
is nothing so hyperdulical in tenor as the one Burnet had once preached 'On
King Charles the Martyrs Day, 1674/5', *The Royal Martyr Lamented*; a piece
maliciously picked out for reprinting in 1689, obviously with the intention of
embarrassing its author by highlighting his current treachery, and reissued
again in 1698/9 and 1710 (the year of Sacheverell's trial)[21] – so that it clearly
became something of an albatross round his neck.

Here, Burnet had assembled ('as in *the Indies*, the Art of Painting is only
the putting together of little Plumes of several Colours') a sort of 'Eikon
Basilike' of his own out of extracts plucked from Charles's papers: 'no exact
work', he admits, 'but true and lively Colours' nevertheless,

> being those mixed by our Martyr himself, though perhaps unskilfully
> placed by me. And as the Popish Legend tells of two Pictures of our
> Saviour done by himself, one particularly which he left in *Veronica's*
> Handkercher when he wiped his face with it; so from the sweat of
> our Royal Martyr some Lineaments of his Face shall be offered.[22]

'*Ecce homo*'! 'Behold', once again, 'the man' – and Mrs Behn in the
background, of course, hands clasped, kneeling in adoration! Yet there is a
protestant astringency about the Juxtaposition of '*Mexique Paintings*' (as

Marvell had called them) and 'Popish Legend' which, even here, restricts
any haemorrage of 'awful', as it were 'aphradisiac' sentiment.

Yet Burnet, on his own account, 'was bred up with a high veneration' of
Eikon Basilike; disturbed by the rumour that it might not have been the work
of the victim himself; happy to be reassured that it bore all the marks of that
monarch's actual conversation; disconcerted, again, in 1673, when he 'had a
great share of favour and free conversation with the then duke of York', to
be told by him that, not his father, but 'Dr. Gawden writ it'; and, despite this,
still reluctant to write it off as out-and-out forgery.[23] Thus January 30th,
1675 finds him 'Gawdening' himself, in his own small way, and 'Martyr' is
very much the catchword, variously qualified as 'our', 'our Royal' (seven
times), 'our Blessed' and 'our Murthered Martyr'; making, in sum, 'our
Martyr'd King' 'a *Patient Martyr*', indeed! And, touching upon 'the right of
Succession' ('clear and undisputed as it was'): 'when the Righteous Heir of
our Murthered Martyr' had come, in 1651, to claim with Scottish help his
English inheritance,

> then again did carnal Wisdom and the care of Mens Lives and Estates
> prevail over those strong tyes of Loyalty and Subjection; God having
> reserved the establishing him on his Father's Throne to his own
> immediate Arm.[24]

To have these, his pronouncements of fourteen years since, disinterred in
1689 and flung in his face, cannot have been best pleasing to Burnet who, on
not the 30th, but 31st of January that year,

> Being the Thanksgiving-Day for the Deliverance of this Kingdom
> from Popery and Arbitrary Power, by His Highness the Prince of
> Orange's Means,

delivered a sermon to the Commons rejoicing, once again,

> that so total a revolution could have been brought about so easily, *as
> if it had been only the shifting of Scenes*,

but altogether undarkened by disquieting memories of yesterday, a '*Tragick
Scaffold*' and '*Royal Actor* born' who

> nothing common did or mean

Upon that memorable Scene:

> But with his keener Eye
> The Axes edge did try.[25]

'It were better to strike it out of our Kalendar', Burnet had begun in 1681,
and to make our *January* determine at the 29th, and add these
remaining days to *February*. But alas! This cannot be done –

though, at a ticklish time like January '89, throwing an emphasis on the day
after might achieve something – and had he not once assured those aldermen
that 'If we were delivered from our fears of Popery . . .':

> If we come *to love the Truth and Peace* [his text is *Zechariah* 8. 19],
> then shall even this Fast of the tenth month, according to the Jewish
> account, be to us a Joy and a gladness and a chearful Feast.[26]

But nowhere in this 1681 sermon is a discontinuation 'of our publick
humiliation on this and such like solemn days'[27] actually proposed. On the

contrary:

we cannot wipe out this blot: what was done, can never be forgotten.

It cannot by others, and by us it ought not to be forgotten.[28]

So Charles is still, once or twice and towards the beginning, 'this *Martyr*' and 'this Royal Martyr', though these 'thises', now, after all the engaging 'ours' of 1675, sound more defensive, 'stand-offish': even, perhaps (in the root sense) 'apostatical'. Nor, now, will Burnet bother with an 'Eikon Basilike' of his own elaboration. It has become 'a task above my strength'; and besides, there is always 'this Royal Martyr's' (or 'Dr. Gawden's') original:

his character given us in such true and lasting colours, in that Picture

which he drew for himself, in *his solitudes and sufferings.*[29]

Five pages later '*the true Martyr of Christ*' has become what Papists inscribe 'under the pictures and prints made for *Garnet*', Catesby's Jesuit confessor, executed for connivance in Gunpowder Plot. And that is that. The word 'martyr' is heard no more.

If Burnet does not, therefore, altogether deserve his place on 'D.J.'s' title page on the strength of his 1681 sermon, 'D.J.' has, notwithstanding, caught a definite drift. There is brief genuflection, still, but now no suspicion of a 'posture of prosternation' or prolonged 'Oblations to the immortal Man, *Viro Immortali*', Burnet being not at all the kind of fool or knave to dote madly 'on the Divine Right of Succession, &c.', or sing placebo to the 'folle vanité' of an Alexander. In his sermon of 26th November, 1691, he will go so far as to admit that, granted a happy compound of majesty and mercy,

A Prince so tempered puts a temptation upon his people, (if they are not under the conduct of a Religion that guides them by surer Lights) to suspect that he is allied to the Divinity it self; and is something of a God in humane appearance: And therefore no wonder if after his death they follow him with Divine Adorations. And as this in barbarous Ages gave rise to almost all the Idolatry of the *Greeks*, so even in more polite Times the *Roman* Historian [Julius Capitolinus] observes, that no man made any shows of mourning or lamentations at *Marcus Aurelius's* Funeral, *all men holding it for certain, that as he had been lent to the World by the Gods; so he was then gone back to take his place among them.*[30]

But 'Wonder en is gheen Wonder': 'And therefore no wonder if . . .'

We, it goes without saying, seeing 'by surer Lights', even with a William around, will resist temptation; but if the Romans could not ('politer' than the Greeks though they may have been), yet Marcus Aurelius's divinization was, in effect, 'by his own Merits and the Peoples Election', and so far just. Julius Capitolinus's very next sentence –

Finally, before his funeral was held, so many say, the senate and people, not in separate places but sitting together, as was never done before or after, hailed him as a gracious god[31] –

shows him in receipt, to an eminent degree (and courtesy, what is more, of a unique 'Convention'!), of just that '*publique testimony* of his Sanctity' which Hobbes regards as the defining feature of 'CANONIZATION'. He was made,

as it were, 'Divine, by Law and [in his case] Sense'; accorded the *'solid Glory'* of being *'thought fit . . . to Reign'*, as opposed to assuming preemptively a divine right to do so, or being state-crafted, like Romulus, into a divinely convenient figurehead, or added as one more empty vessel to that 'grand amas de belles Satuës & d'Effigies de Divinitez véritablement salutaires' which accumulated as a result of 'la coûtume de *l'Apothéose*' introduced into Rome by Augustus.

And so we are back with Burnet's 'compleatest Pattern of a perfect Prince': Marcus Aurelius, who is also, I have been arguing, a key to the interpretation of the paintings on the King's Staircase. Did Burnet influence the choice of subject? Possibly. But Wind (who never so much as mentions Aurelius, let alone Burnet) speculates that the likeliest source of inspiration was Anthony Ashley Cooper, grandson of Dryden's 'Achitophel' and inheritor of his title.

To this Shaftesbury, as to the 'Philaretus Anthropopolita' who had written in his ancestor's cause (and who, thinks Wind, may even have been Locke himself, at that time not only the grandfather's secretary but supervisor, too, of the grandson's education) – to the Third Earl, as to the author of *Some Seasonable Remarks*, Julian was 'this discerning Prince': no insidious subverter of true Christianity, in fact, but 'a great restrainer of persecution'.[32] 'Voici donc Julien réhabilité en champion de la tolérance, dans le plus pur esprit de la politique de Locke!' exclaims Jean-Paul Larthomas, summarizing with reinforcement Wind's deductions in an article on 'Julien en Angleterre dans le Milieu Whig'.[33]

Larthomas, however, does[34] mention Aurelius, quoting Gibbon who, after a synopsis of *The Caesars* in chapter 24 of his *Decline and Fall*, opines that, although 'In the cool moments of reflection, Julian preferred the useful and benevolent virtues of Antoninus', yet in warmer, more ambitious mood, he 'was inflamed by the glory of Alexander' and even, adds a footnote, inclined to favour the Greek simply because he was one: 'But when he seriously compared a hero with a philosopher' – as, for instance, in the *Oratio ad Themistium* – 'he was sensible that mankind had much greater obligations to Socrates than to Alexander'.[35] For

> Who, I ask, ever found salvation through the conquests of Alexander? What city was ever more wisely governed because of them, what individual improved? Many indeed you might find whom those conquests enriched, but not one whom they made wiser or more temperate than he was by nature, if indeed they have not made him more insolent and arrogant. Whereas all who now find their salvation in philosophy owe it to Socrates.[36]

Julian, in serious mode, looks a copy out of Aurelius.

In lighter vein, too, it is the Socratically-featured Silenus – 'Ne sçais-tu pas d'ailleurs, que j'ay beaucoup de ressemblance avec Socrate', he cries[37] – who defends with raillery and cross-question the way to heaven against the pretentions of pride and overweening ambition; 'leurs railleries, & . . . la façon de débiter leur doctrine & leur morale' being, witness Spanheim's lengthy note, as characteristic of both look-alikes as baldness, snub-noses and *'yeux*

hors de la teste'. And of the six 'heroes' brought finally to the bar, only Marcus Aurelius suffers his interrogations without perceptible discomfiture.

But Larthomas does not see it this way on the King's Staircase. If Gibbon pense que Julien avait sérieusement hésité a faire décerner la palme à Alexandre plutôt qu'à Marc Aurèle . . .Verrio, lui, n'hésite pas: c'est Alexandre qui doit l'emporter, parce qu'Alexandre c'est maintenant Guillaume III! L'assemblée des Césars, du côté de Romulus, figure dans sa peinture la cohorte des princes 'papistes', tous plus ou moins inféodés au parti de Rome. C'est la victoire de Guillaume sur les Stuarts et les prétentions catholiques. Julien cautionne ici l'apothéose de la 'Glorious Revolution'![38]

Larthomas, in short, smiles as the Wind sits, and catches a slight chill, though most of what he says is reasonable enough. He has, moreover, just been speaking of

l'ambition de rivaliser, à Hampton Court, avec l' 'Apothéose des Stuarts', par Rubens, qui ornait déjà le plafond de la fameuse salle des Festins, à Whitehall;[39]

but the parallel seems not to have alerted him to the possibility of wider coherences where the King's Staircase is concerned. Unlike Wind, he does not so much as glance at that 'separate allegory on the North wall over which Apollo presides', matching his sister, Diana, to the east and Mercury opposite. His real business, after all, is with Julian, not sorting out the 'confused medley of subject' which *The Dictionary of National Biography* claims is typical of Verrio at Hampton Court.[40] Under such circumstances it will be superfluous to bother one's head over Ceres. A stop-gap over the doorway on Julian's landing of 'a Pyra, or Funerall Pyle, done in Stone-Colour', as Bickham describes it,[41] will be even more ignorable. Won't it?

23: Funeral Bak'd Meats and Gendres de Mérite

The doorway leads from the landing into the King's Guard-Chamber, (Pl 6.) first room of his suite. Judging from the shadowy scene which surmounts it, it might be the gateway to Hades: a variation on the theme of the plutonian cavern which opens beneath Ceres on the wall opposite. The great, as yet unlit funeral pyre looms in the background, a recumbent corpse sandwiched between its pyramidally layered logs. In front, accompanied by his 'fidus Achates' and others, Aeneas consults the Cumaean Sibyl, 'Holding the Altars' and Virgil prescribes and Ogilby literally translates[1] at least to the extent of being couched in supplicatory posture over a large rock. Venus's, his mother's two doves, fluttering just above is head, make identification easy. They are to lead him, as he helps piously to cut wood for that pyre, to the Golden Bough, giving access to the underworld, Anchises and visions of things to come which will culminate in the times of Julius Caesar and

> Augustus, promised oft, and long foretold,
> Sent to the realm that Saturn ruled of old;
> Born to restore a better age of gold.[2]

'AUGUSTUS CAESAR DIVUM GENS AUREA CONDIT SAECULA': the tag – 'Augustus Caesar, offspring of the gods, founds a golden age' – is a staple of imperial image-mongers; had been used, for instance (and as Roy Strong's *Splendour at Court* records, p. 79), in Florence in 1539 to supply the legend for a statue of Charles V atop a triumphal arch,

> arrayed à l'antique, crowned with laurel and carrying the imperial
> sceptre, river gods at his feet, flanked, to his right, by the figures of
> Spain and New Mexico, followed by Neptune, to show 'That the
> Western Ocean is dominated by His Majesty', while to the left, stood
> Germany, with shield and lance, together with Italy and Africa.

Very impressive:

> Africa and India shall his power obey;
> He shall extend his propagated sway
> Beyond the solar year, without the starry way,
> Where Atlas turns the rolling heavens around,
> And his broad shoulders with their lights are crowned,

etcetera, etcetera, just as Anchises had foretold of his prototype, only more so.[3] But here at Hampton Court sits Julian the Apostate, and a wicked whisper crumbles the 'Augustus Caesar, divi genus'[4] of Anchises's heroic prophecy into Silenus's 'Ce faiseur de Poupées' whose 'propagated sway' amounts to 'un grand amas de belles Statuës & d'Effigies de Divinitez véritablement salutaires', those of Charles V and Louis XIV being late additions to the lumber. 'Tu nous as fabriqué des Dieux', Silenus tells him.[5]

So the scene above the guard-room doorway, its dusky clouring suited to its ghostly business, is an evocation of the *Aeneid*, Book 6. The funeral pyre, it follows, will be that of Misenus, once Hector's and afterwards Aeneas's

trumpeter, first encountered sounding the alarm as the Harpies attack for a third time two hundred or so lines into Book 3, but unheard of since. Now, as Book 6 opens, he suddenly resurfaces, drowned – cast up, seemingly, even as Aeneas's interview with the Sibyl is in progress – to give a name to Cape Misenum and, more urgently, to the anonymous 'corpus amici' (6. 149) abruptly and shockingly revealed to and by the prophetess as the consultation is about to end. 'Ramus enim necesse erat ut unius causa esse interitus', as Servius darkly observes: 'For it was necessary that the Bough should be the cause of one death'.[6] Proper disposal of the polluting body is enjoined as a precondition of success in the quest to come. Aeneas obliges with what R.G. Austin, calls 'a *locus classicus* for the most elaborate kind of Roman funeral ceremony'.[7] Death is given its fullest and most formal due just as the hero is on the verge of disturbing its dominion with his living presence. Aeneas (whose solicitude for preparatory wood-cutting leaves him, significantly, a mere dove's flutter or so away from the Golden Bough) thus establishes his *bona fides*: gives evidence that he acts, ultimately, in the name of due order, not with a view to its disruption.

And death shall have its dominion. The Book draws to an end with the prospect (for Aeneas; sad retrospect for Virgil, Octavia and the Emperor himself) of another most elaborate Roman funeral ceremony.

> What groans of men shall fill the Martian field!
> How fierce a blaze his flaming pile shall yield!
> What funeral pomp shall floating Tiber see,
> When, rising from his bed, he views the sad solemnity![8]

Octavia's son, Augustus's heir and lifeblood of his dynastic designs, the young Marcellus, 'puer', perhaps, of *Eclogue* IV, will be, has been struck dead as much out-of-the-blue as Misenus and, what is more, in the very same place:

> Clausus ab umbroso qua tundit pontus Averno
> fumida Baiarum stagna tepentis aquae,
> qua iacet et Troiae tubicen Misenius harena,
> et sonat Herculeo stucta labore via,

to quote Propertius, elegizing upon the event:

> Where the sea, locked out from shadowy Avernus,
> beats against Baiae's steaming pools of warm water
> where both the Trojan trumpeter Misenus lies
> buried in the sand and the causeway built by the toil
> of Hercules resounds.[9]

Virgil does not mention this coincidence. Perhaps he did not have to. Perhaps it did not seem a coincidence, Marcellus's death being, in its way, as 'necessary' as Servius says Misenus's was – or may be even Queen Mary's, cut summarily down by the smallpox in 1694, who was apt to anticipate

> punishment upon us for the irregularity by us committed upon the
> revolution. My husband did his duty and the nation did theirs, and we
> were to suffer it, and rejoice that it pleased God to do what he did.
> But as to owr persons it is not as it ought to be, tho' it was unavoidable,

and no doubt that it is a just judgement of God, but I trust the Church and nation shall not suffer, but that we in owr private concerns and persons may bear the punishment as in this we do.[10]
There is always a price to be paid.

'Tu noster Marcellus eras, GULIELMUS', is also (not very surprisingly) a cry echoed and re-echoed through the pages of the *Threnodia Academia Cantabrigiensis* and corresponding Oxonian *Exequiae* composed on the death, aged eleven, of Anne's sole surviving child, William Henry, Duke of Gloucester, in the summer of 1700.[11] 'It is so great a loss to me as well as to England, that it pierces my heart', William was to confess to Marlborough. The country at large was less put out. The boy had been sickly from birth. Great hopes were not to be had of him. Though the Universities, as they were duty-bound, did their bit, there was no effusion of vernacular grief to match that occasioned by Mary's death. To John Evelyn, nevertheless, he was 'a hopefull child' and his loss 'very astonishing', while the King himself had, insists Hester W. Chapman, 'deeply and undemonstratively loved' the sister-in-law's son (and hence 'nephew', though not so strictly as Marcellus was Augustus's) whose survival would have made George I redundant.[12] William had likewise, to judge from his reaction to her dying, 'deeply and undemonstratively loved' his wife. The repeated references to Mary, therefore, which are another leitmotif of both the *Threnodia* and the *Exequiae* might have struck him as more than cold and academically inert formalities.

Are we then, expected to see William in the Aeneas over the doorway leading, as it were, into the Book 6 of his personal apartments? Dryden, after all, had lately been exploring potential parallels: making, in his version of the *Aeneis,* what William Myers sums up as

> calculated modifications of the original, all of which were concerned
> to use the coming of Aeneas to the kingdom of Latinus, of Augustus
> to the Roman republic, and of William of Orange to the kingdom of
> England as representative instances of the historical process.[13]

'Furious' he was, even so, claims Peter Levi, that Tonson, his publisher, in appropriating otherwise untouched (save for the addition of line numbers and dedications to selected subscribers) the plates designed by Francis Cleyn and executed by (amongst others) Wenceslaus Hollar for Ogilby's handsome 1653/4 folio, should have presumed to beg all questions in quest of a crude compliment by simply substituting the Dutchman's saturnine features for the jovial, sometimes cavalierly moustachioed countenance of the original, much more gallant-looking Aeneas: a countenance which should, if Levi is right, have 'shone with majestie' in many contemporary eyes; for, he alleges, this figure 'is visibly that of the future Charles II', at that time on his travels, playing the part of 'the prince in exile, wandering overseas until the gods bring him home'.[14]

Tonson had had his bookseller's eye on a commercial coup: the cachet of a dedication to the King himself. 'He has missd of his design', Dryden is pleased to report to his sons in Italy,

> though He had prepard the Book for it: for in every figure of Eneas,

he has caused him to be drawn like K. William, with a hookd Nose.[15]
'The profits might have been more', he adds, reverting to the subject of 'My
Virgil' later in the letter; 'but neither my conscience nor honour wou'd suffer
me to take them'.[16] He might have derived some wry comfort from the fact
that Tonson's new-model, hatchet-faced hero looks unprepossessingly, even
somewhat satirically out of place in his usurped setting, calling to mind,
perhaps (to add a further ironic twist), Swift's description of Dryden himself,
challenging Virgil in *The Battel of the Books* and 'lifting up the Vizard of his
Helmet' to parley:

> The brave *Antient* suddenly started, as one possess'd with Surprize
> and Disappointment together; For, the Helmet was nine times too
> large for the Head, which appeared Situate far in the hinder Part,
> even like the Lady in a Lobster, or like a Mouse under a 'Canopy of
> State, or like a shrivled Beau from within the Penthouse of a modern
> Perewig.[17]

'A shrivled Beau', certainly, would suit the new Aeneas compared to his
plump-cheeked predecessor. Nor, as Dryden claims, has quite 'every figure
of Eneas' been altered. Here and there a plate remains which has escaped
cosmetic surgery and survives to show what has elsewhere been supplanted.
'Looke heere upon this Picture, and on this.' How can remarriage to such 'a
Mildew'd eare' be justified?

> Have you eyes?
> Could you on this faire Mountaine leave to feed,
> And batten on this Moore? Ha? Have you eyes?
> You cannot call it Love. . . .[18]

John Hall of Richmond, of course, wouldn't necessarily have wanted to,
disposed, as he was, to consider 'fear . . . a wiser Passion then love'; 'For'
he argues, 'they that are governed in their choice by love, consult not of the
dangers or inconveniences that may happen', whereas fear always thinks
much more precisely upon the event.[19] But Dryden, and not absolutely in jest
(though no one is expected entirely to forget *David's Hainous Sinne, Heartie
Repentance* and *Heavie Punishment*, to run through the divisions of Thomas
Fuller's 'Divine Poem',[20] which begins with lust for Uriah's wife, Bathsheba,
and draws to an end with a lament for Absalom) – Dryden had begun *Absalom
and Achitophel* with 'the hey-day in the blood' goldenly sovereign and
untamed, glancing back towards 'pious times', unperverted by the crippling
'Priest-craft' which has since established a castrating grip upon an adjective
which is also, outstandingly, Aeneas's epithet.

So when (as Dryden translates), 'Armed like the rest', for forestry not
battle, 'the Trojan Prince appears, / And, by his pious labour, urges theirs' at
the wood-cutting for Misenus in Book 6,[21] he is running true to form. Yet
'cloven holms and pines', on a previous, not-to-be-forgotten occasion, have
been 'heaped on high' into another 'fatal pile' which Misenus's now, cannot
help but recall: a pile built, contrastingly, not out in the open, in a display of
corporate solidarity and acknowledgement of a responsibility to recognise
and remember public service (Misenus was a herald; now *his* name is put,

literally, on the map), but 'Within [a] secret court, with silent care';[22] and built, moreover, not in response to a prophetic Sibyl's call for 'pious dues',[23] but on the spurious excuse that 'a Massylian priestess I have found', out of her 'impious art',[24] has recommended a bonfire of all relics of Aeneas's love. For the 'I', of course, is Dido, about to be abandoned, pretending to seek a remedy but in fact despairing, set on suicide and inwardly consumed by, to enlist a Spenserian distinction, a fire 'made to burne', not 'fairely for to shine'[25]. 'Could a pious man', pleads Dryden in Aeneas's excuse, 'dispense with the commands of Jupiter, to satisfy his passion?'[26]

'No', is the answer demanded; yet his 'pious man' is palpably more 'cursedly confined' than the Davidic Charles who, 'In pious times', 'kindly spreads his spacious wing, / And hatches plenty' with all the regal largesse of Denham's Thames, as though, once upon a time, *amor* and *pietas*, passion and piety, were as one and libido concurrent with divine will. But Achitophel, first Earl of Shaftesbury, is quick to engineer 'Bays and Dams' to alter all this, diverting the generous flood ('Heroick, or Numinal; as Courting an Universall Good') into 'narrow and restrictive' courses to turn the wheels of his own, more sinister machinations.

Achitophel, patently, is 'a Mildew'd eare / Blasting' his else perfectly 'wholsom' brother-subject (and Charles's most notably 'natural' son), Absalom/Monmouth. But whatever Dryden may have thought of William III, he scarcely saw Aeneas in this light, or even the Augustus he foreshadows who, though a 'conqueror', and thus 'of a bad kind, was the very best of it'.[27] Indeed, David Bywaters detects as much of James II in Aeneas as of William. True, 'as Zwicker and others have shown, Aeneas's title resembles William's to the English throne'. As Trojan leader, although he had 'married Creusa, Priam's daughter', he could through her 'have no title while any of the male issue were remaining' and, Dryden is at pains to point out, one or two of them did survive; so 'In this case, the poet gave him the next title, which is that of an elective king'. Latium he gains through conquest and marriage to the heiress, Lavinia; 'yet claimed no title to it during the life of his father-in-law',[28] in marked contrast, of course, to William. 'Whereas', however (to resume Bywaters),

> Whereas Aeneas's title refers to William's, his manners refer to James's: "Those Manners were Piety to the Gods, and dutiful Affection to his Father; Love to his Relations; Care of his People; Courage and Conduct in the Wars; Gratitude to those who had oblig'd him; and Justice in general to Mankind".[29]

'Throughout his discussion of Virgil's moral and Aeneas's manners', therefore, 'Dryden reflects upon the crimes of William and the virtues of James', whilst being always

> careful rather to allow these lessons to arise incidentally from his material than arrange them in a coherent parallel.[30]

'Historical process', in the case of the *Aeneid*, ironically demands that a man of James's virtues should commit the crimes of a William; but it will hardly encourage an intelligent appreciation either of Virgil's message or

Dryden's colouring of it to feature Aeneas pre-emptively as William, and the poet was understandably aggrieved at his publisher's barefaced presumption. Perhaps, too, where the King's Staircase is concerned, it is wrong to succumb to the temptation, Tonson-wise, to paint any particular figure Orange, whether Alexander or Marcus Aurelius (though the colour would fit) or Aeneas; none of whom, as depicted, bears the least physical resemblance to William, whereas the emperor meant (it has been argued) for Constantine and distinguished by golden armour has, at least, the nose . . . But may be, here too, lessons are supposed 'to arise incidentally from [the] material', rather than a specific parallel being intended. The designer of the programme must have expected monarchs other than William to mount the stairway, although it would have been William to begin with and, come 1700, there must have been (were, witness *Carmen Seculare*) hopes that here was a watershed. Mary had died, and more lately William of Gloucester, 'noster Marcellus'; yet Ryswick tantalized with promise of peace and plenty and, 'Closing the Volumn of the finish'd Age, / (Tho' Noble, 'twas an Iron Page)', a new century opened up possibilities of more golden things to come.

The funeral rites for Misenus, his pyre and 'stately tomb',[31] also mark a watershed. 'The shipwreck of unstable youth is now over and done with', allegorises the late fifth-century A.D. grammarian, Fulgentius. Phase one is finished, all that wandering and widow Dido. 'Having done with these matters', Aeneas, Fulgentius has Virgil explain in his *Expositio Virgilianae Continentiae*, 'reaches the temple of Apollo . . . and there takes counsel on the course of his future life':

> First, he must needs dispose of Misenus: *misio*, for *orreo* in Greek, is setting aside, and *enos* is praise. Unless you have destroyed the illusion of vain praise you will never penetrate the secrets of wisdom, for the man hungry for vainglory never seeks the truth but takes as his truth the falsities poured on him by flattery. Then there is Misenus's battle with horn and shell against Triton. Notice how clear the application is: the bubble of vainglory is noisily inflated, only to be pricked by Triton, taken as *tetrimmenon*, in Latin *contritio*, for contrition destroys all vain praise. Also the goddess of wisdom is called Tritonia, for all humbling makes a man wise.

Moreover, 'a broken and contrite heart, O God, thou wilt not despise', the psalmist assures us,[32] with whom Fulgentius's Virgil has naturally become very well acquainted.[33]

With the exception of Marcus Aurelius, the protagonists of Julian's *Caesars* make no scruple of blowing their own trumpets; are all more or less Misenuses, challenging deity only to have their bubbles of vainglory unceremoniously punctured, not by a torturously etymologised Triton, but shrewdly socratized Silenus. 'Notice how clear the application is', potentially, to the King's Staircase! The mounting monarch is admonished not to take 'as his truth the falsities poured on him by flattery': all that unctuous 'AUGUSTUS CAESAR DIVUM GENS AUREA CONDIT SAECULA' stuff with which kings and kaisers had been ritually anointed, time out of mind. The Apostate, in the

appropriate role of devil's advocate, scrutinizing the old Roman fashion for what Hobbes calls 'CANONIZATION', discovers much 'illusion of vain praise'. 'On painted Cielings you devoutly stare', declares Pope's lethal couplet, 'Where sprawl the Saints of Verrio or Laguerre';[34] but a devout regard and most believing mind are not, in this instance, what is called for at all. Nor, though goddesses

On gilded clouds in fair expansion lie,
And bring all Paradise before your eye[35] –

most strikingly, in Bickham's words, 'a beautiful Figure of *Venus*, in any easy, careless Posture, with one Leg on a Swan'[36] – nor, though there are bare breasts and open arms aplenty, can titillations of this kind quite allay an impression that something more cerebrally provocative is, for once on offer.

So Edward Croft-Murray, discussing, in his *Decorative Painting in England, 1537-1837,*

The Great Staircase, now better known as the King's Staircase, with
its *Marriage of the Thame and Isis* and with its complicated allegory
associating the emperor Julian the Apostate and his satire on the Caesars
with William III as the upholder of Protestantism and freedom,

goes on to remark that

As far as composition goes, it is perhaps the most audacious of
[Verrio's] conceptions, and on the wall where Julian is seen writing
at Mercury's dictation, the painter attains a dignity and spaciousness
rare for him; but –

since no self-respecting art-critic can afford to be caught, after Pope, damning Verrio with even faint praise –

but the garishness of the colours and the intolerable coarseness of
the handling turned what might have been his masterpiece into one of
the most unpleasant daubs ever produced by the Baroque age.[37]

And if Wind is right and the conception was basically someone else's, all that Verrio is left with is the daubing.

Nor is the conjecture unlikely. It would, indeed, have been 'most audacious' for a Roman Catholic Stuart sympathiser, known for '*Italian* Bite', and the father of a son captured fighting for James in Ireland,[38] to have proposed a scheme which gave such prominence to Julian the Apostate. Postulate an impeccably protestant inventor, on the other hand, and the design, to an initiated eye, begins to look quite cleverly complimentary, if by no means *absolutely* flattering. Verrio's baroque daubing may have deterred, from Walpole's day forward, much seriously detailed scrutiny, but Julian comes in such a questionable shape as to invite interrogation, sitting there almost like the parody of a saint – Jerome, say, or Augustine – in his study: or a Matthew, may be, with Mercury for an angel and no Holy Church in the offing, but a pagan temple of Virtue. There at any rate, is Hercules in one of its niches, leaning on his club and glancing over his shoulder towards a statue of what appears to be Fortitude next door: so if the figure looking round the pilaster on his left is Voluptas, he is making his customary 'Choice'.

Even Aeneas's shadowy Sibyl seems to be gesturing vatically in the

Apostate's direction, the line of her right arm echoing that of Mercury's, introducing the review of Caesars. The *Aeneid*'s perspective lengthens into history. 'AUGUSTUS CAESAR DIVUM GENS' threatens, in this light, to dwindle into a lower-case 'faiseur de Poupées'. Julius, Trajan, Alexander are similarly touched with a styptic pencil, and the first Christian emperor with them: Constantine, arguably no longer 'the Great'; for, as Locke observes in *A Third Letter for Toleration*, taking up the tune of *Some Seasonable Remarks*,

after *Christianity was received for the Religion of the Empire*, and whilst Political Laws, and Force, interposed in it, an horrible Apostacy prevailed to *almost the utter exclusion* of the true Religion, and a general introducing of Idolatry.[39]

So Constantine, like Octavius, had been in his turn responsible for 'un grand amas de belles Statuës & d'Effigies de Divinitez véritablement salutaires': another 'faiseur de Poupées'.

Nor can Marcus Aurelius himself, Burnet's 'compleatest Pattern of a perfect Prince', entirely escape censure, having given way to 'l'affection naturelle des Péres envers leurs Enfans' and allowed an unworthy son to succeed despite, Silenus objects,

ayant un Gendre de mérite, qui eust bien mieux gouverné l'Empire, & mêmes beaucoup mieux gouverné ce Fils, qu'il ne pouvoit se gouverner luy-même.[40]

'Un Gendre de mérite', therefore, might have been the answer to the problem posed by Commodus; could, Burnet was already suggesting at the time of the Exclusion Crisis, be the solution to that posed by James, one way out of current difficulties being:

that there should be a protector declared, with whom the regal power should be lodged; and that the prince of Orange should be the person.[41]

This scheme was 'dressed up' during two hours of what would these days be called 'brainstorming' with Sir Thomas Littleton, after which, says Burnet modestly, 'I dreamt no more of it. But some days after he told me the notion took with some'. He subsequently learnt, 'but in great secrecy, that the king himself liked it'.[42] When, however, the stoically austere Aurelius had given best to 'l'affection naturelle', 'la coûtume établie d'en faire leurs herétiers' and wishful thinking,[43] how could 'The easiest King and best-bred man alive', as he is dubbed in Rochester's 'A Satyr on Charles II'[44] be expected to do any better? He didn't. 'Un Gendre de mérite' (a description, incidentally, which would also fit Aeneas) had to wait until 1688 before being given his chance.

Of course, William was James's son-in-law, not Charles's. Parallels are not precise but, *mutatis mutandis*, close enough to make a contemporary reader of Spanheim's translation sit up and take notice, especially if his eye had happened to travel to the footnotes, which include some startlingly blunt advice offered by 'un Général de la Cavalerie' to Valentinian,

qui le consultoit sur la choix d'un Collégue à l'Empire. *Si vous n'aimez que vostre Famille, Seigneur, vous avez un Frére; si vous aimez l'Estat, choisissez quelqu'un, qui soit capable de le gouverner.*[45]

'For *Princes* more of *solid Glory* gain', as Shadwell was to attest in 1689,

'Who are *thought fit*, than who are *born* to *Reign*'. 'Give us a King, Divine, by Law and Sense', echoes *An Epistle to Mr. Dryden*; and *''Tis Personal Virtue only makes us great'*, proclaims Defoe in *The True Born Englishman.*

Which is the purport, it has been suggested, of the scheme 'dressed up' in (and all but smothered up under) Verrio's baroque daubing over the walls and ceiling of the King's Staircase: 'Give us a Marcus Aurelius', or 'un Gendre de mérite' like the one Marcus Aurelius would have nominated as his successor had he been 'the *complete* Pattern of a perfect Prince', instead of merely the 'compleatest' one Burnet (or Julian the Apostate) could think of. Spanheim, for his part, is proud to pronounce 'Sa Serenité Electorale' one better; but that, to quote Lord Plausible from Wycherley's *The Plain Dealer*, is 'like an Author in a Dedication'. 'Tell me not, my dear Friend', he expostulates,

> what people deserve, I ne'r mind that; I, like an Author in a Dedication,
> never speak well of a man for his sake, but my own.[46]

But what people, or more specifically Caesars (and in particular the one climbing it), deserve is crucially at issue on the King's Staircase, and the lesson is that 'conscious thinking' must judge: certainly not the sort of 'emotional Jacobitism' which Brooks-Davies has diagnosed as persistent in Pope, which is endemic in what Dryden conceives to be 'pious', prompts Verrio's botcheries in the very paintings themselves, and transfigures Mary's countenance, in Behn's *Congratulatory Poem to Her Sacred Majesty . . . Upon Her Arrival in England*, into 'That Face that Awes, and Charms our Hearts' so wringingly (as opposed to ringingly) 'the more'.

24: Retouchings

Julian's, obviously, will have been the very last countenance in Christendom calculated, on recognition, to 'Awe' or 'Charm' or surprise with spontaneous joy 'spread Hearts' after the fashion of Waller's *Upon His Majesties Happy Return*. Open minds, on the other hand, have from time to time made something positive of him, though never a *'deuterot Christos'*. Still, an 'apostatical' can, with a little ingenuity, be made to sound very like an 'apostolical' succession.

The circle of 'bright *Maria*'s Charms' had been broken by death. So loud was the ensuing chorus of lamentations that, one of them suggests,

> The Plains are apprehensive from the sound
> That their great *Ceres* can no more be found.[1]

'Earth's Harmony, Life, Lustre and Delight', mourns Eusebia, or the Church of England, in Nahum Tate's *Mausolaeum*,[2]

> Have hence with my *Astraea* took their Flight.
> Time journeys on, and Nature keeps her Round;
> Our Vales may bloom again, our Groves be green,
> No more the Goddess of the Spring be seen!
> She's fled –

to exchange, in the corner of Verrio's ceiling, courtesies *en passant* with another 'Goddess of the Spring', Proserpina.

In the absence, as it were, of her 'presence', devoid of shaping spirit, 'Time journeys on', 'To morrow, and to morrow, and to morrow, . . . from day to day', leaving scope only for the journey-work of 'skill'. 'Accepting William as king', notes Howard Nenner,

> whether by election, conquest, or merely as *de facto* without regard
> to how he came by that estate, depended upon a shift of emphasis
> from the mysterious essence of monarchy to its practical and
> necessary function.[3]

Monarchy ceases to move in a mysterious way. 'Wonder en is gheen wonder.' What is needed now is not a piously loyal and most believing, but an objectively analytical and Stevinian eye. Who better to signalize such a shift than the Apostate, who sits, not like Rymer's Mary, 'above Mechanick sway', shedding propitious influences, but (true to his cognomen) apart, to scrutinize past 'popetries', expose their engineering, give credit where it is due and suggest a more rational way forward.

'She's fled!' Tate's 'Goddess of the Spring', his '*Astraea*', Smith's 'great *Ceres*', gone! But there, conspicuously, is 'great *Ceres*' on the King's Staircase, reposing at the nexus of a goldenly poetic picture of universal harmony, oblivious, it seems, to the bickerings and causidical rhetoric of next door. And, despite the promise of Prioresque 'laughing Hours' overhead, and accompanying 'young Idea' of a floriferous future (turned by Verrio into a 'mannikin-pis'),[4] Peace and Plenty were, in fact, to prove beyond William's

management. It was more than a decade after his death before

> At length great ANNA said – Let Discord cease!
> She said, the World obey'd, and all was Peace![5]

That old Stuart magic again, of course! We remember the end of *Absalom and Achitophel*:

> He said. Th'Almighty, nodding, gave Consent;
> And Peals of Thunder shook the Firmament.
> Henceforth a Series of new time began,
> The mighty Years in long Procession ran:
> Once more the Godlike *David* was Restor'd,
> And willing Nations knew their Lawfull Lord.[6]

A 'Lawfull Lord' will comprise not only 'king' (*de jure* as well as *de facto*) but also 'husband', making 'willing Nations' ('the whole island', as James VI and I had put it, insisting he was no bigamist) into a lawfully wedded wife, enhancing the sense of a renewed 'emotional togetherness' and adding a 'physically, physiologically natural element' to 'knew' which is entirely missing from the 'thought fit' of Shadwell's compliment to William. The more promiscuously 'pious' energies of the poem's opening are refocused. Monarchy does move (in more senses than William Cowper had in mind) 'in a mysterious way'; has just now been restored a second time by miracle: a *fiat*, this time, articulated by the King himself. 'Wonder en is gheen wonder', says the Dutchman; but Dryden's 'tour extraordinaire' says just the opposite. Pope (if the metaphor is not unfortunate in view of Belinda's card-table) follows suit, although his touch is lighter, neater – more, it has been suggested, like Waller's, whose own Romulean 'CANONIZATION' of O.P., however, in *Upon the late Storme*, upon examination tends to confirm, not confound Stevin's hypothesis. When, too, 'Gold, though the heavy'st Metall, hither swims' in the *Panegyrick*, patently, 'miracle is no miracle'; where would the wit be, else?

There are no signs, either, in Ceres's scene at Hampton Court, that it has been necessary 'To digg for Wealth'. Equally, there are no signs of witty short-circuitry. The gold plate seems to have materialized as spontaneously as the flowers, fruit, sheaf of corn. It is a world of pure, musical 'presence' not skilfully exploitative manipulation as an alternative to honest hard labour. All the figures are of 'machining persons', 'above Mechanick sway'.

> It is when she tries to forget her sister [history], and yearns after a
> dreamland outside of time,that poetry becomes idyllic,

remarks Renato Poggioli, discussing 'pastoral poetry and the pastoral ideal' in *The Oaten Flute*.[7] What we have here is 'idyll': an attempt to forget, or transcend, history; turn chronology and the mundane series of cause-and effect with which Waller is apt to play so speciously fast-and-loose into a series of new, musical time, and rest timelessly content in 'the songs of Apollo'.

But, as the ending of *Love's Labours Lost* regrets, 'The Words of Mercurie / Are harsh after the songs of Apollo', and there is other writing on the wall next door, much weighing and finding wanting. Virgil, in *Eclogue* IV, may

imagine a near future when his miraculous child, maturing,

> will foregather with the gods; he will see the great men [heroes] of
> the past consorting with them, and be himself observed by these.[8]

In *The Caesars*, when 'the great men of the past' pretend to such high society, they find their credentials embarrassingly open to question. Are we then faced, as in *Love's Labours Lost*, with a final 'You that way, we this way': the prospect of 'idealogy and *Realpolitik*', in Snell's words, each pursuing 'its own journey without paying much attention to the other', idyll deliberately shutting its eyes on or overpeering history, political reality having no room for 'a dreamland outside of time'. Or can they be brought into fruitful conjunction?

Entering his apartments to get on with his kingly business, the Caesar *in situ* will necessarily have to turn his back on the bright picture of a Golden World which, insofar as it evokes memories of *Eclogue* IV, re-echoes 'the last echoes of "the song of Sibyl"':[9] specifically, as the Latin of the fourth line of Virgil's poem makes plain ('Ultima Cumaei venit iam carminis aetas'), the Cumaean Sibyl – the one whose figure is depicted in monochrome over the guard-chamber doorway, ushering Aeneas (and the king with him, 'Gendres de mérite', both!) into the underworld and towards another vision of a Golden Age to be instituted by Augustus, albeit one much complicated now by its epic context, and already clouded by history in that Marcellus, at the time of writing, was dead.

The cost and pathos inseparable from historical process are not to be denied. Augustus himself, who is to make good the past and begin 'a Series of new time', will not escape – has not escaped – unscathed. Moreover, mounting the stairway has already revealed him, not in magnifically Sibylline projection, but under Silenic censure; although it will have to be admitted in the end that, however odd-looking the fixed stare and conspiratorial-seeming the word-in-your-ear on the wall, in the book Zeno's intervention does nothing but good, magically transforming a dangerously unstable youth into 'un homme sage & reglé'.[10] Julian was not someone to belittle the virtues of Stoic teaching. Zeno was the founder of the Stoic school; so even comparing him to 'ceux qui marmotent des enchantemen[t]s de Zamolxis' is not designed to denigrate, although the scene as pictured makes Wind think of Jesuit confessors, and may be meant to.

For, in the book (as has been seen), Augustus is humiliated. 'Baissant les yeux de honte', lowering the gaze he piqued himself was so piercing ('the *Physiognomy* of Princes' being, it will be remembered, 'such as strike's an awfull feare and reverence into as many as behold them'), he is himself quelled, abashed and put to silence, by his irrepressible interrogator:

> Quoy! Dit Silène, n'est il pas vray, Auguste, que comme ces faiseurs
> de Poupées s'amusent à faire de petites Nymphes, qu'aussi tu nous
> as fabriqué des Dieux, & César que voilà tout le premier?[11]

Nor does it do much for the dignity of that 'Caesar over there', Julius, lately so bullish about his own divine rights, to be cast as the original barbie-doll in his successor's little power-game – there being no doubt, as Spanheim notes,

that his 'consécration' had little or nothing to do with real worth but was in practice a purely political ploy on Augustus's part,

> comme son Fils adoptif & son Successeur, pour s'acquérir à luy-même la vénération des Peuples, & pour apuyer sa succession.[12]

'For a hundred and fifty years now', writes Wendell Clausen, introducing *Eclogue* IV in his *Commentary on Virgil, 'Eclogues'*,[13]

> Roman proconsuls in the East had been paid divine honours, a subservient people merely transferring the language and gestures of such worship from Greek potentates – Alexander's successors and their successors – to Roman magistrates, men like Pompey, Julius Caesar, Antony. But in the West, in Rome, there was no such tradition, nor as yet, practice –

until Augustus, with a little help from 'His Flattring *Priests* and *Poets*', changed all that, encouraging a nation 'imbastardized from the antient nobleness of their Ancestors' (in the phraseology of J.D's assault upon the Tory cult of Charles, King and Martyr) to adore 'the Image and Memory' of their rulers, 'not only in a religious, but a civill kind of Idolatry'.[14] Hobbes, for his part (as has been seen), finds 'a civill kind of Idolatry' at the very roots of Rome, in the 'CANONIZATION' of Romulus, though he cites no further examples until that of *'Julius Caesar'*, prototype emperor and first and foremost, according to Silenus, of Augustus's 'fabrications'.

And, as has likewise been observed, scepticism about 'not only . . . a religious, but a civill kind of Idolatry', is writ large on the King's Staircase, albeit in an imported, tumescently baroque hand such as might more usually be associated with its promulgation eastwards, in France and Italy. If there is still a trace, a soupçon of Stuart apotheosis in the air, it is confined to a corner of the ceiling (and Mary had deserved it, having proved not only a unifying 'presence' but, in her husband's several absences, an unexpectedly competent 'Manager', too). To be sure, with a new Queen on the throne (as she was to be before the paint was dry), and with Pope about to proclaim that 'Peace and Plenty tell, a STUART reigns', it becomes tempting to imagine Ceres's features resolving themselves into those of Anne; but always there is the Apostate opposite to take with his mercuric acid the gloss off 'the songs of Apollo', the gilding away from the Virgilian image of some 'AUGUSTUS CAESAR DIVUM GENS', and reveal Marcus Aurelius as the one genuinely golden prospect....

Whose name and reputation, naturally enough, had long supplied grist (if nothing like so much as Augustus's) to sundry imperial mills, especially, on the evidence of Frances A. Yates's *Astraea*, that of Charles V: 'an Emperor rare', according to one of her sources, Sir John Harington's version of *Orlando Furioso*,

> And one that shall most worthily compare,
> In war for courage, and in peace for justice,
> With *Trajan*, with *Aurelius*, or *Augustus* –

otherwise, in the original, Italian listing, 'Augusto, Traian, Marco e Severo' (Septimius Severus, that is).[15] Before too, Ariosto's final revision of his epic

was completed, and with the authentic, Greek *Meditations* yet to be rediscovered and published (as they were not until the 1550s), fray Antonio de Guevara had composed a fictionalised *Libro áureo de Marco Aurelio* for the edification of the same 'Emperor rare'; a work almost immediately reworked into the *Relox de Prencipes*, subsequently well-known in England, in Sir Thomas North's translation, as *The Diall of Princes*. Again, the famous equestrian portrait, painted by Titian in 1548, of *The Emperor Charles V at the Battle of Mühlberg* (where the beaten Lutheran princes had been driven back across the Elbe), 'recalls', suggests Yates, 'the antique statue of Marcus Aurelius' in Rome which had inspired much Renaissance imitation. 'He is', she says, 'Romanized as the stoic emperor, the World Ruler on whose domains the sun never sets'.[16] But while Marcus Aurelius is riding high – prancing, almost; for the horse's forelegs are both off the ground in Titian's picture, as they are not in the model adduced, and the tassles of is horse-cloth are dancing, to counterpoint the serene impassivity of the rider and highlight the achieved, truly stoical supremacy of mind over matter – while 'Marco' is thus riding high in the shape of a Holy Roman Emperor who is fulfilling Sophrosina's prophecy in Ariosto, 'el Apostata Juliano' is to be found in the summer of 1549 down among the dead men and the damned at Lille, keeping company with the representatives of defeated Protestantism.

It is his promotion, startling even in a Protestant ambience, to a position of such prescriptive prominence at Hampton Court which gives notice of a recalibration of the 'dial of princes', a re-setting of the clock to point to changed and changing times. Kings and kaisers, on this King's Staircase, are not so much to be magnified as cut down to size, not idolized but exposed to scrutiny. There is no 'Triumph of Caesar' here; rather an acidic (or mercuric) testing which leaves least, if not altogether unscathed the exemplar who, 'in those profound Meditations of Philosophy, which carry the Noble Title of *Himself to Himself*' and Burnet so much admires, urges himself to

Take heed, lest of a philosopher thou become a mere Caesar in time,
and receive a new tincture from the court.[17]

The spectator, too (though Walpole is rendered entirely incurious by the crass execution), is alerted by Julian's presence to 'take heed': look not 'to believe and take for granted', as Bacon puts it, 'Of Studies',[18] 'but to weigh and consider' – and make an informed selection, since the ordonnance of the picture is not of itself diagnostic, except insofar as it indicates a rivalry between a central Julius (whom no one has any trouble identifying) and the figure known from *The Caesars* to be Alexander: Tweedledum and Tweedlee when regarded through the Aurelian end of a telescope.

So there is evidence to be sifted and a considered choice to be made. And one, crucial choice which has already been made in real life: 'un Gendre de mérite', who might be (is!) another Marcus, has been preferred to a legimate Commodus (brother or son) who was proving or promised to prove pernicious. The indefeasible right of hereditary succession has been violated; a principle which 'Some people' (the Drydens rather than the Stevins of this word) took, like

the extraordinary power of the sea and large rivers, . . . on the whole

to be God's work, about which men trouble themselves in vain,

because any interference will only, in due course, provoke 'a just Reprise': a potentially devastating reversion to pre-ordained shore- or blood-lines. When, as shortly, 'Peace and Plenty' and Pope were to proclaim that, once again, 'a STUART reigns', a more seepingly restorative process was still to be hoped for, although, ironically the one, plausible way of furthering the 'just Reprise' and ensuring a prolongation of Stuart rule would have been for the prospective James III to have turned, himself, apostate; and so 'heresy', 'choice' would have retained its casting vote and 'the Divine Right of Succession, &c.', lineally determined, been subordinated to law as more parliamentarily established.

'Despite', however, 'soundings from leading Tories, specifically Oxford and Bolingbroke',[19] the Pretender refused to compromise his Catholic faith. Not for nothing was he the son of a father whose pieties in exile made him, almost, a candidate for Roman canonization,[20] and who ('un spectacle digne de quelque attention', remarks Voltaire),[21] even at St Germains, continued to demonstrate, at least with respect to the scrofulous, the true, Stuart touch: 'The Healing Vertue of the Royal Hand', as Thomas Walker had described it in introductory verses to John Browne's *Adenochoiradelogia*, published late in Charles II's day,

> Which Heaven on our Monarchs does bestow,
> To make the Vain, Conceited Rabble know
> That Pow'r and Government, from Heaven flow;
> And that there's some Divinity in *Gods* below. . . .[22]

'There's some Divinity', still, in the 'great ANNA' of *Windsor Forest*, whose fiat may be pat, but is not yet facetious. She is touchingly 'a STUART'; was also the last British monarch actually to touch for the king's evil, though

> It is said that [she] was at first held back by a feeling that the throne
> was not rightfully her own, but should by inheritance belong to her
> young brother[23] –

a scruple which could only have been applauded by 'emotional Jacobites', support her though they might as a step, at least, in the right direction. But 'King *William* of glorious Memory', reports his sometime physician, Sir Richard Blackmore, writing in the days of George I, had had no more truck than 'his present Majesty' with 'that Superstitious and insignificant Ceremony'[24] which (fomented by 'a great many odd and whimsical Opinions, as that *our dear Lord King Charles* is the Antitype *of Edward the Confessor*',[25] its originator) had been vigorously revived at his Restoration by a Merry Monarch 'who, from the records of the Chapel Royal, employed this charm, it is said, on no less than 92,107 persons'[26] before his reign was out. James continued the good work, with the added refinement that the assistance of Anglican clergy was dispensed with, and from October, 1687, his Jesuit confessor, Father Petre, officiated at healings.[27] Blackmore was inclined to suspect a popish plot from the start:

> And the end they had in View might not only be to flatter the Prince

by endowing him with a supernatural wonder-working Virtue, but that by thus ingratiating and insinuating themselves into his Favour, they might confirm him in their superstitious Religion, and by attaching him to their Party, they might become Directors of his Conscience and engage him to employ his Treasure and civil Power to enrich and advance the worldly and ambitious Sons of a degenerate Church.[28]

This savours of the days of Constantine and Constantius and after, when (according to *Some Seasonable Remarks*) the hypocrisy and worldly ambition of a 'usurping Priesthood' with a taste for 'Absolute Tyranny' precipitated 'the Deplorable Fall' of that same disillusioned but eminently 'discerning Prince' who is elevated to such diagnostic distinction on the King's Staircase as author of *The Caesars*: a work where, for example, Augustus's desire to have it believed that his eye-beams are as blinding as the rays of the sun is more to be ridiculed than reverenced. John Browne (a practising surgeon himself) had, in 1684, deemed *Charisma Basilicon, or, the Royal Gift of Healing Strumaes, or Kings-Evill-Swellings by Contact, or Imposition of the Sacred Hands of our Kings of* England *and of* France, *given them at their Inaugurations*, worthy of a book to itself, appended as a third part to his otherwise 'Anatomick-Chirurgical Treatise', *Adenochoiradelogia*. 'Reason by sense no more can understand', as the *Hind and the Panther* has it, 'The game is play'd into another hand'[29] – with spectacularly effective results, it appears, since Browne will

> humbly presume to assert that more souls have been healed by His Majesties Sacred Hand in one year, than have ever been cured by all the Physicians and Chirurgions of his three kingdoms ever since his happy Restauration:

which certainly puts the 'Anatomick-Chirurgical' parts of his undertaking firmly in their place. 'If he . . . were not the right Heir to the Crown', needless to say, 'these wonderful effects would not so apparently have been performed by him'.

> Should an Usurper or Tyrant . . . touch at the same Experiment, you'l never see such happy success; as tryed by the late Usurper *Cromwell* in the late Rebellious Times.[30]

As it happens, there seems to be no vestige of evidence to show that O.P. set any more store by the exercise than P.O. after him; by whose times the game, as far as medical and political thinking were concerned, was being played in a reverse direction.

'Political thinking since Locke', maintains Laslett, has tended to misunderstand 'the emotional togetherness implied by all political relationships',[31] to discount that 'physically, physiologically natural element' epitomised (to supernatural effect, if Browne is to be believed) in the ritual of touching for the King's evil: a practice resumed by Anne in order to show that 'a STUART reign[ed]', but thereafter discontinued as a *scepsis scientifica* took over in both medicine and politics. Locke, like Hobbes before him, made it his working hypothesis that 'the stuff of society was conscious ratiocinaction':[32] took it for granted that political relationships were not naturally

(and thus God-)given – each bound to each, to wrest a Wordsworthian line, 'by natural piety' – but crafted by 'conscious thinking' and fixed by contract which might, should the need arise, 'be altered by further thinking'. In this scheme of things, if a king is 'Divine' at all, it will not be because he was charged with the grandeur of God at conception (so that even when a people accidentally without one 'concurre in the desire of such a King', says Donne, 'they cannot contract, nor limitte his power' any more than parents can 'condition with God' about the faculties to be infused into the embryo prepared by their sexual congress for His 'inanimation'), but because 'Law and Sense' have decided, for one reason or another, to regard him as such.

In the last analysis, therefore, 'Kings are' – though Dryden was vehemently denying it as he wrote – 'onely Officers in trust';[33] and the best sort of 'Officer', under these circumstances, to put 'in trust' (the legal terminology is crucial: no cavalier loyalty here!) will be a Marcus Aurelius, not an Augustus eager to have himself and his predecessor adored 'not only in a religious, but a civil kind of Idolatry'; or, for that matter, a Constantine, whose effigy not so long since (October 9, 1670) had been unveiled, 'in the presence of Clement X and a host of onlookers',[34] on the base landing of a reconstructed Scala Regia in the Vatican, to put emperors and kings in their place in a deceptious world of priestcraft and popery and ecclesiastical designs upon the state.

For, observes T.A. Marder, discussing in his book on *Bernini's Scala Regia at the Vatican Palace* 'the transforming power' of its 'architectural and figural imagery', and how the 'experience of climbing or descending a staircase' has been turned 'into a theater for stylized behavior that was intended to authenticate papal power':

> In this respect the equestrian image of Constantine, clearly shown in
> the vision as a captive of divine imperatives [his horse boggles rather
> than rears in triumph, and he himself is transfixed by the sign proffering
> victory at the Milvian Bridge], may symbolize the Duke of Modena,
> the French king, the Hapsburg emperor, or the English monarch, all
> of whom (like other rulers) had been characterized as a modern
> Constantine in their own courts.[35]

Here they all are, then: summoned by their own imagery to the foot of a staircase which, thanks to a perspectival tour de force, holds out the prospect of along, arduous climb, but which proves, in the event, much shorter and easier than appearances indicate; so that, says Marder,[36]

> the illusion of sensory perception seems literally to dissolve as one
> leaves the outside world to ascend to the reception of the pope and
> his representatives

in the Sala Regia above, where 'the ideal relationship of *sacerdotium* and *imperium*'[37] was reaffirmed and homage done to 'the usurping Priesthood'. But Julian, notoriously, was inveterately opposed to Constantine, his bishops and the threat of a '*Demogorgon* Pope': hence his place, not on the base landing, at the foot, but above the stairhead at Hampton Court.

Wren's 'royal staircase', listed by Marder together with examples at Turin, Caserta and Versailles as one of 'the most impressive works in the genre'

undertaken in the wake of Bernini's seminal endeavours at the Vatican,[38] might be regarded as a protestant response to the soaring, escalatory pretentions of popery and 'baroque absolutism': a structure conceived, together with its 'figural imagery', not so much in emulation as sober and freethinking remonstrance. Emulation might, indeed, have been in the air had Alexander stood grandiloquently for William; but the scheme, on reflection (and the Apostate is there to provoke reflection), seems more subtly devised than that, and based, too, on a closer, wittier and more sharply discerning reading of Spanheim's *Les Césars* than Wind supposes, for all his emphasis upon 'the fascination' ('intellectual fascination', it becomes in the revised version of the essay)[39] of the programme, as distinct from the 'mediocrity' of brushwork which since Walpole has been regarded as little better than wallpaper.

'Your Friend *Plato*', Sir Thomas More's *alter ego* reminds Hythlodaeus in Burnet's 1684 translation of the *Utopia*, 'thinks that then Nations will be happy, when either Philosophers become Kings, or Kings become Philosophers'.[40] Erasmus's Folly had long since laughed this idea out of court, noting particularly (with Aurelius as her prime example and Cicero and Socrates as corroboration) an unfortunate correlation between a gift for 'conscious thinking' and propensity to beget fools[41] which makes Commodus and a latter-day 'unfeather'd, two Leg'd thing' look like symptoms of the same disease. But Julian, in the end (and although he allows Folly her say in the ironically socratic shape of Silenus), is of Plato's party, as Locke was of Shaftesbury's. And, manifestly, the nearest Rome ever got to a philosopher-king was Marcus Aurelius, Commodus and Faustina notwithstanding.

Faustina, moreover, a notoriously promiscuous wife remembered out of mere weakness and a foolish-fond concession to convention with divine honours, has become, over the King's Staircase, Mary, most dutiful of co-regents and unexceptionably faithful of consorts; now, by merit more than birthright, being conveyed to a seat amongst the gods: a place, perhaps, at high-table, alongside the spouses of Aurelius's own sponsors, Saturn or Kronos, Time, and Jupiter himself.

Other Caesars and 'Alexander, falsely styled the Great', have, as seen, to make do with lesser deities; Constantine with no genuine deities at all, but 'Molesse' and 'Luxure', 'Softness' and 'Luxury': qualities appropriate to an emperor who 'debaucht Christianity' and laid the foundations of St Peter's and the Papacy. (In the case of the basilica, quite literally, according to one of the roundel reliefs decorating the vault above Bernini's equestrian statue, which shows him heaving a pickaxe while Pope Sylvester prays and Saints Peter and Paul appear in the clouds overhead.)[42]

Constantine, in Julian's book, was always going to be a rank outsider. Of the five also-rans in his Cesarewitch, it is may be Augustus who is the most impressively backed, by Apollo – again appropriately, given his patronage of learning and poetry and, above all, of Virgil, whose verses resonate in the golden octave of Ceres's idyll of Peace and Plenty on the one hand, and, on the other, are yet more specifically the source of that '*Pyra*, or Funerall Pyre, done in Stone-Colour' above a thus sombrely epic exit which, nevertheless,

gives access to the vision of another Golden World to come. Indeed, the bust
placed in front of the picture, as part of the pediment of the doorway, looks
thoughtfully forward (or back) to the prospect, although the Sibyl behind
points sideways, indicating the wall-space in between, which is given over to
a most unvirgilian and saturnalian (as opposed to goldenly saturnian) pageant.

'On n'a qu'à voir sa maison pour en mépriser souverainement le maître',
writes Prior, reporting, 1 March (NS), 1698, from Paris to Arnold Van Kepple
(by now Baron Ashford, Viscount Bury and Earl of Albemarle, but still too
Dutch for English), and making hay with his adverb:

> bas-relief, fresco, tableaux, tout représente Louis le Grand, et cela
> d'une manière si grossière que le Czar y trouveroit à redire. Il ne
> sçauroit cracher dans aucun coin de ses appartements sans voir sa
> propre figure ou celle de son lieutenant le Soleil, et sans se trouver
> Héros et Demidieu en peinture.

'He is strutting in every panel', Charles Montague had been told ten days
earlier,

> and galloping over one's head in every ceiling, and if he turns to spit
> he must see himself in person or his Viceregent the Sun with *Sufficit
> orbi*, or *nec pluribus impar*.[43]

But, thinks James Lees-Milne,

> We can to some extent discount Matthew Prior's boast on being
> conducted round Versailles . . . that 'the memorials of my master's
> actions are to be found everywhere but in his own houses'. For to be
> truthful William III's glorification is to be met with on the pediment
> of the east front of Hampton Court, in the rule of Hercules casting
> out envy, hatred and malice. . . .[44]

Or 'Superstition, Tyranny and Fury', says Wind,[45] seeing here, and in William's
association with Hercules more generally, another good reason for linking
him with Alexander on the Staircase, though perhaps there are better ones
for not such as would, to some extent, bear out Prior's boast.

Versailles was what George L. Hersey has called an 'absolute palace': 'a
three-dimensional table of organization, a kind of taxonomic or iconographic
working model of the monarchy it housed', 'a matrix for absolute rituals'[46]
developed there to a degree so exaggerated as to lend spice to Prior's jest
about the 'Vir Immortalis' being absolutely reduced to spitting in his own
face, offering insult to his own image. Hersey, moreover, has begun by noting
in his introduction that,

> as everyone knows, there is still no great royal palace in Great Britain.
> The tiniest princedoms often have more impressive royal residences.[47]

Plans, however, were afoot 'in 1647-8, and again in the 1660s', to rebuild
Whitehall on a suitably comprehensive scale, along lines initially draughted by
Inigo Jones and afterwards developed and adapted by his assistant and would-
be successor as Surveyor, John Webb.[48] At their grandest, claims Sir John
Summerson, the realized results would have been 'Akin to what Philip II
achieved at the Escorial' and 'for Louis XIV to excel if he could' when he
came to construct Versailles.[49]

Philip II, of course, had been that 'Muy Alto y Muy Poderoso Principe' whose triumphal entry into Lille in 1549 had put the Apostate so firmly into his accustomed Gehenna; and the '*Idea* which provided the building with its underlying symbolism', argues René Taylor convincingly in an essay on 'Architecture and Magic: Considerations on the *Idea* of the Escorial', 'was nothing less than Solomon's Temple'.[50] The same '*Idea* or fore-conceite'[51] lies also, suggests Bold – hadn't Charles I (being Prince) visited the Escorial on his way home from wooing the Infanta? – behind 'Jones's designing of a New Jerusalem in St James's Park' to underline

> the Solomonic connotations of Stuart kingship which had been
> reinforced by Bishop Williams in his sermon *Great Britain's Salomon*
> (sic), preached at the funeral of James I,

and canvassed, as has been seen, by Rubens on the ceiling of the Banqueting House: a building which Webb (Jones himself suffered no such inhibitions) seems to have been understandably anxious to incorporate in new designs.[52]

That a visitor, therefore, to Hampton Court (no 'absolute palace' by Hersey's standards) should find himself, on its King's Staircase, not harangued by some 'Judgement of Solomon', but teased by a 'Judgement of Julian the Apostate', speaks volumes.

The North wall is all *otium cum harmonia*, an arcadian theophany: Apollo and his Muses in concert with Pan, a languorously ruminative Ceres, coy Flora, quickening Zephyr, Peace and Plenty and fructifying waters (Bickham's '*Thame* and *Isis*' if you will, with tributaries) – 'a dreamland', in sum, 'outside of time', beyond (except insofar as Clio is one of the Muses!) history. Beyond, too – though like Clio, like Calliope; and there, sure enough, she is to Apollo's left, flanked by Melpomene and Euterpe, her book open, perhaps (witness Ripa)[53] at *Aeneid* 6 – beyond, too, the brazen clangours of 'arma virumque cano'; there being, as before noted, no arms at all, not even ones that have been beaten into ploughshares or pruning-hooks, in this picture – and, incidentally, no mere mortal soul to make use of them, either.

Opposite, contrastingly, above the entrance to the King's Guard Chamber, the scene is not arcadian but epic: drawn from the very poem which opens by proclaiming 'Arms and the Man' so sonorously as its subject, and with mortality made monumental in the shape of the funeral pyre of Misenus: the Trojans' stridently contentious trumpet, who left a name to pinpoint Aeneas's Torbay and give a bearing, too (perhaps), upon the fate of the young Marcellus. Book VI, in due course, is to open a window upon a future, now flatteringly imperialized, Golden Age; but the human cost of getting there is not to be belied. There is an underworld of implication; and this painting, not inappropriately, is 'done in Stone-Colour'.

Betwixt and between, a devil's advocate has been about his more colourfully dissentient business. And who shall stand unhacked, unchipped, in the light of this startlingly unexpected, vividly satirical intervention? Not Virgil's Augustus, for one; or Alexander, 'falsely styled the Great', Julius Caesar, Trajan. Certainly not Constantine. What about a William?

'Truth, 'tis supposed, may bear all lights', remarks the Third Earl of

Shaftesbury, beginning his Essay on the 'Freedom of Wit and Humour';
 and one of those principal lights, or natural mediums, by which all
 things are to be viewed, in order to a thorough recognition, is ridicule
 itself, or that manner of proof by which we discern whatever is liable
 to just raillery in any subject.[54]

So here we have three lights: arcadian, epic, satiric. And 'In an age when', to
quote from John W. O'Malley's summary of the gist of Paolo Prodi's *Il
Sovrano Pontifice*, 'royal absolutism advanced under the impetus of the
powerful alliance of throne and altar'; when the papacy itself had 'offered a
first model of the modern priest-king',[55] and built a Scala Regia to emphasise
its primacy in this respect (though somewhat late in the day since, by then,
'which way soever we cast our Eyes' claims *The History of the House of
Orange*, 'we shall find Attempts of the same Nature prosper'):[56] in such an
age, here is one prince, on a principal staircase of an important palace, prepared
not to follow fashion by having himself promoted, in a perspective that begs
all question, as some divinely-rightful judge, absolute Solomon or such, but
daring to stimulate rational assessment, challenge that 'Freedom of Wit and
Humour' recommended by Shaftesbury.

On the understanding, naturally, that it will discover little 'liable to just
raillery': that 'conscious thinking' will rate him, in the end, another Silenus-
silencing Aurelius – such as Claudius Pompeianus, too, might have proved,
had reason only prevailed and 'un Gendre de mérite (like William himself)
been preferred to an incorrigible and calamitous next-of-blood. Like William
himself? Like, come to that, Aeneas: another 'Gendre de mérite' who preserved
a nation and, for all Dryden's 'pious' qualms of conscience and touching
'emotional Jacobitism', a most potently positive analogue.

As for that (in Shaftesbury's words)[57] 'virtuous and gallant', 'that elegant
and witty', 'generous and mild Emperor', Julian: don't we, in him, as Burnet
contends, 'have a Witness in favour of [Christianity] beyond Exception'?[58]
For such virtues as he, of all observers, detected in it – 'the Temperance, the
Gravity, and above all the Charity' he enjoined his own, heathen 'Priests and
People' to imitate – must be taken as read. Only 'its Primitive Candour and
Ingenuity' had begun, in the times of Constantine and Constantius, to be
corrupted by 'a usurping Priesthood' swelling with political ambition and an
appetite for the flesh-pots and 'poison, sweet poison' of preferment; 'first
poured upon the church', as William Whiston (a stubborn advocate of
'primitive' Christianity) will confirm, 'by *Constantine the Great*, and greedily
swallowed, both by papists and protestants, ever since'.[59] Hence Julian's else
inexplicable apostasy.

A shrewd judge he remained, nevertheless. And if so unexceptionable a
witness (against all the odds) where Christianity is concerned, why not where
Caesars? What Louis XIV, however, could afford to empanel him – or Philip
II, except to abuse him as diabolical cliché in a papistical triumph of 'idol
lordship'? What Charles II, for that matter? – Who had had aspirations, himself,
to sun-kingship and been depicted (by Verrio, who else?) driving Phoebus's
chariot across the ceiling of his Withdrawing Room at Windsor Castle: a

work long since destroyed but which Croft-Murray has gone so far as to suggest, judging from Peter Vanderbank's *circa* 1690 engraving,

> was actually the inspiration for Lebrun's first proposals for the Passage du Rhin ceiling at Versailles, showing Louis in a suspiciously similar composition.[60]

Moreover, on the ceiling of St George's Hall (likewise painted by Verrio, likewise since destroyed), and even as his 'Lazy, Long, Lascivious Reign'[61] was drawing towards its end, 'Chast, pious, prudent, C[harls] the Second'[62] was to be raised to yet greater heights: portrayed seated in majesty and full Garter Regalia upon a rainbow to indicate, thinks Katharine Gibson,

> both his judicial supremacy and his divinity, because it was the allegorical position of Ripa's *Giuditio*, and the usual seat of Christ the Judge.[63]

St Edward's crown ('odd and whimsical Opinion', remember, would have it '*that our dear Lord King Charles* is the *Antitype* of *Edward the Confessor*') – St Edward's crown is poised above his already be-laurelled head, sustained on the one hand by Religion (identified by her 'twin Tablets of the Old and New Law') and on the other by Piety, with her stork. This, at least, is Gibson's reading of the pictorial evidence still available (a drawing of *circa* 1805 which she attributes to John Francis Rigaud, and a watercolour of about 1815 by Charles Wild).

A stork, certainly, – traditionally the destroyer of serpents as well as respecter of parents – would not be out of place in a hall ('the finest Room in the World', enthuses Elias Ashmole)[64] dedicated to St George the dragon-slayer. Besides, storks, according to Filippo Picinelli's *Mundus Symbolicus*, are to be associated with a prince who has made it his business '& sicarios exscindere, & suam patriae tranquillitatem restituere' ('both to extirpate murderers and restore [as it were] the King's Peace to his native land'); and so, by extension, with 'Christus Judex', 'Christ the Judge', Whose 'usual seat', as has been seen, is the rainbow.[65]

In any Last Judgement, of course, there are the damned; and here in this picture are their correlates, spilling over its bottom edge, driven downwards by Justice with uplifted sword, scales and attendant Virtues, into a confused involvement with the Hydra of Faction, Rebellion, Sedition, perhaps heresy (for Charles was shortly to die, reputedly a Roman Catholic). And 'Fallor?' cries Thomas Spark, describing all this in his 'Aula Vindesoriae':[66] is he deceived?

> an agnosco permistum Te quoque Turbae
>
> Shaftesburi, ô Anglis caput horum & causa malôrum!

Or does he recognize amongst the mob, Shaftesbury, author and fomenter of England's ills? No, needless to say, he is not deceived: there he is at the bottom of the pile! Verrio, with his penchant for '*Italian* Bite', was not going to miss a trick out of Michelangelo's book (who had notoriously placed his least favourite Master of Ceremonies, Biagio de Cesena, in a similarly invidious position in the Sistine Chapel). 'On the Cieling', confirms Ashmole,

> are painted the Triumphs of King *Charles* II. over Faction, Rebellion

and Sedition, where the Painter has put the Picture of the Earl of *Shaftesbury*, Lord Chancellor in that Reign, representing Sedition with Libels in his Hand, a Man, who served all Times and Parties, according to his Interest, and was named as one of the King's [Charles I's] Judges, though he had the Wit not openly to appear.[67]

One of these 'Libels' might well have been *Some Seasonable Remarks*. And where else would one expect find 'the Emperour Julian', archetypical apostate, in such a scenario, except in the very pit of hell, as at Lille during Don Phelippe's *Felicissimo Viaie*? Yet (thanks, speculates Wind, to Shaftesbury's grandson) – yet at Hampton Court, and on if not 'the finest [Staircase] in the World', yet one of them, he sits taking (in legal phrase) cognizance himself: judging, not judged – the representative of 'conscious thinking', proof against all 'emotional Jacobitism', who turns Verrio's decorations here (coarsely executed though they may be, and vitiated by other sign's of the artist's disaffection) into perhaps, after their fashion , as significant a document in English constitutional history as Magna Charta.

25: 'Image Government'

The Legislative Power, declares the title of a tract published in 1656 by the radical Fifth Monarchist, William Aspinwall, *is Christ's Peculiar Prerogative*: a timely reminder when, it may be recalled, Joseph Jane had been reporting from The Hague as lately as July, 1655, rumours 'that Cr. Will assume a legislative power before he proceede to his title, for that is an easy stepp',[1] and one which seemed ever more and more likely to be taken.

'An easy stepp', may be, and one which the Wallers of this world wanted; but, warns Aspinwall, with Zeal-of-the-land-Busyish iteration and a side-swipe, too, possibly, at Cromwell's current position as *Lord* Protector,

> The Power of *giving Laws*, or the Legislative Power, which is a Lordly Sovereign Power, Christ hath reserved to himself, as his peculiar Royalty.[2]

That Christ had once exercised such a power, he has been arguing,

> Witness all the Laws, Statutes and Judgements, given to Gods people by the hand of *Moses*, when he brought them out of the Land of *Aegypt*. And that Government he exercised for the space of many hundreds of years together, until the *Babylonish* Captivity, when *Nebuchadnezzar*, the head of *Image government*, wrested it (as I may say) out of Christs hand. But Christ hath promised, That as formerly he did exercise this power, so he will assume this power again, when he hath broken down all *Image government*; and then he will restore Judges unto his people as at the first, and Counsellors as at the beginning.[3]

Isaiah, chapter 1, verse 26! The very text adduced by Cromwell himself, addressing, on January 22, 1655, a legislature he was about summarily to dissolve; and a tacit reference-point, also, in Marvell's contemporaneous *First Anniversary*, where Oliver is seen 'first growing to [him] self a Law', not exactly like 'the Kings of *Britain*, and other Nations' arraigned by Aspinwall because 'they have not regarded this counsel, but assumed a Power of making Laws unto themselves'[4] – but not exactly unlike them, either. Marvell has his hero 'walk still middle betwixt' Judge-as-at-the-first and Sovereign Lord, the King, as he does 'betwixt' War and Peace'.[5]

The end, however, was '*Image government*'. At his first induction, the brand-new Protector ('*God* gave this Title for a difference', remember, 'Betwixt the *Kings of Babel*, and his *Prince*') had been soberly, if richly attired in black velvet, suit and cloak, with only a broad band of gold about his hat for distinction. His second investiture, nearly four years later in June, 1657, required 'a *Robe* of purple velvet' and, as well as 'a *Bible* richly gilt and bossed' and a Sword of State, a '*Sceptre* of massy gold',[6] just as Waller recommends – in lines, perhaps, tailored to this very occasion – at the end of what Wikelund calls 'the kingship coda' to *A Lamentable Narration*, the first printed version *Of a War with Spain, and a Fight at Sea*:

> With Ermins clad, and Purple; let him hold

A Royal Scepter, made of Spanish Gold.[7]

The desideratum of the preceding couplet, a crown of the same 'rich Oare' to see 'the State fixt', was to be added shortly, but posthumously: too late, and futilely in effigy at his funerals.

And now his gratefull Vassals when he's dead,
 Put a rich Crown upon his uselesse head,
And so ingeniously their *Mock-Prince* deride,
 Emblematizing why the *poor man dy'd*:
Who with one impious gripe three Kingdomes got,
 Alas, all King, except his *Name* and *Hat*,

as John Crouch was to scoff from the safety of 1660.[8] 'The Hearse', records Cowley, opening *A Discourse by Way of Vision*[9]

was Magnificent, the Idol Crowned and (not to mention all other
Ceremonies which are practised at Royal interments, and therefore
by no means could be omitted here) the vast multitude of Spectators
made up, as it uses to do, no small part of the Spectacle itself.

All of which, in his estimation, amounted only to a babel or Babylonish medley of 'Much noise, much tumult, much expense, much magnificence, much vainglory, and yet, after all this, but an ill sight': '*Image government*', in short, corpse-cold and with its feet of clay embarrassingly exposed.

For Aspinwall, when he speaks of '*Nebuchadnezzar*, the Head of *Image government*', plainly alludes to Daniel, chapter 2, where that 'king of kings' (as he is described in verse 37, and in Ezekiel, 26.17 beforehand; elsewhere, of course, it is Christ's title) has dreamed a dream of a great and ostensibly glorious statue, the head of which – representing, says Daniel, Nebuchadnezzar himself –

was of fine gold, his breast and his armes of silver, his belly and his
thighes of brasse: His legs of yron, his feete part of yron, and part of
clay.[10]

These last, miscast and ultimately divided extremities of the Fourth Monarchy (the iron imperium of Rome having succeeded the 'brasse' of Macedonia, silver of Persia, gold of Chaldea) – these 'feete and toes', smitten by 'a stone was cut out without hands', disintegrate; whereupon the whole colossus collapses into nothingness, 'dust of the Summer threshing-floor' dispersed by the wind.[11] '& the stone that smote the image became a great mountaine, and filled the whole earth' (Daniel, 2.35), in a prefigurement of

that *Kingdom* of Christ, or *world to come*, wherein Christ shall reign
as King, and his Saints together with him, for above a thousand years
. . . which shall never have an end whilst the World lasts:

endure, in other words, until Doomsday and the Last Judgement itself. 'Let this comfort your hearts', Aspinwall exhorts his godly readers, 'that the Lord Jesus will shortly appear in his Kingdom, *Rev.* 22. 7. 12'.[12]

He didn't, obviously. Indeed, Providence (and not necessarily 'by meer permission', either, but perhaps 'out of Complacency') was shortly to see another golden head set restoratively upon '*Image government*' in Great Britain. And 'This Gyant-Isle' (by and large) rejoiced in a '*Loyal Spring*', 'Warmed

with Reflections of the *British Sun'* which 'at his Meridian height appears' to open Crouch's offering *'upon the Happy Return'* as Waller's: in imitation of it, in fact, since Waller is named in a prefatory letter as the first of '3 *Seraphims'* whose lead Crouch is following on this occasion.[13]

 Kings are Gods Christs; *Charls* Christ-like doth appear

 For Reformation in His thirtieth Year,

exults John, not now Crouch, but Collop (Jesus Himself, 'that Sun of righteousness', having, in the imagery of Jeremy Taylor, only 'entered upon our hemisphere' and His ministry 'after he had lived a life of darkness and silence for thirty years').[14] But this is not at all the kind of 'Reformation' or Second Coming that Aspinwall and his ilk were so eagerly expecting.

The window of opportunity had closed. Stephen Marshall's moment of 'καιρός' was lost in the momentum of 'κρονός', the current of time's more 'useless Course'.[15] All John Owen's 'shaking and translating' had failed to precipitate a definitive *'μετάθesiς* , 'change' (as he insists, not 'removal', the usual rendering of his text, Hebrews, 12. 27).[16] The body politic had not been 'raised incorruptible'.

But still, in 1656, might be, thinks Aspinwall, in despite of Cromwell and his fading scruples about seizing the legislative power. In spite of Cromwell? Because of him, urges James Harrington (who published his most famous work likewise in that year) – if only he could be persuaded to cease 'Troubling the Waters', drink deeply of them and transform himself into 'Olphaus Megaletor Lord Archon and sole Legislator of OCEANA': of, that is to say, 'a commonwealth rightly ordered' (and therefore instituted by 'one man' and 'made altogether, or at once', there being no future in grinding 'with the clack of some demagogue' in parliamentary mills) such as 'may for any internal cause be as immortal, or long-lived, as the world' and, moreover, being designed 'for increase' not simply 'preservation', spread its sway to become

> like an holy asylum unto the distressed world, and give earth her
> sabbath of years or rest from her labours, under the shadow of [its]
> wings.[17]

This way, then, the Milliennium!

A tantalizing prospect, Harrington's title-page[18] carried an epigraph from Horace, *Satires*, Book 1, 1, 68f.: 'Tantalus a labris sitiens fugientia captat / Flumina: quid rides?' etcetera. 'Why laugh at Tantalus, sunk in a river whose waters nevertheless always elude his parched lips? He's you!' The miser whom Horace is addressing wallows in wealth, gapes thirstily over his gold, cannot use a drop of it to buy real, necessary comforts, 'bread, vegetables, a pint of wine'; instead he torments himself night and day with the thought of thieves. And here (*Oceana*, next page is to be dedicated to him) is 'His Highness the Lord Protector', awash with power and opportunity, standing over a 'nation which seemed (as it were ruined by his victory) to cast herself at his feet'.[19] Can he escape a miserable, Tantalean mind-set and Hobbes's 'generall inclination of all mankind, a perpetuall and restlesse desire of Power after power [gold upon gold] that ceaseth onely in Death'?[20] Will he commit rape?

– a crime comparable to Julius Caesar's, whose *'felix scelus'*,
 extinguishing liberty, became the translation of ancient into modern
 prudence, introduced in the ruin of the Roman Empire by the Goths
 and Vandals:

led to 'the execrable reign of the Roman emperors' and 'an empire of men
and not of laws';[21] not to mention his own most gory death and 'the total
extinction of his family', innocent or guilty, by 'that execrable race of the
Claudii' which was promptly 'rewarded with the Roman empire' itself, and
'full possession of the famous patrimony'.[22] Such are the fruits ('felix' means,
at root, 'fruitful') of personal and dynastic ambition!

Will the Protector, then, ravish the nation at his feet, or raise her *virgo
intacta*? Spend his present dictatorial powers, not to enslave her (and himself
to Tantalean torments: 'such horrid distortion of limbs and countenance' as
is not to be beheld, let alone laughed at), but to call into being 'a perfect and
(for ought that in human providence can be foreseen) an immortal
commonwealth'.[23] Wet his lips (as it were) and pronounce a *fiat lux*, like
Olphaus, whose name (with appropriate aspiration - 'ολ[ός], not 'ολ[οός],
'destructive', 'deadly') seems[24] to be a compound of 'whole', 'complete in
its parts', 'universal', and 'light': 'a light', indeed (φάος), 'to lighten the
Gentiles: and to be the glory of thy people Israel' such as illuminates Luke 2.
32 and the *Nunc dimittis*. (Crucially, too, Olphaus is to resign when his task
is done.)

The Archon's most immediate inspiration, however, is Lycurgus; he and
Moses being the only two previous legislators ever 'to have introduced or
erected an entire commonwealth at once'.[25] Moses, according to Aspinwall,
never himself exercised the legislative power which is 'Christ's Peculiar
Prerogative'. He simply executed God's orders. Harrington, though, repeatedly
refers to consultations also with his Midianite (and therefore presumably
pagan) father-in-law, Jethro, and 'use of humane prudence' when needful in
setting up the commonwealth of Israel. Those trips up Mount Sinai, too, for
instructions, are tellingly mirrored in Lycurgus's to Delphi: in the first instance
so that he could '(for the greater impression of his institutions upon the
minds of his citizens)' pretend 'to have received the model of that
commonwealth from the oracle of Apollo'; in the second, to secure
retrospective approval for 'the policy which he had established' and make
assurance double sure.

 It hath been a maxim with legislators not to give checks unto the
 present superstition, but to make the best use of it, as that which is
 always the most powerful with the people,

comments Harrington, adding drily, on the authority of Cicero, *De
Divinatione*, 'that there was never any such thing as an oracle, except in the
art of priests'.[26]

This, needless to say, does not mean that Harrington thought that there
never was a God on Sinai (although it may reflect upon some of his more
florid, religiously-tinged rhetoric). The point is that either way it makes little
or no difference. 'As in the commonwealth of Israel, God is said to have

been king', he asserts in 'The Preliminaries',[27] 'so the commonwealth where the law is king is said by Aristotle to be the kingdom of God'. 'A commonwealth', confirms Olphaus, just before the promulgation of his perfected model, 'is a monarchy, where God is king, in as much as reason, his dictate, is her sovereign power'.[28] The common denominator, in the words of 'The Preliminaries' again,[29] is the institution of 'an empire of laws and not of men'.[30]

Lycurgus's second trip thus serves a further purpose: it removes the legislator from his laws, allowing them to work independently. He never goes back to Sparta. Having, before his departure, extracted an oath that none of his arrangements will be altered until his return, he leaves for Delphi, consults the oracle, receives and publishes its favourable response – and commits suicide. ' "Give us good men and they will give us good laws" is the maxim', we have been assured, 'of a demagogue',

> and (through the alteration which is commonly perceivable in men, when they have power to work their own wills) exceeding fallible. But 'give us good orders, and they will make us good men' is the maxim of a legislator and the most infallible in politics.[31]

Lycurgus lays down his life to prove it.

The Athenians, too (although Aristotle's 'kingdom of God' was realized less efficiently there than in Sparta), showed a grasp of this principle when they banished Aristides who, through no fault of his own (rather the reverse), threatened

> under the name of the Just to become universal umpire of the people in all cases, even to the neglect of the legal ways and orders of the commonwealth.[32]

A 'brother justice' who (to remember the phraseology of *Measure for Measure*) comes to be regarded, through the sheer exemplarity of his conduct, as 'indeed Justice' blurs the line between scrupulously administering 'an empire of laws' and working his own will, beginning to hold sway over it: grows potentially princely, away from any kind of 'kingdom of God' towards 'Image Government', 'an empire of men and not of laws', *Habemus Caesarem* and the surreptitious exchange of liberty for flattery – 'a game, at which they are best provided that have light gold',[33] as witness what happens to that metal in Waller's *Panegyrick*!

Had Lycurgus returned to Sparta, not only would he have released its inhabitants from their promise to alter nothing, but also willy nilly, must have found himself cast in the role of 'universal umpire of the people' and subjected, as such, to a variety of insidious and perhaps, over time, irresistible pressures and temptations. Olphaus, after seizing his moment of 'καιρός' to set up the rotational orders of Oceana and propel them into potentially 'perpetual circulation',[34] would be placed in an analogous position: that of a 'good man' whose goodness pre-empts, as opposed to being the purchase of, 'good orders'.

He too, therefore, must contrive to disappear: not, like Lycurgus, by killing himself (hardly a Christian act, or one likely to recommend itself to Cromwell),

but by committing what James Holstun, discussing 'James Harrington's Commonwealth for Increase' in his book on *A Rational Millennium*,[35] calls 'political suicide'. This he achieves by abdicating 'the magistracy of Archon' (whereupon, we are told, some members of the shocked Senate, like offspring angry and in despair at the prospect of parental dissertion, 'flew from their places, offering as it were to lay violent hands upon him' to prevent his withdrawal)[36] – and retreating post-haste into the privacy and obscurity of the country for an interlude of prayer and meditation. When he reappears, it is to find that (unfazed by initial flurries) the 'good orders' he instituted have been working steadily, in his absence, upon his own subsumption.

From author he is to become officer, although due but carefully regulated gratitude is, of course, to be registered for his original efforts as once-upon-a-time 'sole legislator' of Oceana *'(Pater Patriae)'*.[37] Olphaus accepts the proposals and command of a temporary standing army to guard 'against dissenting parties', though he questions the necessity for such an extraordinary force, given the fundamental invulnerability of 'good orders' which have leapt into the world 'at once' (like Minerva) adult and fully armed against 'ought that in human prudence can be foreseen'.

> But seeing it was otherwise determined by the senate and the people [the senate, 'after due deliberation and mature debate', proposing; the people, by ballot and without further discussion, disposing, 'according unto the orders of this commonwealth', performed with all appropriate pomp and circumstance] the best course was to take that they held the safest, in which, with his humble thanks for their great bounty, he was resolved to serve them with all duty and obedience.[38]

Thus this new-and-improved Julius, having dared to be his own, anything but 'mistaken *Brutus*' and not cut but confirmed 'the bond of Union with that stroke', returns to political life to reaffirm that not *'Habemus Caesarem'* but *'Habemus Ordines'* or *'Legem'* is to be the unshakeable credo of the new republic – and afterwards (who knows?) the world.

But

> still the Government is not in the Law, but in the person whose Will gives a being to that law. This declared Will of those who have power is of the Essence of Law,

objects Matthew Wren (son of the notoriously Laudian bishop of that name), taking up, in his *Considerations on Mr. Harrington's Commonwealth of Oceana*[39] a Hobbist line which Harrington had set out to snap at the beginning of his book. And in England, especially, 'We will have a King', notes Roger Morrice, 'for the Lawes know nothing but the name of a King'.[40] This was in 1688, and Morrice was a Williamite.

Interestingly, Olphaus's role in the new-model Oceana is likened to that of a Prince of Orange. Lately in the Netherlands the collapse, after his death in 1650, of the formidable Court Party forged by William II to throw off irksome limitations to his power, had led to resurgent anti-Orangists imposing yet more severe restrictions upon the Stadholderate and dynastic designs. Though,

as Harrington elsewhere observes, 'we have in our time seen Amsterdam', in the face of assault by Orange mercenaries, 'necessitated to let in the sea upon her, and to become (as it were) *Venice*',[41] currently sovereign power lay firmly in the hands of the States General, making the comparison in *Oceana* less double-edged than it might have been. Originally, of course, the house of Orange had contributed crucially to the defeat of the King of Spain and rise of the Dutch Republic; and this, manifestly, is what Harrington has foremost in mind. 'The Low Countries', he contends,

> under a monarch were poor and inconsiderable, but in bearing a prince, could grow unto a miraculous height and give the glory of his actions by far the upper hand of the greatest king in Christendom. There are kings in Europe to whom a king of Oceana would be but a petty companion. But the prince of this commonwealth is the terror and judge of them all.[42]

Once again (though, this time, no insult intended, either way: far from it) there is a parallel between O.P. and P.O. – or might be, if once English laws, instead of knowing 'nothing but the name of a King', could forget it, and people stop worrying their heads about 'the person whose Will gives a being to that law' and be prevailed upon to conform to 'good orders' for their own sake.

The Second Coming itself was about as likely. O.P. was drawn (struggling, perhaps, and against his better judgement, but none-the-less inexorably) towards the legislative power, 'Image government' and the crown which, Clarendon thought, would have reconciled 'most Men of Estates' whose ruling passion was not so much Alexander as the King: who wanted, above all, the rehabilitation of laws which knew 'nothing but the name of a King' and were not over-particular as to the 'person whose Will gives a being to that law' – so long, of course, as there was one.

As for P.O.: when, in 1688, England imported its own new-model prince it was with a view to making him king, and he responded to the challenge with decisive expedition. In his own country, too, he had been recovering powers lost in 1650. A devastating invasion launched by Louis XIV (with English co-operation) in 1672 had driven the Dutch back into his arms. How, after all, had they ever become so vulnerable to French attack? Remember Henry Stubbe's contemporary diagnosis:

> The want of a *State-holder* left all *emergent controversies* difficult to be reconciled: for *that office*, together with the *hereditary reverence* which the generality had for the Princes of Orange, was the cement of the Republick.[43]

Scarcely music, this, to Harringtonian ears, though perfectly in tune with Wren's expectations. '*Commonwealths*', he remarks in the second of his rebuttals of *Oceana, Monarchy Asserted*, published in 1659,

> are like Engines which being wound up can not in the greatest necessity vary from the Designation of the Artificer, but *Monarchies* are animate Bodies, moving and acting according to all exigencies by vertue of their own Soules.

He goes on, later, to improve the point:

A *Commonwealth* having no eies of her own is forced to resign her self to the Conduct of *Lawes*, which are blind too, though in a known Road they faithfully and without wandring performe the part of a Guide; But if a stone be laid, or a pit be digged in this Path, the Blind leading the Blind, they both fall, and then she runs a danger of her Neck. If in this Case a *Commonwealth* be beholding to some hand to lead her to avoid the Danger, it is oddes she will never be able to free herself of the new Guide, who carrying her through unknown Waies in the end ravishes or strangles her. But a *Prince* having his Eyes about him chooses his own Way, and though for the Generall he keeps to the High Way of *Lawes*, yet when that leads to a Precipice, he can see how to goe about, till having scaped the Danger, he may safely return to the common Road.[44]

How easily, where monarchy is concerned, he slips into the traditional, organic imagery of the body politic! As easily as Waller the following year when 'This Gyant-Isle has got her Eye again' and (with an echo of Cicero on Caesar) 'might spare the Ocean, and oppose / Your conduct to the fiercest of her Foes'. But 'Kings are Gods Christs', also, not just Caesars. The returning Charles neatly resolves the either/or of Watson's '*Habemus Caesarem*'. He is the two-in-one. Body recovers soul, the state is reanimated and 'Image government' had a glorious time ('The Sons of *Belial*', too, subsequently): much more so than during the later, so-called 'Glorious Revolution'.

For one thing, a transplanted Prince of Orange (Stuart wife notwithstanding) could hardly expect to attract the kind of '*hereditary reverence*' abroad that Stubbe claims he elicited at home and regards as the cement of Dutch national identity. Not that this will matter so much, given widespread acceptance of Defoe's dictum that 'Fame of Families is all a Cheat, / '*Tis Personal Virtue only makes us great*': '*Personal Virtue*', for instance, which makes a fit 'Manager' for that 'vast Machine' to which he likens the constitution, making it sound ('Manager' apart) not unlike one of Wren's 'Engines'. But Lycurgus had starved himself to death in a foreign country rather than go home and run the risk of being expected, as its originator, to 'manage' the constitution he had, singly and all at once, set up in Sparta; and, in Oceana, Olphaus takes albeit less drastic steps to follow his example. '*Personal Virtue*', once the 'vast Machine' is up and running, will not serve Harrington's turn.

In fact, protests Richard Baxter,

> The whole scope of the design is by the Ballot and Rotation to secure us from the danger of a probability of being Ruled by Wise or Honest men, and put the business out of doubt, that strangers to Prudence, and enemies to Piety shall be our ordinary Rulers.[45]

'By the Ballot and Rotation' a third of both the Senate and the 'Prerogative' (the deliberative and decision-making bodies respectively) is annually replaced – 'before', Baxter objects,

> they know where they are, and what it is they are Called to do; and from the Academy of the Shop or Ale-house, we must have freshmen in their rooms that are as wise as they were.[46]

In Harrington's own terms, these assemblies thus become '[river] beds made
. . . to receive the whole people, by a due and faithful vicissitude into their
current'.[47] 'The ideal of rotational government', observes Holstun, 'is not
representation, but near-universal participation'.[48] 'The entire citizen body, in
its diverse capacities', says Pocock, introducing *The Political Works*,

> constantly 'poured itself' into government, renewing authority in
> hands whose virtue and freedom could be guaranteed, and renewing
> itself as reason passing into action, matter into form, and body into
> soul.[49]

It was, as he later puts it, 'in the orders and forms of government [that] the
body politic possessed a soul',[50] not in Wren's sovereign

> One Person, which in a *Monarchy* is a Naturall Person, and in a State
> an Artificiall One, procreated by a majority of Votes.[51]

'Who reads Mr Hobbes, if this be news?' jeers Harrington, quoting the
passage in the 'Conclusion' to Book 3 of *The Art of Lawgiving*. It is tawdry,
second-hand stuff, and his final word on Wren, before a last, brief paragraph
dismissing the rest of his work as rubbish is, 'He looks upon persons, but
things are invincible':[52] things and the 'good orders' which stem from a
rational understanding of their *modus operandi* and 'make us', in turn, 'good
men' – men, so to speak, of 'ordinary' virtue, since virtue will now have
become a function of 'good orders' rather than 'extraordinary', personal achieve-
ment. *"Tis'* thus not *'Personal Virtue only makes us* [individually] *great'* – ethically
egregious and worthy, therefore, of a position of power and influence – but
an ethos of virtue produced by 'good orders' which makes us, collectively,
great. *'Personal Virtue'*, like that of Aristides the Just, may be a dangerous
distraction, a temptation to 'look upon persons' and neglect the 'things' which
are and might (properly understood) make us 'invincible': lead to a lapse
from 'an empire of laws' (effectively, in *Oceana*, 'the kingdom of God', Christ)
back into a gothically degenerate 'empire of men', 'useless time' and –

> Thus (Image-like) an useless time they tell,
> And with vain Scepter, strike the hourly Bell –

'Image government'.

No wonder, then, that Holstun should detect a certain 'ambivalence' about
Oceana's treatment of Olphaus in 'The Corollary'; an interesting word, he
observes, in itself, deriving from *corolla*, Latin for 'a little crown', and meaning
in the seventeenth century (amongst other things still current or otherwise)
'something additional or beyond ordinary measure, a surplus, a
supernumerary';[53] which is what, by this stage, Olphaus has become. He
may have articulated a *Fiat Lux* to bring 'good orders' into light and rotation,
as an individual of outstanding *'Personal Virtue'* who has seized a once-in-a-
thousand-years moment of 'καιρός', 'opportunity', to redeem the time. That
moment past, it would only, were he to shine sun-like himself, obscure a
clear vision of *'Democratick* Stars' ('Nights vulgar Lights', as Waller calls
them, complimenting Cromwell for doing just that) wheeling in their courses
of 'annual, triennial and perpetual revolution'.[54] Harrington may talk in terms
of *'primum mobile'*, *'Nebulosa'* (Sir Thomas Browne, in his *Christian*

Morals,[55] refers to '*Lacteous* or *Nebulous* Stars, little taken notice of, or dim in their generations'), 'prime magnitude', 'galaxies', 'orbs', 'regions' and 'tropics', and speak of the resolving 'prerogative' as

> the moon; either in consideration of the light borrowed from the
> senate as from the sun, or of the ebbs and floods of the people,
> which are marked by the negative or affirmative of this tribe;[56]

but any suggestion of a singularly focal sun or '*Sponsus reipublicae*' would be anathema to his whole enterprise.

Yet, inevitably, it had been as such a sun, 'the beauty and Bridegroom of Nature, appointed by God' and not barely and Hobbistically (and as Wren puts it in *Monarchy Asserted*) 'the diffused strength of a Multitude . . . united in One Person, which, in a *Monarchy* is a Naturall Person' but a limb of Divinity, that Charles had burst again upon the scene in countless 'Happy Returns', putting to shame the futile 'popetries' of Cromwell's funeral. Of course, too, initial enthusiasm had faded as cloud-cover came and went and gathered to an ominous wrack as James made a catholic botch of affairs. Still, however, 10 June, 1688, with the storm about to break, 'A young APOLLO', forecasts Behn, 'rising from the Gloom, / Dress'd in his Father's Brightest Rays, shall come';[57] and Dryden, in *Britannia Rediviva*, fancies that the real, midsummer sun

> bended forward and ev'n stretch'd the sphere
Beyond the limits of the lengthen'd year;
To view a Brighter Sun in *Britaine* Born:[58]

he of the unforgettably '*Awful little* EYES', James III in prospect.

But never in performance, combusted as he was to be, in conjunction with his father, by a half-sister and a brother-in-law who, nevertheless, (unlike Charles in his Withdrawing Room at Windsor, or Louis XIV, 'galloping over one's head' just about everywhere at Versailles) does not drive Phoebus's car, the solar chariot, across the ceiling of the King's Staircase at Hampton Court. Neither does he pluck Apollo's lyre (or, as Spanheim insists, cithara); that is left to Nero on the East wall, whose touch transforms the instrument into a once fashionably Charles-like guitar. Nor would he have it believed 'qu'il sortoit de ses yeaux des rayons aussi perçans, que du Soleil': that is an Octavian, an Augustan conceit.

Yet for all its satiric edge, the scene is, from a Harringtonian viewpoint, still unhappily precoccupied with 'the execrable reign of the Roman emperors, taking rise from that *felix scelus*, the arms of Caesar' which gave a mortal wound to all 'good orders' and 'empire of laws', precipitating instead (save notably in Venice) 'an empire of men' and sixteen hundred years of 'modern' as opposed to 'ancient prudence', basis of all true liberty. The spectator 'looks upon persons': is required (with *Les Césars* as Baedeker) to pick out, no thanks to conventional perspectives, the 'one good Emperour' whose '*Personal Virtue*' made him 'the compleatest Pattern of a perfect Prince' and, as such, cynosure of all those who were to climb the staircase from William III forward.

Nebuchadnezzar's dream of '*Image government*', in short, continues. Only the level of dreaming has altered. Christ had not (has not!) appeared in person to end it; and Harrington's 'depersonalized' variation on a postmillennarian theme (postmillennarians, in contrast to premillennarians, believed that the

Second Coming would follow not precipitate, the Thousand Years) found no favour in practice: certainly not among Epimonuses de Garrula[59] like Edmund ('Trumpet gen'ral', as Marvell calls him in *The last Instructions to a Painter*)[60] Waller, who has been heard[61] speaking with airy dismissiveness in Parliament of 'a new form of government, like *Sir Thomas Mores Utopia, Plato*, and *Oceana*'. And, most critically of all, certainly not with Cromwell himself who, for the scheme to succeed, would have had to seize an irrecoverable instant in the mid-sixteen-fifties to introduce, all 'at once', the fundamentals of a system which 'may for any internal causes be as immortal, or long-lived, as the world', and so offer an escape from the ceaseless round of Polybius's '*anakuklōsis politeiōn*' – the endless succession, in six phases, of good and bad versions of monarchy, aristocracy and democracy.[62]

'May' became almost instantaneously a 'might have been', not much to be regretted, given that, as Wind's suggested deviser of the programme for the King's Staircase trenchantly observes, 'The most ingenious way of becoming foolish is by a system'.[63] For what, in the light of this axiom, is to be made of one which privileges a set of supposedly infallible 'good orders', based on agrarian arrangements blind to ineluctable economic realities and the ever-growing power of capital, over 'good men' who, retaining their own eyes, might 'vary from the Designation of the Artificer' and 'see how to goe about' when necessity dictated?

In 1656 it might still have seemed (though Harrington himself clearly had his doubts) that *Oceana* might prove more than merely tantalizing, after the manner of the second book of More's *Utopia* (parallels between Olphaus/Cromwell and Utopus have, needless to say, often been adduced). After 1660 there was no chance whatsoever that any such drastic re-ordering, such radical new-modelling, would ever, in practice, be seriously in danger of realisation, James II or no James II. There was to be no apocalypically decisive break with the past, no abruption of time's 'useless Course'. In 1688 a way forward was to be contrived by, as Nenner has it, 'Colour of Law': 'Colour', that is (since their substance signally failed to endorse the 'Liberties' supposedly entailed upon them), of 'our Antient Laws', as distinct from Harringtonian 'good orders'. Even the baroquely absolutist pencil of a Verrio (notorious *bon viveur* that he was) might, given a little time and money, be prevailed upon to lend fashionable pigmentation to the thoughts of an Apostate. 'The *Norman* Bastard *William* himself' (Nebuchadnezzar of 'Image government' in England)[64] could, with a little judicious brushwork, be painted legitimate, rendering inevitable comparisons not more odious than odorous. By a mere shift of accent, 'The mighty Máchine of Affairs' shades into 'a vast Machíne' not so much dependent upon solar power as serviced by a 'Manager' and 'Engineers', though lubricated, still, by 'the maxim of a demagogue' (irresistible invitation, as Harrington was well aware, to party politics): 'give us good men and they will give us good orders'.

And still today, a successor to the Walpole and Pitts who were to come continues to tell 'an useless time', aided and abetted by spin-doctors who make '*Image government*' their business, and whose *cantus firmus* is '*Habemus Caesarem*'.

King's Staircase at Hampton Court Palace, the bearded Marcus Aurelius (second left) and other emperors looking at Julian the Apostate (right).

Crown copyright: Historic Royal Palaces

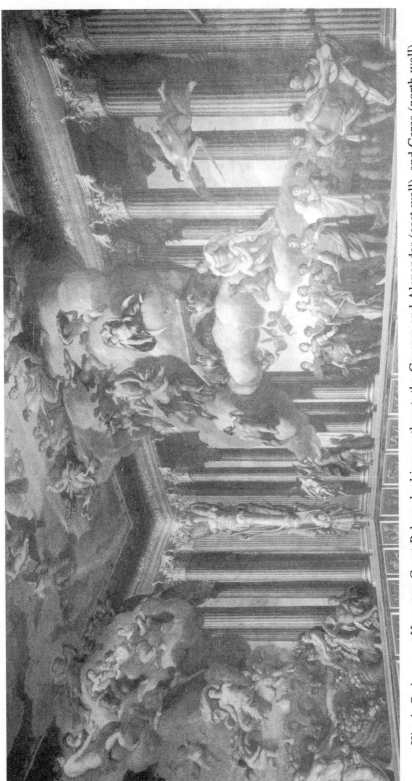

King's Staircase at Hampton Court Palace, looking northeast: the Caesars and Alexander (east wall), and Ceres (north wall)

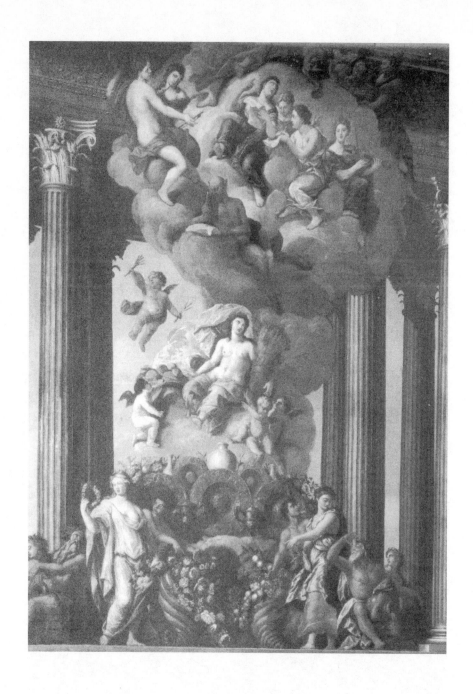

King's Staircase at Hampton Court Palace, looking north: Ceres
Crown copyright: Historic Royal Palaces

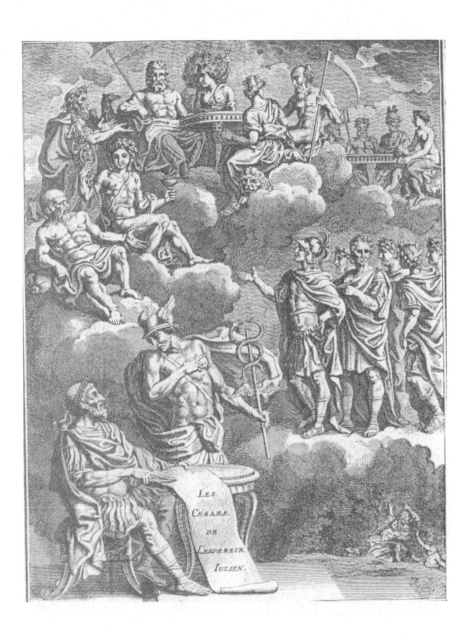

Ezekiel Spanheim, *Les Césars*, frontispiece by Pierre le Pautre

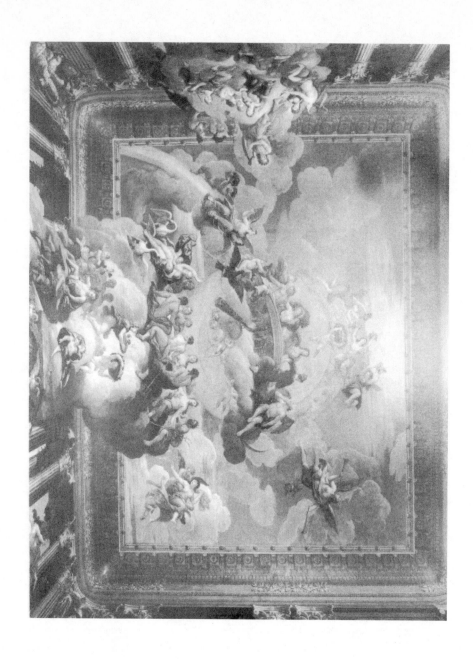

King's Staircase at Hampton Court Palace, ceiling
Crown copyright: Historic Royal Palaces

King's Staircase at Hampton Court Palace, doorway to the King's
Guardchamber: pediment and monochrome of Aeneas, the Cumean Sibyl,
and the funeral pyre of Misenus
Crown copyright: Historic Royal Palaces

Notes

Preface

1. Wasserman, 'Nature Moralized', ELH. 20, 1953, p. 71.
2. Shakespeare, *Richard II*, 3. 2. 37-53, First Folio text, prepared by Helge Kökeritz, New Haven, 1954. The line numbering, however, is that of the Arden Edition, general editors, H.F. Brooks and Harold Jenkins.
3. Shakespeare, *Richard II*, 3. 1. 67.
4 ibid., 3. 3. 65-67.
5. *Oxford English Dictionary*, Humour, *sb.* I. 1.
6. Shakespeare, *2 Henry IV*, 1. 2. 190-198.
7. ibid., 1. 2. 211-212.
8. Marvell, 'The Mower against Gardens', 35-36, *The Poems and Letters of Andrew Marvell*, edited by H. M. Margoliouth, vol. 1, *Poems*, revised by Pierre Legouis and E.E. Duncan-Jones, Oxford, 1971, p. 44.
9. Shakespeare, *Richard II,* 3. 2. 57; Psalm 136, 5. 8, Geneva Version.
10. Peter Browne, *The Procedure, Extent and Limits of Human Understanding*, London, 1728, pp. 141-142.
11. F.W. Brownlow, *Two Shakespearean Sequences,* London, 1977, p. 99, pertinently notes that 'Richard is the one person who is definitely not acting. . . . The consummate actor is Bolingbroke' and, of course, his son after him.
12. Lucy Hutchinson, *To Mr Waller upon his Panegirique to the Lord Protector*, printed, with Waller's *Panegyrick* in parallel (the line in question is 70 in both instances) as an appendix to David Norbrook, 'Lucy Hutchinson versus Edmund Waller: An Unpublished Reply to Waller's *A Panegyrick to my Lord Protector*', *The Seventeenth Century*, 11, 1996. See p. 77.
13. This phrase is from *Numerus Infaustus*, 1689, 'now reprinted', London, 1736, p. 43.
14. See his introductions to John Locke, *Two Treatises of Government*, Cambridge, 1963, Signet reprint, 1965, p. 83, and Sir Robert Filmer, *Patriarcha and Other Political Works*, Oxford (Blackwell), 1949, p. 42.
15. Walzer, *The Revolution of the Saints*, London, 1968, p. 153.
16. Francis Bacon, *Of the Advancement of Learning* in *Philosophical Works*, edited by J.M. Robertson, London, 1905, p. 119.
17. Hobbes, *Leviathan*, pt. 2, ch. 17, Everyman edition, introduction by A.D. Lindsay, London, 1914 , p. 89
18. Clarendon, *The Correspondence of Henry Hyde, Earl of Clarendon, and of his brother Laurence Hyde, Earl of Rochester, with the Diary of Lord Clarendon from 1687 to 1690,* edited by Samuel Weller Singer, 2vols, London, 1828, vol. 2, pp. 194 (October 16, 1688) and 211 (November 27, 1688).
19. The following quotations, however, are taken from the London, 1736 reprint. See pp. 60, 48, 50 respectively. Wasserman, in *The Subtler Language* (Baltimore, 1959, p. 128), by quoting from this tract to illustrate Pope's reference to the fate of William Rufus in *Windsor Forest*, gives the erroneous impression of pro-Stuart affiliations. In fact the opposite is true (although, of course, when the piece was reprinted in 1736, George II was on the throne).
20. *An Epistle to Mr. Dryden*, broadside, Exeter, November 5, 1688.
21. Nenner, *By Colour of Law,* Chicago/London, 1977.
22. Pope, *Windsor Forest*, 42, *The Poems of Alexander Pope*, edited by John Butt, London, 1963, p. 196.
23. Waterton, *Essays on Natural History, chiefly Ornithology*, London, 1838, pp. viii, 210-212.

24. Shaftesbury, Anthony Ashley Cooper, 3rd Earl of, *Characteristics of Men, Manners, Opinions, Times*, edited by J.M. Robertson with an Introduction by Stanley Grean, Indianapolis/NY., 1964, two vols in one, vol. 2, p. 210, n. 1.

25. See James Boswell, *Life of Johnson*, edited by R.W. Chapman, London, 1953, p. 699, n. 2. Boswell quotes the notorious lines from James Grainger's poem *The Sugar-Cane* (1764). Thomas Percy, however, 'had a mind to make a great thing of Grainger's rats', and Johnson proceeds facetiously to observe that 'I should like to see *The History of the Grey Rat, by Thomas Percy, D.D., Chaplain in Ordinary to His Majesty*' (by then George III). Boswell, leading him on, objects that 'I am afraid a court chaplain could not decently write of the grey rat', to which the reply is: 'Sir, he need not give it the name Hanover rat' (*Life*, p. 77).

26. Francis Atterbury, *A Sermon Preach'd before the Honourable House of Commons*, May 29, 1701, London, 1701, p. 4. See Chapter 15 below.

27. See Shakespeare, *Macbeth*, edited by Kenneth Muir, London, 1962, 1. 7. 4 and textual note.

28. Laslett, introduction to *Patriarcha*, p. 42. See also John Hall of Richmond, *Of Government and Obedience*, London, 1654, p. 205.

29. Erskine-Hill, *The Augustan Idea*, p. xv.

30. ibid., p. 248.

31. Erskine-Hill, *The Social Milieu of Alexander Pope*, New Haven/London, 1975, 'Literature and the Jacobite Cause', *Modern Language Studies*, 9, 1979, and 'Alexander Pope: the political poet in his time', *Eighteenth Century Studies*, 15, 1981-2.

32. Marvell, *The Rehearsal Transpros'd and The Rehearsal Transpros'd, the Second Part*, edited by D.I.B. Smith, Oxford, 1971, p. 135.

1: Prologue

1. John, 19.15, 'Authorized Version', 1611.

2. Richard Watson, *Regicidium Judaicum*, The Hague, 1649, p. 7.

3. No place of publication is specified. Wing suggests Bruges.

4. Kantorowicz, *The King's Two Bodies*, Princeton, 1957, p. 47f.

5. Owen Felltham, *The Poems*, edited by T-L. Pebworth and C.J. Summers, *SCN*, Editions and Studies, 1, Pennsylvania, 1973.

6. *Leviathan*, pt. 2, ch. 6, ed. cit., p. 66.

7. *A Perfect Diurnall*, 3-10 July, 1643, p. 11.

8. Edmund Waller, *Poems, &c.*, second edition, London, 1645, facsimile, Menston, 1971, 'Speeches', p. 15.

9. *A Perfect Diurnall*, 3-10 July, 1643, p. 12.

10. ibid., 12-19 June, 1643, p. 2.

11. Edward Hyde, Earl of Clarendon, *The History of the Rebellion*, Oxford, 1705-1706, vol. 2, pt. 1, pp. 259-260.

12. *A Perfect Diurnall*, 2-9 September, 1644, p. 462, misnumbered 262.

13. See *A Perfect Diurnall*, 23-30 September, 1644, p. 484, and Waller, *Poems, &c.*, 1645, 'Speeches', p. 18.

14. *A Perfect Diurnall*, 7-14 October, 1644, p. 501.

15. Calamy, *The Noble-Mans Patterne of True and Real Thankfulnesse*, London, 1643, pp. 41-42.

16. Hobbes, *Philosophical Rudiments concerning Government and Society* (his own translation of *De Cive*), London, 1651, p. 10.

17. P.R. Wikelund, '"Thus I passe my time in this place": An Unpublished Letter of Thomas Hobbes', *English Language Notes*, 6, 1969, pp. 266-267 and footnote 14.

18. Hobbes, *Considerations*, London, 1680, p. 19.

19. Dryden, *Of Dramatic Poetry and Other Critical Essays*, edited by George Watson, London, 1962, vol. 2, p. 137.

20. William Haller, 'Two Early Allusions to Milton's *Areopagitica*', *Huntington Library Quarterly*, 12, 1949, p. 211.

21. Wither, *A Suddain Flash*, p. 12. Text from *The Miscellaneous Works of George Wither*, Second Collection, Spenser Society Publications, no. 13, Manchester, 1872.

22. As David Norbrook has also realized. See his article on 'Lucy Hutchinson versus Edmund Waller' already mentioned (Preface, n. 12), which makes intelligent comparative play, likewise, with Watson's *Anti-Panegyrike*, and also his ' "Safest in Storms": George Wither in the 1650s' in *Heart of a Heartless World: Essays in Cultural Resistance in Memory of Margot Heinemann*, edited by David Margolies and Marroula Joannou, London/Boulder, Colorado, 1995.

23. *Leviathan*, pt. 1, ch. 4, ed. cit., p. 16.

2: **In Medias Res.**

1. The full title of Waller's poem as printed by Thomas Newcomb, London, 1655, is *A Panegyrick to my Lord Protector, by a Gentleman that loves the Peace, Union, and Prosperity of the English Nation*. This, the second of the two editions of the poem to appear in that year, is the one chosen by Thorn Drury as the basis for his text in *The Poems of Edmund Waller*, London, 1893. I use it throughout, retaining the original spelling and punctuation wherever possible. The lines quoted here are 64-67, Newcomb, p. 5.

2. Chernaik, *The Poetry of Limitation*, p. 162.

3. *Galatians*, 6. 7.

4. Francis Thynne, *Emblemes and Epigrames*, 1600, edited by F.J. Furnivall, Early English Text Society, London, 1876, p. 29.

5. Lovelace, *Poems*, edited by C.H. Wilkinson, Oxford, 1930, pp. 146-147.

6. *Ovid's Metamorphosis*, Englished by G[eorge] S[andys], London, 1640, p. 2.

7. Ovid, *Metamorphoses*, Book 1, 94f.

8. Waller, *Panegyrick*, 41-42.

9. *Ovid's Metamorphosis*, loc. cit.

10. Milton,'On the Morning of Christ's Nativity', 132, *Poems*, edited by John Carey and Alastair Fowler, London, 1968, p. 107.

11. Watson, *Effata Regalia*, London, 1661, 'Epistle Dedicatory', sig. A3r-A3v.

12. Watson, *Anti-Panegyrike*, p. 8.

13. ibid., 'prosaïke glosses', no. 4 and title page.

14. Waller, *Panegyrick*, 36.

15. Watson, *Anti-Panegyrike*, pp. 5, 8.

16. Cromwell, *The Writings and Speeches of Oliver Cromwell*, edited by W.C. Abbott, Cambridge, Mass., 1937-1947, vol. 3, pp. 377-378.

17. ibid., loc. cit., Instructions to Penn, 4 December, 1654.

18. Anchitel Grey, *Debates in the House of Commons*, London, 1763, vol. p. 428 (Monday, 8 November, 1675).

19. Waller, *Poems, &c.*, 1645, 'Speeches', p. 8.

20. ibid., p. 14.

21. Ovid, *Fasti*, 1. 357f.

22. Hobbes, *Leviathan*, pt. 1, ch. 14, ed. cit., p. 67.

23. Lucy, *Observations, Censures and Confutations of Notorious Errours in Mr. Hobbes his 'Leviathan'*, London, 1663, p. 439. The first edition had been published in 1657.

24. P.H. Hardacre, 'A Letter from Edmund Waller to Thomas Hobbes', *Huntington Library Quarterly*, 11, 1947-1948, p. 432. M.C. Deas, in 'A Study of the Life and Poetry of Edmund Waller', also provides a transcript of this letter which differs in some minor details. She dates it February, 1658, as opposed to Hardacre's 'prior to May 1657'.

25. Waller, 'Of Divine Love', Canto 5, 1 and 5-8, *Poems, &c.*, London, 1686, p. 279.

26. *Calendar of State Papers, Domestic Series* [*CSPD*], *Commonwealth*, vol. 8 (1655), p. 54, 12 December, 1655.

3: **A Deluding Streame**.

1. Quoted by Thorn Drury, *Poems*, London, 1905, vol. 1, p. lxi. See also Abbott, vol. 3, pp. 748-749, with some minor verbal discrepancies (e.g. 'avenged' for 'revenged'). The letter is dated [Whitehall] 13 June, 1655.
2. Cromwell, *Oliver Cromwell's Letters and Speeches: with Elucidations*, London, 1873, vol. 5, p. 231.
3. John Thurloe, *State Papers*, London, 1742, vol. 3, pp. 748-749. The Intercepted letter is dated 'St. Barnabas Day, June 11'.
4. *CSPD, Commonwealth,* vol. 9 (1655-6), p. 214, 6 March, 1655/6.
5. Charles Herle, *David's Song of Three Parts*, London, 1643, p. 25.
6. Watson, *Anti-Panegyrike*, 'Advertisement', p. 1.
7. Watson, *The Panegyrike and the Storme*, 'The Author of the Second Answer [i.e. Watson himself] his letter unto the Gentleman that sent him the first with Mr. Wallers copie' (of *Upon the late Storme*), p. 1.
8. Watson, *Anti-Panegyrike*, 'Advertisement', p. 6.
9. ibid., 'prosaïke glosses', 13, 14. 'Stanzas' 37-39 of the *Panegyrick* comprise lines 145-156, quoted below.
10. Waller, *Panegyrick*, 145-156. Newcomb prints 'Which' for 'With' in 150.
11. Watson, *Anti-Panegyrike*, p. 19.
12. Hall, *Of Government and Obedience*, London, 1654, p. 203.
13. Hall, op. cit., p. 194.
14. ibid., loc. cit.
15. Hall, *Of Government and Obedience*, p. 205.
16. Hall, op. cit., p. 204.
17. Thomas White, *The Grounds of Obedience and Government*, second edition corrected and amended by the author, London, 1655, pp. 136, 138.
18. Hall, *Of Government and Obedience*, p. 205.
19. ibid., loc. cit.
20. Hobbes, *Leviathan*, pt. 2, ch. 21, ed. cit., p. 116.
21. For a convenient summary of Hall's position, see Perez Zagorin, *A History of Political Thought in the English Revolution*, London, 1954, pp. 91-93. He did not at all approve of Hobbes's doctrine of contracts.
22. Hall, *Of Government and Obedience*, p. 190.
23. White, *The Grounds of Obedience and Government*, pp. 135-136.
24. Hall, *The True Cavalier Examined by his Principles*, London, 1656, p. 128, sig. A2r, pp. 101, 129.
25. Hobbes, *Considerations*, 1680, p, 20.
26. ibid., pp. 19-20.
27. Collop, 'Summum jus summa injuria in jure regni', *Poems*, edited by Conrad Hilberry, Madison, 1962, p. 75.
28. Cotton,'To Poet E[dmund] W[aller]', *Poems*, edited with an introduction by John Buxton, London, 1958, pp. 113-114.
29. Hall, *The True Cavalier*, p. 106.
30. Collop, loc. cit. Hilberry's identification (p. 201) of the 'notary' with Cicero is clearly wrong.
31. Hall, *Of Government and Obedience*, p. 204.

4: **Rendering unto Caesar**.

1. Cowley, *Poems*, edited by A.R. Waller, Cambridge, 1905, pp. 195-196.
2. Chaucer, *The Canterbury Tales*, Fragment VII 2484-2485, in *The Works*, edited by F.N. Robinson, second edition, London, 1957, p. 195.
3. The quotation, from Lovelace's 'A Mock Song' (*Poems*, p. 154), is there meant, needless to say, sarcastically.

4. Nethercot, op. cit., Oxford, 1931, p. 153.
5. See T.R.Langley, 'Abraham Cowley's *Brutus*:Royalist or Republican?' *The Yearbook of English Studies*, 6, 1976, p. 41f.
6. Cowley, *Essays, Plays and Sundry Verses*, edited by A.R. Waller, Cambridge, 1906, p. 361.
7. Watson, *Anti-Panegyrike*, p. 19.
8. Nethercot, *Abraham Cowley*, loc. cit.
9. Cowley, *Poems*, p. 437.
10. Hobbes, *Leviathan*, pt. 2, ch. 29, ed. cit., p. 174.
11. Hardacre, p. 433.
12. Hall, *Of Government and Obedience*, p. 202.
13. Waller, *Panegyrick*, 5-8.
14. Hall, *Of Government and Obedience*, pp. 120-121.
15. Hobbes, *Leviathan*, pt. 2, ch. 21, ed. cit., pp. 113-114.
16. Hall, *Of Government and Obedience*, pp. 190-191.
17. Waller, *Panegyrick*, 9-12.
18. Waller, *The Second Part of Mr. Waller's Poems*, London, 1690, sig. A7[r].
19. Allison, *Toward an Augustan Poetic*, p. 52.
20. Waller, *The Works*, edited by Elijah Fenton, London, 1729, 'Observations on some of Mr. Waller's Poems', lxii. The relevant lines from *Jerusalem Delivered*, bk 3, stanza 52 run
 Above the waves as Neptune lift his eyes
 To chide the winds, that Trojan ships oppress'd.
 See Torquato Tasso, *Jerusalem Delivered*, the Edward Fairfax translation newly introduced by Roberto Weiss, London, 1962, p. 70.
21. Jonson, *Conversations with William Drummond of Hawthornden*, in *Works*, edited by C.H. Herford and P. and E. Simpson, Oxford, 1925, vol. 1, p. 132. R.C. Wallerstein's 'The Development of the Rhetoric and Metre of the Heroic Couplet, especially in 1625-1645', *Publications of the Modern Language Association*, 50, 1935, pp. 166-209, contains more information on Sandys's versificatory habits.
22. 'An Essay to the Translation of Virgil's *Aeneis*', appended to *Ovid's Metamorphosis*, London, 1640, p. 298. First so printed 1632.
23. Bodin, *Six Bookes of a Commonwealth*, translated by Richard Knolles, London, 1606, pp. 533-534.
24. Chernaik, *The Poetry of Limitation*, p. 157. For Dryden's account, quoted in part by Chernaik, see *Essays*, edited by W.P. Ker, Oxford, 1900, vol. 2, pp. 168, 171-172. (Watson, for reasons of space, omits a large section of the 'Dedication of the *Aeneis*' in his Everyman collection of the critical essays.)
25. Thomas May, however, addressing Virgil in the rhyming gloss to the engraved title-page of his translation of *Lucan's Pharsalia*, had preferred the later poet on the grounds that
 Thou gott'st *Augustus* love, he *Nero*'s hate;
 But twas an act more great, and high to move
 A Princes envie, then a Princes love.
 (Text from 3rd edition, 'Corrected by the Author', London, 1635, sig. a1[v]. The first edition had appeared in 1627.)
 The point is touched on by Clark Hulse, *Metamorphic Verse*, pp. 202-204. For later developments, see the chapter on 'The Decline of the Classical Norm' in Howard D. Weinbrot's *Augustus Caesar in 'Augustan' England*.
26. Dawbeny, *Historie & Policie Re-viewed*, London, 1659, pp. 207, 272, sig. A4[r].
27. Dryden, *Essays*, Ker, vol. 1, p. 270.
28. Dawbeny, op.cit., p. 208.
29. ibid., pp. 208-209.
30. Dawbeny, op. cit., sig. A3[r], and see also the '*Anagramma Genethliacum & Epithalamium*' to come, p. 272, which repeats the line (*Eclogues*, 4. 49). Modern texts read 'cara deum suboles, magnum Jovis incrementum': 'Dear scion of the gods, great after growth of Jupiter', in Guy Lee's rendering (Virgil, *Eclogues*, Latin text with a verse translation and brief notes, Liverpool, 1980).
31. Cromwell, *The Writings and Speeches* (Abbott), vol. 3, p. 469.

32. Wither, *Vaticinium Casuale*, London, 1655, p. 9, *Miscellaneous Works*, First Collection.
33. Wither, *The Protector*, London, 1655, pp. 2-3.
34. ibid., p. 4.
35. Wither, *Salt upon Salt*, London, 1659, p. 5, *Miscellaneous Works*, Fourth Collection.
36. ibid., p. 4.
37. ibid., p. 7.
38. W.W. Skeat, *An Etymological Dictionary of the English Language*, Oxford, 1879-1882, Impression of 1989, MUSE (1), quoting Cotgrave.
39. Puttenham, *The Arte of English Poesie*, edited by G.D. Willcock and Alice Walker, Cambridge, 1936, p. 66.
40. Baxter, *Poetical Fragments*, London, 1681, sig. Agv.
41. *Salt upon Salt*, 'To the Reader', sig. A2v and p. 11.
42. *The Protector*, p. 31, *Salt upon Salt*, p. 16.
43. For the background, see C.S. Hensley, *The Later Career of George Wither*, The Hague, 1969 (*Studies in English Litereature*, 43).
44. Wither, *The British Appeals*, London, 1651, p. 11.
45. Waller, *Upon the present War*, 61-64, text from Samuel Carrington, *The History of the Life and Death of His most Serene Highness, Oliver, Late Lord Protector*, London, 1659, pp. 195-199. These lines, p. 197.
46. Francis Atterbury, ms. note in his copy of the 1668 edition of Waller's *Poems*, &c., now in the Westminster Chapterhouse Library, quoted by H.C. Beeching, *Provincial Letters and Other Papers*, London, 1906, p. 181.
47. Neve, *Cursory Remarks on some of the Ancient English Poets*, London, 1789, p. 65. In all editions of Waller's poems from 1664 to 1710, 'To the King on his Navy' was printed first.
48. P. R. Wikelund, 'Edmund Waller's Fitt of Versifying: Deductions from a Holograph Fragment, Folgar MS. X. d. 309', *Philological Quarterly*, 49, 1970, pp. 68-91.
49. James VI and I, *Poems*, edited by James Craigie, Edinburgh, 1955, vol. 1, p. 240.
50. Waller, *Poems, &c.,* 1645, p. 2.
51. Sir William Monson, *Naval Tracts*, edited by M. Oppenheim, vol. 4, London, 1913, p. 6: the Earl of Lindsey's Fleet Orders, 30 May, 1635. The French and Spaniards had come to blows after the former had allied themselves to the Dutch that January. Waller's friend, the Earl of Northumberland subsequently replaced Lindsey as admiral, operating under similar instructions. Chernaik (p. 145) dates the poem 1636.
52. Waller, 'Of Salley', *Poems, &c.,* 1645, p. 66.
53. Waller,*Upon the present War*, 113-114, Carrington, p. 199.
54. Wither, *Salt upon Salt*, p. 30.

5: **Building upon an Old Frame**.

1. Waller, *Panegyrick*, 113-116.
2. Catlin (trans), *De Tristibus*, London, 1639, p. 45, rendering 3. 5. 31-36 of the Latin. 'Soonest' and 'soone' have been unmetrically transposed in the original.
3. Sir Robert Stapylton (trans), *Pliny's Panegyricke*, Oxford, 1644, p. 19.
4. Waller, *Panegyrick*, 53-56.
5. Stapylton, op. cit., pp. 20-23.
6. *Panegyrick*, 97-100,
7. Stapylton, op. cit., p. 9.
8. Waller, *Panegyrick*, 81-84.
9. Stapylton, op. cit., sig. A3r.
10. Joseph Spence, *Observations, Anecdotes and Characters of Books and Men,* edited by J.M. Osborn, Oxford, 1966, vol. 1, p. 196, no. 457.
11. Spence, *Observations*, vol. 1, p. 176, no. 403 and p. 177, no. 405.
12. William Benson, *Virgil's Husbandry, or an Essay on the Georgics: Being the First Book Translated into English Verse*, London, 1725, p. xiv.
13. Carrington, *History*, p. 61.
14. Carrington, op. cit., 'Advertisement', facing p. 1.

15. Waller, *Panegyrick*, 77-78.
16. Carrington, *History*, p. 37
17. Waller, *Panegyrick*, 119-120.
18. Carrington, *History*, p. 266.
19. ibid., p. x.
20. Waller, *Panegyrick*, 135-140.
21. Watson, *Anti-Panegyrike*, 'prosaïke glosses', no. 10.
22. ibid., p. 17.
23. Hall, *The True Cavalier*, p.125.
24. ibid., p. 67.
25. Rymer, *Preface to Rapin*, 1674, in *Critical Essays of the Seventeenth Century*, edited by Joel E. Spingarn, Bloomington, 1963, vol. 2, p. 172.
26. Waller, *Panegyrick*, 49, 169-170.
27. Marvell, *Horatian Ode*, 11-16, *Poems*, p. 91.
28. Charleton, *A Brief Discourse*, London, 1669, pp. 20-21.
29. Marvell, 'The unfortunate Lover', 16, *Poems*, 1971, p. 29.
30. Marvell, *Horatian Ode*, 21-24.
31. Lucan, *Pharsalia*, Book 1, 137.
32. Marvell, *The First Anniversary*, 15, *Poems,* p. 109.
33. Marvell, *Horatian Ode*, 53.
34. 'His Theaters loud shout / Was his delight', Thomas May, *Lucan's Pharsalia*, 1635, sig. A3ʳ.
35. Marvell, *Horatian Ode*, 33-34.
36. ibid., 29 and 'The Garden', 69-70, *Poems*, p. 53.
37. Shakespeare, *King Lear*, 1.1. 136-137.
38. Marvell, 'The Garden', 5.
39. Waller, *Panegyrick*, 141-145.
40. Marvell, 'Upon the Death of Lord Hastings', 25, *Poems*, p. 4.
41. Ben Jonson, *The Masque of Queenes*, *Works*, vol. 7, p. 301.
42. Enid Welsford, *The Court Masque*, Cambridge, 1927, p. 339.
43. Enderbie, *Cambria Triumphans*, London, 1661, sig. A2ʳ.
44. Waller, *Panegyrick*, 153-154.
45. Creech, *T. Lucretius Carus, his Six Books De Natura Rerum*, 'done into English Verse with Notes', Oxford, 1682, p. 175.
46. Waller, 'Upon His Majesties repairing of Pauls', 36, *Poems, &c.,* 1645, p. 4.
47. William Laud, *A Relation of the Conference between William Laud and Mr. Fisher the Jesuit* (1639), a new edition, with an introduction and notes by C.H. Simpkinson, London, 1901, 'Epistle Dedicatory' (to Charles I), p. xxvi.
48. Henry Wilkinson, *Babylon's Ruin, Jerusalem's Rising*, London, 1643, p. 26.
49. Sir William Dugdale, *The History of St. Pauls Cathedral in London*, London, 1658, sig. Oo2ᵛ, misnumbered p. 192.
50. Marvell, *Horatian Ode*, 33-36. *First Anniversary*, 352.
51. Owen, *The Shaking and Translating of Heaven and Earth*, *Works*, edited by W.H. Goold, London, 1850-1855, vol. 8, p. 268.
52. *Panegyrick*, 69-70.
53. See Milton's note on 'The Verse' prefixed to *Paradise Lost*, *Poems*, Carey and Fowler, p. 457.
54. Watson, *Anti-Panegyrike*, 'prosaïke glosses', no. 5.
55. Watson, op. cit., p. 9.
56. Carrington, *History*, p. 3.
57. Pugh, *Brittish and Outlandish Prophesies*, London, 1658, p. 152.
58. Waller, *Panegyrick*, 125-126.
59. Waller, *Upon the present War*, 108, Carrington, p. 199.
60. Drummond of Hwthornden, *Forth Feasting*, 315-318, *The Poems*, edited by W.C. Ward, London, 1894, vol. 1, p. 199.
61. Carrington, *History,* p. xi. Cf. *The First Anniversary*, 13-14, and Chapter 6 to follow.

6: **Troubling the Waters.**

1. Interest in Marvell's political poetry quickened in the wake of J.A. Mazzeo's chapter on 'Cromwell as Davidic King' in *Renaissance and Seventeenth-Century Studies* (NY, 1964) and was further stimulated by J.M. Wallace's *Destiny his Choice: The Loyalism of Andrew Marvell* (Cambridge, 1968). Derek Hirst, in ' "That Sober Liberty": Marvell's Cromwell in 1654' (*The Golden & the Brazen World: Papers in Literature and History, 1650-1800,* edited by J.M. Wallace, Berkeley/Los Angeles/London, 1985), usefully Summarizes results and presses his own case for what he calls (p. 45, Borrowing a term from John Evelyn) '*the virtues of* "unkingship" '. See also Patsy Griffin's more recent close analysis of *The First Anniversary* in her *The Modest Ambition of Andrew Marvell,* (Newark/London, 1995), and David Norbrook's chapter 8, 'Republicanizing Cromwell', in *Writing the English Republic,* Cambridge, 1999, pp. 337-357.

2. See Marvell, *Poems,* Commentary, pp. 319-320.

3. Waller, *Panegyrick,* 125-126.

4. Marvell, *First Anniversary,* 388-393.

5. Dryden, *MacFlecknoe,* 1-2, *Poems and Fables,* edited by James Kinsley, London, 1962, p. 232.

6. Marvell, *First Anniversary,* 1-6.

7. ibid., 401-402.

8. ibid., 164.

9. ibid., 7-8.

10. ibid., 41-42.

11. ibid., 13-14.

12. Cowley, *Essays, Plays and Sundry Verses,* pp. 360-361.

13. Clarendon, *History of the Rebellion,* 1705-6, vol. 3, pt. 2, p. 648.

14. Marvell, *Horatian Ode,* 27-28.

15. Shakespeare, *Macbeth,* 1.7. 51-52.

16. Marvell, *First Anniversary,* 110, 19, 21-22.

17. Cyril Tourneur, *The Atheist's Tragedy,* edited by Irving Ribner, London, 1964, 1.1.123-129.

18. Psalm 2. 12, Marvell, *First Anniversary,* 106..

19. Marvell, *First Anniversary,* 111.

20. ibid., 155-156.

21. Cromwell to Parliament, 22 January, 1654/5, Abbott, vol. 3, p. 589. *The First Anniversary* is recorded by Thomason on 17 January.

22. Marvell, *First Anniversary,* 145-148.

23. ibid., 33-36.

24. Marvell, *First Anniversary,* 251, 244, 250. Judges 8. 5-9.

25. ibid., 255-256.

26. OED, Force, *sb.* I. 5.c.

27. For a fuller discussion of Bracton's position, see Kantorowicz, p. 143f.

28. Bible, Geneva/Tomson/Junius, NT. Title dated 1611, colphon 1612. Old Testament, p. 102v.

29. Marvell, *First Anniversary,* 257-262.

30. Judges, 9. 9, Geneva Version.

31. Marvell, *First Anniversary,* 293, 297.

32. ibid., 133.

33. ibid., 157-158.

34. ibid., 173-174.

35. ibid., 131, 144.

36. ibid., 139.

37. ibid., 175-178.

38. ibid., 159-160.

39. ibid., 140.

40. Legouis and Duncan-Jones, however, attribute 'A Jolt on Michaelmas Day, 1654' to

Denham, see Marvell, *Poems*, p. 324, n. on l. 177. For an account of Berkenhead, see P.W. Thomas, *Sir John Berkenhead, 1617-1679,* Oxford, 1969. For the poem as quoted, see *Rump: Or an Exact Collection of the Choycest Poems and Songs relating to the late Times*, London, 1662, pt. 1, p. 365.

41. Sandys, *Ovid's Metamorphosis*, 1640, pp. 26, 35.
42. Berkenhead, 'A Jolt', *Rump*, p. 363.
43. Marvell, *The Rehearsal Transpros'd and The Rehearsal Transpros'd, the Second Part*, edited by D.I.B. Smith, Oxford, 1971, p. 231.
44. Robert South, 'A Sermon preached upon Prov. X. 9. At Westminster-Abbey, 1667', *Sermons*, vol. 2, sixth edition, London, 1727, p. 37
45. Marvell, *The Rehearsal Transpros'd*, p. 135.
46. William Wordsworth, *The Prelude*, text of 1805, Bk. 10, 612.
47. Marvell, 'A Dialogue between the Soul and the Body', 43-44, *Poems*, p. 23.
48. Marvell, *The Rehearsal Transpros'd*, p. 135.
49. ibid., p. 232.
50. ibid., p. 231.
51. Marvell, *First Anniversary*, 224.
52. Judges, 8. 23, 'Authorized' Version.
53. Joseph Jane to Sir Edward Nicholas, 'Hage', 9 July, 1655, *The Nicholas Papers*, vol. 3, edited by G.F. Warner, Camden Society, 1897, p. 13.
54. Lucy, *Observations*, p. 289.
55. Marvell, *First Anniversary*, 263.
56. Wither, *A Suddain Flash*, London, 1657, p. 39, *Miscellaneous Works*, Second Collection.
57. Milton, *A Second Defence*, translated by Helen North, *Complete Prose Works*, Yale, 1966, vol. 4, pt. 1, p. 672.
58. See Marvell, *Poems and Letters*, vol. 2, *Letters*, p. 305, and n. on line 22, p. 378.
59. Marvell, *First Anniversary*, 221-228.
60. Latin quoted from Milton, *Works*, Columbia Edition, vol. 8, NY., 1933, p. 224.
61. Wither, *A Suddain Flash*, p. 35.
62. Milton, *A Second Defence*, *Prose Works*, vol. 4, p. 672.
63. Lewis and Short, *Latin Dictionary*, ordo, I. B.
64. ibid. ordo, I. C. 4. A.
65. Shakespeare, *Macbeth*, 5. 2. 20-22.

7: **More Directed to the Monarchy than the Person.**

1. Hall, *Of Government and Obedience*, sig. b2ᵛ.
2. Waller, *Panegyrick*, 125-126.
3. Watson, *Anti-Panegyrike*, 'prosaïke glosses', 8. In 'Errours to be amended', '*mushrome*' is corrected to '*mushromes*' which would require an accompanying comma to make sense.
4. Waller, *Panegyrick*, 14.
5. Hall, *True Cavalier*, p. 123.
6. Wither, *A Suddain Flash*, pp. 16, 17.
7. ibid., p. 11.
8. Clarendon, *History of the Rebellion*, 1705-6, vol. 3, pt. 2, bk. 14, p. 589.
9. Hall, *True Cavalier*, p. 109.
10. Marvell, *First Anniversary*, 389-390.
11. ibid., 234 f., 283-284.
12. Wither, *A Suddain Flash*, p. 16.
13. Wither, *The Protector*, pp. 3, 6.
14. Wither, *A Suddain Flash*, p. 15.
15. Wither, *The Protector*, p. 9.
16. Wither, *Salt upon Salt*, p. 30.
17. Wither, *A Suddain Flash*, p. 4.
18. Wallace, *Destiny his Choice*, Cambridge, 1968, p. 136.

19. Waller, *Upon the late Storme*, 29-30, text from *Three Poems upon the Death of his late Highnesse*, London, 1659, F2ʳ.
20. The original reads 'Greeks calls'.
21. Marshall, *The Right Understanding of the Times*, London, 1647, pp. 18, 23.
22. Marvell, *Upon Appleton House*, 744, *Poems*, p. 85.
23. Marvell, *First Anniversary*, 215-216.
24. *Wisdome of Soloman*, 4. 7, 10.
25. Marvell, *First Anniversary*, 217-218.
26. Waller, *Panegyrick*, 186-188.
27. Owen, *The Advantage of the Kingdom of Christ*, *Works*, vol. 8, p. 318.
28. Waller, *Panegyrick*, 173-174.
29. Watson, *Anti-Panegyrike*, p. 22.
30. *An Apologetick for the Sequestred Clergie of the Church of England*, p. 2. '*Aceldama*' means 'The field of blood' (*Acts* 1. 19): the land which Judas bought with the thirty pieces of silver he was given for betraying Christ.
31. Revelation, 19. 15-16.

8: **Non Angeli sed Angli**

1. Marvell, *First Anniversary*, 115.
2. Grey, *Debates*, vol. 1, pp. 128, 220.
3. Marvell,*The Rehearsal Transpros'd*, p. 16.
4. Waller, *Panegyrick*, 45-48.
5. Verstegen, *Restitution*, London, 1673, pp. 161-162. First edition, 1605.
6. John Hare, *St. Edward's Ghost*, 1647, text from *Harleian Miscellany*, vol. 8, London, 1811, pp. 101, 96.
7. Waller, 'Of the danger His *Majesty* (being Prince) escaped in the rode at Saint *Andere'*, 85 f., *Poems, &c.,* 1645, p. 8.
8. Hawkins, *A Discourse*, pp. 172-173, sig. M6ᵛ-M7ʳ. The pagination is confusing because sigs H-I, pp. 97-128 are omitted from the British Library copy, though the text itself is continuous and complete.
9. Waller, 'To the King on his Navy', 16, *Poems, &c.,* 1645, p. 3.
10. See Francis Atterbury, *Some Passages out of Waller*, MS. W.A.M. 65018, Westminster Chapterhouse Library, fol. 3ʳ.
11. Marshall, *The Song of Moses*, London, 1643, p. 8.
12. *CSPD., Commonwealth,* vol. 10 (1656-7), p. 126, October 4, 1656.
13. Waller, *Upon the present War*, 12, Carrington, p. 195.
14. Waller, 'Of Divine Love', Canto 5, 47-50, *Poems, &c.,* 1686, p. 282.
15. Waller, 'To the Queen Mother of France', 23-25, *Poems, &c.,* 1645, p. 62.
16. Waller, 'To his Worthy Friend, Sir *Thomas Higgons*', 19-20, *Poems, &c.,* 1686, p. 241.
17. See 'Articles, or Instructions for Articles, to be Exhibited by his Majestie's Heigh Commissioners, against Mr. John Cosin', *The Correspondence of John Cosin, D.D.*, Part 1, Surtees Society, Edinburgh, 1868, p. 196. Also W.M. Lamont, *Godly Rule*, London, 1969, p. 66.
18. 'A Presage of the Ruine of the *Turkish* Empire', 51, *Poems, &c.,* 1686, p. 266.
19. Cosin, *Correspondence*, loc. cit.
20. Milton, *Eikonoclastes*, London, 1650, pp. 227-228.
21. Waller, *Upon the late Storme*, 26.
22. Wither, *Salt upon Salt*, p. 9.
23. ibid., p. 10.
24. Shakespeare, *Henry V*, 4. 1. 135-136, 1. 2. 97.
25. Walzer, p. 8.
26. Wither, *Salt upon Salt*, p. 7.
27. Carrington, *History*, p. 195 and advertisement facing p. 1.
28. Wither, *Verses Intended to the King's Majesty*, London, 1662, p. 7, *Miscellaneous Works*, First Collection.

29. Waller, *Panegyrick*, 184.

30. Wither, *The Protector*, London, 1655, p. 28.

31. Marvell, *The Character of Holland*, 133-134, *Poems*, p. 103.

32. John Owen, *Works*, vol. 8, p. 260.

33. Marvell, *First Anniversary*, 399.

34. Sedgwick, *A Second View of the Army Remonstrance*, London, 1649, p. 15.

35. Butler, *Hudibras*, edited by J. Wilders, Oxford, 1967, p. 7, First Part, Canto 1, 200-203.

36. Milton, *Areopagitica*, London, 1644, p. 37.

37. ibid., p. 36.

38. Parker, *A Reproof*, London, 1673, p. 191.

39. Wither, *A Suddain Flash*, p. 38.

40. Wither, *The Protector*, p. 18.

41. Marvell, *First Anniversary*, 180.

9: **Restoration**.

1. Walzer, pp. 171-177.

2. Waller, *Panegyrick*, 49-50.

3. Watson, *Anti-Panegyrike*, p. 7.

4. Domenicus Nannus Mirabellius, *Novissima Polyanthea*, Frankfurt, 1617, p. 1154. Waller seemingly owned a copy of the 1628 edition. At least, I have seen such a volume, bearing his apparently genuine signature, in the possession of Professor Brian Vickers, sometime Fellow of Downing College, Cambridge.

5. Butler, *Hudibras*, First Part, Canto 2, 1-2, Wilders, p. 29.

6. Ross, *Mystagogus Poeticus*, London, 1648, p. 87.

7. Horace, *Odes*, 3. 4. 65. The translation is by Christopher Smart, *The Works of Horace translated literally into English Prose*, Edinburgh, 1835, vol. 1, p. 129.

8. Waller, *To the King, upon His Majesties Happy Return*, 19-26, text, Small Folio, London, 1660.

9. Felton, *A Dissertation*, London, 1713, p. 216.

10. Dominique Bouhours, *The Art of Criticism*, translated by 'a Person of Quality', London, 1705, p. 60. The original French title is *La Manière de Bien Penser dans les Ouvrages d'Esprit* (Paris, 1678).

11. Waller, *Panegyrick*, 41.

12. Watson, *Anti-Panegyrike*, p. 6. '[M]ember' is 'Nember' in the text. 'The vast / World' is presumably '*the greater* or *more world*, the macrocosm' (OED, World, *sb*. II. 9), anticipating Waller's 'little World' to come (49) which, as has been seen, 'improperly is sed, / *The Great worlds image*, since *without an head*'. A 'cosmos' as an 'ordered and harmonious system' is by definition opposed to a 'waste'.

13. Reynell, *The Fortunate Change*, London, 1661, p. 7.

14. Waller, *Upon His Majesties Happy Return*, 15-16.

15. Waller, *The Works*, 1729, 'Observations', p. lxvii.

16. 'The rest of the Chapters of the Booke of Esther', 15. 7 and 13-14, 'Authorized' Version.

17. Alexander Pope, *Dunciad*, 4. 187, *Poems*, edited by John Butt, p. 776.

18. John Rawlinson, *Vivat Rex, A Sermon Preach'd at Pauls Crosse on the Day of his Majesties happie Inauguration* (March 24, 1614), Oxford, 1619. See also Walzer, *The Revolution of the Saints,* p. 157.

19. Waller, *Upon His Majesties Happy Return*, 1-14.

20. Flecknoe, *Heroick Portraits with other Miscellany Pieces made and dedicated to his Majesty*, London, 1660, sig. B1ʳ.

21. Valentine, *God Save the King, a Sermon Preach'd in St. Paul's Church, 27ᵗʰ March, 1639, Being the Day of His Majesties Most Happy Inauguration, and of his Northern Expedition*, London, 1639, p. 18.

22. Waller, *Upon His Majesties Happy Return*, 113-114.

23. ibid., 32.

24. Sandys, *Ovid's Metamorphosis*, 1640, p. 56. Waller, *Upon His Majesties Happy Return*, 33-34.

25. Pope, *Windsor Forest*, 42, *Poems*, ed. cit., p. 196.

26. Pope, *Windsor Forest*, 7-8. Waller, *On St. James's Park*, 1-3, *Poems*, &c., 1686, p. 158.

27. Marvell, 'The Mower against Gardens', 35-36, *Poems*, p. 44.

28. ibid., 13-14.

29. Henry Carey, Earl of Monmouth, *Historical Relations of the United Provinces of Flanders, Written Originally in Italian by Cardinall Bentivoglio*, London, 1652, p. 2.

30. Johnson, 'Life of Waller', *The Lives of the Poets*, Letchworth, 1925, vol. 1, p. 160.

31. Waller, *On St. James's Park*, 71-74, *Poems*, &c., 1686, p. 162.

32. Marvell, 'Upon the Hill and Grove at Bill-Borow', 35-36, *Poems*, p. 61.

33. May, *Lucan's Pharsalia*, 1635, sig. E2ᵛ.

34. Marvell, *Horatian Ode*, 48, 52.

35. Burke, *Reflections on the Revolution in France*, Letchworth, 1955, pp. 45-46.

36. Waller, *Panegyrick*, 143-144.

37. ibid., 156.

38. ibid., 137-138.

39. Thomas Lodge, *The Workes of Lucius Annaeus Seneca*, London, 1620, p. 506. Seneca refers to Ovid (*Metamorphoses*, 2. 1-400), whose Phoebus tries to deter Phaethon by describing no 'fragrant Zodiack' but one through which he will run the gauntlet of the savage Bull and clutching Crab mentioned by Marvell in his Latin version of 'The Garden' ('Hortus', 53, *Poems*, p. 55), and all the other monsters which make it difficult enough for the sun-god himself to stop his fiery horses from bolting.

40. Cromwell, ed. Abbott, vol. 3, p. 587.

41. Dabbs, *'Dei Gratia' in Royal Titles*, Paris, 1971, pp. 104-105.

42. See Kevin Sharpe, 'An Image Doting Rabble', in Sharpe and Steven N. Zwicker, eds, *Refiguring Revolutions*, p. 48. Sharpe stresses the point that 'From its inception the Protectorate involved the restoration of a court and courtly life' (p. 46) – and so, by extension, 'The name and all th'addition to a king'.

43. Raymond, *An Abridgement*, p. 43. Personal communication from Dr R.I.V. Hodge, sometime Research Fellow of Churchill College Cambridge and author of *Foreshortened Time; Andrew Marvell and Seventeenth Century* Revolutions (Cambridge [Brewer, etc.], 1978), q.v. p. 139 and ch. 5, n. 22, p. 167.

44. Milton, *Poems*, Carey and Fowler, p. 326.

10: **No Force but Love, nor Bond but Bounty.**

1. Marvell, *First Anniversary*, 126.

2. Walzer, *The Revolution of the Saints*, p. 164.

3. ibid., pp. 152, 165.

4. Waller, *Upon His Majesties Happy Return*, 34.

5. This is how Charles I was referred to during his trial. See, for example, *The Charge against the King*, in *The Constitutional Documents of the Puritan Revolution, 1625-1660*, selected and edited by S.R. Gardner, Oxford, 1906, p. 371.

6. Waller, *Upon His Majesties Happy Return*, 91-94.

7. Hall, *Of Government and Obedience*, p. 205.

8. Hall, *True Cavalier*, p. 109.

9. Poyntz, *A Vindication of Monarchy*, London, 1661, p. 129.

10. Baxter, *The Saints Everlasting Rest*, pt. 4, London, 1652, p. 182.

11. Waller, *On St. James's Park*, 59, 61, *Poems*, &c., 1686, p. 162.

12. Cowley, *A Discourse by Way of Vision, Essays, Plays and Sundry Verses*, p. 375.

13. Waller, *Panegyrick*, 112.

14. Hall, *Of Government and Obedience*, pp. 495, 489.

15. Coke, *Justice Vindicated*, London, 1660, p. 25.

16. Hall, *Of Government and Obedience*, p. 488.

17. ibid., p. 490.
18. ibid., p. 205.
19. Hall, *True Cavalier,* p. 109.
20. Yeats, *Autobiographies*, London, 1961, p. 293.
21. Rawlinson, *Vivat Rex*, p. 9.
22. Dawbeny, *Historie & Policie Re-viewed*, p. 13.
23. Butler, *Mercurius Menippeus*, first published 1682, see *Satires and Miscellaneous Prose and Poetry*, edited by R. Lamar, Cambridge, 1928, p. 356.
24. Walker, *The History of Independency*, Part 1, London, 1648, p. 46, and Cleveland, *The Character of a London Diurnall*, London, 1651, p. 6.
25. Cleveland, *Majestas Intemerata,* London ? 1649, pp. 93-94.
26. Carrington, *History*, p. 242.
27. ibid., p. 243.
28. Dryden, *Heroique Stanza's*, 73-76, *Poems and Fables*, p. 9.
29. Waller, 'Upon His Majesties repairing of Pauls', 37-38, *Poems, &c.,* 1645, p. 4.
30. Waller, 'Of Divine Love', Canto 5, 29-30, *Poems, &c*, 1686, p. 281.
31. Waller, *Upon His Majesties Happy Return*, 94, 74.
32. Walzer, p. 159.
33. Waller, 'Of the danger His Majesty . . . escaped [in] the rode at Saint *Andere*', 83-84, *Poems. &c.,* 1645, p. 8.
34. Waller, *Upon His Majesties Happy Return*, 93.

11: **Indulgent to the Occupant**

1. The version quoted, published London, 1689, came together with 'An Appendix . . . Relating to the Prince of Orange': *plus ça change, plus c'est la même chose.* For the quotation, see p. 15.
2. Waller, *Panegyrick*, 117-120.
3. James Heath, *A Chronicle of the Late Intestine War in the Three Kingdoms of England, Scotland and Ireland*, London, 1676, p. 394.
4. Allison, p. 83.
5. Luke 4.40.
6. Carrington, *History, pp. 266-267.*
7. Clarendon, *History of the Rebellion*, 1705-6, vol. 3, pt. 2, p. 653.
8. Waller, *Panegyrick*, 161-164.
9. Jonson, *Works*, vol. 8, p. 228.
10. Waller, *Panegyrick*, 165-168.
11. Fenton, *Works of Edmund Waller*, 1729, 'Observations', p. lxiv.
12. Fairfax, *Jerusalem Delivered*, book 8, stanza 83.
13. Tasso, *Il Goffredo*, Venice, 1583, canto 8, stanza 78.
14. Fairfax, op. cit., book 8, stanza. 81.
15. Waller, *Upon His Majesties Happy Return*, 63-72.
16. Waller, *On St. James's Park*, 98, *Poems, &c.,* 1686, p. 164.
17. Sir John Denham, *Coopers Hill*, 'B' text, 349f., in Brendan O'Hehir, *Expans'd Hieroglyphicks*, Berkeley/Los Angeles, 1969, pp. 161-162.
18. Waller, 'Upon His Majesties repairing of Pauls', 27-28, *Poems, &c.,* 1645, p. 4.
19. Marvell, *The Character of Holland*, 18, *Poems*, p. 100.
20. *Observations Concerning the Present Affayres of Holland and the United Provinces*, n.p., 1622, p. 1.
21. ibid., p. 2.
22. Marvell, *The Character of Holland*, 47-50.
23. Waller, *Upon His Majesties Happy Return*, 44.
24. Hobbes, *Leviathan*, Introduction, p. 1.
25. Job 38. 8, 11 and 41. 1.
26. Waller, *Upon His Majesties Happy Return*, 49-50.

27. Though Charles Montagu, Earl of Halifax, was to purloin (toning them down somewhat) lines 56 f. of the *Panegyrick* for the King in his piece 'On the Death of Charles II':

> We reap the swarthy Indians' Sweat and Toil
> Their Fruit without the mischiefs of their Soil.
> Here in cool Shades, their Gold, and Pearls receive,
> Free from the heat, which does their lustre give, etc.

Text from *A Collection of Poems*, London, 1701, p. 380.

28. Waller, 'The Triple Combat', 44-46, *The Second Part of Mr. Waller's Poems*, 1690, p. 48. The poem celebrates the arrival of the Duchess of Mazarin in England in 1675.

29. Waller, 'Upon His Majesties repairing of Pauls', 41-42, *Poems, &c.,* 1645, p. 4.

30. ibid., 37-38.

31. Waller, 'The Triple Combat', 17-18.

32. Shakespeare, *2 Henry IV*. 2. 4. 152.

33. Thorn Drury, *The Poems of Edmund Waller*, London, 1905, vol. 2, p. 214. Why, however, should she, like her rivals, not have appeared *in propria persona*?

34. Rochester, 'Dialogue', 1-4, *The Complete Poems*, edited by D.M. Vieth, New Haven / London, 1968, p. 129.

35. Rochester, 'A Satyr on Charles II', 11-12, Vieth, p. 60.

36. Rochester, *Sodom*, BL MS. Harl. 7312, p. 123.

37. 'The rest of the Chapters of the Booke of Esther', 15. 11-15.

12: **Pious Times – Dryden's** *Absalom and Achitophel.*

1. Dryden, *Absalom and Achitophel*, 1-2, *Poems and Fables*, p. 190.

2. ibid., 19.

3. ibid. 10.

4. Genesis 10. 1.

5. Jonson, *Mercurie Vindicated*, *Works*, vol. 7, pp. 414, 412.

6. Pope, *Dunciad*, 4. 244.

7. Dryden, *The Medall*, 272, *Poems and Fables*, p. 233.

8. Jonson, op. cit., *Works*, vol. 7, p. 413.

9. Miner, *Dryden's Poetry*, Bloomington/London, 1967, p. 122.

10. Dryden, *Absalom and Achitophel*, 170-173.

11. ibid., 50.

12. ibid., 66.

13. ibid., 83-84.

14. Marvell, *Upon Appleton House*, 2, 6,, 45-47, *Poems*, pp. 63-64.

15. Dryden, 'Postscript to *The History of the League*', in *Works*, Berkeley/Los Angeles, 1956-, vol. 18, edited by A. Roper and V.A. Dearing, 1974, p. 409.

16. Dryden, *The Medall*, 246-247.

17. Dryden, *Absalom and Achitophel*, 8.

18. ibid., 622.

19. Swift, *Gulliver's Travels*, edited by Harold Williams, Oxford, 1959, p. 268.

20. 2 Corinthians, 3.6.

21. Dryden, *Works*, vol. 18, p. 414.

22. Dryden, *Absalom and Achitophel*, 15.

23. Poyntz, *A Vindication of Monarchy*, p. 103.

24. Burnet, *The History of my own Time*, a new edition by Osmund Airy, Oxford, 1897-1900, vol. 2, p. 214.

25. Dryden, *Absalom and Achitophel*, 354.

26. Galatians 4.30.

27. Dryden, *Absalom and Achitophel*, 758.

28. Dryden, *The Medall*, 277-278.

29. Price, *To the Palace of Wisdom*, Carbondale/Edwardsville, 1964, p. 60 and Laslett, introduction to Filmer, p. 13.

30. Filmer, *Patriarcha*, etc., p. 42.

31. Milton, *Paradise Lost,* 9. 211-212.
32. Dryden, *Essays*, Ker, vol. 2, p. 177.
33. Dryden, *Absalom and Achitophel*, 419-422.
34. ibid., 416, 411.
35. ibid., 181.
36. Locke, *Two Treatises*, Cambridge 1963, Signet reprint, 1965, p. 83.
37. ibid., p. 72.
38. Dryden, *Absalom and Achitophel*, 233.
39. Filmer, *Patriarcha,* etc., p. 241.
40. *Leviathan*, Pt p, ch. 13, ed. cit. p. 65.
41. Lucy, *Observations,* 1663, p. 139.
42. ibid., p. 148.
43. Dryden, *The Second Part Absalom and Achitophel*, 1-2, *Poems and Fables*, p. 244.
44. Filmer, *Patriarcha*, etc., p. 61.
45. Dryden, *Absalom and Achitophel*, 301-302.
46. J[ohn] C[rouch], *A Mixt Poem . . . Upon the Happy Return of His Sacred Majesty Charls the Second*, London, 1660, p. 8.
47. George Owen Harry, *The Genealogy of the High and Mighty Monarch, James, by the Grace of God, King of Great Brittayne, &c.*, London, 1604.
48. Dryden, *Works*, vol. 18, p. 395.
49. Hawkins, *A Discourse*, p.134 (sig, K3v).
50. Dryden, 'Postscript', *Works*, vol. 18, p. 394.
51. F., E. *A Letter*, London, 1679, p. 5.
52. Pope, *Dunciad*, 4. 75-76.
53. Milton, *Works*, edited by F.A. Patterson *et al.*, NY, 1931-1938, vol. 6, p. 128.
54. MacKenzie, *Jus Regium*, London, 1684, p. 158.
55. Milton, *Works*, ibid., vol. 8, pp. 224, 225.
56. Filmer, *Patriarcha*, etc., p. 61 (the square bracketed phrase is not included in the MS. Version), and Milton, *Paradise Lost*, 3. 309.
57. Milton, *Works*, NY, vol. 8, pp. 222, 223.
58. ibid., pp. 224, 225.
59. ibid., 222, 223.
60. Marvell, 'On Mr. Milton's *Paradise Lost*', 51-52, *Poems*, p. 139.
61. Milton, *Paradise Lost*, 9. 998-999.
62. Milton, *Works,* NY, vol. 8, p. 223.
63. Milton, *Paradise Lost*, 3. 412f. For Milton's claim to have written 'Easy my unpremeditated verse', see 9. 24.
64. ibid., 5. 149.
65. Waller, *Panegyrick*, 31-32.
66. Wither, *Salt upon Salt*, p. 8.
67. Dryden, *Absalom and Achitophel*, 49-50.
68. See *The Verney Papers*, 'Notes of Proceedings in the Long Parliament, Temp. Charles I', edited by J. Bruce, Camden Society, London, 1845, p. 181 (entry for Thursday, 23 June, 1642).

13: **The Exquisite Truth**.

1. Waller, *Upon the late Storme and Death of his Highnesse Ensuing the same,* 6-8, text from *Three Poems*, London, 1659.
2. Stevens, *Opus Posthumous*, edited by S.F. Morse, London, 1959, p. 163..
3. Hobbes, *Leviathan*, pt. 4, ch. 45, p. 361.
4. Waller, *Works*, 1729, 'Observations', p. lxvi.
5. Watson, *The Storme Raised by Mr Waller . . . Allayed*, sig. E1r.
6. See the summary given by George Sandys, *Ovid's Metamorphosis*, 1640, p. 270 (wrongly numbered 272).
7. Hobbes, *Leviathan*, 'A Review and Conclusion', p. 388.

8. Holland, *The Romane History*, bk 1, p. 12.

9. Waller, *Works*, 1729, 'Observations', p. lxvi.

10. Wither, *Salt upon Salt*, p. 49.

11. Hobbes, *Leviathan*, pt. 1, ch. 4, p. 16.

12. Waller, *Upon the late Storme*, 27-28.

13. ibid., 9-22.

14. Pope, *Prose Works*, edited by Rosemary Cowler, vol. 2, Oxford, 1986, p. 212.

15. Thurloe, *State Papers*, vol. 8, p. 792. The letter is dated 'Dunkerke, 15 August 1659'. For further contemporary reference to the perceived importance of Dunkirk, see C.H. Firth, *The Last Years of the Protectorate*, London, 1909, vol. 2, pp. 218-219.

16. Dryden, *Absalom and Achitophel*, 318.

17. ibid., 339, 314.

18. Filmer, *Patriarcha*, etc., p. 61.

19. Dryden, *Absalom and Achitophel*, 836.

20. ibid., 146-149.

21. Dekker, op. cit., 1606, *Non-Dramatic Works*, edited by Alexander Grosart, London, 1884-1886, vol. 2, p. 15.

22. Haley, *The First Earl of Shaftesbury*, Oxford, 1968, pp. 345-346.

23. ibid., loc. cit.

24. Dryden, *Absalom and Achitophel*, 154.

25. Budick, *Poetry of Civilization*, New Haven / London, 1974, p. 92.

26. Johnson, 'Life of Dryden', *Lives of the Poets*, Letchworth, 1925, vol,. 2, p. 243.

27. See George Watson's introductory comment to 'The Author's Apology for Heroic Poetry', prefixed to *The State of Innocence* (1677), *Of Dramatic Poetry and Other Critical Essays*, vol. 1, p. 195.

28. Genesis, 1. 3.

29. Nicholas Boileau-Despréaux, *Oeuvres Diverses*, Paris, 1675, *Le Traité du Sublime ou de Merveilleux dans le Discours, Traduit du Grec de Longin*, Preface, sig. aviv.

30. Dryden, *Absalom and Achitophel*, 1026.

31. ibid., 131.

32. Tillotson, 'Success not always answerable to the probability of Second Causes', Sermon 35, preached on Wednesday, April 16, 1690, *Works*, London, 1735, vol. 1, p. 330.

33. Pope, *Windsor Forest*, 326-327.

34. Pope, *The Rape of the Lock*, Canto 3, 45-46.

35. Dryden, *The Hind and the Panther*, The First Part, 126-127, *Poems and Fables*, p. 358.

36. ibid., 125.

37. Dryden, *Essays*, Ker, vol. 2, p. 171.

38. Collins, *A Discourse on Free-Thinking*, London, 1713, p. 171.

39. Tillotson, 'The Possibilty of the Resurrection asserted and proved', Sermon 140, preached at Whitehall, 1682, *Works*, vol. 3, p. 249.

40. Manningham, *A Solemn Humiliation*, London, 1686, p. 22.

41. Manningham, *A Short View of the most Gracious Providence of God in the Restoration and Succession*, London, 1685, pp. 22-23.

42. Grey, *Debates*, vol. 1, p. 160.

43. ibid., vol. 1, p. 29. The 'first article' referred to reads, 'That the Chancellor hath traiterously, about the month of *June* last, advised the King to dissolve the Parliament, and said *there could be no further Use of Parliaments; that it was a foolish Constitution and not fit to govern by; and that it could not be imagined, that three or four hundred Country Gentlemen could be either prudent Men or Statesmen:* And *that it would be best for the King to raise a standing Army and to govern by that*; whereupon it being demanded how that Army should be maintained, He answered, *by Contribution and free Quarter, as the last King maintained his Army in the War*'. See Clarendon, *The Life*, Oxford, 1759, p. 447.

44. Spragens, *The Politics of Motion*, London, 1973, pp. 192-193.

45. Dryden, *Absalom and Achitophel*, 424.

46. Dryden, *Absalom and Achitophel*, 'To the Reader', *Poems and Fables*, p. 189, 53-55. Cf. 2 Samuel, 17. 23.

47. Hobbes, *De Cive, English Works*, edited by William Molesworth, London, 1839, vol. 2, p. 5.
48. Dryden, *The Hind and the Panther*, The Third Part, 860-865.
49. ibid., The Second Part, 228.
50. ibid., The First Part, 1.

PART 2.

14: **Wonder en is gheen Wonder**.

1. Simon Stevin, *Essay on Waterscouring*, edited by R.J. Forbes, *The Principal Works*, vol. 5, Amsterdam, 1966, p. 205.
2. F., E., *A Letter*, 1679, p. 5.
3. Laurence Sterne, *Tristram Shandy*, vol. 6, ch. 2, edited by Graham Petrie wth an introduction by Christopher Ricks, Harmondsworth, 1967, p. 398.
4. Wilson, *The Dutch Republic*, London, 1968, p. 92.
5. Stevin, *Principal Works*, vol. 1, edited by E. J. Dijksterhuis, Amsterdam, 1955, pp. 4, 58, 59.
6. Henry Carey, *Historicall Relations*, 1652, p. 2.
7. See Chapter 11, n. 20 above.
8. Genesis, 1. 9.
9. Felltham, *A Brief Character*, London, 1652 pp. 71-72.
10. *Observations Concerning the Present Affayres of Holland and the United Provinces*, p. 143.
11. Dugdale, *The History of Imbanking*, London, 1662, p. 371, col. b.
12. ibid., sig. A2v.
13. Camden, *Britain, or a Chorographicall Description of the most flourishing Kingdomes, England, Scotland, and Ireland, and the Isles adjoyning*, London, 1637, p. 492.
14. Felltham, *A Brief Character*, p. 2.
15. Shakespeare, *Much Ado About Nothing*, 3. 4. 50.
16. Dryden, *Amboyna*, London, 1673, p. 61.
17. Felltham, *A Brief Character*, p. 91.
18. Shakespeare, *Richard II*, 2. 1. 43.
19. Jonson, 'To Penshurst', 102, 45, 1-8, *Works*, vol. 8, pp. 93-94.
20. *Observations*, p. 2.
21. Stevin, *Principal Works*, vol. 5, pp. 428, 429.
22. John Wilkins, *Towards a Real Character*, London, 1668.
23. Stevin, *Principal Works*, vol. 1, pp. 385, 85.
24. ibid., vol. 5, p. 427.
25. ibid., vol. 1, p. 59.
26. Marvell, *The Character of Holland*, 48.
27. ibid., 47, 49-50.
28. See Wilfrid Blunt, *Tulipomania*, Harmondsworth, 1950, p. 13.
29. Felltham, *A Brief Character*, p. 65.
30. Marvell, 'The Mower against Gardens', 21-23.
31. ibid., 30, 31, 37-38.
32. Denham, *Coopers Hill*, 'B' Text, 233-234, 161, O'Hehir, pp. 153, 149.
33. ibid., 191-192, p. 151.
34. ibid., 165-180, pp. 149-150.
35. ibid., 181, 183-184.
36. Waller, 'To the King on his Navy', 25, *Poems, &c.*, 1645, pp.2-3.
37. ibid., 24.

38. Guillaume De Saluste, Sieur Du Bartas, *The Divine Weeks and Works*, translated by Joshua Sylvester, edited by Susan Snyder, Oxford, 1979, vol. 1, p. 424, 'Babilon', 107-108. The most obvious source of the story is Josephus.

39. Genesis, 11. 10.

40. Marvell, 'The Mower against Gardens', 24-26.

41. Milton, *Paradise Lost*, 4. 393-394.

42. Waller, 'To the King on his Navy', 19-32.

43. Rymer, *A Short View of Tragedy*, London, 1693, p. 79.

44. John Dennis, *The Impartial Critick*, London, 1693. See Spingarn, *Critical Essays of the Seventeenth Century*, vol. 3, pp. 175-176.

45. Dennis, *Miscellanies in Verse and Prose*, London, 1693, p. 79.

46. Waller, 'To the King on his Navy', 13-14, *Poems, &c.,* 1645, p. 3.

47. Cowley, *Essays. Plays and Sundey Verses*, p. 344.

48. Denham, *Coopers Hill*, 'A' Text, 205f., O'Hehir, p. 124.

49. ibid., 'B' Text, 349-352, O'Hehir, pp. 161-162.

50. Spenser, *Faerie Queene*, bk. 7, canto 7, st. 58.

51. Denham, *Coopers Hill*, 'B' Text, 231.

52. Anon., *England's Path*, in *Somers Tracts*, edited by Sir Walter Scott, vol. 11, 1814, pp. 376-377.

53. Marvell, *The Character of Holland*, 20, 47.

54. Shakespeare, *Troilus and Cressida*, 1.3. 112.

55. *England's Path, Somers Tracts,* vol. 11, p. 373.

56. Coleridge, 'On Poesy and Art', *Biographia Literaria*, edited by J. T. Shawcross, Oxford, 1954, vol. 2, p. 262.

57. Marvell, *The Character of Holland*, 37-38.

58. Felltham, *A Brief Character*, pp. 48-49.

59. Denham, *Coopers Hill*, 'B' Text, 161-164.

60. Stubbe, *A Justification of the Present War against the United Netherlands*, London, 1672, p. 6.

61. Stubbe, *A Further Justification*, London, 1673, sig. C3r.

62. Dryden, *Absalom and Achitophel*, 149.

63. Stubbe, *A Further Justification*, sig. C3v.

64. Dryden, *Amboyna*, London, 1673, p. 22 (Act 2, Scene 1) and *Works*, 1956-, vol. 12, 1994, edited by Vinton A. Dearing, p. 31.

65. Winstanley, *The English and Dutch Affairs Display'd to the Life*, London, 1664, p. 56. The marginal 'See my Englands Worthies', p. 43, identifies the author.

66. Anon., *A Parallel between O.P. and P.O.*, broadside, London, 1694, stanzas 2, 6, 7.

67. Richard Hurd, *Moral and Political Dialogues; With Letters on Chivalry and Romance*, 3 vols, London, 1765, vol. 1, p. 46.

68. Burnet, *History of His Own Time*, edited by M.J. Routh, Oxford, 1823, 6 vols, vol. 4, p. 397.

69. Matthew Prior, *Carmen Saeculare*, st. 22, London, 1700, p. 11.

70. This phrase is from *The Character of a Trimmer*. See Halifax, George Savile, Marquess of, *Complete Works*, edited by J.P. Kenyon, Harmondsworth, 1969, p. 63.

71. Prior, *Carmen Seculare* [sic], st. 22, *Poems on Several Occasions*, London, 1709, p. 152. See also Denham, *Coopers Hill*, 'B' Text, 191-192, 234, 170.

72. Prior, *Carmen Seculare*, st. 4, *Poems,* 1709, p. 141.

73. Denham, *Coopers Hill*, 'B' Text, 189f.

74. Prior, *Carmen Seculare*, see stanzas 1, 24, *Poems*, 1709, pp. 138, 154.

75. ibid., see stanzas 16, (p. 149), 23 (pp. 152-153), 22 (p. 151).

76. Pope, *Windsor Forest*, 43.

77. See for example, Prior's *An Ode Humbly Inscribed to the Queen*, 1706, *Poems*, 1709, p. 280.

78. Quoted by Edward Carpenter, *The Protestant Bishop*, London, 1956, p. 82.

15: **Restoration, Revolution**.

1. Francis Atterbury, *A Sermon Preach'd before the Honourable House of Commons* . . . *May 29ᵗʰ, 1701*, London, 1701, p. 23
2. Bennett, *The Tory Crisis in Church and State*, Oxford, 1975, p. 4.
3. Ibid., p. 104.
4. Atterbury, op. cit., p. 25.
5. Hickes, 'A Sermon preach'd on 29ᵗʰ May, 1684', text from, Hickes, *A Collection of Sermons*, London, 1713, vol. 2, p. 26.
6. Hickes, 'A Discourse about the Soveraign Power', November 28, 1682, *A Collection of Sermons*, vol. 1, pp. 324-325.
7. Hickes, *A Vindication*, London, 1692, pp. 23-24.
8. ibid., p. 41.
9. Hall, *Of Government and Obedience*, p. 194.
10. Anon., *The Weasel Uncased*, in *Poems on Affairs of State*, vol 5, edited by William J. Cameron, New Haven / London, 1971, p. 250.
11. Hickes, 'A Sermon preach'd 29th May, 1684', *A Collection of Sermons*, vol. 2, pp. 38, 39-40.
12. Behn, *A Pindaric Poem to the Reverend Doctor Burnet*, 1689, 66-76, the *Works of Aphra Behn*, edited by Janet Todd, vol. 1, London, 1992, p. 309.
13. Gilbert Burnet, *A Sermon, preached at St James's, before the Prince of Orange, 23 December, 1688*, London, 1689, p. 1.
14. Behn, op. cit., 96-103. *Works*, vol. 1, p. 310.
15. Waller, *Instructions, Poems, &c.*, 1686, p. 222.
16. Behn, *A Congratulatory Poem to Her Sacred Majesty Queen Mary*, 89-104, *Works*, vol. 1, p. 306.
17. The phrase is Douglas Brooks-Davies's, who subtitles his book, *Pope's 'Dunciad' and the Queen of the Night*, Manchester, 1985, 'a study in emotional Jacobitism'.
18. Shakespeare, *The Winter's Tale*, 5. 1. 123-125.
19. Behn, *A Congratulatory Poem to the King's Most Gracious Majesty*, 45-52, *Works*, vol. 1, p. 298.
20. Waller, *Instructions*, 123-126, *Poems, &c.*, 1686, p. 211.
21. Atterbury, *Some Passages out of Waller*, fol. 1ᵛ.
22. See, for instance, Johan Doetichum, *Map of the Netherlands*, 1598, reproduced in Simon Schama, *The Embarrassment of Riches*, Fontana Press, 1988, p. 55. Schama (p. 54) speaks in the plural of 'Maps that popularly featured the *leo belgicus* superimposed on the Netherlands'.
23. 1 Peter, 5.8. Isaiah, 9.6.
24. Behn, *A Congratulatory Poem to Her Most Sacred Majesty*, 30-33, *Works*, vol. 1, p. 295.
25. Dryden, *The Life of St. Francis Xavier, Works*, vol. 19, 1979, p. 4.
26. Shakespeare, *Hamlet* 1, 2. 120-121.

16: **'Bright *Maria's* Charms'**

1. Anon., *The English Gentleman Justified*, London, 1701, p. 53.
2. Defoe, *The True-Born Englishman* , London, 1701, 10ᵗʰ edition with explanatory preface, p. 23.
3. ibid., p. 60.
4. Dryden, 'The Tenth Satire of Juvenal', 73-78, *The Satires of Juvenal and Persius*, 1693, text from *John Dryden*, edited by Keith Walker, Oxford, 1987, p. 361.
5. J.H., *The Tenth Satyr of Juvenal done into English Verse*, 1683, published, London, 1693, p. 4.
6. Shadwell, *The Tenth Satyr of Juvenal, English and Latin, The English by Tho[mas] Shadwell*, London, 1687, pp. 3, 5, sig. A2ᵛ.
7. Higden, *A Modern Essay on the Tenth Satyr of Juvenal*, London, 1687, sig. A4ᵛ, p. 11.
8. Shakespeare, *I Henry IV*, 5. 1. 19-21.

9. John Fletcher, *The Humorous Lieutenant*, 4. 8.130, *The Dramatic Works in the Beaumont and Fletcher Canon*, general editor Fredson Bowers, vol. 5, Cambridge, 1982, p. 396.

10. See Chapter 5, n. 60 above.

11. Shakespeare, *Richard II*, 2. 4. 9.

12. Henry Hyde, Earl of Clarendon, *Correspondence*, etc., 1828, vol. 2, p. 211.

13. Defoe, *The Mock Mourners* (1702), 305, *Poems on Affairs of State*, vol. 6, edited by Frank H. Ellis, New Haven/London, 1970, p. 387.

14. Samuel Dillingham to William Sancroft, 30 July, 1650, *Memoirs of the Great Civil War in England*, edited by Henry Cary, London, 1842, vol. 2, p. 226.

15. Behn, *A Congratulatory Poem*, 52, *Works*, vol. 1, p. 305.

16. Dryden, 'To my Dear Friend Mr. Congreve', 48, *Poems and Fables*, p. 490. '*Tom* the first' was Shadwell.

17. Rymer, *A Short View of Tragedy*, sig. A7ʳ.

18. Rymer, *A Poem on the Arrival of Queen Mary*, London, 1689. p. 4.

19. Mary II, Queen, *Memoirs of Queen Mary of England*, edited by R. Doebner, London, 1886, p. 23.

20. Henry Hyde, Earl of Clarendon, *Correspondence*, etc., vol. 2, pp. 261-262.

21. Jurieux, Pierre, *A Pastoral Letter on the Death of the Queen*, London, 1695, p. 22.

22. Stepney, *A Poem Dedicated to the Blessed Memory of Her Late Gracious Majesty Queen Mary*, London, 1695, p. 4.

23. Waller, *On St. James's Park*, 61-62, *Poems, &c.*, 1686, p. 162.

24. Waller, *Panegyrick*, 151-152.

25. Howard Nenner, *By Colour of Law*, traces in detail the complicated constitutional manoeuvrings of the day. For this point, see especially his chapter on 'The Triumph of the Legal Mind'.

26. Rymer, *A Poem on the Arrival of Queen Mary*, pp. 3, 4.

27. Mary II, Queen, *Memoirs of Queen Mary of England*, p. 7.

28. Rymer, *A Poem*, p. 4.

29. Anon., *The Protestant Mask Taken off the Jesuited Englishman*, London, 1692/3, p. 25.

30. ibid., p. 23.

31. For reproductions of the engravings in question, see *Poems on Affairs of State*, vol. 5, pp. 148, 151.

17: **Machines and Máchines**

1. Shakespeare, *Hamlet*, 2. 2. 122-123, edited by Harold Jenkins, London, 1982.

2. Camden, *Hibernia*, 48-49, George Burke Johnston, 'Poems by William Camden: With Notes and Translations from the Latin', *Studies in Philology*, 72, 1975, p. 72. Johnston's translation of the lines quoted (p. 73) runs:
 > Gradually the artifice
 > Of the vast universe is released, and hand in hand,
 > The sisters come down from the loftiest spheres.

3. Dryden, *Essays*, Ker, vol. 2, p. 165.

4. Milton, *Paradise Lost*, 6. 553.

5. Rymer, *Preface to Rapin*, 1674, Spingarn, vol 2, p. 171.

6. Defoe, *The Mock Mourners. A Satyr by Way of Elegy on King William*, 82-107, *Poems on Affairs of State*, vol. 6, p. 379.

7. Dryden, *Essays*, Ker, vol. 1, p. 32.

8. Waller, *Poems, &c.*, 1645, p. 11.

9. Waller, *Works*, 1729, 'Observations', p. vii.

10. Johnson, *Rambler* no. 137, *Works*, Yale Edition, vol. 4, edited by W.J. Bate and Albrecht B. Strauss, New Haven/London, 1969, p. 360.

11. Milton, *Paradise Lost*, 2. 1051-1052.

12. Chaucer, *The Canterbury Tales*, Fragment I(A) 2988, Robinson, p. 46.

13. The quotation is from some 'Discommendatory Verses', 1700, attacking Christopher Codrington, printed in Richard C. Boys, 'Sir Richard Blackmore and the Wits', *Contributions*

to *Modern Philology*, 13, p. 68, University of Michigan Press, 1949.

14. Dryden, *Absalom and Achitophel*, 758, 766,

15. John Donne, *Sermons*, edited by George R. Potter and Evelyn M. Simpson, vol. 3, Berkeley/Los Angeles, 1957, p. 289 and Introduction, p. 28. His text is 1 Peter, 1.17.

16. Rochester, 'A Satyr against Reason and Mankind', 29, *Complete Poems*, p. 95.

17. Hobbes, *Leviathan*, pt. 2, ch. 17.

18. Stephen, *Hobbes*, London, 1924, p. 196.

19. Donne, *Pseudo-Martyr*, London, 1610. p. 172.

20. Hobbes, *Leviathan*, Introduction, p. 1.

21. Pope, *Epistle to Burlington*, 173-176, *Poems*, p. 549.

22. Marvell, 'The Mower against Gardens', 38-40.

23. See *Jowitt's Dictionary of English Law*, second edition, by John Burke, London, 1977, vol. 2, p. 1059.

24. Johnson, 'Life of Pope', *Lives of the Poets*, Letchworth, 1925, vol. 2, p. 216.

25. Pope, *Windsor Forest*, 333.

26. Pope, *Epistle to Burlington*, 126.

27. John Scott, commenting in his *Critical Essays* (London, 1785, p. 306) on 'the circumstance of the "*landscape laughing*" ' in Thomson's *Spring* (1746, 197), notes that 'a fine prospect, which is agreeable to the eye, is said to "*smile*"; but the word "*laugh*", however authorized, is too strong and must convey a personal idea'.

28. Pope, *Windsor Forest*, 230. Frances M. Clements ('Lansdowne, Pope, and the Unity of *Windsor Forest*', *Modern Language Quarterly*. 33, 1972, p. 48) detects an allusion ' to Lansdowne's own works, including many poems in praise of James II and his bride Mary d'Esta of Modena, in which both are compared to classical gods', and James himself even to the risen Christ – profanely in Samuel Johnson's opinion (*Lives*, Letchworth, 1925, vol. 2, p. 45).

> So the World's Saviour, like a Mortal drest,
> Altho' by daily Miracles confest,
> Accus'd of Evil-Doctrine by the *Jews*
> Their rightful Lord they impiously refuse;
> But when they saw such Terror in the Skies,
> The Temple rent, their King in Glory rise,
> Dread and Amazement seiz'd the trembling Crowd,
> Who, conscious of their Crime, adoring bow'd.
> ('To the King; in the First Year of His Majesty's Reign', *Poems upon Several Occasions,* London, 1712, p. 9)

Lansdowne, the dedicatee of *Windsor Forest*, had pronounced Jacobite leanings, and a pronounced taste, too, as these lines likewise show, for Waller, though not quite, perhaps, his address. Hobbes's idea of 'a *Mortall God*' is notably different!

18: **Peace and Plenty and Julian the Apostate.**

1. 'In 1699, Antonio Verrio, the leading decorative painter of the two previous monarchs returned to the royal service tp paint the King's Staircase and two ceilings on the King's side.' (Kerry Downes, *The Architecture of Wren*, Granada Publishing, London/Toronto/Sydney/NY, 1982, p.101).

2. Pope, *Epistle to Burlington*, 145-148.

3. Pomey, *The Pantheon*, 'Made English by J.A.B., M.A.', London, 1694, Garland facsimile, NY./London, 1976, p. 220.

4. ibid., p. 216.

5. Carew, 'A Song', *The Poems of Thomas Carew*, edited with an introduction by Rhodes Dunlap, Oxford, 1964, p. 102.

6. Ross, *Mystagogus Poeticus*, London, 1648, pp. 374-375.

7. Camden, *Britannia*, London, 1695, columns 264, 265.

8. Camden, *Britain*, translated by Philemon Holland, London, 1637, p. 367.

9. Camden, *Britannia*, 1695, col. 265.

10. Pomey, *Pantheon*, p. 218.

11. Bolzani, *Les Hieroglyphiques*, translated by I. De Montlyard, Lyon, 1615, p. 632.

12. Pomey, *Pantheon*, p. 219.

13. See, e.g., Frances A. Yates, *Astraea*, Harmondsworth, 1977, p. 29f.

14. Virgil, *Eclogues* 4.6, *The Works of Virgil*, translated by John Dryden, with an introduction by James Kinsley, Oxford, 1961, p. 17.

15. Ross, *Mystagogus Poeticus*, p. 374.

16. Hesiod, *Theogony*, 969f.

17. Hopper, *Medieval Number Symbolism*, NY., 1938, pp. 101, 178, 198, 199.

18. Cirlot, *Dictionary of Symbols*, translated by Jack Sage, London, 1962, p. 223.

19. Ross, *Mystagogus Poeticus*, p. 373.

20. Wind, 'Julian the Apostate at Hampton Court', *The Journal of the Warburg and Courtauld Institutes*, 3, 1939-40, p. 128.

21. Marvell, *The Rehearsal Transpros'd*, Smith, p. 295f.

22. Spanheim, *Les Césars de l'Empereur Julien*, Heidleberg, 1660, sig. (I)2r.

23. Burnet, *History of His Own Time,* Oxford, 1823, vol. 2, pp. 388-389.

24. Spanheim, *Les Césars*, Paris, 1683, sig. eiv.

25. Burnet, *History of His Own Time*, 1823, vol. 3, p. 232.

26. He was born in 1652 (d. 1716), the son of Jehan le Pautre (Paultre), 1618-1682, who had a younger brother of the same name, father of Pierre Lepautre, the sculptor (d. 1744). See François Souchal, *French Sculptors of the Seventeenth and Eighteenth Centuries*, Oxford (Cassirer), 1981, vol. 2. The Lepautre family tree is printed out on the end-papers.

27. T.E. Clark and H.C. Foxcroft, *A Life of Gilbert Burnet*, Cambridge, 1907, p. 565.

28. Spanheim, *Relation de la Cour de France en 1690 . . . suivie de la Relation de la Cour d'Angleterre en 1704*, edited by Emile Bourgeois, *Annales de l'Université de Lyon*, NS II, Droit, Lettres, Fascicule 5, Paris/Lyon, 1900, p. 594 and Introduction, p. 17.

29. Spanheim, *Les Césars*, sig. eeiiir, and *Juliani Imp. Opera*, 1696, sig. f1v-f2r.

30. 'Philaretus Anthropolita', *Some Seasonable Remarks*, London, 1681, p. 2.

31. ibid., pp. 17-18.

32. ibid., p. 14.

33. ibid., p. 13

34. ibid., pp. 17, 18-19.

35. Spanheim, *Relation de la Cour de France*, Introduction, p. 21.

36. Spanheim, *Les Césars*, 1683, sig, āār.

37. Burnet, *A Sermon preach'd before the Queen*, 16 July, 1690, London, 1690, pp. 22-23.

38. Fielding, *A Journey from This World to the Next*, introduced by Claude Rawson, London, 1973, p. 44.

39. Marvell, *The Rehearsal Transpros'd*, p. 283.

40. Hickes, *Jovian, or an Answer to Julian the Apostate*, London, 1683 p. 1.

41. ibid., p. 53.

42. Johnson, *Works*, London, 1710, p. ix.

43. Wind, 'Julian the Apostate at Hampton Court', p. 131.

44. Johnson, *Works,* p. x.

45. Spanheim, *Les Césars*, p. 138.

46. Wind, 'Julian the Apostate at Hampton Court', p. 129.

19: 'Saturnian Times'

1. Spanheim, *Les Césars*, pp. 18-19.

2. Prior, *Carmen Saeculare*, 1700, p. 13. Cf. *Carmen Seculare*, in *Poems on Several Occasions*, 1709, p. 155 (st. 25).

3. See *The History of the King's Works*, edited by H.M. Colvin, vol. 5, London, 1976, p. 169.

4. Prior, *Carmen Seculare*, st. 24, *Poems*, 1709, p. 154.

5. Peck, *Desiderata Curiosa*, London, 1732-35, vol. 1, lib. 6, p. 43.

6. Florio, *Queen Anna's New World of Words*, London, 1611.

7. See *Wren Society Publications* , vol. 4, 1927, 'Hampton Court Palace', edited by Arthur T.

Bolton and H. Duncan Hendry, p. 76.

8. Virgil, *Works*, translated by John Ogilby, London, 1654, p. 20.

9. Wind, 'Julian the Apostate at Hampton Court', p, 129, n. 4.

10. Bickham, *Deliciae*, 1742, p. 23.

11. Anon., *Apelles Britannicus*, 1741? p. 3.

12. Bickham, *Deliciae*, p. 24, *Apelles*, p. 3.

13. Virgil, *Eclogues*, 4.11. The translation is Dryden's.

14. Ogilby's note, Virgil, *Works*, 1654, p. 20.

15. Bickham *Deliciae*, p. 24.

16. Spanheim, *Les Césars*, p. 38.

17. Wind, op. cit., p. 130, n. 1. Weinbrot, *Augustus Caesar in 'Augustan' England*, p. 62.

18. Spanheim, *Les Césars*, p. 275.

19. ibid., pp. 52-53.

20. Bickham, *Deliciae*, pp. 24-25.

21. Suetonius, *History of Twelve Caesars*, translated by Philemon Holland, with an introduction by Charles Whibley, London, 1889, vol. 2, p. 85.

22. Spanheim, *Les Césars*, p. 59.

23. ibid., p. 355.

24. Mirimonde, 'Les Concerts des Muses', *Gazette des Beaux-Arts*, 63, 1964, p. 140.

25. Quoted by Richard T. Pinnell, *Francesco Corbetta and the Baroque Guitar*, vol. 1, UMI Research Press, Michigan, 1980, p. 137. What follows draws heavily on his account, especially pp. 137-139.

26. Hamilton, *Mémoires du Comte de Grammont*, présentation par Philippe Daudy, Paris, 1965, p. 151.

27. Besides Mirimonde, op. cit., see Henry Bardon, *Le Festin des Dieux*, Paris, 1960, and Emanuel Winternitz, *Musical Instruments and their Symbolism in Western Art*, New Haven/ London, 1979.

28. Pinnell, *Francesco Corbetta*, p. 138.

29. Spanheim, *Les Césars*, pp. 60-61, 62.

30. Juvenal, *Satires*, 8, 213-214.

31. Euripides, *Andromache*, 693f.

32. Macaulay, *The History of England from the Accession of James II*, edited by C.H. Firth, London, 1914, vol. 4, p. 1882.

33. Burnet, *A Sermon Preached at the Coronation of William III and Mary II*, London, 1689, pp. 24, 26-27.

34. Burnet, *A Sermon Preached at White-Hall, 26th November, 1691. Being the Thanksgiving-Day for the Preservation of the King and the Reduction of Ireland*, London, 1691, p. 25.

35. Burnet, *A Sermon preach'd before the King, at Whitehall, 2nd December, 1697*, second edition, London, 1698, p. 19; Spanheim, *Les Césars*, p. 87.

36. Burnet, Letter to Philip van Limborch, quoted in T.E. Clarke and H.C. Foxcroft, *A Life of Gilbert Burnet*, p. 355.

37. See Erwin Panofsky, *Studies in Iconology*, NY., 1962, p. 208f.

38. Spanheim, *Les Césars*, pp. 305-306.

39. 'Philaretus Anthropolita', *Some Seasonable Remarks*, p. 19.

40. Spanheim, *Les Césars*, p. 311.

41. See Wind, 'Julian the Apostate at Hampton Court', p.132, n. 2: 'The passage in question (336B) which, according to modern editions (cf. Loeb Library) is supposed to be spoken by Jesus himself, was attributed in the 17th century editions to Constantius, the son of Constantine, υἱος being read for 'Ιησοῦς.'

42. Spanheim, *Les Césars*, sig, aaʳ.

43. See Rudolf Wittkower, 'The Vicissitudes of a Dynastic Monument', *Studies in the Baroque*, Over Wallop, Hampshire, 1982, p. 86.

44. Dryden, *Britannia Rediviva*, 89-90, *Poems and Fables*, p. 427.

45. Hall, *An Holy Panegyrick*, London, 1613, pp. 80-81.Cf. Parry, *The Golden Age Restor'd*, Manchester, 1981, pp. 234-235. Parry quotes from *Works*, 1627, which may help to

explain his assertion that 'the death of Prince Henry is not touched on' in Hall's tactfully positive summary of the reign. It certainly is in the 1613 text, see pp. 95-98.

46. Blackmore, *King Arthur*, London, 1697, p. 246.
47. Whittel, *Constantinus Redivivus*, London, 1693, p. 1.
48. Burnet, *A Sermon preach'd before the Queen,* 16 July, 1690, p 22.
49. Burnet, *A Sermon preached before the King and Queen,* 19 October, 1690, London, 1690, pp. 13, 15-16.
50. Fleming, *A Practical Discourse, Occasion'd by the Death of King William*, 2nd edition, corrected, London, 1703, p. 125.
51. Burnet, *A Sermon preached at the Coronation of William III and Mary II*, London, 1689, pp. 24-25.
52. Robert South, 'A Sermon preached upon Prov. X. 9. At Westminster Abbey, 1667', *Sermons*, London, 1727, vol. 2, p. 38.

20: **More than Conqueror**

1. Spanheim, *Les Césars*, pp. 143-144.
2. ibid., 46-47.
3. ibid., 77-78.
4. Bickham, *Deliciae Britannicae*, p. 29 and *Misopogon* 338C in *The Works of the Emperor Julian*, with an English translation by Wilmer Cave Wright, Loeb, London/NY., 1913, vol. 2, p. 423.
5. Marcus Aurelius Antoninus, *The Golden Book of Marcus Aurelius*, translated by Meric Casaubon, 1634, introduced by W.H.D. Rouse, London, 1906, p. 112.
6. Brown, P., *The World of Late Antiquity*, London, 1991, p. 51.
7. Macaulay, *History of England*, 1914, vol. 5, p. 2306.
8. Burnet, *A Pastoral Letter writ by the Right Reverend Father in God, Gilbert, Lord Bishop of Sarum,* London. 1689, p. 21.
9. Anon., *The Pastoral Letter Reburnt*, broadside, London, 1693.
10. Howard Nenner's description: for a fuller account, see his *The Right to be King: The Succession to the Crown of England, 1603-1714,* Basingstoke/London, 1995, p. 202f.
11. Burnet, *A Sermon*, 23 December, 1688, London, 1689, p. 167.
12. Temple, *An Introduction to the History of England*, London, 1695, p. 144.
13. Wasserman, *The Subtler Language*, Baltimore, 1964, p. 116.
14. Pope, *Windsor Forest,* 63.
15. William L. Sachse, *Lord Somers: A Political Portrait*, Manchester, 1975, p. 90.
16. Pope, *Windsor Forest*, 61.
17. These phrases are culled from lines preserved in the 1712 MS. of the poem, but subsequently suppressed as too politically sensitive. See Pope, *Poems*, edited by John Butt, p. 198, n. on *Windsor Forest*, 91.
18. Pope, *Windsor Forest*, 53.
19. ibid., 55, 60.
20. Temple, *An Introduction to the History of England*, pp. 182-183.
21. ibid., pp. 183-184.
22. ibid., pp. 237-240 (sic, the numbers 238, 239 being omitted).
23. ibid., p. 173.
24. ibid., pp. 210-211.
25. ibid., pp. 148-149, 225.
26. ibid., pp. 177, 173, 140.
27. ibid., p. 144.
28. ibid., pp. 136-137.
29. Waller, *Panegyrick*, 77-78.
30. Raleigh, *The History of the World*, London, 1614, pt 1, bk 4, ch. 2, section 23, pp. 211-212.

21: **A King Divine by Law and Sense**

1. *Herodian of Alexandria, His History of Twenty Roman Caesars and Emperors (of his Time)*, translated by James Maxwell, London, 1629, Bk 1, pp. 7, 8.
2. Burnet, *A Sermon,* 2 December, 1697, London, 1698, pp. 19, 20.
3. Walpole, *Anecdotes of Painting in England*, London, 1879, p. 236.
4. ibid., 239.
5. Michael Baxandall, *Painting and Experience in Fifteenth Century Italy,* Oxford, 1974, pp. 11, 15.
6. Wind, 'Julian the Apostate at Hampton Court', pp. 127, 135.
7. *Apelles Britannicus*, p. 3.
8. ibid., p. 4.
9. Holland, *The Romane Historie*, 1609, p. 52.
10. Spanheim, *Les Césars*,pp. 275-276.
11. See Chapter 13 above.
12. Hobbes, *Leviathan*, pt 4, ch. 45, ed. cit., p. 361.
13. Shadwell, *A Congratulatory Poem*, London, 1689, p. 7.
14. Spanheim, *Les Césars*, sig. aaivv.
15. *An Epistle to Mr. Dryden*, broadside, Exeter, November 5, 1688. See Chapter 17 above.
16. Jonson, *Sejanus*, 5. 451.
17. Spanheim, *Les Césars*, p. 33.
18. Snell, *The Discovery of the Mind*, translated by T.G. Rosenmeyer, Oxford, 1953, pp. 292-293.
19. John, 18.36.
20. See Benjamin Hoadly, *The Nature of the Kingdom, or Church of Christ*, London, 1717, and Pope, *Dunciad*, 3. 400.
21. Erasmus, *The Praise of Folly*, translated by John Wilson, edited with an introduction by Mrs P.S. Allen, Oxford, 1913, p. 46.
22. Roy Strong, *Britannia Triumphans: Inigo Jones, Rubens and Whitehall Palace*, Over Wallop, Hampshire, 1980, p. 52f.
23. Susan Saward notes this figure's appearance in 'scenes of imperial apotheosis in the later part of the Roman Empire' while discussing Rubens's depiction of the apotheosis of Henri IV of France in *The Golden Age of Marie de' Medici*, Epping, 1982, p. 100. See also her plates 61, 62 and 63.
24. Rymer, *A Poem on the Arrival of Queen Mary*, p. 4.

22: **'Cette Folle Vanité d'Alexandre'**

1. Roy Strong, *Splendour at Court*, London, 1973, p. 101.
2. Calvete De Estrella, *El Felicissimo Viaie*, Antwerp, 1552, p. 144b (sig. Aaviv).
3. John, 10.1.
4. Calvete De Estrella, loc. cit.
5. Strong, op. cit., p. 103.
6. Calvete De Estrella, op. cit., 146b (sig. Bbiiv).
7. Bolton and Hendry, 'Hampton Court Palace', *Wren Society Publications*, 4, 1927, p. 59.
8. James I, King, *A Defence of the Right of Kings*, in *The Political Works of James I*. With an introduction by Charles Howard McIlwain, Cambridge, Mass., 1918, p. 255. See also p. 97f.
9. James I, *Political Works*, p. 12.
10. Pope, *Dunciad*, 4. 188.
11. James I, *A Speech to the Lords and Commons of the Parliament*, 21 March, 1609, *Political Works*, p. 307.
12. Robert Burton (Nathaniel Crouch), *The History of the House of Orange*, London, 1693, p. 147.
13. Spanheim, *Les Césars*, p. 261, note b.
14. ibid., loc. cit.

15. Anon., *A Brief Display of the French Counsels*, London, 1694, p. 84.
16. Whittel, *Constantinus Redivivus*, London, 1693, pp. 98-99, 94-95.
17. Wither, *The British Appeals*, 1651, p. 11.
18. 'D.J.', *King Charles I. no such Saint*, etc., London, 1698, pp. 7-8.
19. ibid., p. 27.
20. ibid., p. 2. Cf. Milton, *Eikonoklastes*, London, 1650, sig. B1ʳ.
21. See Clark and Foxcroft, *Life of Burnet*, 1907, p. 524.
22. Burnet, *The Royal Martyr Lamented*, London, 1689, p. 6.
23. Burnet, *History of His Own Time*, 1823, vol. 1, pp. 86-88.
24. Burnet, *The Royal Martyr Lamented*, 1689, pp. 27-28.
25. Burnet, *A Sermon,* 31 January, 1688/9, London, 1689, p. 31 and Marvell, *An Horatian Ode*, 52f.
26. Burnet, *A Sermon*, 30 January, 1680/1, London, 1681, pp. 29-30.
27. ibid., p. 19.
28. ibid., p. 2.
29. ibid., p. 7.
30. Burnet, *A Sermon*, 26 November, 1691, London, 1691, p. 5.
31 Julius Capitolinus, *Scriptores Historiae Augustae*, Loeb, London/Cambridge, Mass., 1967, vol. 1, p. 177. English translation by David Magie.
32. Shaftesbury, 'A Letter Concerning Enthusiasm', *Characteristics*, edited by J.M. Robertson, 1964, vol. 1, p. 19.
33. Larthomas, 'Julien en Angleterre', in *L'Empereur Julien*, edited by Jean Richer, vol. 2, *De la Légende au mythe*, Paris, 1981, p. 63.
34. ibid., p. 65.
35. Edward Gibbon, *The History of the Decline and Fall of the Roman Empire*, edited by David Womersley, Harmondsworth, 1994, vol. 1, p. 910, n. 4.
36. Julianus, *Letter to Themistius,* in *Works*, Loeb, vol. 2, p. 231.
37. Spanheim, *Les Césars*, p. 118.
38. Larthomas, 'Julien en Angleterre', p. 65.
39. ibid., p. 64.
40. DNB., Oxford, 1975, vol. 2, p. 2155.
41. Bickham, *Deliciae*, p. 29.

23: **Funeral Bak'd Meats and Gendres de Mérite**

1. Virgil, *Aeneid,* 6. 124,Ogilby, *The Works*, 1654, p. 332.
2. Dryden, *Aeneid,* 6, 1079-1081, Folio Society, London, 1993, p. 186.
3. ibid., 6, 1077-1102, p. 186.
4. Virgil, *Aeneid* 6. 792.
5. Spanheim, *Les Césars*, p. 276.
6. See Charles Paul Segal, '*Aeternum Per Saecula Nomen*: The golden Bough and the Tragedy of History', *Arion* 4, 1965, p. 620.
7. Virgil, *Aeneidos Liber Sextus*, with a commentary by R.G. Austin, Oxford, Oxford, 1977, p. 102. Note on 212-235.
8. Dryden, *Aeneid*, 6. 1206-1209, Folio Society, p. 189.
9. Propertius, *The Elegies*, edited and translated by G.P. Goold, Loeb, Cambridge, Mass./ London, 1990, 3. 18. 1-4.
10. Mary II, *Memoirs of Queen Mary of England*, pp. 45-46.
11. The Latin is from George Oxenden's contribution to *Threnodia Cantabrigiensis in Immaturum Obitum Illustrissimi ac Desideratissimi Principis Gulielmi Duci Gloucestrensis*, Cambridge, 1700, sig. C2ᵛ. At least four other poets in this collection allude to Marcellus, and seven in *Exequiae Desideratissimo Principi Gulielmo Gloucestriae Duci Ab Oxoniensi Academia Solutae*, Oxford, 1700.
12. Evelyn, *Diary* edited by E.S. de Beer, London, 1959, p.1057. Hester W. Chapman, *Queen Anne's Son,* London, 1954, p.142.

13. Myers, *Dryden*, London, 1973, p. 162.
14. Levi, introduction to Dryden, *Aeneid*, Folio Society, p. xiv.
15. Dryden, *The Letters*, collected and edited by Charles Ward, Durham, North Carolina, 1952, p. 93.
16. ibid., p. 94.
17. Swift, *A Tale of a Tub, to which is added The Battle of the Books and the Mechanical Operation of the Spirit*, edited by A.C. Guthkelch and D. Nichol Smith, Oxford, 1958, pp. 246-247.
18. Shakespeare, *Hamlet*, 3. 4. 53, 64-66.
19. Hall, *Of Government and Obedience*, p. 195.
20. Fuller, *David's Hainous Sinne*, 1631, *The Poems and Translations in Verse*, edited with an introduction and notes by Alexander Grosart, Edinburgh, 1868, pp. 37-90.
21. Dryden, *Aeneid*, 6. 269-70, Folio Society, p. 163.
22. ibid., 4. 712, p. 112.
23. ibid., 6. 229, p. 161.
24. ibid., 4. 698, 711, p. 112.
25. Spenser, *The Faerie Quene*, bk. 1, canto 4, st. 9.
26. Dryden, 'Dedication of the *Aeneis*', *Essays*, Ker, vol. 2, p. 188.
27. ibid., p. 171.
28. ibid., pp. 174-175.
29. David Bywaters, *Dryden in Revolutionary England*, Berkeley/Los Angeles/Oxford, 1991, pp. 152-153. See also Ker, vol. 2, p. 177.
30. Bywaters, op. cit., pp. 154-155.
31. Dryden, *Aeneid*, 6, 332, Folio Society, p.164.
32. Psalms, 51.15 ('Authorized' Version), 50.19 (Vulgate).
33. Fulgentius, *Fulgentius the Mythographer (The mythologies, The exposition of the contents of Virgil*, etc.), translated from the Latin, with introductions, by Leslie George Whitbread, Ohio State U.P., 1971, p. 128, and Fabius Planciades Fulgentius, *Opera*, edited by Rudolfus Helm, Stutgardiae, 1970, p. 96.
34. Pope, *Epistle to Burlington*, 145-146,
35. ibid., 147-148.
36. Bickham, *Deliciae*, p. 23. An improvement upon 'riding on a Swan', (*Apelles Britannicus*, p. 3), but still not accurate. 'Cupid riding upon another' is a repeated mistake.
37. Croft-Murray, *Decorative Painting in England,1537-1837*, vol. 1, London, 1962, p. 59.
38. The painter's eldest son, John Baptist, served as a captain in James's army in Ireland and was made prisoner at Drogheda in 1690, but released almost immediately at William III's special intervention. The order to release him calls him 'son to him that painted Windsor Castle' (Croft-Murray, op. cit., p. 57).
39. Locke, *A Third Letter for Toleration*, London, 1692, p. 295.
40. Spanheim, *Les Césars*, pp. 88-89.
41. *History of my own Time* vol. 2, Oxford, 1900, p. 281.
42. ibid., pp. 281-282.
43. Spanheim, *Les Césars*, p. 88, notes.
44. Rochester, 'A Satyr on Charles II', 4, *Complete Poems*, p. 60.
45. Spanheim, *Les Césars*, loc. cit.
46. William Wycherley, *The Plain Dealer*, 1.1, *The Complete Plays*, edited by Gerald Weales, NY., 1967, p. 390.

24: **Retouchings**

1. Robert Smith, Upon the Late Loss of the Queen, *Poems on the Death of Her most excellent Majesty Queen Mary*, by J. Rawson and Robert Smith, London, 1695, p. 8.
2. Tate, *Mausolaeum*, London, 1695, p. 15.
3. Nenner, *The Right to be King*, p. 193.
4. A precedent for inserting such an aerial figure at a 'Feast of the Gods' might be found in Joachim Wttewael's painting *The Wedding of Peleus and Thetis* (1602), though the

circumstances are hardly comparable. Henry Bardon, in *Le Festin des Dieux*, also makes much of Wttewael's voluminous cloud-architecture, derived from Goltzius's famous engraving of Bartholomeus Spranger's *The Wedding of Cupid and Psyche*. Verrio's bridge or staircase of cloud on the back wall may also owe something to this design. Le Pautre's efforts are nothing so massively tumescent. Of course, if Verrio was, indeed, a pupil of Pietro da Cortona (see Croft-Murray, p. 51) he could have learnt a thing or two about painting clouds from him.

5. Pope, *Windsor Forest*, 326-327.

6. Dryden, *Absalom and Achitophel*, 1026-1031.

7. Poggioli, *The Oaten Flute*, Cambridge, Mass., 1975, p. 41.

8. *Eclogues* 4.15-16, Poggioli's translation, op. cit., p. 114.

9. Poggioli, op. cit., p. 112.

10. Spanheim, *Les Césars*, p. 43.

11. ibid., pp. 276-277.

12. ibid., p. 278.

13. Clausen, *A Commentary on Virgil, 'Eclogues'*, Oxford, 1994, pp. 122-123.

14. 'D.J.', *King Charles I. no such Saint*, etc., London, 1698, p. 2.

15. Lodovico Ariosto, *Orlando Furioso*, translated by Sir John Harrington, 1591, 'The Fifteenth Booke', st. 16, Amsterdam/NY., 1970 (The English Experience, facsimile no. 259). The Italian is from *Orlando Furioso*, edited by Santorre Debendetti and Cesare Segre, Bologna, 1960, canto 15, st. 26.

16. Yates, *Astraea*, p. 22.

17. Marcus Aurelius Antoninus, *The Golden Book of Marcus Aurelius*, 1906, pp. 63-64.

18. Bacon, *Essays*, edited by John Pitcher, Harmondsworth, 1985, p. 209.

19. Nenner, *The Right to be King*, p. 248.

20. See, e.g., Raymond Crawfurd, *The King's Evil*, Oxford, 1911, p. 138.

21. Voltaire, *Le Siècle de Louis XIV*, edited by Antoine Adam, Paris, 1966, vol. 1, p. 185.

22. John Browne, *Adenchoiradelogia,* London, 1684, sig. (d)6v.

23. Helen Farquhar, 'Royal Charities, Part 3: Touchpieces for the King's Evil, James II. to William III.', *British Numismatic Journal*, Second Series, 4, 1920, p. 120.

24. Blackmore, *Discourses on the Gout, Rheumatism, and the King's Evil*, London, 1726, p. lx.

25. William Beckett, *A Free and Impartial Enquiry into the Antiquity and Efficacy of Touching for the Cure of the King's Evil*, London, 1722, quoting from John Bird's *Ostenta Carolina*, 1661.

26. William Nisbet, *An Inquiry into the History, Nature, Causes, and Different Modesof Treatment Hitherto Pursued, in the Cure of Scrofula and Cancer*, Edinburgh, 1795, p. 62.

27. Farquhar, op. cit., p. 104.

28. Blackmore, *Discourses*, p. lxvi.

29. Dryden, *The Hind and the Panther*, Part I, 126-127.

30. Browne, *Adenchoiradelogia*, Book 3, pp. 80-81.

31. Locke, *Two Treatises*, Introduction, p. 83.

32. Filmer, *Patriarcha*, etc., Introduction, p. 42.

33. Dryden, *Absalom and Achitophel*, 766.

34. T.A. Marder, *Bernini's Scala Regia at the Vatican Palace*, Cambridge, 1997, p. 179.

35. ibid., p. 250.

36. ibid., p. 224.

37. ibid., p. 197

38. ibid., p. 249.

39. Wind, *Hume and the Heroic Portrait*, edited by Jayne Anderson, Oxford, 1986, p. 61.

40. Burnet (trans.), More, *Utopia*, London, 1684, pp. 40-41.

41. Erasmus, *The Praise of Folly*, translated by Betty Radice, Harmondsworth, 1971, p. 98.

42. Marder, op. cit., p. 198.

43. Prior to Van Kepple, 1 March (NS), and Prior to Charles Montague, 18 February (NS), 1698, *Calendar of the Manuscripts of the Marquis of Bath, preserved at Longleat*, vol. 3 *(Prior Papers)*, Historical Manuscripts Commission, Hereford, 1908, pp. 195, 192.

44. Lees-Milne, *English Country Houses: Baroque, 1685-1715*, Woodbridge, Suffolk, 1970, pp. 9-10.

45. Wind, 'Julian the Apostate at Hampton Court', p. 129.

46. Hersey, *Architecture, Poetry and Number in the Royal Palace at Caserta*, MIT Press, Cambridge Mass./London, 1983, pp. 45, 46.

47. ibid., p. 4.

48. See John Bold, *John Webb: Achitectural Theory and Practice in the Seventeenth Century*, Oxford, 1989, p. 107f.

49. Summerson, *Inigo Jones*, Harmondsworth, 1966, p. 134.

50. Taylor, 'Architecture and Magic', in *Essays in the History of Architecture presented to Rudolf Wittkower*, edited by Douglas Fraser, Howard Hibbard and Milton J. Lewine, London, 1967, p. 89.

51. Sir Philip Sidney's phrase in *An Apology for Poetry* (*Elizabethan Critical Essays*, edited by G. Gregory Smith, Oxford, 1904 vol. 1, p. 157) succinctly sums up what Taylor means here by *'Idea'*.

52. Bold, *John Webb*, p. 111f.

53. Cesare Ripa, *Iconologia*, Padua, 1611, assigns 'tre libri' to Calliope: the *Odyssey, Iliad* and *Aeneid*. As Guy de Tervarent notes, after about 1500, the attributes of the Muses 'varient et sont donc d'un médiocre secours pour l'identification ('Attributs et Symboles dans l'Art Profane, 1450-1600', col. 281, *Travaux d'Humanisme et Renaissance*, 29, Genève, 1958 [Tome 1], 1959 [Tome 2], 1964 [Supplément et Index]). However, the 'Nomina Musarum' – twelve verses once attributed to Virgil, the eighth of which runs 'carmina Calliope libris heroica mandat' – often results in a book or books being given to her. The fourth verse – 'Melpomene tragico proclamat maestu boatu' – will also, perhaps (through association of *boatus*, 'outcry, bellowing, roaring', with *bos*, 'bull, cow') account for her horn-playing companion. *Boa*, moreover, is 'a [milk-sucking? Ox-swallowing?] serpent', and the Muse in question, looking suitably intense and dressed in tragic black (Ripa, p. 519), winds what appears to be a cross between a 'corno torto' (great cornett) and a serpent. Euterpe plays her usual (transverse) flute. There is another flautist, this time with an end-blown pipe, below – possibly Erato sometimes so equipped (Tervarent, col. 280). Flutes are erotic, and 'Erato, è detta dalla voce Greca ἔϱος, significante amore' (Ripa, p. 370). Her head is fetchingly inclined, dress seductively off-the-shoulder. Immediately in front, a well-covered but largely unclad sister bows (underhand) a 'cello or bass viol: Terpsichore? Across the cloud, beneath Melpomene and company, sits a green-garbed violinist. Thalia, reports Alexander Ross (*Mystagogus Poeticus*, 1648, p. 301), derives from θαλλεῖν, 'to grow green', and she frequently (Tervarent, col. 280) holds a 'petit violon': a 'fiddle' appropriate to the Muse of Comedy. In between, three instrument-less ladies put their heads together. One points heavenwards (at Apollo, with his lyre). The pose is sometimes that of Polyhymnia, but here 'vestimento azzuro' (Ripa, 371) bespeaks Urania. Her gesture, too, is renownedly that of Plato in Raphael's *School of Athens*, where Aristotle, in contrast, reaches horizontally forwards, palm downwards, fingers spread, to indicate more pragmatic interests. Urania's foremost associate makes a not entirely dissimilar movement, suggesting a not entirely dissimilar distinction between things *naturalis* and *moralis*. She must be Clio, the historian, linked to Tragedy and Epic by the line of Melpomene's *cornet à bouquin*, or rather *à bos primigenius*. Both she and Urania look up from papers. The wide-gesturing Polyhymnia, behind – 'signat cuncta manu loquiturque Polymnia gestu', says the 'Nomina' – makes up this threesome, holding the group together.

54. Shaftesbury, 'An Essay on the Freedom of Wit and Humour', *Characteristics*, vol. 1, p. 44.

55. O'Malley, Review of Paolo Prodi, *Il Sovrano Pontifice*, Bologna, 1982, in *The American Historical Review*, 88, 1983, p. 1017. Quoted by Marder, *Bernini's Scala Regia*, p. 302, n. 196.

56. Burton, op. cit., 1693, p. 147. See Chapter 22, above.

57. Shaftesbury, 'Miscellaneous Reflections', *Characteristics*, vol. 2, pp. 210-212

58. Burnet, *Sermon*, 16 July, 1690, London, 1690, p. 22.

59. Whiston, *Memoirs of the Life and Writings*, London, 1753, p. 135.

60. Katharine Gibson, 'The decoration of St George's Hall, Windsor, for Charles II', *Apollo*,

vol. 147, no. 435 (NS), May, 1998, p. 34, citing E. Croft-Murray, 'A Drawing by Charles le Brun for the Passage du Rhin in the Grande Galerie at Versailles', *British Museum Quarterly*, 19, 1954, pp. 58-60.

61. Defoe, *The True Born Englishman,* 1710, p. 17.
62. The first line of 'The History *of Insipids*: A Lampoon, 1676', in fact by John Freke but once attributed to Rochester. Text from John Wilmot', Earl of Rochester, *Poems*, edited by V. De Sola Pinto, 2nd edition, London, 1964, p. 107.
63. Gibson, op. cit., p. 35.
64. Ashmole, *The Antiquities of Berkshire*, London, 1719, vol. 3, p. 117.
65. Picinelli, *Mundus Symbolicus*, edited by August Erath, Cologne, 1694, Garland Facsimile, NY./London, 1976, vol. 1, p. 281.
66. Spark, 'Aula Vindesoriae', *Musarum Anglicanae,* Oxford, 1699, vol. 2, p. 71.
67. Ashmole, *The Antiquities of Berkshire*, vol. 3, p. 118.

25: 'Image Government'

1. See Chapter 6, p. 49 above.
2. Aspinwall, *The Legislative Power is Christ's Peculiar Prerogative*, London, 1656, p. 16.
3. ibid., pp. 12-13.
4. ibid., p. 19.
5. Marvell, *First Anniversary*, 244.
6. See Carlyle, *Cromwell's Letters and Speeches*, 1850, vol. 4, pp. 302-303. He is quoting Whitelocke's *An exact Relation of the Manner of the solemn Investiture, &c.*
7. See P.R. Wikelund, 'Edmund Waller's Fitt of Versifying', *Philological Quarterly,* 49, 1970, p. 89, where he speculates that the 'coda' may have been appended 'under the urgent stimulus of politcal circumstances between 1656 and 1658'. It was naturally retained by Carrington, whose text of *Upon the present War* is the source of the quotations here (*History*, 1659, p. 199). Equally naturally it was omitted from post-Restoration editions of Waller's poems published during his lifetime, as Thorn Drury notes, *Poems*, 1905, vol. 2, p. 27.
8. Crouch, *A Mixt Poem*, London, 1660, p. 8.
9. Cowley, *A Discourse by Way of Vision, Essays, Plays and Sundry Verses*, 1906, p. 342.
10. Daniel, 2.32-33, 'Authorized' Version.
11. Aspinwall, *The Legislative Power*, pp. 11, 41.
12. ibid., pp. 33-34, 50.
13. Crouch, *A Mixt Poem*, pp. 1-2, sig, A2ᵛ. The other two 'Seraphims' are Cowley and Martin Llewellyn.
14. John Collop, *Itur* [sic] *Satyricum in Loyall Stanzas*, 1660, *Poems*, 1962, p. 163. Jeremy Taylor, *The Great Exemplar of Sanctity and Holy Life* (1649), Pt 1, *Ad* Section 9, *The Whole Works*, London, 1880, vol. 1, p. 97.
15. Marvell, *First Anniversary*, 139.
16. Owen, *Works*, vol. 8, p. 257.
17. Harrington, *The Political Works,* edited by J.G.A. Pocock, Cambridge, 1977. See pp. 358, 321, 207, 337, 323.
18. ibid., p. 155.
19. ibid., p. 207.
20. Hobbes, *Leviathan*, pt 1, ch. 11, p. 49.
21. Harrington, *Political Works*, pp. 88, 401.
22. ibid., p. 338.
23. ibid., p. 209.
24. Had the name been 'Olophaus' the etymology might have been clearer but the pronunciation, perhaps, too suggestive of 'Olophernes'. 'Megaletor' signifies 'great hearted'.
25. Harrington, *Political Works*, p. 210.
26. ibid., pp. 210-211, 341.
27. ibid., p. 178.

28. ibid., p. 338.
29. ibid., p. 161.
30. Cf. Harrington, *The Prerogative of Popular Government*, ch. 2, *Political Works*, p. 401f.
31. Harrington, *Political Works*, p. 205.
32. ibid., p. 343.
33. ibid., p. 339.
34. ibid., p. 287.
35. Holstun, *A Rational Millennium*, NY/Oxford, 1987, p. 229.
36. Harrington, *Political Works*, p. 342.
37. ibid., p. 348.
38. ibid., p. 351.
39. Matthew Wren, *Considerations on Mr. Harrington's Commonwealth of Oceana*, London, 1657, p. 8.
40. 'Entring Book', Dr Williams's Library, MS. 31 Q, vol. 2, p. 393, quoted by Howard Nenner, *By Colour of Law*, p. 197.
41. Harrington, *The Art of Lawgiving*, *Political Works*, p. 683.
42. Harrington, *Political Works*, p. 352.
43. Stubbe, *A Further JustificatI*, 1673, sig. C3r.
44. Wren, *Monarchy Asserted or the State of Monarchicall & Popular Government in Vindication of the Considerations upon Mr. Harrington's OCEANA*, London, 1659, pp. 171-172.
45. Baxter, *A Holy Commonwealth, or Political Aphorisms, opening the Principles of Government*, London, 1659, p. 266.
46. ibid., p. 232.
47. Harrington, *Political Works*, 264.
48. Holstun, *A Rational Millennium*, p. 197.
49. Harrington, *The Political Works*, p. 69.
50. ibid., p. 143.
51. Wren, *Monarchy Asserted*, p. 97.
52. Harrington, *Political Works*, pp. 698, 700.
53. Holstun, pp. 227-228.
54. Harrington, *Political Works*, p. 228.
55. Sir Thomas Browne, *Christian Morals*, Pt 3, section 24, *Works*, edited by Charles Sayle, Edinburgh, 1927, vol. 3, p. 504.
56. Harrington, *Political Works*, p. 287.
57. Behn, *A Congratulatory Poem to her Most Sacred Majesty*, 58-59, *Works*, vol. 1, p. 295.
58. Dryden, *Britannia Rediviva*, 8-10, *Poems and Fables*, p. 425.
59. Epimonus is a character in *Oceana* who, as his name indicates (ἐπιμονὴ='tarrying, delay', 'staying still'), speaks up with facetious fluency or 'garrulity' against change. In the book he is brushed aside without difficulty.
60. Marvell, *The last Instructions to a Painter*, 26, *Poems*, p. 154.
61. See p. 95 above.
62. Harrington, *Political Works*, pp. 321, 17-18.
63. Shaftesbury, 'Advice to an Author', *Characteristics*, 1964, vol. 1, p. 189.
64. See Gerrard Winstanley, *The True Levellers Standard Advanced* (1649), *The Works*, edited by George R. Sabine, Ithaca, NY., 1941, p. 259.

Bibliography

(Anonymous works are listed under the first significant word of their titles.)

Account of Mr. Blunts late Book, entituled, King William and Queen Mary Conquerors, now under the Censure of the Parliament, An, London, 1693.

Allison, A.W., *Toward an Augustan Poetic: Edmund Waller's 'Reform' of English Poetry'*, Lexington (Kentucky U.P.), 1962.

Ammianus Marcellinus, see Holland, Philemon, below

Anthropopolita, Philaretus, *Some Seasonable Remarks upon the Deplorable Fall of the Emperour Julian, London, 1681.*

Apelles Britannicus, London, 1741?

Apologetick for the Sequestred Clergie of the Church of England, An, 'New Munster, in the year of confusion' (London, 1649?).

Art of Complaisance or the Means to oblige in Conversation, The, London, 1673.

Ariosto, Lodovico, *Orlando Furioso*, edited by Santorre Debendetti and Cesare Segre, Bologna, 1960. See also Harington, Sir John below.

Ashmole, Elias, *The Antiquities of Berkshire*, London, 1719.

Aspinwall, William, *The Legislative Power is Christ's peculiar Prerogative*, London, 1656.

Atterbury, Francis, *A Sermon preach'd before the Honourable House of Commons . . . May 29th, 1701*, London, 1701.

 Some Passages out of Waller, MS. W.A.M. 65018, Westminster Chapterhouse Library.

Bacon, Sir Francis, *The Philosophical Works*, edited by J.M. Robertson, London, 1905.

 Essays, edited by John Pitcher, Harmondsworth, 1985.

Bardon, Henry, *Le Festin des Dieux*, Paris, 1960.

Bartas, Guillaume De Saluste, Sieur Du, *The Divine Weeks and Works*, translated by Joshua Sylvester, edited with an introduction and commentary by Susan Snyder, 2 vols, Oxford, 1979.

Baxandall, Michael, *Painting and Experience in Fifteenth-century Italy*, Oxford, 1974.

Baxter, Richard, *A Holy Commonwealth, or Political Aphorisms, opening the Principles of Government*, London, 1659.

 Poetical Fragments, London, 1681.

 The Saints Everlasting Rest, London, 1652 (first edition, 1650).

Beckett, William, *A Free and Impartial Enquiry into the Antiquity and Efficacy of Touching for the Cure of the King's Evil*, London, 1722.

Beeching, H.C., *Francis Atterbury*, London, 1909.

 Provincial Letters, and Other Papers, London, 1906.

Behn, Aphra, *The Works*, edited by Janet Todd, 7 vols, London, 1992-, vol. 1, Poetry.

Bennett, G.V., *The Tory Crisis in Church and State*, Oxford,1975.

Benson, William, *Virgil's Husbandry, or an Essay on the Georgics: being the First Book translated into English Verse*, London, 1725.

Bible, 'Authorized Version', 1611, reprint, Oxford, 1985.

 'Geneva Version', Tomson NT., Junius *Revelation*, NT. title dated London, 1611, colophon 1612. See A.S. Herbert, *Historical Catalogue of Printed Editons of the English Bible, 1525-1961,* (London/NY, 1968) *no. 312.*

Bickham, George, the Younger, *Deliciae Britannicae*, London, 1742.

Blackmore, Sir Richard, *King Arthur*, London, 1697.

 Discourses on the Gout, Rheumatism, and the King's Evil, London, 1726.

Blunt, Wilfrid, *Tulipomania*, Harmondsworth, 1950.

Bodin, Jean, *Six Bookes of a Commonwealthe*, translated by Richard Knolles, London, 1606.

Bold, John, *John Webb: Architectural Theory and Practice in the Seventeenth Century*, Oxford, 1989.

Boileau-Desprèaux, Nicholas, *Oeuvres Diverses*, Paris, 1675.

Bolzani, G.P.V., *Les Hieroglyphiques,*, translated by I. de Montlyard, Lyon, 1615, Garland facsimile, NY./London, 1976.

Bolton, Arthur T., and H. Duncan Hendry (eds) 'Hampton Court Palace', *Wren Society Publications*, vol. 4., 1927.

Boswell, James, *Life of Johnson*, edited by R.W. Chapman, London, 1953.

Bouhours, Dominique, *The Art of Criticism* (*La Manière de Bien Penser dans les Ouvrages d'Esprit*), translated by 'a Person of Quality', London, 1705.

Boys, Richard C., 'Sir Richard Blackmore and the Wits', *Contributions in Modern Philology*, 13, University of Michigan Press,1949.

Brief Display of the French Counsels, A, London, 1694.

Brooks-Davies, Douglas, *Pope's 'Dunciad' and the Queen of the Night*, Manchester, 1985.

Brown, Peter, *The Procedure, Extent, and Limits of Human Understanding*, London, 1728.

Brown, Peter, *The World of Late Antiquity*, London, 1991.

Browne, John, *Adenochoiradelogia, or an Anatomick-chirurgical Treatise of Glandules & Strumaes, or King's-Evil-Swellings,* London, 1684.

Browne, Sir Thomas, *Christian Morals* in *Works*, edited by Charles Sayle, Edinburgh, 1927, vol. 3.

Brownlow, F.W., *Two Shakespearean Sequences*, London, 1977.

Budick, Sanford, *Poetry of Civilization: Mythopoeic Displacement in the Verse of Milton, Dryden, Pope and Johnson*, New Haven/London, 1974.

Burke, Edmund, *Reflections on the Revolution in France*, with an introduction by A.J. Grieve, Letchworth (Everyman, 460), 1910, reprint, 1955.

Burnet, Gilbert, *The History of My Own Time*, a new edition based on that of M.J. Routh, Part 1, 'The reign of King Charles II', edited by Osmund Airy, 2 vols, Oxford, 1897-1900.

 History of His Own Time, edited by M.J. Routh, 6 vols, Oxford, 1823.

 A Pastoral Letter writ by the Right Reverend Father in God, Gilbert, Lord Bishop of Sarum, London, 1689.

 The Royal Martyr Lamented, a sermon originally preached on King Charles the Martyr's day, 1674/5, reprinted, London,1689.

 A Sermon preached before the Aldermen of the City of London, 30 January, 1680/1, London, 1681.

 A Sermon preached at St. James's, before the Prince of Orange, 23 December, 1688, London, 1689.

 A Sermon preached before the House of Commons, 31 January, 1688/9, London, 1689.

 A Sermon preached at the Coronation of William III and Mary II, April 11, 1689, London, 1689.

 A Sermon preach'd before the Queen, 16 July, 1690, London, 1690.

 A Sermon preached before the King and Queen, 19 October, 1690, London, 1690.

 A Sermon preached at White-Hall, 26 November, 1691, London, 1691.

 A Sermon preach'd before the King, at Whitehall, 2 December, 1697, London, 1698.

 (trans.) Sir Thomas More, *Utopia*, London, 1684.

Burton, Robert (Nathaniel Crouch), *The History of the House of Orange*, London, 1693.

Butler, Samuel, *Hudibras*, edited by John Wilders, Oxford, 1967.

 Satires and Miscellaneous Prose and Poetry, edited by R. Lamar, Cambridge, 1928.

Bywaters, David, *Dryden in Revolutionary England*, Berkeley/LosAngeles, 1991.

Calamy, Edmund, *The Noblemans Patterne of True and Real Thankfulnesse*, London, 1643.

Calendar of State Papers, Domestic (CSDP).

Calvete De Estrella, Juan Christóbal, *El Felicissimo Viaie d'el muy Alto y muy Poderoso Principe Don Phelippe*, Antwerp, 1552.

Camden, William, *Britain, or a Chorographical Description of the most flourishing Kingdomes, England, Scotland, and Ireland, and the Isles adjoyning*, translated by Philemon Holland, London, 1637.

 Britannia, published by Edmund Gibson, London, 1695.

 'Poems by William Camden: with Notes and Translations from the Latin', by George Burke Johnston, *Studies in Philology*, vol. 72, 1975.

Capitolinus, Julius, *Scriptores Historiae Augustae*, with an English translation by David Magie, London/Cambridge, Mass. (Loeb), 1967,

Carew, Thomas, *The Poems*, edited by Rhodes Dunlap, Oxford, 1964.

Carey, Henry, Earl of Monmouh, *Historicall Relations of the United Provinces of Flanders, written originally in Italian by Cardinall Bentivoglio*, London, 1652.

Carlisle, Thomas Merke, Bishop of, *The Bishop of Carlisle's Speech in Parliament, concerning Deposing of Princes*, London, 1679.

Carpenter, Edward, *The Protestant Bishop*, London, 1956.

Carrington, Samuel, *The History of the Life and Death of his Most Serene Highnesse, Oliver, late Lord Protector*, London, 1659.

Cary, Henry (ed.), *Memoirs of the Great Civil War in England*, London, 1842.

Catlin, Zachary, *De Tristibus* (a translation of Ovid's *Tristia ex Ponto*), London, 1639.

Chapman, Hester W., *Queen Anne's Son*, London, 1954.

Charleton, Walter, *A Brief Discourse concerning the Different Wits of Men*, London, 1669.

Chaucer, Geoffrey, *The Works*, edited by F.N. Robinson, second edition London, 1957.

Chernaik, Warren L., *The Poetry of Limitation*, New Haven/London, 1968.

Cicero, Marcus Tullius, *The Oration of Cicero for Marcus Marcellus*, London, 1689.

Cirlot, J.E., *Dictionary of Symbols*, translated by Jack Sage, London, 1962.

Clarendon, Edward Hyde, Earl of, *The History of the Rebellion*, 6 vols, Oxford, 1705-1706. *The Life of Edward Earl of Clarendon*, Oxford, 1759.

Clarendon, Henry Hyde, Earl of, *The Correspondence of Henry Hyde, Earl of Clarendon, and of his Brother Laurence Hyde, Earl of Rochester, with the Diary of Lord Clarendon from 1687 to 1690*, edited by Samuel Weller Singer, 2 vols, London, 1828.

Clarke, T.E., and Foxcroft, H.C., *A Life of Gilbert Burnet*, Cambridge, 1907.

Clausen, Wendell, *A Commentary on Virgil, 'Eclogues'*, Oxford, 1994.

Clements, Frances M., 'Lansdowne, Pope, and the Unity of *Windsor Forest*', *Modern Language Quarterly*, vol. 33, 1972.

Cleveland, John, *The Character of a London Diurnall*, London, 1651. *Majestas Intemerata*, London? 1649.

Coke, Richard, *Justice Vindicated*, London, 1660.

Coleridge, Samuel Taylor, *Biographia Literaria*, edited with his 'Aesthetical Essays' by J.T. Shawcross, 2 vols, Oxford, 1907.

Collop, John, *Poems*, edited by Conrad Hilberry, Madison, 1962.

Colvin, H.M. (ed.), *The History of the King's Works*, vol. 5, London, 1976.

Cook, E., *Argumentum Anti-Normanicum*, 1682, reissue, London, 1689.

Corns, Thomas (ed.), *The Royal Image: Representations of Charles I*, Cambridge, 1999.

Cosin, John, *The Correspondence of John Cosin, D.D.*, part 1, Surtees Society 52, Edinburgh, 1868. Part 2 (55), 1870.

Cotton, Charles, *Poems*, edited with an introduction by John Buxton, London, 1958.

Cowley, Abraham, *Essays, Plays and Sundry Verses*, edited by A.R. Waller, Cambridge, 1906. *Poems*, edited by A.R. Waller, Cambridge, 1905.

Crawfurd, Raymond, *The King's Evil*, Oxford, 1911.

Creech, Thomas, *T. Lucretis Carus, his Six Books De Natura Rerum*, 'done into English verse with notes', Oxford, 1682.

Croft-Murray, Edward, *Decorative Painting in England, 1537-1837*, London, 1962. 'A Drawing by Charles le Brun for the Passage du Rhin in the Grande Galerie at Versailles', *British Museum Quarterly*, vol. 19, 1954.

Cromwell, Oliver, *Letters and Speeches: with Elucidations*, edited by Thomas Carlyle, third edition, 4 vols, London, 1850, 5 vols, 1873 (including, among the additional material, Cromwell's letter to Waller, 13 June, 1655). *The Writings and Speeches of Oliver Cromwell*, edited by W.C. Abbott, 4 vols, Cambridge, Mass., 1937-47.

Crouch, John, *A Mixt Poem, partly Historicall, partly Panegyricall, upon the Happy Return of His Sacred Majesty Charles the Second*, London, 1660.

Dabbs, J.A., *'Dei Gratia' in Royal Titles*, Paris, 1971.

Dawbeny (or Daubeny), Henry, *Historie & Policie Re-viewed*, London, 1659.

Deas, M.C., *A Study of the Life and Poetry of Edmund Waller*, 1931, unpublished doctoral dissertation, no. 411, University Library, Cambridge.

Defoe, Daniel, *The True-Born Englishman*, London, 1701 (10th ed. with explanatory preface)
 The Mock Mourners, 1702, *Poems on Affairs of State*, vol. 6, edited by Frank H. Ellis, New Haven/London, 1970.
Dekker, Thomas, *Non-dramatic Works*, edited by Alexander Grosart, 5 vols, London, 1884-86.
Denham, Sir John, *Expans'd Hieroglyphicks: a Critical Edition of Sir John Denham's 'Coopers Hill'*, by Brendan O'Hehir, Berkeley/Los Angeles, 1969.
 Poetical Works, edited with notes and introduction by Theodore Howard Banks, second edition, Archon Books, 1969.
Dennis, John, *The Impartial Critick*, 1693, see below, Spingarn, vol. 3.
 Miscellanies in Verse and Prose, London, 1693.
Derham, William, *The Artificial Clock-Maker*, London, 1696.
Dictionary of National Biography, The (DNB.), compact edition, 2 vols, Oxford, 1975.
Donne, John, *Pseudo-Martyr*, London, 1610.
 Sermons, edited by George R. Potter and Evelyn Simpson, 10 vols, Berkeley/Los Angeles, 1953-1962
Downes, Kerry, *The Architecture of Wren*, Granada Publishing, London/Toronto/Sydney/NY, 1982
Drummond of Hawthornden, William, *The Poems*, edited by W.C. Ward, 2 vols, London, 1894.
Dryden, John, *Works*, general editors, E.N. Hooker, H.T. Swedenberg, jun., etc., Berkeley/Los Angeles, 1956–.
 John Dryden, edited by Keith Walker, The Oxford Authors, Oxford, 1987.
 Amboyna, London, 1673.
 Essays, selected and edited by W.P. Ker, 2 vols, Oxford, 1900.
 Of DramaticPoesy and Other Critical Essays, edited by George Watson, 2 vols, London [Everyman 568-569], 1962.
 Poems and Fables, edited by James Kinsley, London, 1962.
 Virgil, *Aeneid*, translated by John Dryden, with 72 illustrations by Francis Cleyn engraved by Wenceslaus Hollar, &c., and an introduction by Peter Levi, Folio Society, London, 1993.
 The Works of Virgil, translated by John Dryden, with an introduction by James Kinsley, Oxford, 1961.
 The Letters of John Dryden, collected and edited by Charles Ward, Durham, North Carolina, 1952.
Dugdale, Sir William, *The History of St. Pauls Cathedral in London*, London, 1658.
 The History of Imbanking, London, 1662.
Edgington, Brian, *Charles Waterton, A Biography*, Cambridge, 1996.
Enderbie, Percy, *Cambria Triumphans*, London, 1661
England's Path to Wealth and Power, 1700, *Somers Tracts*, edited by Sir Walter Scott, vol. 11, 1814.
English Gentleman Justified, The, London, 1701.
Erasmus, Desiderius, *The Praise of Folly*, translated by John Wilson, 1668, edited with an introduction by Mrs P.S. Allen, Oxford, 1913.
 The Praise of Folly, translated by Betty Radice, Harmondsworth, 1971.
Epistle to Mr. Dryden, An, broadside, Exeter, November 5, 1688.
Erskine-Hill, Howard, *The Augustan Idea in English Literature*, London, 1983.
 The Social Milieu of Alexander Pope: Lives, Example and the Poetic Response, New Haven/London, 1975.
 'Alexander Pope: the political poet in his time', *Eighteenth Century Studies*, 15, 1983.
 'Literature and the Jacobite Cause', *Modern Language Studies*, 9, 1979.
Evelyn, John, *Diary*, edited by E.S. de Beer, London, 1959.
Exequiae Desideratissimo Principi Gulielmo Gloucestriae Duci ab Oxioniensi Academia Solutae, Oxford, 1700.
Fairfax, Edward, *Jerusalem Delivered* (a translation of Tasso's *Gerusalemme Liberata*), introduced by Roberto Weiss, London (Centaur Press), 1962.

Farquhar, Helen, 'Royal Charities, Part 3: Touchpieces for the King's Evil, James II to William III', *British Numismatic Journal*, Second Series, vol. 4, 1920.

F., E., *A Letter from a Gentleman of Quality in the Country to his Friend . . . being an Argument relating to the Succession to the Crown*, London, 1679.

Felltham, Owen, *The Poems*, edited by T- L. Pebworth and C.J. Summers, Pennsylvania State U.P., 1973 (SCN Editions and Studies, vol. 1).

A Brief Character of the Low Countries, London, 1652.

Felton, Henry, *A Dissertation on Reading the Classics and Forming a Just Style*, London, 1713.

Fielding, Henry, *A Journey from This World to the Next*, with an introduction by Claude Rawson, London (Everyman, 112), 1973.

Filmer, Sir Robert, *Patriarcha and Other Political Works*, edited with an introduction by Peter Laslett, Oxford (Blackwell), 1949.

Firth, C. H., *The Last Years of the Protectorate*, 2 vols, London, 1909.

Flecknoe, Richard, *Heroick Portraits with other Miscellany Pieces made and dedicated to his Majesty by Richard Flecknoe*, London, 1660.

Fleming, Robert, *A Practical Discourse, Occasion'd by the Death of King William*, second edition, corrected, London, 1703.

Fletcher, John, *The Humorous Lieutenant, The Dramatic Works in the Beaumont and Fletcher Canon*, general editor Fredson Bowers, vol. 5, Cambridge, 1982.

Florio, John, *Queen Anna's New World of Words,* 1611, facsimile, Menston, 1968.

Freke, John, 'The History of *Insipids*: A Lampoon, 1676', text from V. De Sola Pinto (ed), John Wilmot, Earl of Rochester, *Poems*, 2nd edition, London, 1964.

Fulgentius, Fabius Planciades, *Opera*, edited by Rudolfus Helm, Stutgardiae, 1970.

Fulgentius the Mythographer, (*The Mythologies,* etc) translated from the Latin, with an introduction by Leslie George Whitbread, Ohio State U.P., 1971.

Fuller, Thomas, *The Poems and Translations in Verse*, edited with an introduction and notes by Alexander Grosart, Edinburgh, 1868.

Gardiner, S.R.(ed.), *Constitutional Documents of the Puritan Revolution, 1625-1660*, Oxford, 1906.

Gibbon, Edward, *The History of the Decline and Fall of the Roman Empire*, edited by David Wolmersley, 3 vols, Harmondsworth, 1994.

Gibson, Katharine, 'The Decoration of St George's Hall, Windsor, for Charles II', *Apollo*, vol. 147, 1998.

Grey, Anchitel, *Debates in the House of Commons*, London, 1763.

Griffin, Patsy, *The Modest Ambition of Andrew Marvell*, Newark/London, 1995.

H., J., *The Tenth Satyr of Juvenal done into English verse*, 1683, London, 1693.

Haley, K.H.D., *The First Earl of Shaftesbury*, Oxford, 1968.

Halifax, George Savile, Marquess of, *Complete Works*, edited by J.P.Kenyon, Harmondsworth, 1969.

Hall, John, of Richmond, *Of Government and Obedience*, London, 1654.

The True Cavalier Examined by his Principles, London, 1656.

Hall, Joseph, *An Holy Panegyrick*, London, 1613.

Haller, William, 'Two early allusions to Milton's *Areopagitica'*, *Huntington Library Quarterly*, vol. 12, 1949.

Hamilton, Antony, *Memoires du Comte de Grammont*, 'presentation par Philippe Daudy', Paris, 1965.

Hardacre, P.H., 'A Letter from Edmund Waller to Thomas Hobbes', *Huntington Library Quarterly*, vol. 11, 1947-1948.

Hare, John, *St. Edward's Ghost, Harleian Miscellany*, vol. 8, London, 1811.

Harington, Sir John (trans), Lodovico Ariosto, *Orlando Furioso*, 1591, Amsterdam/NY. (Da Capo Press), 1970 (The English Experience, facsimile no. 259).

Harrington, James, *The Political Works*, edited by J.G.A. Pocock, Cambridge, 1977.

Harry, George Owen, *The Genealogy of the High and Mighty Monarch, James, by the Grace of God, King of Great Brittayne, &c.*, London, 1604.

Hawkins, Richard, *A Discourse of the Nationall Excellencies of England*, London, 1658.

Heath, James, *A Chronicle of the late Intestine War in the Three Kingdoms of England, Scotland and Ireland*, London, 1676.

Hensley, C.S., *The Later Career of George Wither*, The Hague, 1969 (*Studies in English Literature*, 43).

Herle, Charles, *David's Song of Three Parts*, London, 1643.

Herodian, *Herodian of Alexandria , his History of Twenty Roman Caesars and Emperors (of his time)*, translated by James Maxwell, London, 1629.

Hersey, George L., *Architecture, Poetry and Number in the Royal Palace at Caserta*, MIT. Press, Cambridge, Mass./London, 1983.

Hickes, George, *A Collection of Sermons*, 2 vols, London, 1713.

 Jovian, or an Answer to Julian the Apostate, London, 1683.

 A Vindication of Some among Our Selves against the False Principles of Dr. Sherlock, London, 1692.

Higden, Henry, *A Modern Essay on the Tenth Satyr of Juvenal*, London, 1687.

Hirst, Derek, ' "That Sober Liberty": Marvell's Cromwell in 1654', in *The Golden & the Brazen World*, see J.M. Wallace, below.

Hoadly, Benjamin, *The Nature of the Kingdom, or Church of Christ*, London 1717.

Hobbes, Thomas, *The English Works*, edited by William Molesworth, 5 vols, London, 1839-45.

 Considerations upon the Reputation,Loyalty, Manners & Religion of Thomas Hobbes of Malmsbury, London, 1680 (first published 1662).

 Leviathan, with an introduction by A.D. Lindsay, London (Everyman, 691), 1914, repr. 1965.

 Philosophical Rudiments concerning Government and Society (Hobbes's own translation of *De Cive*), London, 1651.

Hodge, R.I.V., *Foreshortened Time: Andrew Marvell and Seventeenth Century Revolutions*, Cambridge, 1978.

Holland, Philemon (trans), Livius, Titus, *The Romane Historie*, London, 1600.

 (trans) Ammianus Marcellinus, *The Roman Historie*, London, 1609

 (trans) Suetonius Tranquillus, Gaius, *History of Twelve Caesars*, with an introduction by Charles Whibley, Tudor Translations, 22, London, 1899.

 See also Camden, above.

Holstun, James, *A Rational Millennium*, NY./Oxford, 1987.

Holyoke, Francis, *Rider's Dictionarie*, 'corrected and augmented' by, London, 1606.

Hopper, Vincent, *Medieval Number Symbolism*, New York, 1938.

Horatius Flaccus, Quintus, *The Works of Horace Translated into English Prose by Christopher Smart*, Edinburgh, 1835.

Hulse, Clark, *Metamorphic Verse*, Princeton, 1981.

Hurd, Richard, *Moral and Political Dialogues; with Letters on Chivalry and Romance*, 3 vols, London, 1765.

Hutchinson, Lucy, 'To Mr: Waller upon his Panegirique to the Lord Protector', see David Norbrook below.

James VI and I, King, *Poems*, edited by James Craigie, 2 vols, Edinburgh, 1955 -1958 (Scottish Text Society Publications, 3rd series, 22, 26).

 Political Works, with an introduction by Charles Howard McIlwain, Cambridge, Mass., 1918.

J., D., *King Charles I. no such Saint, Martyr, or Good Protestant as Commonly Reputed*, London, 1698.

Johnson, Samuel 'Julian', *Works*, London, 1710.

Johnson, Samuel, *The Lives of the Poets*, with an introduction by L. Archer Hind, 2 vols Letchworth (Everyman, 770-771), 1925.

 The Rambler, edited by W.J. Bate and Albrecht B. Strauss, 3 vols, New Haven/London, 1969 (Yale *Works*, vols 3, 4, 5).

Jonson, Benjamin, *Works*, edited by C.H. Herford and P. and E. Simpson, 11 vols, Oxford, 1925-52.

Jowitt's Dictionary of English law, second edition by John Burke, London, 1977.

Julianus, Flavius Claudius, surnamed 'the Apostate', *Opera, et S. Cyrili contra eundem libri decem*, Greek and Latin, edited by Ezekiel Spanheim, Leipzig, 1696.

 Works, with an English translation by Wilmer Cave Wright, London/NY. (Loeb), 1913.

 Les Césars de l'Empereur Julien, translated by Ezekiel Spanheim, Heidleberg, 1660.

 Les Césars, revised and expanded edition of previous entry, Paris, 1683.

Jurieux, Pierre, *A Pastoral Letter on the Death of the Queen*, London, 1695.

Juvenalis, Decimus Junius,*The Tenth Satyr of Juvenal, English and Latin,*
 the English by Thomas Shadwell, London, 1687. See also Higden, Henry, and H., J. above.

Kantorowicz, E.H., *The King's Two Bodies*, Princeton, 1957.

Lamont, W.M., *Godly Rule*, London, 1969.

Langley, T.R., 'Abraham Cowley's *Brutus:* Royalist or Republican', *The Yearbook of English Studies*, vol. 6, 1976.

Lansdowne, George Granville, Baron, *Poems upon Several Occasions*, London, 1712.

Larthomas, Jean-Paul, 'Julien en Angleterre dans le Milieu Whig', in Jean Richer (ed.), *L'Empereur Julien*, vol. 2, *De la Legende au Mythe*, Paris, 1981.

Laud, William, *A Relation of the Conference between William Laud . . . and Mr. Fisher the Jesuit* (1639), a new edition with an introduction and notes by C.H. Simpkinson, London, 1901.

Lees-Milne, James, *English Country Houses: Baroque, 1685-1715*, Woodbridge, Suffolk, 1970.

Lewis, C.T., and Short, C., *A Latin Dictionary* (Lewis and Short), Oxford, 1984.

Livius, Titus, see Holland, Philemon above.

Locke, John, *A Third Letter for Toleration*, London, 1692.
 Two Treatises of Goverment, edited with an introduction by Peter Laslett, Cambridge, 1963 (Signet, 1965).

Lodge, Thomas (trans), *The Workes of Lucius Annaeus Seneca*, London, 1620.

Loewenstein, David, *Milton and the Drama of History: Historical Vision, Iconoclasm and the Literary Imagination,* Cambridge, 1990.

Lovelace, Richard, *Poems*, edited by C.H Wilkinson, Oxford, 1930.

Lucy, William, *Observations, Censures and Confutations of Notorious Errours in Mr. Hobbes his Leviathan*, London, 1663.

Macaulay, Thomas Babington, Lord, *The History of England from the Accession of James II*, edited by C.H. Firth, 6 vols, London, 1913-15.

Manningham, Thomas, *A Short View of the Most Gracious Providence of God in the Restoration and Succession*, London, 1685.
 A Solemn Humiliation for the Murder of K. Charles I, London, 1686.

Marcus Aurelius Antoninus, *The Golden Book of Marcus Aurelius*, translated by Meric Casaubon, 1634, with an introduction by W.H.D. Rouse, London, 1906.

Marder, T.A., *Bernini's Scala Regia at the Vatican Palace*, Cambridge, 1997.

Marshall, Stephen, *The Right Understanding of the Times*, London, 1647.
 The Song of Moses the Servant of God, and the Song of the Lamb, London,, 1643.

Marvell, Andrew, *The Poems and Letters*, edited by H.M. Margoliouth, 2 vols, revised by Pierre Legouis and E.E. Duncan-Jones, Oxford, 1971.
 The Rehearsal Transpros'd and The Rehearsal Transpros'd, the Second Part, edited by D.I.B. Smith, Oxford, 1971.

Mary II, Queen, *Memoirs of Queen Mary of England*, edited by R. Doebner, London, 1886.

May, Thomas, *Lucan's Pharsalia*, London, 1635 (third edition, 'corrected by the author'. First edition, 1627).

Mazzeo, J.A., *Renaissance and Seventeenth-century Studies,*, New York, 1964.

Milton, John, *The Works*, edited by F.A. Patterson *et al.*, New York (Columbia), 18 vols, 1931-38.
 Complete Prose Works, edited by Douglas Bush *et al.*, New Haven (Yale), 8 vols, 1953-1983
 Prose Works, 1641-1650, 3 vols, Menston, 1967-68.
 The Poems, edited by John Carey and Alastair Fowler, London, 1968.

Miner, Earl, *Dryden's Poetry*, Bloomington/London, 1967.

Mirimonde, A.P., 'Les Concerts des Muses chez les Maîtres du Nord', *Gazette des Beaux-arts*, vol. 63, 1964.

Monson, Sir William, *Naval Tracts in Six Books,* edited by M. Oppenheim, 4 vols London, 1902-1913 (Navy Records Society Publications, 22, 23, 43, 45), vol. 4, 1913.

Montagu, Charles, Earl of Halifax, *On the Death of Charles II*, in *A Collection of Poems*, London, 1701.

Myers, William, *Dryden*, London (Hutchinson University Library), 1973.

Nannus Mirabellius, Domenicus, *Novissima Polyanthea*, Frankfurt, 1617.

Nenner, Howard, *By Colour of Law*, Chicago/London, 1977.

 The Right to be King: The Succession to the Crown of England, 1603-1714, Basingstoke and London, 1995.

Nethercot, A.H., *Abraham Cowley, the Muse's Hannibal*, Oxford, 1931.

Neve, Philip, *Cursory Remarks on Some of the Ancient English poets, particularly Milton*, London, 1789.

Neville, Henry, *Plato Redivivus*, London, 1681.

Nicholas Papers, The, Camden Society, 1896-1920, vol. 3, 1897, edited by G.F. Warner.

Nisbet, William, *An Inquiry into the History, Nature. Causes, and Different Modes of Treatment hitherto pursued, in the Cure of Scrofula and Cancer*, Edinburgh, 1795.

Norbrook, David, 'Lucy Hutchinson versus Edmund Waller: an unpublished reply to Waller's *A Panegyrick to my Lord Protector*', *The Seventeenth Century*, 11, 1996.

 ' "Safest in Storms": George Wither in the 1650s', in *Heart of the Heartless World: Essays in Cultural Resistance in Memory of Margot Heinemann*, edited by David Margolies and Maroula Joannou, London/Boulder, Colorado, 1995.

 Writing the English Republic: Poetry, Rhetoric and Politics, 1627-1660, Cambridge, 1999.

Numerus Infaustus, 1689, 'now reprinted', London, 1736.

Observations Concerning the Present Affayres of Holland and the United Provinces, n.p., 1622.

Ogilby, John, (trans.), *The Works of P. Virgilius Maro*, London, 1654.

O'Hehir, Brendan, *Harmony from Discords: a Life of Sir John Denham*, Berkeley/ Los Angeles, 1968.

 See also Denham, John, above)

O'Malley, John W., Review of Paolo Prodi, *Il Sovrano Pontifice* , Bologna, 1982, *The American Historical Review*, vol. 88, 1983.

Owen, John, *The Shaking and Translating of Heaven and Earth*, in *Works*, edited by W.H. Goold, 24 vols, London and Edinburgh, 1850-55, vol. 8.

Oxford English Dictionary, The (OED.), compact edition, 2 vols, Oxford, 1971.

Panofsky, Erwin, *Studies in Iconology*, New York (Harper), 1962.

Parker, Samuel, *A Reproof to the Rehearsal Transprosed*, London, 1673.

Parallel between O.P. and P.O., A, broadside, London, 1694.

Parry, Graham, *The Golden Age Restor'd*, Manchester, 1981.

Pastoral Letter Reburnt by a Poetical Flambeau, The, broadside, London, 1693.

Peck, Francis, *Desiderata Curiosa*, 2 vols, London, 1732-35.

Perfect Diurnall, A, for: 12-19 June, London, 1643; 3-10 July, 1643; 2-9 September, 1644; 23-30 September, 1644; 7-14 October, 1644.

Picinelli, Filippo, *Mundus Symbolicus*, edited by August Erath, Cologne, 1694, Garland facsimile, NY./London, 1976)

Pinnell, Richard T., *Francesco Corbetta and the Baroque Guitar*, Michigan, 1980.

Poems on Affairs of State: Augustan Satirical Verse, 1660-1714, edited by G. de F. Lord, etc., 7 vols, New Haven, 1963-1975.

Poggioli, Renato, *The Oaten Flute*, Cambridge, Mass., 1975.

Pomey, Antoine, *The Pantheon*, 'Made English by J.A.B., M.A.', London, 1694, Garland facsimile, NY./London, 1976.

Pope, Alexander, *The Poems*, edited by John Butt, London, 1963.

 Prose Works, edited by Rosemary Cowler, vol. 2, Oxford (Blackwell), 1986.

Poyntz, Sir Robert, *A Vindication of Monarchy*, London, 1661.

Price, Martin, *To the Palace of Wisdom: Studies in Order and Energy from Dryden to Blake*, Carbondale and Edwardsville, 1964.

Prior, Matthew, *Carmen Saeculare* [sic], London, 1700.

 Poems on Several Occasions, London, 1709.

 'Prior Papers', *Calendar of the Manuscripts of the Marquis of Bath preserved at Longleat*, vol. 3, Historical Manuscripts Commission, Hereford, 1908.

Protestant Mask Taken Off from the Jesuited Englishman, The, London, 1692/3.

Propertius, Sextus, *The Elegies*, edited and translated by G.P. Goold, Cambridge, Mass./London (Loeb), 1990.

Pugh, Thomas, *Brittish and Out-landish Prophesies*, London, 1658.

Puttenham, George, *The Arte of English Poesie*, edited by G.D. Willcock and Alice Walker, Cambridge, 1936.

Raleigh, Sir Walter, *The History of the World*, London, 1614.

Rawlinson, John, *Vivat Rex, a Sermon preach'd at Pauls Crosse on the Day of his Majeties Happie Inauguration,* March 24, 1614, Oxford, 1619.

Reasons for Crowning the Prince & Princess of Orange Joyntly, and for placing the Executive Power in the Prince Alone, London, 1689.

Reynell, Carew, *The Fortunate Change, being a Panegyrick to his Sacred Majesty Charls the Second immediately on his Coronation*, London, 1661.

Ripa, Cesare, *Iconologia*, Padua, 1611, Garland facsimile, NY./London, 1976.

Rochester, John Wilmot, Earl of, *The Complete Poems*, edited by D.M. Vieth, New Haven/London, 1968.

 Poems, edited by V. De Sola Pinto, second edition, London, 1964.

 A Farce of Sodom, BL. MS. Harl. 7312.

Ross, Alexander, *Mystagogus Poeticus*, London, 1648.

Rump: or an Exact Collection of the Choycest Poems and Songs relating to the Late Times, London, 1662.

Rymer, Thomas, *A Poem on the Arrival of Queen Mary, February 12th 1689*, London, 1689.

 Preface to Rapin, vol. 2.

 See Spingarn, Joel E., below

 A Short View of Tragedy, London, 1693.

Sachse, William L., *Lord Somers: a Political Portrait*, Manchester, 1975.

Sandys, George, *Ovid's Metamorphosis, Englished, Mythologized, and Represented in Figures* [together with] *An Essay to the Translation of Virgil's Aeneis, by G.S.,* London, 1640. His translation of Book I of the *Aeneid* was first appended to his *Metamorphosis* (1621-1626) in 1632.

Saward, Susan, *The Golden Age of Marie de'Medici*, Epping, 1982.

Schama, Simon, *The Embarrassment of Riches: An Interpretation of Dutch Culture in the Golden Age*, Fontana Press, 1988.

Scott, John, *Critical Essays*, London, 1785.

Sedgwick, William, *A Second View of the Army Remonstrance*, London, 1649.

Segal, Charles Paul, '*Aeternum per Saecula Nomen*, the Golden Bough and the Tragedy of History', *Arion*, vol. 4, 1965.

Seneca, Lucius Annaeus, see Lodge, Thomas, above

Shadwell, Thomas, *A Congratulatory Poem to the most Illustrious Queen Mary upon her Arrival in England*, London, 1689.

 See also Juvenalis above.

Shaftesbury, Anthony Ashley Cooper, Earl of, *Characteristics of Men, Manners, Opinions, Times*, edited by J.M. Robertson, with an introduction by Stanley Grean, Bobbs-Merill, 1964.

Shakespeare, William, *Comedies, Histories, & Tragedies*, London, 1623: facsimile edition, prepared by Helge Kökeritz, with an introduction by Charles Tyler Prouty, New Haven, 1953.

 Arden Editions of:
 Hamlet, edited by Harold Jenkins, 1982.
 Henry IV , Part I, edited by A. R. Humphreys, 1961.
 Henry V, edited by J.H. Walter, 1967.
 King Lear, edited by Kenneth Muir, 1959.
 Macbeth, edited by Kenneth Muir, 1962.
 Measure for Measure, edited by J.W. Lever, 1965.
 Much Ado about Nothing, edited by A.R. Humphreys, 1981.
 Richard II, edited by Peter Ure, 1956.
 Troilus and Cressida, edited by Kenneth Palmer, 1982
 The Winter's tale, edited by J.H.P. Pafford, 1965.

Sharpe, Kevin, ' "An Image Doting Rabble": The Failure of Republican Culture in Seventeenth-century England', in Kevin Sharpe and Steven N. Zwicker, eds, *Refiguring Revolutions*, Berkeley/Los Angeles/London, 1998. See under Zwicker below.

Sidney, Sir Philip, *An Apology for Poetry*, in *Elizabethan Critical Essays*, edited by G. Gregory Smith, 2 vols, Oxford, 1904, vol. 1.

Skeat, Walter W., *An Etymological Dictionary of the English Language*, Oxford, 1989 (first edition 1879-1882).

Smith, Robert, 'Upon the Late Loss of the Queen', *Poems on the Death of Her Most Excellent Majesty Queen Mary*, by J. Rawson and Robert Smith, London, 1695.

Snell, Bruno, *The Discovery of the Mind*, translated by T.G. Rosenmeyer, Oxford, 1953.

Souchal, François, *French Sculptors of the Seventeenth and Eighteenth Centuries*, Oxford (Cassirer) 1981.

South, Robert, *Sermons*, sixth edition, 11 vols, London, 1727.

Spark, Thomas, 'Aula Vindesoriae', in *Musarum Anglicanae*, vol. 2, London, 1719.

Spanheim, Ezekiel, *Relation de la cour de France en 1690 . . . suivie de la relation de la cour d'Angleterre en 1704*, edited by Emile Bourgeois, *Annales de l'Université de Lyon*, NS II, Droit, Lettres, Fascicule 5, Paris/Lyon, 1900.
 See also Julianus above

Spence, Joseph, *Observations, Anecdotes, and Characters of Books and Men*, edited by J. M. Osborn, Oxford, 1966.

Spens, Susan, *George Stepney (1663-1707), Diplomat and Poet*, Cambridge, 1997.

Spenser, Edmund, *Poetical Works*, edited by J.C. Smith and E. De Selincourt, London, 1912.
 The Faerie Queene, edited by J.C. Smith, 2 vols, Oxford, 1909.

Spingarn, Joel E. (ed.), *Critical Essays of the Seventeenth Century*, 3 vols, first edition, Oxford, 1907, reissue (2nd printing), Bloomington, 1963.

Spragens, Thomas A., Jun., *The Politics of Motion: The World of Thomas Hobbes*, foreword by Antony Flew, London, 1973.

Stapylton, Sir Robert, *Pliny's Panegyricke*, Oxford, 1644.

Stephen, Leslie, *Hobbes* London, 1924.

Stevens, Wallace, *Opus Posthumous*, edited by S.F. Morse, London, 1959.

Stepney, George, *A Poem Dedicated to the Blessed Memory of her late Gracious Majesty Queen Mary*, London, 1695.

Sterne, Laurence, *The Life and Opinions of Tristram Shandy*, edited by Graham Petrie, with a new introduction by Christopher Ricks, Harmondsworth, 1967.

Stevin, Simon,*The Principal Works*, edited by E. Crone, E.J. Dijksterhuis, R.J. Forbes, etc., 5 vols, Amsterdam, 1955-66.

Strong, Roy, *Britannia Triumphans: Inigo Jones, Rubens and Whitehall Palace*, Over Wallop, Hampshire, 1980.
 Splendour at Court: Renaissance Spectacle and Illusion, London, 1973 (reprinted in revised form as *Art and Power: Renaissance Festivals, 1450-1650*, Woodbridge, Suffolk, 1984).

Stubbe, Henry, *A Justification of the Present War against the United Netherlands*, London, 1672.
 A Further Justification, London, 1673.

Suetonius Tranquillius, Gaius, see Holland, Philemon above.

Swift, Jonathan, *Gulliver's Travels*, edited by Harold Williams, Oxford, 1959.
 A Tale of a Tub, &c., edited by A.C. Guthkelch and D. Nichol-Smith, Oxford, 1958.

Sylvester, Joshua (trans.), see Bartas above.

Tasso, Torquato, *Il Goffredo*, Venice, 1583. See also Fairfax, Edward, above.

Tate, Nahum, *Mausolaeum*, London, 1695.

Taylor, Jeremy, *The Great Exemplar of Sanctity and Holy Life*, 1649, *The Whole Works*, London, 1880, vol. 3.

Taylor, René, 'Architecture and Magic: Considerations on the *Idea* of the Escorial', in *Essays in the History of Architecture presented to Rudolf Wittkower*, edited by Douglas Fraser, Howard Hibbard and Milton J. Lewine, London, 1967.

Temple, Sir William, *Introduction to the History of England*, London, 1695.

Tervarent, Guy de, 'Attributes et Symboles dans l'Art Profane, 1450-1600, *Travaux d'Humanisme et Renaissance*, vol. 29, Genève, 1958 (Tome 1), 1959 (Tome 2), 1964 (Supplément et Index).

Thomas, P.W., *Sir John Berkenhead, 1617-1679*, Oxford, 1969.

Threnodia Cantabrigiensis in Immaturum Obitum Illustrissimi ac Desideratissimi Principis Gulielmi Duci Gloucestrensis, Cambridge, 1700.

Thurloe, John, *State Papers*, 7 vols, London, 1742.

Thynne, Francis, *Emblemes and Epigrames*, 1600, edited by F.J. Furnivall, *Early English Text Society*, London, 1876.

Tillotson, John, *Works*, London, 1735.

Tourneur, Cyril, *The Atheist's Tragedy*, edited by Irving Ribner, London, 1964.,

Valentine, Henry, *God Save the King: A Sermon preach'd in St. Paul's Church, 27th March, 1639, being the Day of His Majesties Happy Inauguration, and of his Northern Expedition*, London, 1639.

Verney Papers, 'Notes of Proceedings in the Long Parliament, temp. Charles I', edited by J. Bruce, *Camden Society*, London, 1845.

Verstegen (Rowlands), Richard, *Restitution of Decayed Intelligence in Antiquities concerning the Most Noble and Renowned English Nation*, London, 1673 (first edition 1605).

Virgil (Vergilius Maro, Publius), *Aeneidos Liber Sextus*, with a commentary by R.G. Austin, Oxford, 1977.

See also Dryden, Ogilby, Sandys above.

Voltaire, François Marie Arouet de, *Le Siècle de Louis XIV*, edited by Antoine Adam, 2 vols, Paris, 1966.

Walker, Clement, *The History of Independency*, London, 1648.

Wallace, J.M., *Destiny his Choice: the Loyalism of Andrew Marvell*, Cambridge, 1968.

(ed.) *The Golden & the Brazen World: Papers in Literature and History, 1650-1800*, Berkeley/Los Angeles/London, 1985.

Waller, Edmund, *Poems, &c.*, 1645, together with poems from Bodleian MS Don D 55, Menston, 1971.

Poems, &c., (5th edition) London, 1686

The Second Part of Mr. Waller's Poems, London, 1690.

Poems, &c., (9th edition, for Jacob Tonson), London, 1712.

The Works of Edmund Waller in Verse and Prose, published by Mr. Fenton (Elijah Fenton), London, 1729.

The Poems of Edmund Waller, edited by G. Thorn Drury, two vols, London, 1905 (first edition, 1893).

A Panegyrick to my Lord Protector, by a Gentleman that loves the Peace, Union, and Prosperity of the English Nation, London (for Thomas Newcomb), 1655.

To the King, upon His Majesties Happy Return, [London, 1660] STC W529A.

Upon the late Storme and Death of his Highnesse ensuing the Same, text from *Three Poems upon the Death of his late Highnesse Oliver Lord Protector of England, Scotland, and Ireland*, 'written by Mr. E. Waller. Mr. J. Dryden. Mr. Sprat', London (for William Wilson), 1659.

Upon the present War with Spain, and the First Victory Obtained at Sea, text from Samuel Carrington, *The History of the Life and Death of His Most Serene Highness, Oliver, late Lord Protector*, London, 1659.

Wallerstein, Ruth C., 'The Development of the Rhetoric and Metre of the Heroic Couplet, especially in 1625-1645', *Publications of the Modern Language Association*, 50, 1935.

Walpole, Horace, *Anecdotes of Painting*, London, 1879.

Walzer, Michael, *The Revolution of the Saints*, London, 1966.

Wasserman, E.R., 'Nature Moralized: Divine Analogy in the Eighteenth Century', ELH., 20, 1953.

The Subtler Language, Baltimore, 1959, second printing, 1964..

Waterton, Charles, *Essays on Natural History, Chiefly Ornithology*, London, 1838,

Watson, Richard, *Effata Regalia*, London, 1661.

The Panegyrike and the Storme, two Poetike Libells by Ed. Waller, Vassa'll to the Usurper, Answered by more Faythfull Subjects of his Sacred Majestty Charles ye Second, np. [Bruges?], 1659.

Regicidium Judaicum, or a Discourse about the Jewes Crucifying Christ;with an Appendix or Supplement upon the late Murder of our Blessed Soveraigne, Charles the First The Hague, 1649.

Weinbrot, Howard D., *Augustus Caesar in 'Augustan' England*, Princeton, 1978.

Welsford, Enid, *The Court Masque*, Cambridge, 1927.

Whiston, William, *Memoirs of the Life and Writings*, London, 1753

White, Thomas, *The Grounds of Obedience and Government*, London, 1655.

Whittel, John, *Constantinus Redivivus*, London, 1693.

Wikelund, P.R., 'Edmund Waller's Fitt of Versifying: Deductions from a Holograph Fragment, Folgar MS. X. d. 300', *Philological Quarterly*, vol. 49, 1970.

' "Thus I passe my time in this place" ': An unpublished letter of Thomas Hobbes', *English Language Notes*, vol. 6, no. 4, June, 1969.

Wilkins, John, *An Essay towards a Real Character and a Philosophical Language*, London, 1668.

Wilkinson, Henry, *Babylon's Ruin, Jerusalem's Rising*, London, 1643.

Wilson, Charles, *The Dutch Republic*, London, 1968.

Wind, Edgar, *Hume and the Heroic Portrait*, edited by Jayne Anderson, Oxford, 1986.

'Julian the Apostate at Hampton Court', *Journal of the Warburg and Courtauld Institutes*, vol. 3, 1939-40.

Winstanley, Gerrard, *The True Levellers Standard Advanced*, 1649, *The Works*, edited by George R. Sabine, New York, 1941.

W[instanley], W[illiam], *The English and Dutch Affairs Display'd to the Life*, London, 1664.

Winternitz, Emanuel, *Musical Instruments and their Symbolism in Western Art*, New Haven/ London, 1979.

Wither, George, *The Miscellaneous Works*, 6 vols, Manchester, 1872-78.

The British Appeals with God's Merciful Replies, on the Behalf of the Common-Wealth of England, London, 1651.

The Protector, a Poem Briefly Illustrating the Supereminency of that Dignity, London, 1655.

Wittkower, Rudolf, 'The Vicissitudes of a Dynastic Monument' in *Studies in the Baroque*, Over Wallop, Hampshire, 1982.

Wordsworth, William, *The Prelude*, text of 1805, edited with an introduction and notes by Ernest de Selincort, revised by Helen Darbishire, London, 1961.

Wren, Matthew, *Considerations on Mr. Harrington's Commonwealth of Oceana*, London, 1657.

Monarchy Asserted or the State of Monarchicall & Popular Government in Vindication of the Considerations upon Mr. Harrington's Oceana, London, 1659.

Wycherley, William, *The Complete plays*, edited by Gerald Weales, New York U.P., 1967.

Yates, Frances A., *Astraea*, Harmondsworth, 1977.

Yeats, W.B., *Autobiographies*, London, 1961.

Zagorin, Perez, *A History of Political Thought in the English Revolution*, London, 1954.

Zwicker, Steven N., *Dryden's Political Poetry: the Typology of King and Nation*, Providence, 1972.

Lines of Authority: Politics and English Literary Culture, 1649-1689, Ithaca/ London, 1993.

Politics and Language in Dryden's Poetry: The Arts of Disguise, Princeton, 1984.

with Kevin Sharpe (eds), *Politics of Discourse: The Literature and History of Seventeenth-century England*, Berkeley/Los Angeles, 1987.

Refiguring Revolutions: Aesthetics and Politics from the English Revolution to the Romantic Revolution, Berkeley/Los Angeles, 1998.

INDEX